DESIGN ESSENTIALS FOR THE MOTION MEDIA ARTIST

DESIGN ESSENTIALS FOR THE MOTION MEDIA ARTIST

A Practical Guide to Principles & Techniques

ANGIE TAYLOR

Routledge
Taylor & Francis Group

LONDON AND NEW YORK

First published 2011 by Focal Press

2 Park Square, Milton Park, Abingdon, Oxon OX14 4RN
711 Third Avenue, New York, NY 10017, USA

Routledge is an imprint of the Taylor & Francis Group, an informa business

First issued in hardback 2017

Library of Congress Cataloging-in-Publication Data
Application submitted

British Library Cataloguing-in-Publication Data
A catalogue record for this book is available from the British Library.

ISBN 13: 978-0-240-81181-9 (pbk)
ISBN 13: 978-1-138-45293-0 (hbk)

Dedication

To the memory of Monkey, my darling little pooch who understood my every thought and loved me regardless. To Stanley for being a girl's best friend and helping us through a difficult year. To my Mum and Dad for their continued love and support. But most of all to Jo, the love of my life—this is *our* book.

CONTENTS

FOREWORD

Rob Chiu | Director
www.theronin.co.uk

The first time I encountered Angie Taylor's writing was in 2001 when I read her book *Creative After Effects 5.0*. I'd recently finished a part-time bachelor degree in Graphic Design, and I had decided to explore After Effects on my own. I had been working in various print design agencies in the north of England for four or five years and had quickly grown complacent with the medium. I was always a storyteller at heart, and for my dissertation piece, I had already created my first short film in After Effects 3.1. I put it all together using an old VHS camcorder and a pile of scanned photographs. I boldly decided to embark upon the path of freelancing as a motion designer in the hope that someone would hire me and let me escape the world of static design.

Figure F.1 **Rob Chiu.** Motion designer and director of film and photography. *www.theronin.co.uk.*

Figure F.2 **Dr. Nakamats titles.** Main and end titles for a documentary on the infamous Japanese inventor Dr. Nakamats. Directed by Kaspar Astrup Schröder and produced by Plus Pictures. *www.theronin.co.uk/Motion/?Dr_Nakamats_Titles.mov*

At the time, I had probably only two pieces to my name: *Journey,* which was my degree piece, and a short live action film called *Dual/Duel,* which was my first experiment with full live action. I had a very basic understanding of how to make things move between point A and point B in After Effects, and when my first live commission came in, I had no idea what I was *really* doing. One afternoon, I was in a Borders bookstore (that, sadly, no longer exists), and I came across Angie's book *Creative After Effects 5.0*. It was just what I had been looking for. It explained everything to me in simple terminology and also in a way that didn't impose a design style on me or even influence me in any way. It was perfect. I purchased it that day and set off on a mission to learn and master After Effects.

I never did complete my second objective of mastering After Effects, and I still use only the slightly less than basic functionalities of it, but I always refer back to Angie's book every time I get stuck on how to do something. For the past ten years, her book (I now use the version 7 edition) has been my guide whenever I get lost (which is often).

Figure F.3 Webbys gala opener. During a one-month stay in New York, I directed the Webbys gala introductory sequence for *Digital Kitchen*. As part of a larger package completed by DK for the Webbys awards show, this became the final "director's cut" version, complete with a Hecq soundtrack. Shot in one day around Manhattan and Brooklyn with a low-key crew, I edited the sequence in New York and sent it to DK's Chicago office for the graphics to be added. It was then returned to me in London for final grading and editing duties. My thanks to Dave Skaff, Abbe Daniel, and Rama Allen for giving me the freedom to see through my vision on this project! *Rob Chiu, Rama Allen, Hecq, Gene Park, Frank Donnangelo, Anthony Vitagliano, Nick Campbell, Jason Esser, Peter Kallstrom, Mike Alfini, Erica Rangel, Abbe Daniel, Andrea Biderman, Josh Hartsoe, Julie Rutigliano, Chris Caiati.*

I had never met Angie, and I didn't know anything about her, other than what I had learned through her book. I knew that she was at heart a punk girl and had a very distinct personal style, but that was about all. In 2007 I gave a talk in her hometown of Brighton at a conference for Adobe Flash designers called "Flash on the Beach." My work was a little out of place there, as it is not Flash oriented at all, and yet quite a few people attended to hear my presentation and see some of the work I had created over the years.

Figure F.4 Flash on the Beach. Created for the "Flash on the Beach" conference in Brighton, United Kingdom. Audio by Hecq. My special thanks to Susie Q and John Davey. *www. theronin.co.uk/Motion/?Flash_on_ the_Beach.mov.*

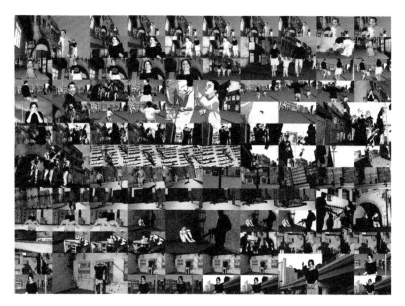

Figure F.5 Black Day to Freedom. Created as a fictional back story to the global problem of the displacement of peoples, *Black Day to Freedom* portrays a city in turmoil, with the loss and tragedy of a young family at the center of the tale. Animated entirely in After Effects, the piece is both unique in appearance and powerful in impact. Character illustration by Steve Chiu, voice snippets by David Dunkley Gyimah, directed and written by Rob Chiu. Audio by Diagram of Suburban Chaos. *www.theronin.co.uk/ Motion/?Black_Day_To_ Freedom.mov.*

At the end of the talk, people came to ask me questions and thank me for sharing my experiences and work. That's when I first met Angie. She was standing in line with everyone else to thank me! She told me her name, and, of course, I instantly recognized it, and I was instantly honored! The person from whom I had learned virtually everything there was to know about After Effects had come to congratulate *me* on my work, and she had no idea at the time what a big part she had played in bringing me to where I was that day. We kept in touch over the years since, and when Angie asked me to contribute something to this book, I again was deeply honored.

Figure F.6 Things Fall Apart. Motion collective Devoid of Yesterday (consisting of directors Rob Chiu and Chris Hewitt) team up again (along with audio designer Ben Boysen) for a new short narrative-led piece that explores a child's pent-up anger and frustration that ultimately lead to a force that marks the end of innocence. Sometimes … things just fall apart. Starring Jordan Chiu. *www.theronin. co.uk/Motion/?Things_Fall_ Apart.mov.*

Figure F.7 Glasgow 2014 20th Commonwealth Games. Created as a launch vehicle for the new Glasgow 2014 identity as designed by Marque Creative, this short piece places athletes in and around urban Glasgow. The film depicts the symmetry between the city and the games, culminating in the final revelation of the new identity. Commissioned by Marque Creative. Directed, edited, animated, composited, and graded by Rob Chiu. Additional logo animation by Hoss Gifford. DoP by Paul O'Callaghan. Location and talent producer Iain Hopkins for 1759, gaffer Dave Hutton, and spark Simon Hutton. Sound design and score by Hecq. *www.theronin.co.uk/Motion/?2014_Glasgow.mov.*

For those of you who have never heard of me—and that is probably a lot of you—I have worked under the name of The Ronin for the past ten years for clients such as Cartier, Leica, Nokia, Greenpeace, and the BBC, among many others. Two of the pieces that were directly inspired by reading Angie's book are a short trailer for the Leeds Film Festival and a short film called *Black Day to Freedom*, which is an animation entirely built in After Effects, although it looks as if it could have been created in a basic 3D program.

This piece was actually inspired, at least technically, by a chapter in Angie's book in which she had built a very basic city with skyscrapers and lights. I took this as a starting point and created my own world to help anchor the story. Since then, I have moved into directing live action, which currently still uses motion graphics and compositing. Although some of my more recent work for the Glasgow Commonwealth Games and Else Mobile Phones are very much polished pieces of work, I created both on an ordinary personal computer (with the help of some animators on Else) and did all of the directing, editing, animating, compositing, and color grading myself. I am at heart still deeply in love with just picking up a camera and shooting things myself and then jumping onto a computer and literally experimenting with an edit, a look, or a way to incorporate graphics into the frame.

Figure F.8 **Created for Else Mobile Phones as half viral campaign, half official website content and commissioned by The Visionaire Group in Los Angeles, California.** *The Time Has Come* acts as an introduction to a new mobile device. The entire campaign was shot on location in downtown Los Angeles and other parts of California. Directed, edited, composited, and graded by Rob Chiu; producer, Maria Park for The Visionaire Group; production company, The Visionaire Group; director of photography, Eric Koretz; first camera assistant, Rob Kraetsch; second camera assistant, Dave Edsall; gaffer, Henry Dhuy; grip, Aryeh Kraus; creative director, Jeff Lin for The Visionaire Group; animators (for TVG), Chris Wang, Francisco Camberos, and Anthony Possobon; score and sound effects, Ben Lukas Boysen; storyboard artist, Jason Badower. *www. theronin.co.uk/ Motion/?Else_Mobile.mov.*

It feels like I have come full circle by being given the honor of writing this foreword for Angie, and I hope I can encourage readers to keep this book handy as a reference book—a sort of design bible for the years to come. If, like me, you are always finding yourself tearing out your hair over problems, then you too will be coming back to these pages to find a solution. I hope that some of you, like me, will one day have the privilege of meeting Angie so you can thank her in person for all of her hard work and contributions to the design community. I also hope that you will be able to enjoy the same experiences I have in the course of your work, which, in my case, really all started out from a random discovery in a bookstore in the north of England.

ACKNOWLEDGMENTS

I'd like to thank the following people:

My editor, Karen Gauthier, for helping to make this twice the book it could have been.

The whole team at Focal Press for commissioning this book and having continued faith in me despite my limited availability and the extended deadlines! In particular, I offer heartfelt thanks to Dennis McGonagle, Carlin Reagan, and Paul Temme.

I also thank the following contributors of text and images (in alphabetical order):

Joan Armatrading (Introduction), Stefano Buffoni (type), Robert Butler (drawing), Steve Caplin (communication), Stefan Chinoff (type), Rob Chiu (Foreword), Temple Clark (planning), Mark Coleran (color), Madeleine Duba (animation), Malcolm Garrett (composition), Matt Gauthier (drawing), Ryan Gauthier (drawing), Nicolas A. Girard (text), Andrey Gordeev (color), Greenpeace (color), George Hedges (planning), Joost van der Hoeven (editing), Birgitta Hosea (technical), Robert Hranitzky (type), Waikit Kan (type), Lokesh Karekar (color), Rachel Max (drawing and composition), Stuart Price (composition), Jamie Reid (type), Sonia Melitta Watson (drawing), Murray Taylor (drawing and composition), Richard Walker (color), and Kate Williams (type, color, planning, and animation)

My thanks to Steve Forde for supporting me in my job at GridIron Software and allowing me to take my vacation early so I could finish this book.

I thank Rob Pickering for inspiring me, motivating me, and introducing me to strange new concepts!

I thank Simon Harper for his invaluable feedback on the cover!

I thank all of my friends and colleagues at Adobe, Apple, Wacom, and other companies (you know who you are!) for working with me and providing me with additional inspiration for this book.

My thanks to Rory Duncan at IBM for getting me involved in this industry back in 1993 and continuing to inspire me ever since.

And finally, I thank all of my other family members and friends for their endless support, inspiration, and love. And, most important, I thank anyone I forgot to mention in my rush to get this to the publisher!

INTRODUCTION

You, the Reader

The aim of this book is to provide inspiration, motivation, and knowledge to three main groups of people: designers who have a good handle on the technical side of things but would like a refresher on some of the fundamental teachings of art and design; students of digital media and motion graphic design courses; and their teachers. In particular, this book will be helpful to anyone who uses computers to generate animation or video content, whether it's for the web, television, film, or any other form of media.

I, the Author

My name is Angie Taylor (Figure I.1), and I'll be taking you through this journey to explore the fundamentals of design. I provide an industry perspective that is based on a 16-year career in the digital media industry. I worked as a freelance designer and animator for companies such as the BBC, Adobe, and Channel 4 Television in the United Kingdom. I also worked on music videos with other artists and designers, including director Chris Cunningham and musician Beck. At the time of writing this book, I was employed as the European Creative Director at GridIron Software. I have published two other books with Focal Press: Creative After Effects 5 and Creative After Effects 7 (Figures I.2 and I.3).

Figure I.1 **Angie Taylor, the author.**

My Motivation

I decided to write this book after a spell teaching BA and FdA Digital Media courses in 2008. I wanted to share the knowledge I gained during my own studies at art college (Figure I.4) and during my career as an animator and designer.

Digital Media Design is a new, evolving area that encompasses many disciplines. Teaching emphasis is often weighted toward technical software skills, and this is certainly a popular teaching approach with students who can't get enough of software training.

Design Essentials for the Motion Media Artist. DOI: 10.1016/B978-0-240-81181-9.00007-8

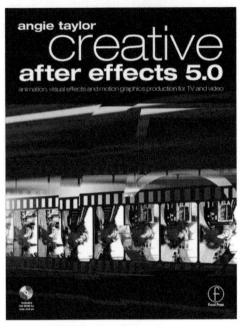

Figure I.2 **Creative After Effects 5.**

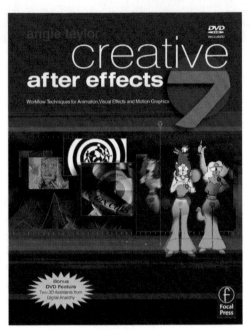

Figure I.3 **Creative After Effects 7.**

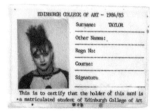

Figure I.4 **Angie Taylor (Edinburgh College of Art—1984).**

Another angle that is popular in universities is the academic study of theory and practice, which can encourage students to conceptualize and develop ideas. However, in my experience, many digital media courses are not putting enough emphasis on teaching the core principles of art and design. Perhaps it's because there is such a plethora of new theory and practice to consider that the good old-fashioned rules are forgotten. There may also be a wrongful assumption that students are already familiar with these basics. Of course, it goes without saying that people also need access to the right resources. I noticed that the students had to take out an average of ten books from the library just to cover the information that was required to become familiar with the basic rules of art and design. Often only a fraction of the content of these books was actually required for them to proceed with and complete their college work. This is what made me realize that students, teachers, and embarking designers need a book that's a "one-stop shop" for the core design principles.

I want to address these issues by providing the right amount of information to ensure that after reading this book, you have sufficient understanding to complete your journey to becoming a more well-rounded motion design professional. I also hope to inspire you to get real enjoyment from the subject, without swamping you with too much information.

This book will cover everything you need to know to form a good foundation in digital media design, but it is not intended to be a fully comprehensive study of each of the subjects covered. If you need to continue with further study on any of the subjects discussed, you'll be pointed to the best resources for continuing your learning and expanding your knowledge.

The Fundamental Gap

Until recently there was no single, specified route into digital media design. It's quite common to see people entering the profession from a variety of directions. Some may come from an art and design background, others could enter the profession from a more technical perspective or from a management role, for example. In the design industry, everyone has a different story to tell about how he or she arrived at graphic design as their chosen profession. This makes for an exciting and diverse environment and ultimately provides a wealth of creative inspiration.

It's absolutely crucial that newcomers to the field of digital media design learn the fundamentals of art and design in order to progress with their chosen career. As an art college graduate I took my knowledge of these basic principles for granted, and I presumed that people undertaking similar courses in digital media design would also have an awareness of them. However, I've discovered that many designers who don't come from a traditional art or design background have missed out on learning these important fundamental skills. This book aims to fill any gaps, providing a good, solid foundation to build upon.

My concern is that without these skills designers can waste much of their time reinventing the wheel, only to realize later that they could have used tried and tested formulas that already exist. You may be thinking that formulas and design don't seem to go hand-in-hand and wondering if design, as a strictly creative pursuit, shouldn't be free from formulaic constraints. In order to understand why rules are important for designers, it's important to fully appreciate the difference between art and design.

Art and Design: What's the Difference?

Although theories abound on this subject, my basic understanding of the difference between art and design is fairly straightforward. Art is pure self-expression and is usually achieved with a combination of exploration, discovery, experimentation, and freedom. By obsessing with your craft you lose yourself within it, and that's when true creativity happens. Artists

do their work solely with the intent of expressing themselves, and that is their single motive (although financial reward is a bonus for a few successful artists!). By being able to freely express themselves, artists tend to be very experimental in their approach and can often work for years on a single piece of work. Design is about communicating ideas to other people. You can use techniques you have stumbled upon while being "artistic" within your designs, but the execution is generally more considered and structured than a piece of pure self-expressionistic art.

Besides your own artistic discoveries, you can also use influences and ideas passed down from other artists and designers to figure out ways to communicate a predetermined idea. Designers usually work with constraints, whether dictated by client, product, budget, time, materials, or technical issues. They solve problems and use creativity to communicate visually, usually in order to sell products and services or sometimes just to communicate ideas.

Rarely will you find an individual who can do both art and design exceptionally well. It is typical to be more suited to one or the other, although it is fairly common for personal experiments to feed into a designer's commercial work. When I was at college, I was idealistic and saw myself as a "fine artist." I didn't want to "sell my art," and I considered design as a sellout of my precious ideals. Of course, this was very naïve of me, since both disciplines are equally valid and feed each other. After graduation I very quickly realized that I needed to make money in order to survive, so I had to think of a way I could earn a living doing what I loved.

I started out as a prop and model designer and also had some comic strips published. The more involved I became in these creative industries, the more I wanted to know about design, so I attended a few graphic design night classes and studied the skills I would need to become a more qualified designer.

What Makes a Great Designer?

Thomas Edison said, "Genius is one percent inspiration and 99 percent perspiration." It may seem to the average person on the street that a designer knows instinctively what makes a design successful. Although this can be true to a certain extent, the instinctive choices designers and artists make are often based upon years of education, study, experience, and trial and error. I don't believe you are simply born a good designer. You may have a propensity toward being a good designer, but I believe that "talent" is the result of a lucky combination of motivation, inspiration, hard work, confidence, luck, self-belief, assertiveness,

diplomacy, imagination, logic, practicality, and passion. It's clearly true that some people have a good eye or a more fertile imagination than others, but it is essential that these gifts are combined with other qualities to become a true success.

In my case I have a natural curiosity that makes me question things. I want to know how things work. My grandfather (Figure I.5) used to take things apart and get me to put them back together again (it was a great way to keep me quiet!). I also used to watch my brother drawing as a kid, and I really wanted to know how he could make things look so realistic. One day, I asked him, and he showed me how. I practiced constantly until I could draw as well as he could. I discovered that drawing was the only thing that calmed my busy mind. It was so meditative and calming that I wanted to draw all the time, and the more I did it, the better I became at it. I also love the challenge of problem solving, and drawing has encouraged me to learn about design, since drawing is all about problem solving. I was very lucky to be surrounded by supportive parents, teachers, and peers, but if these natural personality traits had not been channeled in the right way, I may never have become a designer.

Figure I.5 **My grandfather.**

So what about self-taught designers? How do they learn these rules? Well, chances are they will have absorbed these rules even if they're unaware of the fact. They may not have attended formal courses or even read books on the subject, but these rules can be picked up by studying and seeking inspiration in other designers' work. Provided they are conscious that they are in fact studying and learning as they work, they will learn the rules as they progress.

Another trait of a good designer is openness—openness to ideas, rules, other people, and the world around you. If you share ideas with others, you will receive at least double what you give out. You should never be afraid to share ideas. I have always found this to be a good way to be in life as well as within your work. To be a good designer, you must learn to be observant and to study things around you—how they look, feel move, smell, and sound. The work of a designer is a full-time job; you should never stop looking, seeing, noticing, and recording colors, shapes, patterns, and textures. A good designer is somebody who is aware of the rules of design and uses them with understanding. But a *great* designer is somebody who knows the rules but also pushes and bends them in creative ways, as an artist does.

The Rules of Design

I've been working as a designer for well over a decade, but I still consider myself to be more of a fine artist. I love to experiment, but sometimes I still find it hard to maintain the focus required of a designer. But by simply applying some basic rules I learned along the way, I can create designs that work. I use the rules of design every day in my work, and they have saved me a lot of time and heartache over my lifetime. There are rules regarding color, typography, and composition, among others. Motion designers also use movement and sound to communicate ideas, so they have to learn about the rules of editing and animation. With this book, my aim is to take these varied design fundamentals and put them in one place.

Design is all about visual communication—delivering a message to your audience through the use of imagery. It's a much more powerful form of communication than through words alone. To be able to communicate visually, you need to learn the visual language, which has been developed much the same way that spoken languages have developed. You wouldn't attempt to invent your own spoken language to communicate with others, so why are some designers so resistant to using this established language to communicate their ideas and instead put themselves through the pain of trial and error? Part of the problem is that a language requires rules, and rules can be considered restrictive. This is true, but in the world of design restrictions are usually considered beneficial; without them, the choices available to you would be too overwhelming.

Imagine if I asked you to create a picture for me but only provided you with one pencil and one sheet of paper. You would draw it and hand it back to me. Now imagine that I asked you to draw another picture for me, but this time I asked you first to go into an art shop and pick whatever materials you want to use before starting the drawing. You could choose oil paint, gouache, watercolors, pencils, crayons, and pens. You could have any paper or material you fancied, including canvas, cartridge paper, or ink board. I bet I wouldn't get the drawing back from you for some time! It would be natural for you to "shop around" and perhaps even experiment with some of the available materials before settling down to the task at hand. The same happens with design: If you have no restrictions, it can be debilitating and can lead to procrastination.

I understand the concern over following rules. How can one be truly groundbreaking without breaking a few rules? I'm not saying you can never break the rules. You can—but how can you have fun breaking the rules if you don't know what they are? So learn the rules first, and then decide which ones to break, and have fun being creative while you're doing it.

Book Conventions

This book contains nine chapters, one on each of the core areas that I believe to be important for digital media designers. Each principle is explained with text, illustrations, and photography where necessary. An accompanying website contains any necessary digital files for download, as well as updates and links to other resources. (*www.motiondesignessentials.com*).

This book does not aim to teach you software skills. There are already plenty of other books available to help you learn those technical skills. However, I will point you in the right direction for supporting materials, and I will tell you which applications may be best suited to a particular task.

I have decided to keep this book succinct and to the point. I teach in a very practical way and like to communicate in direct, plain English, avoiding jargon and unnecessary use of exclusive or difficult academic language. I hope this makes the book enjoyable and easy to read

An Artist's Perspective: Joan Armatrading

When I began writing this book, I decided that I wanted it to be a book that would inspire creative thoughts as well as teaching software techniques. During the process of writing, I have chatted a lot with other creative people to ask them how they deal with the demands of their work and how they keep coming up with new ideas. I've decided to share a few of these tips and tricks with you. They come from some of the best creative people I know, in fields ranging from web and new media design to more traditional skills such as ceramic design and performance art. Here are some of the answers from legendary singer/songwriter Joan Armatrading, who I worked with as director of the Women of the Year Awards (*www.womenoftheyear.co.uk/awards-video. htm*). Although Joan is not predominantly known as a visual artist but rather as a musician, she is involved in her own video productions, including music videos and live performances. She gives a very interesting perspective on the creative process (*www.joanarmatrading.com/*).

In 2010, after almost 40 years of an uninterrupted successful career, three-time Grammy-nominated singer/songwriter Joan Armatrading released her latest CD, *This Charming Life*, to continuing critical acclaim. Joan shows no sign of slowing down either. In 2008, at the age of 58, Joan ran her first New York Marathon, helping to raise

Figure I.6 **Singer, songwriter, and artist Joan Armatrading.**

over $100,000 for charity. In 2007, her CD *Into the Blues* debuted at number 1 in the Billboard Blues Chart. This made her the first female U.K. artist to debut at number 1 in the Blues Chart and also the first female U.K. artist to be nominated for a Grammy in the Blues category. She was awarded an MBE in 2001. She has been nominated twice as Best Female Vocalist for the Brit Awards. She has received the Ivor Novello award for Outstanding Contemporary Song Collection. She wrote a tribute song for Nelson Mandela and sang it to him in a private performance with the Kingdom Choir. Joan has recorded many platinum, gold, and silver albums and is currently on a world tour to promote *This Charming Life*. I asked Joan about her inspiration, what motivates her to be creative, and how she remains fresh.

"I think I was born to make music. My mother bought a piano for the front room because she thought it was a good piece of furniture. I just started to make up my own tunes as soon as it arrived. I'm self-taught on the piano, guitar, and other instruments that I play.

"The drive basically has to do with creating without even knowing properly why I want to. Everything inspires. It could be something that I see, something that someone says, or just a riff I doodle on the guitar."

"I love what I do, and I feel lucky to be doing something as a career that I love so much, I wouldn't want to be doing anything else. I do have other hobbies and interests though; I like to watch the television when I can. I like to go for walks, and if I ever get the time—do absolutely nothing!"

"I don't find creativity a struggle. I tend to only get drawn into creative writing when the muse takes me. I don't really say it's nine A.M., therefore, I should go and try and write a song. I tend to just wait. So this means sometimes I don't write for months on end because nothing is inspiring me. At those times I just wait until something does. I once wrote a song called "Everyday Boy" when I met someone who was dying of AIDS. He was a very genuine person and inspired me to write the song about him the instant we met."

"I always want to learn more about all kind of things, more history, more about the internet, more about playing the guitar, more about creating the better song, and more about people."

"Especially in creative activities, it's important to be honest with yourself. Be truthful about whether you really have the talent to do the thing you are trying to do at the standard you are aiming for. If you have the talent, then don't let anyone put you off trying to get to the height you are striving for."

DRAWING

Figure 1.1 **An unfinished drawing from my sketchbook.**
© Angie Taylor, 2010.

Synopsis

If you are embarking on a creative path in your career, it is vitally important that you understand how to communicate using a visual language—that is, without the use of words. I believe that drawing is the best way to develop a strong, confident visual language. All good designers draw in some way or another. Not all of them are professional draftspeople. They may not use drawings as a technique in their finished work, but you can be sure that they all use drawing somewhere within their creative process. Some draw to improve their perception of the world around

Design Essentials for the Motion Media Artist. DOI: 10.1016/B978-0-240-81181-9.00008-X

them, and others draw to develop their ideas and techniques. In other words, you don't need to be really good at drawing, but you do need to be prepared to give it a go and explore it as a means of developing what's referred to as an "artist's eye." With an artist's eye you will learn to see and represent the world visually, without the use of words. It's a place where shapes, colors, textures, and light become your words.

Learning to See

Drawing is an art form in itself, especially when it is executed by somebody with good skills. But it's also an important exercise that should be performed solely for the purpose of developing your own unique way of interpreting the world. Through really looking at things and then attempting to draw them, we can prevent ourselves from doing what we're naturally inclined to do, which is to interpret everything we see with words.

The human race has naturally developed to be inclined toward verbal communication. At school we are encouraged to concentrate on learning grammar, spelling, and written communication skills. English is a compulsory subject in most schools; it's considered essential to learning to prepare ourselves for whichever career path we may choose. But unless we opt to take an art or design course, our visual communication skills are largely left for us to develop ourselves. So it's no surprise that we find it more difficult to communicate this way and often misinterpret the nuances of the visual language.

Later in this chapter, I'll share some of the exercises I did at art college that helped me to understand how to communicate visually and to develop my artist's eye, but for now, let's talk about why drawing is so important.

Why Sketching Is Important

Software applications provide new ways of creating imagery without the need for good drawing skills. Compositing imagery using software techniques will not give you the same understanding of form, light, and balance that you'll achieve by observing objects and then drawing them manually. When you source an image from the internet and adapt it, you don't have to think about the physical qualities such as weight, texture, or the form of the object. Instead, all you have to think about is whether it "looks right."

Allow yourself to get hooked on the habit of regular drawing, and it will reward you with an expanded comprehension of the

world around you. When you draw an object, person, or animal, you are forced to consider how it is constructed, what supports it, and how light interacts with it. This gives you a solid foundation for everything you do as a visual designer. It also gives you more originality, insight, and adaptability than a designer who cannot draw.

When I draw, I feel like I get lost in my own little world, where the only two things that exist are the subject of my drawing and me. It's a very intimate experience; after drawing an object or a person, I feel like I have a special relationship with it. I know this may sound weird, but I seem to remember every detail of everything that I've drawn. It's like the subject of my drawing has been channeled deeper inside my mind, into my own private library of special things that I can draw upon for inspiration.

Can Anybody Learn to Draw?

You may be thinking to yourself, "Oh no! I can't draw to save my life! I'll never be a great designer!" Don't worry; it's not too late! You can learn to draw. Learning these new skills will add a new dimension to your work as a designer. I'm not suggesting that your drawings need to form part of your designs but that they will help you to improve your skills and change the way you think about form, composition, and structure. This chapter is designed to teach those who can't draw the fundamental skills they'll need. In some ways you are lucky if you are a complete beginner because you won't have picked up any bad habits, plus you still have the joy and excitement of exploring virgin territory. Actually, I'm quite green with envy.

I also hope this chapter gives those of you who *can* draw some new ideas and exercises. I want to reignite your passion for drawing! In fact, my aim is to get every last one of my readers addicted to drawing and image creation. You may be thinking, well, what's the point of learning how to draw when I can create finished images using collage or software compositing techniques? It is true that software applications like Adobe® Photoshop, Gimp® (GNU Image Manipulation Program), and Corel's® Painter make it easy to create imagery using clip art, stock photography, and other sources. 3D applications also allow artists to create imagery by building 3D models and environments. Nevertheless, I urge you to go back to basics and pick up a sketchpad and some pencils. Practice drawing as a means of developing ideas for your digital creations. Every time you draw, you'll be improving your eye, and your work, including your digital work, will improve as a result.

The Universal Fallacy of "Talent"

I don't believe that "talent" is something you are just born with. I didn't come out of my mother's womb with a pencil in my hand and suddenly start drawing masterpieces. I was, however, lucky enough to be born with a natural curiosity for how things work. This was combined with parents who provided me with drawing materials at an early age and brothers and sisters around me who believed that art was something worthwhile.

I started drawing at an early age and was inspired to do so by watching cartoons, reading comics and watching my older brother draw. I felt inspired to keep practicing so I could be as good as my big brother. Eventually, I was rewarded by witnessing a continued improvement in my drawing skills. At school, I really loved art class and was told that I was "good at art." I had a positive label that bolstered my confidence, so my skills continued to develop.

In my opinion, talent is a mixture of some beneficial personality traits, inspiration, support, confidence, and hard work. It's more about "how much you want it" than the luck of the draw (excuse the pun!). My mother is in her eighties and has just learned to draw and paint within the last three years (Figure 1.2). She always believed in the myth of talent and was constantly lamenting, "I've always wished I could draw." After several years of me nagging and cajoling her, she eventually succumbed when her husband gave her a Japanese ink painting set as a birthday present. She started painting with it and found that its loose, edgy quality suited her "style." She continued to experiment with it and gradually gained confidence. She is now painting with

Figure 1.2 One of my mother's first drawings. She didn't learn to draw until she was 77 years old. © Kathleen Hendry, 2007.

watercolors and has become a member of her local art group (Figure 1.3). I'm sure she would be the first person to tell you, "If I can do it, anyone can!"

So you see, it's largely about attitude. Even if you've never considered yourself to be good at drawing, be brave, take a leap, get a sketchbook, and try it for yourself. No one needs to see your drawings. Just through the act of drawing you'll find your eye, and your work will improve. If you already draw, then stretch yourself. Draw more often. Take on more challenging work. Show your work to friends, get feedback, and use it to help refine your skills. Practice and experience will always make you a better designer.

Motivation

Having said all of this, it is not reasonable to expect to suddenly be able to draw after reading this book and doing the few exercises included. You wouldn't expect to be an expert golfer after reading a book on golf. You'll need to practice a lot to develop your drawing skills. Malcolm Gladwell, author of *The Tipping Point* and a regular contributor to *The New Yorker*, claims that it takes 10,000 hours of study to become a genius in your chosen field. This works out at about three hours per day practicing your skills. But don't be disillusioned by this. After all, you don't need to achieve the genius-level drawing skills of Leonardo da Vinci here! Even ten minutes a day would be a great start.

This chapter presents a few drawing exercises, tips, and tricks that you can use to develop and improve your drawing skills. Once you have completed these exercises, I'm hoping you will have the bug and will not be able to stop the immensely enjoyable and cathartic processes of drawing. There will be times when drawing becomes a chore. At these times, try not to pressure yourself too much, and carry on drawing regardless. When motivation is scarce, I find it helps to see drawing as a form of exercise, kind of like going to the gym. There will be times you enjoy it and get a thrill from the results, but there are other times you just won't want to do it. At times like this, just think about how

Figure 1.3 One of my mum's later drawings. Notice the improvements (although I have a real soft spot for the first one she did; it's hanging on my wall). © Kathleen Hendry, 2007.

good you'll feel once you've done it and what a brilliant artist you'll become as a result. Make it your mission to do one drawing per day as a minimum, even if it is a five-minute doodle over your morning coffee.

And don't be disillusioned if your drawings don't turn out exactly as you'd want them to. Like most artists, who are their own worst critics, most of my drawings disappoint me. You should always expect that 90 percent of your drawings will end up in the trash. As with every other art form, you need to produce a vast number of failures before finding your successes. Don't let this put you off. You'll learn just as much from your failures as your successes. It is just as important to learn what *doesn't* work as what does.

Drawing Materials

When you're starting out, you may want to experiment with different drawing implements and materials until you find the ones you like and feel happy using. You can choose from pencils, pens, markers, charcoal, paint, or crayons. Don't fall into the trap of feeling obliged to use materials you don't feel comfortable with. You'll find that friends and colleagues will want you to use their own favorite materials and implements. By all means, experiment with them, but don't allow yourself to be swayed by others. Find your own materials, and you'll find your own style as a result. You may want to use a material based on artwork that you like. If you try it and don't like it, then move on until you find the materials that are right for you.

I always felt like I wanted to use charcoal because I'd seen charcoal drawings that I really liked. But when I tried to draw with charcoal, I found it dirty, messy, and hard to control. (It also set my teeth on edge.) As a result, the drawings I did with charcoal were pretty terrible. So while you are trying to build your confidence, please avoid using materials that you find difficult. Once your skills improve, then you can begin to experiment more with them and extend your repertoire.

Sketchbooks

It's hard to find time in our busy lives to practice drawing. I recommend that you carry a small sketchbook around with you so you can practice on the train, in waiting rooms, or even during a walk with your dog. I usually carry a small, soft-covered A6 Moleskine sketch pad around with me in my back pocket (*www. moleskine.co.uk*).

It's good to treat yourself to quality drawing materials if you can afford it. You may actually be inspired to draw more often if the materials you use have a pleasing touch and feel. If you feel that

Moleskin sketchbooks are too pricey for simple sketching, then you can buy very good A6 sketchbooks and notebooks very cheaply. In my studio, I have an A1 spiral-bound sketchbook that is great for creating big sketches on my drawing board. At home, I have an A3 sketchbook that is perfect for picking up to sketch out quick ideas or doing a detailed study of my dogs or the plants in my garden. I also have little sketchbooks beside my bed and in the bathroom just in case I feel inspired at an awkward moment (Figure 1.4). Chapter 2 offers more information about when and where to use your sketchbook, plus some sketching tips and tricks.

Figure 1.4 **Pages from various sketchbooks.** © Angie Taylor, 2009.

Drawing Papers

Besides drawing on pages in your sketchbook, you may want to buy loose sheets of paper for creating mounted artwork. Paper is made from pulped wood or pulped materials such as cotton or linen (also referred to as rag). The more expensive papers tend to be made from rag and tend to have more interesting textures to draw on. The cheaper papers are usually made from wood pulp and tend to be smoother and less absorbent. Usually you get what you pay for with paper, but I have found decent cheaply priced papers. My advice is to shop around and try before you buy.

Paper comes in many varieties, ranging from the low-quality, inexpensive newsprint to the different weights and sizes of cartridge papers and handmade papers. Each of these papers has a different quality that you may want to explore. Cartridge papers range from very smooth-surfaced papers (good for creating precise pencil worked drawings) to highly textured, heavier papers, which

lend themselves well to a rougher, freer style of drawing. There are also papers made for office use, such as photocopier paper and inkjet paper, which are smooth and better for drawing with pens.

I often use card or line-board for my drawing. I like to draw with ink, and these boards are designed for ink work. They provide the perfect surface for ink, and some of them are coated with china, which you can scrape away with a scalpel if you make a mistake. These boards are quite expensive, so you may want to use them only for finished line work. I recommend that you explore different materials. Keep looking until you find the one that works best for you. Sometimes you will be surprised to discover that a material you initially rejected encourages new, unexpected marks or techniques.

Pencils

I usually use a propeller pencil (Figure 1.5) for sketching when I'm on the move (sometimes known as a propelling pencil or a mechanical pencil). A propeller pencil is a pencil that looks more like a pen. It has a hard case, just like a pen that contains replaceable leads. There are several benefits to using a propeller pencil. You can buy different weights and qualities of leads, depending on your needs, and you don't have to carry a pencil sharpener because the lead always maintains a consistent width and weight. Rotring makes a great range of propeller pencils, including their Tikky range (*www.rotring.com/*).

Figure 1.5 **My propeller pencil.**

In my studio, I also have a complete collection of traditional wood-encased pencils, ranging from 6H to 6B. The lead in pencils is measured by letters and numbers that indicate the hardness and blackness of the graphite that's used to make the lead. The letter H represents the hardness of the lead. Harder graphite leads give you sharper lines, but the harder the lead, the lighter the marks. These hard pencils are perfect to use for precise edges and detailed technical drawings.

The letter B stands for blackness. Pencils with a high B factor have softer graphite leads that make blacker marks but softer, less-defined strokes. These are great for filling large areas of black and creating texture. They allow you to create dark lines without having to press hard with your pencil.

The following is the scale of the pencils I use, from the Hs (which are progressively harder and lighter as the H numbers increase) to the Bs (which get progressively softer and blacker as the B numbers

increase). You can get even harder and softer pencils than this range, but I find these are usually sufficient for my needs.

6H 4H H 2H H HB B 2B 4B 6B

HB is the average-Joe of the pencil world. It has an equal amount of hardness and blackness. It is the most common, general-purpose pencil used for writing. You can find these in any shop. Art shops will stock a wider range of graphite pencils as well as all sorts of other pencils, crayons, charcoals, and chalks that you can use for drawing. Try experimenting with these to see what you feel the most comfortable with. You'll probably find that a particular medium may suit you better than another, so it's worth taking the time to find out what suits you best.

Pens

I personally enjoy drawing with pens because I like the clean, black lines I can achieve with them (Figure 1.6). Several types of pen are suitable for drawing. Rotring makes a great selection of drawing implements, including their excellent Tikki, Rapidograph, and Isograph pens. Most of their pens are refillable and are a good choice if you do a lot of ink drawing. If you use ink only occasionally, you may want to choose disposable pens, since these don't clog up if they are not used regularly (as refillable pens can sometimes be prone to do). Pilot makes a great range of disposable pens and propeller pencils with all sorts of different tips and ink types. I use a variety of tips for different uses. For example, I use marker pens for blacking in large areas but use finer

Figure 1.6 **Some of the pens I use regularly for drawing.**

fiber-tips or rollerballs for details (*www.pilotpen.com/*) I also like to use fountain-tipped pens as they allow me to create a variety of strokes with a single nib just by altering the angle of the pen.

Correction Fluid

Obviously, you can't easily erase pen marks in the same way that you can pencil marks. A solution to this is to use correction fluid (or liquid paper) such as Tip-ex to cover over any errors. Once the correction fluid has dried, you can then draw on the surface (*www.liquidpaper.com/*).

Ink

An alternative to prefilled pens is to use ink along with dipping pens and brushes to create lines and washes (Figure 1.7). Using ink in this way produces more organic lines and is less predictable than using the technical drawing pens. This can provide more style, character, and flexibility to your drawings. You can also mix the ink with water to dilute it, which allows you to create paler washes of color and shading.

Figure 1.7 Ink, pens, and brushes used for drawing and painting with liquid ink.

Paint

There are also several types of paint you may want to experiment with for drawing and coloring your artwork.

Watercolor

Watercolor is probably the most familiar type of paint. It is a water-soluble, translucent paint that is fairly easy to use. Translucent paints allow you to see the color underneath them, which is ideal for building up paint in layers. It tends to be quite wet when applied, so it benefits from being applied to a dedicated watercolor paper, which is designed with the perfect amount of absorption and texture for this medium.

Masking Fluid

Because watercolor paint is translucent, painting white on top of the other colors will not cover the colors but rather only lighten them. To overcome this problem, watercolor artists use masking fluid to prevent the paint from bleeding into areas that they want to remain white. Challenges such as this mean that watercolor artists have to plan their paintings a little more than those who are using gouache or other opaque paints.

Gouache (and Poster Paint)

Gouache is a better option than watercolor for painting on standard papers because it can be applied using less water. Poster paint is very similar in characteristics to gouache, but it is slightly cheaper. These are both opaque paints, which means that each layer of color will cover the layer underneath it. This makes them less suitable than watercolors for combining colors on the page, but they tend to be better for painting clean, even areas of color. This is why these paints tend to be used for posters, illustrations, comics, and general graphic design work.

Acrylic

Acrylic is a very flexible paint. It is water based (like watercolor and gouache), but it can be painted in a wide range of styles and consistencies using a wide range of implements. It can be watered down and sponged (or brushed) to create thin washes of color, or it can be painted thickly, like oil paints, using brushes, palettes, and knives. Acrylic paint dries very quickly, so it can't be reworked in the same way as oil paint over a long period of time. Unlike watercolor and gouache, it will

become water resistant when it dries, so rewetting the paint is not possible. Mistakes must be painted over with new layers of paint or correction fluid. I personally like the immediacy and diversity of acrylic paint, but I'd recommend starting with gouache if you are new to painting.

Brushes

Literally thousands of different types of brushes are available for applying paint, ink, and other fluids to your drawings. Brushes can have either synthetic bristles (like nylon) or natural bristles (such as sable or hog's hair). As with pens and paper, different materials suit different paint types and techniques. Traditionally, sable brushes were always used for watercolor because sable hair is very soft and fine. Hog bristle brushes were typically used for oil brushes because they were firmer and more robust. You can now buy a diverse range of synthetic brushes that provide all the variety and quality you could possibly require, so there's really no need for animals to suffer for your art.

Brushes are described by shapes and sizes (Figure 1.8). The shapes include round, flat, fan, and angled. Sizes range from negative values denoted by 4/0 (can also be written as 0000) to positive values indicated by single numbers such as 4. Here are the most common sizes:

4/0, 3/0, 2/0, 0, 1, 2, 4, 6, 8, 10, 11, 12, 14, 16, 18, 20, 22, 24

You can find brush measurement charts at *www.dickblick.com/info/brushmeasurement/*.

Erasers

You'll need a decent eraser to get rid of any mistakes you make (remember, you don't have an Undo option). Erasers can also be used as a drawing tool. Drawing doesn't only involve drawing dark strokes on white paper in an additive manner. You can do subtractive drawing using an eraser on a shaded background or use the eraser to add texture or reflection to a surface. Erasers come in many different types; a plastic eraser is good for working with pencil, as are India rubber erasers. India rubber tends to be a bit rougher in texture, so is better for removing stubborn pencil marks, but it can also rub

Figure 1.8 Paintbrushes of various shapes and sizes.

away too much of the paper surface. A plastic eraser tends to be smoother and better for general use. You can also use putty erasers, which are soft and pliable. These are particularly good for working with charcoal, chalks, and other dusty mediums. They're great to draw with, too, since you can manipulate them into interesting shapes.

Other Drawing Aides

Other drawing aides can be useful to help you draw straight lines, edges, circles, curves, and angles that would be difficult to draw freehand. Most people are familiar with rulers for drawing straight edges and compasses, set squares, and protractors for drawing circles, creating right angles, and working out nonstandard angles, respectively. Not as many are familiar with French curves (Figure 1.9). These are usually made from plastic and have a selection of even and uneven curves that you can use as guides in your drawings. All of these can be picked up from your local art shop or online art supply store.

Figure 1.9 **Other drawing aids, including my very well-worn French curves, compass, and set square.**

Lessons

Okay, now you know what materials you can use, so let's get on with some drawing lessons that are designed to help you develop your basic drawing skills. Many of these are based on lessons I was taught at school or Art College. They have stuck with me because I found each of them helped me take my skills to a new level and made me think differently about the techniques I used.

Drawing Basic Shapes

All objects can be broken down into basic geometric shapes or combinations of geometric shapes. When children draw, they tend to represent everything they see with simple shapes and lines (Figure 1.10). This is how you should try to see objects when you start learning to draw. Study the things around you, and break them down into basic shapes. I've done this so much that it's now second nature. When I look at something, I automatically look for shapes, balance, colors, and patterns, much like when you try to see pictures in cloud formations.

Figure 1.10 shows two children's drawings of a house. Notice that the house on the left is made up of a series of square and

Figure 1.10 Two children's drawings of houses done by Matt (aged 5) and Ryan (aged 7).

Figure 1.11 **Drawings of people by Matt and Ryan.**

rectangular shapes, with a triangle representing the roof of the house. The drawing on the right has a lot more detail, such as perspective. In Figure 1.11, the face of the person in the drawing on the left (by Matt, the younger child) is represented by a circle, while the body is drawn with a series of lines. Notice in the drawing on the right, Ryan has used more solid geometric forms like rectangles and circles, and he has also used areas of solid color to represent the sky. When you begin a drawing, you should start by "mapping out" the scene with simple shapes. If you're new to drawing, start by trying to draw individual, simple-shaped objects. Avoid drawing difficult, complex subjects like the human form until you can master these simple shapes.

Here's a method for drawing basic shapes with the aide of a guide. We'll start with something easy like an apple. An apple is roughly circular in shape, so let's start as a child would: by drawing a circle. It's quite tricky to draw a circle freehand if you're new to drawing, so feel free to make it easy on yourself and use a compass. If you don't have a compass, trace around the bottom of a glass or other circular object to form your circle. In Figure 1.12, you can see a simple circular shape that I have drawn using a compass. It's fine to use aids like rulers, set squares, and compasses to help you create basic shapes, but I'd like to encourage you to learn how to draw these shapes freehand. Here's a good way of practicing.

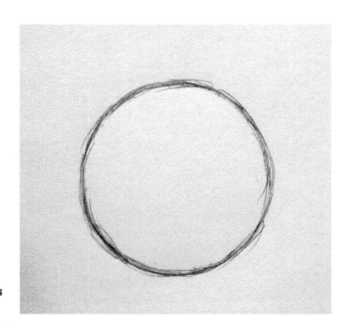

Figure 1.12 A basic circle drawn initially with a compass and then sketched freehand.

Freehand Sketching

To get a feel for drawing a circle freehand, try sketching lightly over the line of the circle you've already drawn with your compass or other guide. The object here is to get a feel for drawing a circular shape using a series of short pencil strokes to make the line bolder. Don't try to draw the circle with one stroke, but use lots of little strokes to gradually build up the shape. Every now and then, step back from the drawing to look at what you've done, checking that the line is well-balanced.

Figure 1.13 The top and bottom are shaped, and then the circle is erased.

Very few apples are perfectly round. They're usually slightly fatter at the bottom than the top and have dimples from which the stalks protrude. To create these, you can use your eraser to remove the edges at the top and bottom as I've done in Figure 1.13. It's then a simple case of redrawing the shapes between the gaps so it looks more like a natural apple shape. The top will be slightly heavier, and the bottom will be narrower (Figure 1.14). Now it's time to add depth and texture to the apple.

Figure 1.14 **The top is fattened, and the bottom is narrowed.**

Adding Depth

Okay, so now we have an outline of an apple, but how do we make it look solid as if it has real depth and weight? You can create depth in your drawings with the use of light and shade. When light hits an object, it reflects off the surface, making the area it reflects off of appear lighter. Light is usually directional, so by shading the object so it looks lighter on one side than the other, we can make it appear more solid.

Hatching

The surface of the apple is curved and quite smooth, and we can represent this curved surface using a technique called hatching. Hatching is a good technique for guiding the viewer's eye toward a particular direction. This technique involves sketching adjacent, repetitive lines lying in the same direction as one another. The eye naturally follows the direction of the individual pencil lines. To emphasize the curved surface, apply layers of shade by combining short strokes and adjusting the angle a little as you move around the surface of the apple.

The first thing you need to do is decide on the directions the strokes should follow. To do this, I find it helps to lightly sketch rough guides around the shape. To figure out where these should go, pretend you have stretched elastic bands around the apple and imagine how these would curve around the surface (Figure 1.15). If you can't picture how this would look, just get an apple or other spherical object and stretch elastic bands around it. Now study the shapes and directions they make.

Figure 1.15 You can draw rough depth guides to determine the direction the shading will follow.

Directional Lighting

To determine the positioning of the shading on the apple, you also need to decide where you think the light source will be. It takes a bit of thought and practice until you instinctively know where to add light and shade to your drawings. It sounds odd, but I find it helps to think about light in the same way that software applications think about it and break it down into individual components. Many software applications allow you to work in 3D. In these applications (and in some 2D applications, too) you can add lights to the scene. The main light types are directional, point, parallel, and ambient.

- Directional lights include spotlights, torches, floodlights, or any other light source that can be pointed in a particular direction. These tend to light a subject strongly from one particular direction, illuminating a small, concentrated area.
- Point lights shine light in all directions, such as with a naked lightbulb. The light tends to spread a little more in all directions, so the subject would usually be lit a little less and the illumination would spread out a little more.
- Parallel lights are distant light sources. They are also directional lights, but because they are so distant, their beams of light are infinitely wide, so the result of the light is spread over a wide distance. Light from these sources would be directional, but the illumination would spread across one whole side of an object.
- Ambient light refers to the environmental light hitting the object from nondirect sources. This is a harder light to understand, so

let me give you an example of where you'd experience ambient light. Imagine you are sitting in a room in your house at night, and a spotlight is providing some directional light. If the spotlight is switched off, the room will darken, but as your eyes adjust to the dark, you'll gradually see that the room is not completely dark. A small amount of light may be shining into the room from under the door or through a crack in the curtains, which provides the room with an overall ambient light. When you're drawing, this light will affect the overall lightness of the object and therefore how much detail you'll see.

Unless you are living in outer space, in a vacuum, or in a place where all light sources have been completely blocked out, some ambient light is sure to exist in any space. The amount of ambient light depends on various factors: the time of day, the weather, and other activity.

When you draw using traditional methods, it can help to think about light in these terms, too. When you study a scene or an object, observe all of the possible sources of light and how much light is coming from the ambient light in the environment. Then think about other directional light sources, like lamps or spotlights, and distant light sources, like the sun. How much of their light is shining on them and from what direction is the light hitting the objects you are studying? There may be several different light sources coming from different directions, and each of these will impact the overall lighting of your scene. Thinking about light in this way will help you to decide where to put the shading and how light or dark it should be. Color is a product of light, so an object's color will appear duller in low-light conditions. (Chapter 6 discusses more about how we perceive color.)

Figures 1.16 and 1.17 show examples of how shading could be positioned on a sphere to represent different strong directional lights. Figure 1.16 shows the light coming from behind the object, and Figure 1.17 shows the light shining on the front of the object. The arrows represent the direction of the light.

In the case of our apple, we'll imagine an overall strong ambient light, but we will have most of the light shining on the object from behind it, above it, and slightly to the right as we look at it (Figure 1.18). For the shading I suggest using a dark, soft pencil—a 4B would work well if you have one. Make the circle darker on the right side than the left. Create the strokes in the direction of the curved surface. Use an eraser if necessary to lighten some of the strokes. This will give the impression that a light source is shining on your apple, giving the feeling of depth. Once you've finished hatching, you may want to smooth the pencil strokes to make the effect more subtle. To do this, rub the pencil marks with your finger, moving along in the direction of the lines.

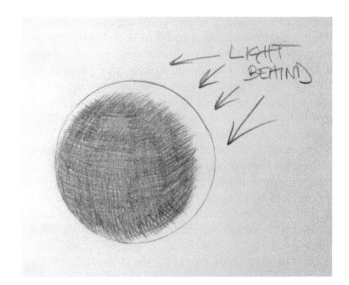

Figure 1.16 Light shining on an object from the top, behind, and right.

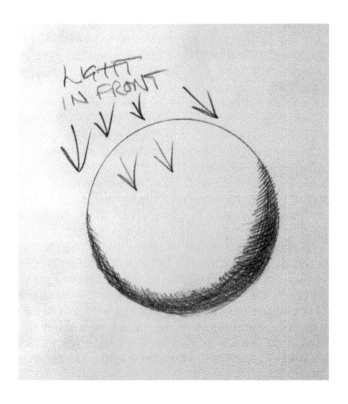

Figure 1.17 Light shining on an object from the top, front, and left.

Figure 1.18 **The apple with the final shading applied.**

Crosshatching

Crosshatching describes the process of drawing two or more "layers" of pencil strokes, each layer following a different direction, creating a kind of crisscross effect. This can be used to create a denser, and usually a darker, shading. The only problem with crosshatching is that it's quite rigid and flat. It also tends to stop the eye from moving freely across the picture. I use crosshatching only for flat surfaces or for areas to which I deliberately want to draw the viewer's attention. We could use crosshatching to create shading on the flat surface the apple is sitting on; this would exaggerate the sense of depth. Think about the angle of the table when determining the angle of the strokes. They should follow the same direction as the line of the table edges.

Creating Texture

Texture is normally thought of as something that you feel, but it can also be described visually. It's really just depth on a smaller scale. In the same way as light and shadow can be added to primitive shapes to create a sense of depth, highlights and shadows can be added to the surface of objects to suggest different textures. Look at the tennis ball and the orange in Figure 1.19. Each individual, tiny

Figure 1.19 Notice the different textures of each circular object. © Angie Taylor, 1994.

fiber on the tennis ball reflects light and shadow in the same way the dimples in the orange do. Notice how I've used the same ink pen for both textures, but I have varied the texture by using different weights and shapes of strokes. By thinking about how the light plays with the surface material of an object and copying this, you can create the impressions of different textures.

A good exercise to explore different textures is to divide a sheet into six squares. In each square, draw a circle, and then use only depth and texture shading to make each into a different object. In Figure 1.20, I've included standard spherical objects such as a tennis ball, a CD, and an orange. But I've also tried to include objects that appear to be circular only from a particular angle, such as the top view of a bottle. I've used different materials to achieve the variety of textures. I like to use inks for shiny surfaces like glass, plastic, leather, and so on, and I use gouache for fluffy or furry textures like the tennis ball. Don't feel like you have to follow my lead, though. Use whatever inspires *you*.

If you don't feel that your skills are quite up to this exercise just yet, then find some images (look in magazines or online) that fit the specifications. Cut out or print out the pictures, and paste them onto a sheet of paper. Study them well, and try to

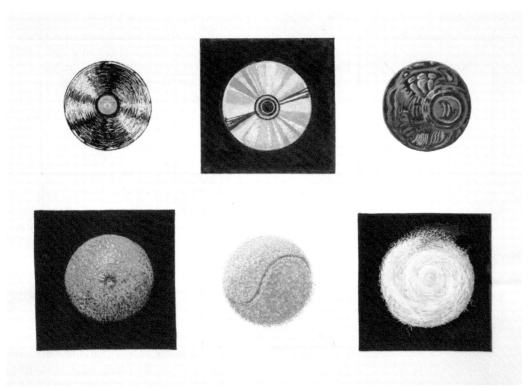

Figure 1.20 **The addition
of color makes it easier to
differentiate among materials.**
© Angie Taylor, 1994.

see if you can understand how the light reflects on the surface
of the object to determine its visual texture. You can even try
tracing over the images with some tracing paper and a pencil.
This can be a valuable way of studying the shape and form of an
object.

It will be more difficult to fully appreciate texture if you use
only a computer for your design work. Drawing by hand is the
best way to explore the composition of materials and their tex-
ture because you have to think about how the textured material
is composed before you can recreate it. With computer software,
the textures can be automatically generated or cloned from exist-
ing images. When drawing with software, you don't generally
feel the vibrations or resistance of the pencil on the rough tex-
ture or grain of the paper you are drawing on. Graphic tablets
tend to have very smooth, slippery surfaces that can be hard to
adapt to, particularly if you press down hard with your drawing
implements (as I tend to do).

Certain software applications (such as Corel Painter and, to
a certain extent, Adobe Photoshop) allow for the simulation of

textured materials such as canvas or rough paper. When you draw in these applications (using a graphics tablet and pen), it approximates the effect of drawing on the real thing, but nothing substitutes for the happy accidents you can stumble upon when using real, physical materials. When drawing on real paper, you don't have the option of undoing your changes (like you have with software). This forces you to be more careful in your design decisions and to plan changes a little more carefully. I see this as a good thing: Removing the option to undo is like adding another helpful limitation that will focus your attention, making it easier to make design decisions.

So although graphic tablets can approximate the feeling of drawing with a pen on paper fairly well, they can't exactly replicate the feeling of holding a piece of charcoal on its edge and dragging it across a rough, grainy-textured sugar-paper. Although traditional materials allow you to hone your craft and explore techniques so you can develop your own style, tablets are the best way to draw directly in the software. They provide you with much more freedom and versatility than a mouse. You might even find a new style that you wouldn't achieve from traditional drawing. If you want to find out about Wacom tablets (Figure 1.21), you can visit their website at *www.wacom.com*.

Figure 1.21 The Wireless Intuous graphic tablet from Wacom.

Other Shapes

You've just practiced drawing an apple, which is a spherical object, but of course there are plenty of other shapes that you can practice drawing: ovals, squares, triangles, rectangles, cubes, and pyramids. Look around your home for objects that have obvious geometric shapes, such as your television or CD player, or the cooking utensils and appliances in your kitchen. Break them down into component shapes, and see if you can represent them on paper with a series of geometric shapes. This makes it much easier to concentrate on getting the underlying structure of the object right first and then adding the details later. Figure 1.22 was drawn freehand (without the use of proper guides), so the perspective is not 100 percent correct. Drawing cubes and other geometric shapes correctly using perspective guides is discussed later in this chapter.

Tone and Contrast

Using a variety of tonal qualities in your drawings will add strength and a sense of drama to your work. *Tone* refers to the lightness or darkness of a shade. Having a good balance of light and dark makes a drawing more powerful and interesting. *Contrast* is the distinction between the light and dark tonal areas in an image. Although the literal meaning of *contrast* is "difference," in the context of art and design, contrast can be an ambiguous term. It is most commonly used to describe the difference between light and dark tones, but it can also be used to describe the differences between light strokes and heavy strokes, hot colors and cool colors, or rough textures and smooth textures.

A great way to learn about contrast and tone is to choose some objects to draw that possess no color but only black, white, and/or gray objects. Place them against a neutral surface, preferably gray. Color can distract you from seeing the tonal qualities of an object, but when you look at neutral objects, it forces you to focus on the tonal qualities without the confusion of color. If the objects are light, place them against a light background or on a piece of white paper. If they are dark, place them on a sheet of black paper. Make sure you have a strong light source that will accentuate the shadows and highlights. Alternatively, you can choose two objects that sit naturally together but are the same color. For my drawing I've chosen a white toilet with a roll of white toilet paper sitting on top of it (Figure 1.23). I chose these because they are both simple but interesting shapes, are the same color, and have different textural qualities.

Figure 1.23 Toilet with roll of toilet paper on top. I used a very soft 6B pencil to recreate the shiny specular light on the toilet with very high-contrasted areas. The light hitting the roll of toilet paper is much softer, more diffuse, and requires much less contrast, and for this I used the edge of a solid graphite 4B pencil. © Angie Taylor, 2009.

Several factors determine an object's tonal quality. What is its underlying structure? What material is it made of? How strong is its structure? What qualities can you portray in your drawing? You may have chosen two objects with the same size, color, and shape, but each may be made of different materials, or one may be a more fragile material than the other. How can you convey this in your drawing?

Surface Quality and Tone

When we discussed directional lighting, we spoke a bit about computer software and how it can help you understand lighting. Software also provides surface controls to adjust the amount of diffuse and specular light the object reflects. Thinking about these can also help you understand how the surface quality of an object, combined with the lighting, can determine the tonal quality required in your drawings.

Consider the quality of the object's surface when deciding how much contrast to use in your representation. All surfaces reflect light in different ways, which creates different visual textures. Shiny

surfaces reflect the light well, bouncing it directly back at the viewer. This means the light is strong and the edges of the illumination are crisp and clear. These shiny objects reflect more light and darkness than dull objects. This highly reflective light is known as specular light. You will need to use high levels of contrast to represent this.

Dull objects have rougher surfaces. These rough surfaces absorb much of the light when it hits the surface. The rough nature of the surface also breaks up the light and reflects it in multiple directions. This results in dulling the light and softening the edges of the illuminated area. This softer light is known as diffuse light.

In my example in Figure 1.23, although the objects are the same color, they have different textures. The toilet is shiny; notice the specular highlights on its surface. The toilet roll has a softer surface, which reflects a diffuse light. I used a variety of different pencils of varying hardness and blackness values to create different amounts of tone and texture in my shading.

Understanding Perspective

Perspective refers to a geometric technique used to add depth to otherwise flat artwork. Perspective techniques can be used to measure and represent three-dimensional qualities, depth, and distance in two-dimensional drawings. Artists working in 3D software don't need to worry about perspective because the computer works it all out for them, but when working in 2D you need to understand a few little tricks to make your drawings look convincing. Drawing correct perspective is a little tricky, so most artists use guides to help them out. I'll show how to create these in the following exercises.

Optical, linear perspective guides were devised during the great Renaissance in Italy in the fourteenth century. Architects and artists discovered that they could apply generic rules to make their paintings appear more three-dimensional. Filippo Brunelleschi is the man credited with the initial discovery of this perspective theory, but the rules were used more famously in paintings by other artists such as Leonardo da Vinci and Piero Della Francesca. You can see perspective in scenes all around you, and observing its effects is good practice, but first you need to understand what you're looking for.

Horizon Line

Take a look at the simple illustration of a beach scene in Figure 1.24. Notice the horizon—the horizontal line that separates the surface of the earth and the sky. Of course, the sea doesn't really touch the sky! It's just that we can see only as far as this point, since

Figure 1.24 **The horizon line in a beach scene.**

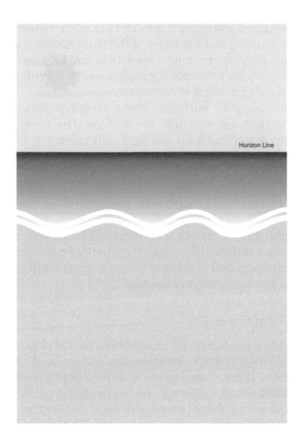

Horizon Line

the earth curves away from us, creating an apparent edge. In fact, if we were being technically correct, the horizontal line in the image should really be a curve, but the curve of the earth is so vast that we can't see it with the naked eye. So despite being technically incorrect, when we draw perspective guides, we tend to use straight lines to work out our grids.

Figure 1.25 **A 3D grid with the three dimensions clearly marked.**

Y Dimension

Z Dimension

X Dimension

The Three Dimensions

I find it helps to fully understand the Cartesian system when thinking about perspective. It describes the three basic dimensions of 3D space, which are represented by the letters X, Y, and Z. The X dimension measures distances from left to right, Y represents distances from top to bottom, and Z represents distances between near and far (Figure 1.25).

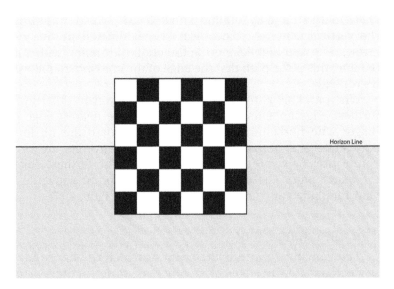

Figure 1.26 **A flat plane in 3D space.**

Figure 1.26 shows a flat chessboard. The background has been divided in half by a horizontal line that we will imagine is the horizon of this scene. Notice that all of the horizontal edges and lines on the chessboard are parallel with the horizon and can be measured using X coordinates (left to right). All vertical edges are perpendicular to the horizon and can be measured using the Y coordinates (top to bottom). The distance of the flat plane from the horizon can be measured using Z coordinates (near to far).

Can you imagine swiveling this chessboard around an imaginary axis? When this is done, the apparent angles of the edges will change. In Figure 1.27, you can see how I've swiveled the

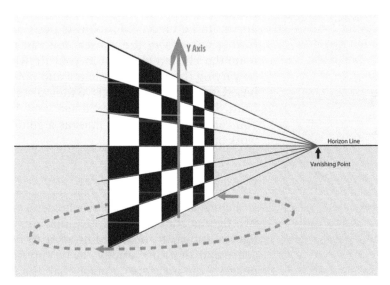

Figure 1.27 **Rotated chessboard.** I have rotated the chessboard around an imaginary Y-axis that runs through the center of the object.

chessboard around by rotating it on its Y-axis, which runs through the vertical center of the object (as highlighted by the green arrow). I've also highlighted the direction of rotation with a dotted line; this is the path that the edge of the chessboard follows as it's rotated.

When a plane is tilted away from the viewer in this way, the furthest edge appears to get smaller and the nearest edge gets bigger. The horizontal lines on the chessboard are no longer parallel to the horizon. They appear to converge, creating a connection between the nearest edge and the farthest edge of the chessboard. These lines point toward a point known as the vanishing point and are highlighted in red in Figure 1.27.

The Vanishing Point

The vanishing point is the point at which the lines that are projected from the edges of an object or series of objects meet together at a single point. This effect is known as convergence. In this example the vanishing point happens to be on the horizon, but this is not always the case, as we'll see later. We can use this phenomenon to create guides to help us draw two-dimensional drawings with convincing three-dimensional depth.

Notice that the right edge of the tilted chessboard has become smaller because it has moved further away from the viewer, while the left edge has become bigger as it's moved closer to the viewer. When objects are placed into a scene, their apparent size varies according to how near or far they are from the viewer. Objects closer to the viewer will appear to be bigger than objects positioned further away from the viewer. You can recreate the illusion of depth in your drawings by varying the size of characters and objects based upon what you perceive their distance from the viewer to be. You'll see later how you can use convergence lines as a guide to work out the sizes.

Eye Level

Figure 1.28 shows our beach scene with two figures added to it. Notice that the two figures appear to be standing next to each other and that they appear to be the same height. You may also notice that the eye

Figure 1.28 Beach scene with two figures added.

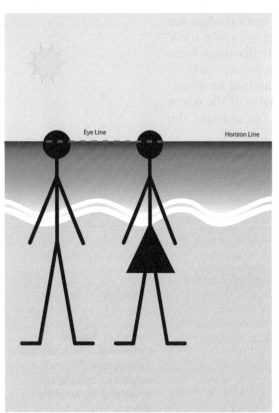

levels of both characters in this picture are the same. By maintaining the same eye level, the viewer believes that the two characters are the same height as each other.

In Figure 1.29, I've made one of the figures smaller than the other but have maintained the same eye level. By doing this, I've made it appear as though the character on the right has moved farther away from the viewer than the figure on the left. As long as the same eye level is maintained, the viewer will believe these characters are the same height but are standing on different areas of the beach.

Watch what happens if I simply drag the "smaller" character on the right further down the frame so she is at a different eye level from the other character. In Figure 1.30, the same character now looks like a small child standing next to an adult. You may also feel as though you are looking down at the child from above. This is because the horizon is at the viewer's eye level, and when the eye

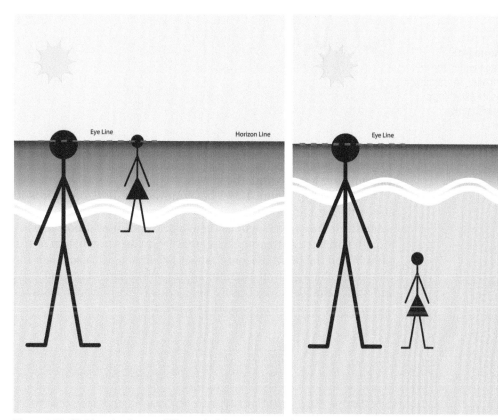

Figure 1.29 Making the figures different heights. One of the figures is made smaller, making it appear farther away from the viewer than the other.

Figure 1.30 Moving one figure beneath eye level. By adjusting the character beneath the viewer's eye level, we can make her appear smaller than the other character.

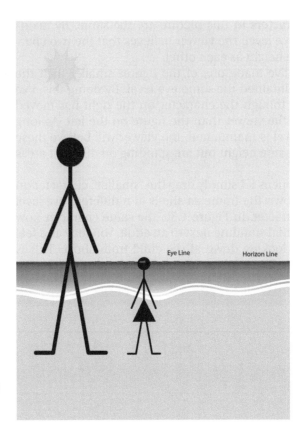

Figure 1.31 **Moving the horizon.** Moving the horizon in line with the smaller character's eye line makes us see things from a lower perspective.

level of a character is the same as the horizon, it means they share the same eye level as you, the viewer.

Notice that in Figure 1.31 I have moved the horizon so it is in line with the child's eye level. Now the viewer is looking at the scene from the same height as the child. Notice how it now feels as though you are looking up at the adult from the same height as the child. When the point of view changes like this, it will also affect the view of the background elements. Compare Figures 1.30 and 1.31, and notice that the child doesn't see as much of the sea as the adult because her view is from a lower perspective.

Lower views are generally better for accentuating vertical elements in your design, so it is a good idea to draw from a low perspective to accentuate the drama of tall buildings or telegraph poles. Higher views are generally better for accentuating horizontal features such as horizontal railroad tracks or crowds of people.

Drawing in Perspective

In this section we'll look at how to draw a basic shape with perspective. Let's build a simple scene containing a box to get us used to the idea of drawing in perspective. Start with a blank piece of paper and draw a horizontal line about one-third of the way down the paper. This will be your horizon. Now draw a straight line (using a ruler as a guide) from the center of the line down to the bottom right corner of the page. Repeat this, drawing another line from the center to the bottom edge, as illustrated in Figure 1.32.

The next step is to draw a square, using the two lines as a guide. Start by drawing a horizontal line between the lines to create the bottom edge of the square. Use a ruler to measure this, and write down the measurement so you can make sure the other edges are exactly the correct length. Use a set-square to make sure your angles are right angles, and draw the uprights the

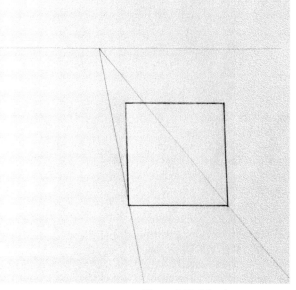

Figure 1.32 **A basic square drawn between our converging lines.**

same length as the bottom edge (Figure 1.32). Next, draw another square using the same technique a little farther behind the first one, like the one in Figure 1.33.

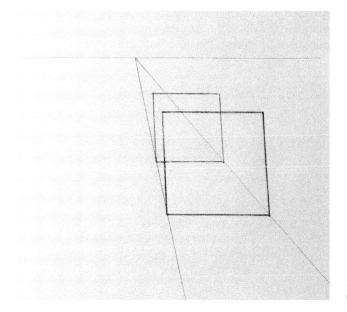

Figure 1.33 **A second square drawn farther behind the first.**

Foreshortening

As you've seen, things appear to get smaller the further they are from the viewer. Distances also get smaller as they move further away from the viewer, as shown in Figure 1.34.

Figure 1.34 Moving objects away from the viewer. Distances appear to get shorter as objects move further from the viewer. In this diagram the tortoise has the same distance to travel as the hare; it just looks shorter. You need to keep this in mind when animating objects in 2D. Distant objects should be animated at a slower speed than foreground objects to create a sense of depth, known as parallax.

This causes an effect called foreshortening. The distance the tortoise has to travel appears shorter, but also notice that the distance between the tortoise and the hare appears shorter than it actually is. Figure 1.35 shows foreshortening in a figure drawing.

Figure 1.35 A figure drawing exhibiting foreshortening. Notice how the limbs look shorter than they actually are because of the angle of view. Observe foreshortening in real life, and apply what you observe in your drawings. © Angie Taylor, 1985.

Keeping in mind that we are supposed to be drawing a cube with equal sides, we'll create the second square about half the measurement of one of the sides (this would be its actual distance). Once you have the two squares, you can use them as a guide to create some new convergence lines to create the adjoining edges. Use the top corners of both squares and the vanishing point to determine where these should be drawn. Figure 1.36 shows how I did it.

Once you have these lines in place, you can start to erase any guidelines you don't need and add shading to the box. In Figure 1.37, I've erased the guides and added shading to make it look like an open box.

Figure 1.36 **New guidelines are drawn using the top corners of the squares as guides.**

Figure 1.37 **Shading is added to give the box depth.**

Depth of Field

Another trick you can use to add depth to your drawings is to mimic the effect of depth of field by making distant objects more blurred than foreground objects. The term *depth of field* is a photography term that is used to describe the area of distance that a

Figure 1.38 **Depth of field.** This picture was taken with the aperture set at f/5.6, giving a narrow depth of field. Notice how the main character is in focus, while the other characters blur into the distance.

particular lens can focus on. Anything within this range will be in focus, and anything outside the range defined by the depth of field will be progressively more out of focus the further away it gets. The depth of field can be adjusted on a camera by increasing or decreasing the aperture. Low f-numbers will have a very narrow depth of field, meaning that a short range of distances will remain in focus. High f-numbers ensure that a wider range of distances remain in focus (Figure 1.38).

This effect also occurs naturally in the human eye. If you look at any scene, you'll notice that things in the foreground are much more detailed than objects that are far away from you. We can shift our focus just like a camera can, but we do it without thinking. When creating drawings with depth—for example, landscapes—try mimicking the effect of depth of field. You'll be surprised at how effective this can be.

Don't See What You Draw; Draw What You See!

As I said earlier, drawing is an essential exercise for anyone who wants to follow a career in visual art or design. The exercise of drawing teaches you how to look, see, and understand the world around you. It helps you to develop as an artist in many unexpected ways. While I am drawing, my mind stops wandering and becomes completely enveloped within the moment. Drawing also helps you to experience different qualities like the softness of a material or the roundness of an object. One of the most useful exercises my art teachers taught me was to draw an object without looking at the paper. Looking at the paper while drawing something can distract you from your subject. By not doing this you become fully engaged with the object, with your hand simply reacting to the "feel" of the object.

This is an easy exercise; all you need to do is to set yourself up with the right materials and environment. It's best to use a large sketchbook or drawing board. A1 is a good choice because it allows lots of space for your drawing. When you don't look at the paper, you tend to wander a little, so it's important that you don't run out of space. I like to use an easel because it allows me

to sit upright and position myself right in front of the object I'm drawing. If you don't have an easel, I recommend sitting with a sketchpad on your knee. Having the sketchpad on a flat table will make it harder for your arm to move freely.

Look at the object, and as you do, allow your hand to follow the edges and contours of it. Avoid the temptation to look down at your drawing until you've thoroughly examined the subject of your drawing and reacted with your hand. The object here is not to create a realistic representation of the object but to feel at one with it, learn to really look at it, and get good communication going between your eyes and your drawing hand. You can choose any subject that inspires you. People tend to be good subjects to draw, but if you'd prefer to draw a static object, that's fine, too. Figure 1.39 shows two life drawing examples by artist Sonia Watson.

Figure 1.39 A life drawing. Sonia Watson created these drawings looking only at the subject and not at the drawing itself. Said Sonia, "I really enjoyed the exercise. It was a whole new experience. I loved it, as it introduced a whole new style to my work." © Sonia Melitta Watson, 2010.

Reverse Drawing

Most of us tend to draw with a dark-colored drawing utensil on white paper, building up our drawing by adding darker strokes. It's also important to know where to leave light areas in your drawings. This exercise teaches you to think about the lightness as much as the darkness. You will need some special materials for this. The object of the exercise is to make your drawing by creating white strokes on a dark surface. You need to first decide how you are going to do this. You could buy some black paper and use chalk, white paint, or pastels to draw with. Alternatively you could take a white sheet of paper, cover it completely with charcoal, and then use erasers to actually create the drawing.

Figure 1.40 **A reverse drawing done on scraperboard.** © Angie Taylor, 2004.

My favorite technique for this exercise is to use scraperboard (also known as scratchboard). This is a china clay–coated board that comes ready-coated with a layer of India ink. The artist then uses scalpels, knives, and etching tools to scrape away the darkness to reveal a drawing of light. Figure 1.40 is an example of a drawing I did on a scraperboard. Notice how I've angled the strokes to follow the contours of the face. I've used heavier strokes in the lighter areas and have used cross-hatching techniques in flat areas like his forehead. When choosing a subject to draw in this way, look for a highly illuminated object and start with the lightest areas. Think of this like creating a sculpture, finding the form of the object *inside* the paper.

Still Life Drawing

Still life is a good way to practice your drawing skills, and it gives you the opportunity to mix objects of different sizes, shapes, and surface quality. Artists have used still life for years to practice their skills, arranging a few objects in a pleasing composition and drawing them. As the name suggests, static objects are usually chosen as a subject matter because they stay still, making it easy to study them for long intervals. You can take

breaks whenever you need to and revisit the scene at any time. For this exercise, choose three or four objects that you would like to draw. Simple shapes like apples, oranges, or bananas are good subjects because they are soft, organic forms. Bottles, plates, and bowls also work well.

Still life doesn't always have to be about fruit. There's nothing to stop you from arranging a scene that includes a basketball, a Frisbee, and a sports drink bottle. Your still life can consist of whichever objects inspire you and that you feel confident drawing. When you position the elements for your still life, remember to consider the space around them as much as the objects themselves. You may want to make the shapes overlap, but make sure you can see the edges of each shape clearly enough to understand how to convey its form adequately. Chapter 3 provides techniques and rules that will help you to position the individual elements (Figure 1.41).

Figure 1.41 A still life drawing.
© Murray Taylor, 2010.

Life Drawing

Life drawing (or figure drawing) is the art of drawing the human body. This is my favorite drawing exercise. I love to draw people because they are probably the most challenging forms to draw, and I enjoy the challenge. Here are a few examples of some life drawings I did when I was in college. Notice how I tried out different drawing styles (Figures 1.42 to 1.45).

Figure 1.42 Life drawing with poster paint on lapping paper.
© Angie Taylor, 1985.

Figure 1.43 Life drawing with chinagraph pencil on cartridge paper. © Angie Taylor, 1982.

Figure 1.44 **Life drawing with acrylic, pen, and ink and on cartridge paper.** © Angie Taylor, 1985.

Figure 1.45 **Life drawing with acrylic, pen, and ink and on cartridge paper.** © Angie Taylor, 1985.

Life drawing classes are a very good way to learn how to study form and structure. The human body is notoriously difficult to master because it consists of so many different shapes and textures. It can also be posed in a never-ending combination of poses. This is what I love most about life drawing: You will never get bored by having to draw the same pose twice!

If you're not confident about drawing people, here's a tip that will help you work out the correct proportions of the human body. In Figure 1.46, the drawing on the left is a human body drawn face-on with no perspective. Notice that I've used a grid consisting of ten equal rows and two columns as a guide to help work out the size of the body parts in relation to one another (for example, the head is approximately 1.5 units, while the chest is 1 unit). You can use this example as a guide to help you work out the correct proportions of the human body.

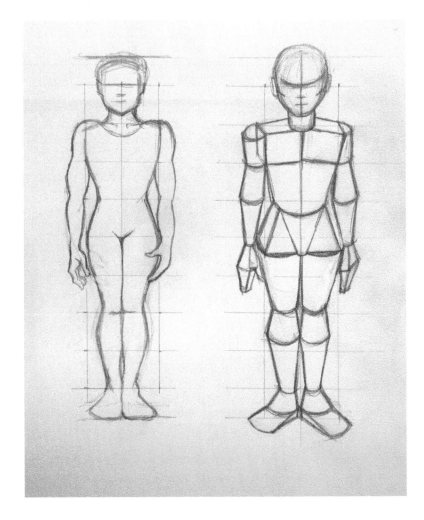

Figure 1.46 The human body broken down into basic shapes. © Angie Taylor, 2010.

The drawing on the right side of Figure 1.46 takes things a stage further. To add a little perspective to the drawing, I've broken down the body parts into basic geometric forms like cubes, spheres, and pyramids to help me build a more three-dimensional character. See how breaking down everything into simple shapes can help you to create more convincing drawings.

Drawing from Photographs or Other Artwork

People may tell you that it's wrong to draw from magazines or photographs, but I don't agree. Although it's always preferable to draw from real life, there's absolutely nothing wrong with copying other images. When I was learning to draw, I regularly copied from magazines and from other artists' work. If it inspires you, use it. Just remember to think about the form, depth, and texture as you're drawing, and you'll learn almost as much as from drawing the real thing. Copying other artists' work is a good way to explore new techniques. Just remember not to feel bad if your drawing doesn't end up looking as good as theirs, particularly if you decide to copy the drawings of a great draughtsman like Michelangelo! Even attempting to understand the processes of such a great artist will inform and inspire your work. Remember, it's not the end result that matters as much as the journey.

Using Photography and Clip Art

As I said earlier, if you feel you really can't draw but you need to create drawings as storyboards or rough sketches, you can use photomontage techniques to create your images. You can still practice some of the exercises in this chapter using these techniques. For example, the perspective lessons can be followed using cutouts in place of human characters. It's important that you still consider the principles of drawing when applying these techniques to make your composite images convincing.

Adobe Photoshop provides a few tools that can help you to work out things like perspective. The amazing Vanishing Point filter is a brilliant tool for creating scenes and placing objects in a scene while maintaining the correct perspective. Chapter 2 talks a little more about the Vanishing Point tool. Some great tutorials about the Vanishing Point tool and other Photoshop features are available on Deke McClelland's fantastically informative, yet compellingly entertaining website at *www.deke.com*. I'd recommend signing up to Deke.com for fabulous freebies, podcasts, and tutorials.

Recap: Practice Makes Perfect

If you've followed the exercises, you should now feel a little more confident about your drawing skills. If you haven't followed the exercises, then you may have imbibed a little knowledge by reading the text, but if you really want to convert that knowledge into drawing skill, you need to practice the techniques.

You should be fairly confident about choosing the correct materials to draw with. Remember to think about all of the things you learned here when choosing a subject. What's the lighting like? Should you draw from an unusual angle to exaggerate the perspective in the drawing? How will you create enough contrast and depth to the object? What kind of shading will you use?

But most important, don't give up! Even at your lowest moments, even if you feel you have created a substandard drawing, persevere! Your efforts will eventually pay off because frequent drawing will definitely help to make you a better designer.

Inspiration

Rachel Max, Designer and Animator

Rachel Max is a designer and an animator (and sometimes an engineer) who currently lives in San Francisco (Figure 1.47). She has also written and directed several short animated films that she has screened in film festivals all over the globe. Max is originally Irish, born and raised in Dublin, but she considers herself fully assimilated into American culture since watching *Pee-Wee's Big Adventure* on video in 1997. You can see Rachel's amazing work at *www.rachelmax.com*. Here is Rachel's story.

Figure 1.47 Rachel Max, self-portrait.

"I went to film school—and even that was sort of an accident, as I had chosen the college originally for its physical therapy program. I didn't realize you could study film, and it sounded great—it was great—hard but great.

"I took a computer animation class right before I graduated, and, oddly, that class had more of an effect on my life than any other class in college. We learned to animate using early frame-by-frame software, but after all I went through in film school with actors

and securing locations and getting insurance, it was so refreshing to just be able to sit down at a computer and make something myself.

"When I graduated, I bought a G3 (and all the software I could afford) and made short animated films in my parents' basement. I figured that was better than running around getting coffee for people on set in L.A. It took a while, but I managed to get a job doing animation and some light broadcast design for a well-known corporation. Once I was in the postproduction environment, I was able to learn more and finally was able to move to New York and become a freelance animator and broadcast designer. I then moved to San Francisco in 2007 (Figure 1.48).

"Since moving to San Francisco, I really haven't had much time to indulge in creative pursuits, sadly. I suppose that's the price you pay for getting hired to do the work you like to do, and this industry is demanding on one's schedule. San Francisco is so beautiful, and the weather is generally nice, so I find it hard to be at my computer the way I used to. I'm in the process of exploring non-computer-related creative pursuits! I like to paint a little, and I'm involved with a comedy show called Mortified. People read their diaries, poems, and songs they wrote in their teens. Hilarious!

"I'm inspired by all sorts of things: *www.motionographer.com* is a site I check every day, and although not work-related, I always check *www.cuteoverload.com* because the power of the cute compels me! For some reason, the song "The Golden Path" by the

Figure 1.48 **Some of Rachel Max's personal works.**

Chemical Brothers often motivates me when I am feeling otherwise unmotivated. I think it's because the song is a lot of fun, and the associated video is awesome. Watching the video makes me feel lucky that I am designing and animating full time and not trapped making copies in a drab office setting (been there, done that!). And, of course, I love to read anything by Stefan Sagmeister, Mark Christiansen, or Douglas Adams.

"I haven't made a film in a while, but I'm really glad I drove myself to make the ones I did. I was learning AE at the time, and there's really no better way to learn a piece of software than to make something of your own. I am most happy with *Dead Kitty* because it played on Comedy Central. Also, I miss my dead cat, and it makes me feel like she's still around (a tiny bit). Tear, roll, splash! I was inspired by Terry Gilliam, I suppose. I love his cutout style of animation.

"Right before I left New York, I had the pleasure of working at Big Film Design (*www.bigfilmdesign.com*) on a proposed title sequence for the movie *Failure to Launch* (Figure 1.49). I worked with an extremely talented art director (J. John Corbett), and we built the animation using several different bird bodies with an elaborate mesh of expressions. This type of animation can be difficult because even though it's computer animated, it can be just as tedious as frame-by-frame stop motion. Using expressions alleviated some of the repetitious work. It was the first time I was working on an idea for a well-known feature, and I was super-excited. The client decided to go with another title sequence in the end, but I am super-happy with this one!

"This job was for the twenty-fifth anniversary of the Nike Air Force One Shoe, which first came out in 1982 and was the first Nike shoe to use air technology. I think the shoe may have also

Figure 1.49 *Failure to Launch* titles.

Figure 1.50 **Nike Air Force One campaign.**

started the whole sneaker-head phenomenon. I worked on this job with Chris Allingham and the crew at RelaTV (*www.RelaTV.com*). In the first part of the promo we dissected a shoe and focused on the various elements that made the Air Force One a whole new type of shoe (Figure 1.50). After zooming out from the air chamber, I used animated lines along the stitching to emphasize the elegant construction and the animation finishes with the Nike swish hitting the shoe—BAM! Awesome. I chose a muted green/blue color palette so the colors wouldn't detract from the animation. It was a lot of fun to work with an object that is so iconic.

"These (Figure 1.51) were two campaigns done for The History Channel at Cathode Ray Club (*www.cathoderayclub.com*). *The Long March* was for TV, and The *Rewind* animation was done for The History Channel website. *The Long March* involved a lot of

Figure 1.51 **The History Channel stills.**

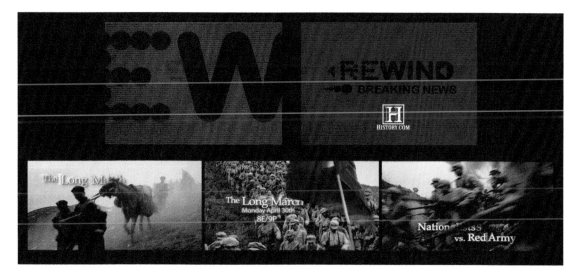

roto, and I loved seeing the result. It proves to me that hard work does pay off. The golden type stands out well against the muted colors of the video. We had a lot of fun with the *Rewind* feedback effect. Initially I thought we'd animate that, but sometimes it's easier to actually create or tape a real-life event than it is to animate it. We created several video feedback loops to create the bad TV feel and composited them in AE. The idea was to play the type against the jerkiness of the feedback. The type is black, so it is legible against the chaos, but it's animated with Hold Keyframes and reveals backward, which ties in with the unexpected behavior of feedback."

PLANNING

Synopsis

The process of first developing ideas and then realizing them as a finished piece of work is possibly the most challenging aspect of your work as a designer. The fear of failure at this point in the project can be so great that it can prevent you from succeeding. But never fear—many tried-and tested-techniques are available that can streamline this process and release your mind from the shackles of creative blocks.

Figure 2.1 **Animation.** Here, the designer, George Hedges, decided to use a comic book style that he developed during the storyboard stage, making the character walk between the frames of the comic. © George Hedges, 2007.

In this chapter, we'll explore some ideas and methods that will help you to develop and maintain your creativity. I'll also give you practical advice on using tools like brainstorming, scheduling, storyboarding, and animatic production. Together, we'll look at some software tools that can help you during the planning process and keep you on track with your creative projects.

Design Essentials for the Motion Media Artist. DOI: 10.1016/B978-0-240-81181-9.00009-1

Inspiration

Over the years I have learned that if you are too conscious of other people's opinions, you will never truly be yourself. The key to pure creativity lies in expressing what's inside *you*. Unfortunately, that's sometimes easier said than done. If you're anything like me, you will probably be your own worst critic, constantly telling yourself you are not good enough. You probably started creating art because you felt inspired by seeing art that you loved. It's very hard to measure up to that. Quite often, what you create will not satisfy your own high standards, and that can be very disheartening. But you must persevere beyond your own technical shortcomings and keep practicing. You *will* get there.

I love music very much, and I am the biggest "frustrated musician" on the planet. I would love nothing more than to be able to play an instrument brilliantly—and, believe me, I've tried! When I was a child, I played the violin for a few years, then classical guitar, bass guitar, drums, banjo, harmonica—the list is endless! Sadly, I have never found the patience and persistence required to play as well as my musical heroes. I guess my expectations are just too high.

I'm sure if I'd been able to stop listening to my inner voice telling me I'd never be as good as the Beatles, I may have been able to master at least one of the instruments I tried and failed with. (Actually, I did persevere with the jaw harp, and I'm actually a pretty mean jaw harpist. Could this be due to the fact that I didn't have any famous jaw harp players to measure myself against?)

Ironically, it can be just as difficult to maintain quality work once you have achieved the standard that you were originally aiming for. How many times have you witnessed a musician bring out a brilliant album and then disappear into obscurity after disappointing subsequent albums. This can often happen, particularly if an artist believes his or her audience is fundamentally flawed for valuing their work, when they don't even believe it's any good themselves. Achieving critical success is obviously rewarding for any creative person, and part of what drives us to be creative is the hunger for acceptance and recognition. But critical success is not as satisfying as the true artistic success that happens when you feel truly replete with your own creative output. You can have the whole world

Figure 2.2 My instruments. I just wish I could play better them better!

thinking you're brilliant and lauding your work, but unless you truly believe it yourself, deep down in your soul, then all of the flattery in the world won't provide you with the artistic success you are striving for.

Achieving your goals, and therefore losing the motivation for "getting there," can be equally tricky as you no longer have a standard to aim for. In my life I have given up on things both because I felt I'd never be good enough and because I felt, "Okay, that's done, bored now, what's next?" (Patience is sadly not one of my virtues.) It can be hard to maintain focus throughout all of these different phases of your creative development, but if you manage it, the rewards are great. It's kind of like a long-term relationship: You go through highs and lows. You will probably be tempted and tested by alternatives when things get tough. But if you persevere and remain faithful, your confidence and commitment to your art will get stronger, and the rewards will be greater.

The Design Process

It's tempting for inexperienced digital media designers to start a project and dive straight into the software without developing a really clear idea of what it is they're intending to create. If you skimp on researching and planning your project, your results will suffer. Each stage in a project must be completed for it to be successful.

Preparation

Establish the brief: The requirements usually come from the client. At times this can be in the form of a comprehensive brief, but on other occasions you may be responsible for putting the brief together based on the client's input.

Do the research: visual, technical, and sketching ideas.

Development

1. Design the project: Develop ideas, brainstorm, create moodboards, and initiate some rough planning.
2. Respond to the brief: Negotiate ideas with the client, and present some initial ideas.
3. Design the project: Create the storyboard, source the core materials, source the images, and generate the assets.
4. Create the digital media product: Implement your designs and develop a working prototype.

Testing

Test the product: Evaluate, carry out technical checking, and conduct audience testing (this should also be done by people outside the development team).

Add the finishing touches: Make any last-minute changes, tweak the design, and get the project signed off.

Delivery

Deliver the final project, providing all required formats. Follow up: Get paid!

Agree to ongoing commitments such as maintenance (particularly for web projects).

The Preparation Stage

Remember that getting into the right frame of mind to produce creative work means you need to make time to inspire yourself, away from the studio. I always allow myself a little bit of time within a schedule for research. Even if the schedule is very tight, spending an hour or so looking through a book or a website can help to clear your mind and spark off some good ideas. Don't be afraid to let the pressure take a backseat for an hour or two.

You should also keep a notebook and pen by your side at all times for jotting down ideas and for the odd bit of doodling. It's important to record all of your ideas, even if you don't want to

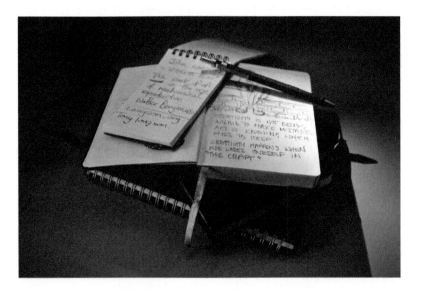

Figure 2.3 Sketchbooks.
© Angie Taylor, 2009.

use them right now. You can quickly store up a whole load of ideas for future reference. You never know—what may have seemed like a bad idea six months ago could be turned into something quite brilliant today.

Always keep your sketchbook close by, jotting down ideas and sketching layouts as you work. This is generally much goes a lot faster than working things out on the computer. In my home-based studio, I have a few sketchbooks and pens dotted around, ensuring that one is always nearby. I even have one next to my bed and another in the bathroom. You never know when inspiration will hit you! I usually get great ideas in the middle of the night, scribble them down, and then look at them in the morning and think, "What on earth does that mean?" But I know not to worry; it usually comes back to me after my morning coffee. Everyone has his or her own way of tapping their creative side. It's important to find yours and make time for it.

Your ideas may evolve throughout the course of a project. This is a good thing, so don't worry too much about it. Don't be too rigid, and be sure to work out lots of rough concepts before settling on your final idea. It's also very important not to be too ambitious with your plans to begin with. Often, people who are new to motion graphic design are inspired to emulate advertisements on TV that include sophisticated special effects and animation that have taken teams of people months to create. Set realistic expectations for yourself. You need to learn to walk before you can run!

Remember, complicated doesn't necessarily mean good. Some of the best designs I've seen are the simplest ones. You know the ones I mean—where you say to yourself, "Why didn't I think of that?" Always begin with well-executed, simple ideas. This will also allow you to be more flexible with your projects as they develop.

Understanding the Brief

Most real-life projects begin with a brief that the client gives you. A brief can be a written document, an email, or even a spoken set of requirements for a specific project. It can include information about target audiences, preferred color schemes, fonts, logos, program information, and any identities or moods that the program-makers wish to convey. It's always a good idea to get your clients' requirements down on paper (or email), even when you get to the stage where the client is asking for small changes. It's much easier to avoid misinterpretations when referring to a written document, and you can use it as proof later if a dispute arises.

When trying to come up with new ideas for future projects, I find that it helps to make up an imaginary brief for yourself. Let's look at an imaginary brief. The client in this job is a national cable TV station. They want a new identity for their regional evening news programs that are to be broadcast simultaneously across the country. The requirements are for the titles to be attention grabbing—showing current news items in an innovative way. The client also wants to be able to easily update the titles with current footage from the different regions. The key is to design one sequence that can be customized for each region but keeping the same look and feel throughout. The client has also asked for the titles to be relatively simple and clean, yet visually exciting. To be sure you understand the brief in the same way the client does, you need to first have a conversation, checking details, making sure you're "on the same page." You need to ask questions—for example, what do they mean by a "simple, clean font"? Their interpretation of the brief may be different from yours, so make sure to ask questions that will provide the answers you need. I find it helpful to read through the brief and jot down questions that pop into my head in preparation for the call. Once you have established what you think is required, you can start to create rough visual examples to present to the client at the next stage.

Establishing the Brief

The parameters of some projects are set before you come on board, and others are not. Details, such as the purpose, the target audience, the key message, the visual theme, the distribution plan, the timescale, the technological requirements, and so on may be outlined for you at the beginning of the project. In such a case, you simply have to understand the requirements and decide if you want to take on the project. Once these decisions are made, you can then move straight on to the research and the development of ideas. At the other end of the scale, a client may come to you with a problem that needs solving but with no specific solution in mind. It may be, for example, that their intended core audience isn't being reached by their current advertising. You will need to get to know the client, what they do, and what type of audience they appeal to. You can do this by asking them a lot of questions and looking closely at their particular area of work. You should also scrutinize their current advertising activities to understand what works and if there are any current problems that need to be addressed.

Research

The research you need to undertake falls under two categories: visual and technical.

Figure 2.4 **Online resources for researching images.** The websites shown here can provide you with free images that you can use in your designs.

Visual Research

Visual research is extremely important as a foundation for developing the graphic style of your project. You need to research what's already out there and take notes on what you think works or doesn't work. Study magazines, books, TV ads, movies, artists, and designers that seem to fit the bill; basically you're trying to get into the "mood" of the brief.

No matter how tight a deadline is, always allow yourself time within the schedule for visual research. Doing this will help you generate concepts for design themes, gauge what is suitable for your target audience, avoid the most obvious and derivative ideas, and learn how the main players in the field present themselves.

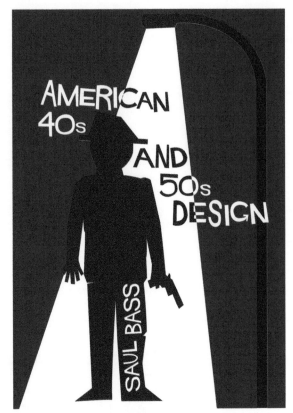

Figure 2.5 **An example of visual research.** Alister Buss was inspired by the famous Saul Bass title sequences for *Anatomy of a Murder.*

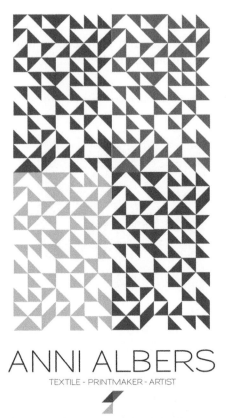

Figure 2.6 **Another example of visual research influencing a design.** Roarke Pearce was inspired by Anni Albers.

When deciding what kinds of imagery to explore in your visual research, think about why particular types of design evoke certain ideas and how this might work for your brief. For example, imagery inspired by Socialist Realism may help you to convey the idea of something revolutionary; psychedelic imagery could help suggest that something is experimental and freeform. Look at a broad range of images for inspiration when you're trying to develop your core concept.

A good exercise to help you discover what works is to create an experimental piece of work based on the work of an existing designer. This can help you to get into the mindset that they were in when they designed it by closely observing the design details. This is a good practical exercise for inspiration, but be careful not use a direct copy of someone else's artwork in your final design, since this could have legal ramifications.

Technical Research

Once you have decided on the content of your design, you must make sure that what you want to achieve is actually possible. Recently, a motion graphic designer I know made an ambitious film title sequence in the style of a video wall using Apple Motion. He offset the film playback in each instance so there was a different shot from the film in each of nearly one hundred individual frames. The camera moved around the video wall and zoomed in on a selected few shots. You can see a similar technique in Figure 2.7, where I've used a third-party plug-in called Trapcode Particular (*www.redgiant.com*) to create particles from video frames. The particles spell out the artist's name in this animation, which was for Beck's *Guero* DVD.

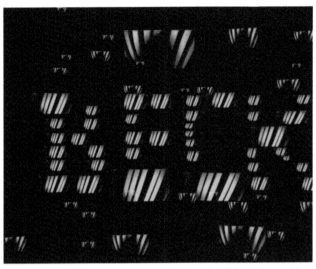

Figure 2.7 **Still of video wall taken from Beck's *Guero* DVD.** © D-Fuse, 2006; Angie Taylor worked as animator.

The designer wanted full quality at full screen as the camera zoomed into the shots, so he kept all of the footage at full, high-definition resolution. This is a brilliant concept, but it proved difficult to achieve technically. When the time came to render the piece, he discovered that the machine he was using did not have the power to render all of the frames in the time he had available. His solution was to rerender the source clips at a lower resolution and frame rate, except for clips that needed to be seen at full screen. This way his file size and rendering difficulties were overcome.

With some careful consideration of the technical problems and some strategic planning during the early stages of the project, this problem could have been identified and the designer could have saved himself a lot of time and trouble. It's very common for embarking professionals to get excited about the creative possibilities and ignore the technical restrictions in this way, so be aware of this and be really careful not to bite off more than you can chew.

Technical research may also involve learning new software techniques; designers and artists naturally love pushing their technical boundaries. Be careful to avoid solutions that require you to learn new techniques if you don't have the time to dedicate to learning them properly. When timescales are really tight, stick with what you're confident you already know. Remember that design solutions that do not involve new

techniques can be just as creative and interesting; new doesn't always mean good. You need to make sure that you carefully research what will be needed to complete the project and check that you have the expertise, software, and processing power to achieve it.

Experimentation

The first process used in the development of all good design work is experimentation, which may not happen during the project itself. You may develop ideas while on a plane trip and then use them in a project six months down the line. But whenever it happens, the time-cost should be included in the job. Designers are pretty unique in that they tend to work 24 hours a day, thinking up new designs and ideas, taking photographs, writing, or sketching. There's really no such thing as an off-duty designer.

Experimentation is a vitally important part of the development of good ideas and techniques. When you experiment with materials and techniques, you can often lose yourself in the craft of what you are doing. I believe it's at this point that great ideas happen. Very few good ideas materialize when you sit staring at the screen, thinking to yourself, "I need a good idea." By losing yourself in what you are doing, you can tap into your subconscious and work more instinctively. It's also important to experiment when you are feeling relaxed. Everyone has a different method, but I find the best time is on a Saturday afternoon, in my garden, doodling in my sketchbook or pottering around with software features I haven't used before.

Sketchbooks and Scrapbooks

The sketchbook is the cornerstone, backbone, and lifeblood of every good designer or artist. It's your friend, confidante, punch bag, and counselor all rolled into one. Regular sketching can be very therapeutic, and I find it quite cathartic to use a sketchbook for purging all of my thoughts and ideas. Everything that passes through your brain can be deposited in some form into your sketchbook so you can let go of it and free yourself up to develop new ideas (Figure 2.8).

I've read several books and papers on creativity, and a surprising number of experts believe that madness and creativity are intrinsically linked. In William J. Cromie's *Harvard Gazette* article "Creativity Tied to Mental Illness," (*October 23, 2003*) he talks about the creative person's inability to "ignore the irrelevant." Experts refer to this as your "latent inhibition."

My head is pretty much always full of "stuff"—work, friends, family, relationships, ideas, inspirations, mundane tasks, creative

Figure 2.8 **Pages from my sketchbook.** © Angie Taylor, 2009.

ideas—all ricocheting around in my brain like flies trying to escape from a jar. My brain is never quiet, and it can be annoyingly hard to ignore. This can be difficult to deal with, not just for me but also for those around me!

I think of my sketching and doodling as a purging process, a way of clearing my mind and getting ideas out. You'll find that once you give your ideas a path to flow out of you, they will come out thick and fast. There won't be enough time in your life to realize all of them, so your sketchbook is a good place to deposit them. You can then go through a selection process, edit them, and work on the most promising ones (Figure 2.9).

Your sketchbook doesn't have to include only sketches. It can also have images cut from the pages of magazines or downloaded from the internet. It can include photographs you have taken, letterforms cut out of a newspaper, written text, equations, inspirational quotations, poetry, scraps of material, leaves, shells, grass, whatever—anything that inspires you and your work.

Remember that your sketchbook should not be looked upon as a chore; it is a pleasure for *you* and you alone. You should never worry about what you are putting into it. Think of it like a filter system: Just throw everything in, and the good stuff will shine through.

Figure 2.9 **Another page from my sketchbook.** © Angie Taylor, 2009.

Art college was a great experience, and I feel very lucky to have had the opportunity to study art. But as with everything else in life, it had as many cons as pros. The worst thing that art college did for me was to make my sketchbook a marked requirement; it stopped being a private pleasure because I had to share it with my tutors. As a result, I started to think too much about what I was putting into it and avoided being honest with myself. It took me a long time to get over it and rediscover the essential privacy of my sketchbook. Your sketchbook is your practice ground for ideas, so it should include failures as well as successes. It's just as important to discover what doesn't work as what does.

When choosing a sketchbook, select an easy size to carry around with you. Make sure you take it everywhere you go because you never know when inspiration will hit you. A good tip to avoid the dreaded "fear of spoiling the first page syndrome" is to start in the middle of the sketchbook and work your way out, randomly selecting pages as you go. If you are concerned about showing it to your tutors or contemporaries, buy a sketchbook that is either spiral bound or has perforated edges so you can remove pages easily.

Brainstorming

Another useful technique to aid the process of idea development is brainstorming. This involves getting a "stream of consciousness" down on paper, a whiteboard, computer, or any other surface you care to use so you can see the big picture. From here you can select promising "leads" to follow. Brainstorming is often used in business, particularly in the design industry. In this context it is often done collaboratively by large groups of people involved in the project. Some people enjoy this process and find they perform better within a team by feeding off the energy created by the group. It can help to have one person lead the discussion to make sure it remains constructive. It's important that you choose the right person to lead the group. It should be somebody dynamic, positive, and proactive who can keep the discussion on track but also allow enough slack for people to be comfortable and creative.

Although this can work with certain groups of people, I'm personally not very keen on group brainstorming because people can be made to feel pressured into agreeing or disagreeing with ideas. They might present their ideas or, even worse, not present them because of existing relationships or peer pressure rather than on their own gut instincts. In this context, or if the brainstorm is not managed properly, it can sometimes be a waste of time. I believe brainstorming can be much more productive when practiced in the first stage individually. Ideas generated from individual brainstorms can then be brought together in a

collaborative way. I'm not suggesting that you shouldn't work collaboratively. Brainstorms need to happen and can work quite well when you do them alone. In this case, the collaborative stage is the second stage in the design process.

There are many software applications that are good for brainstorming such as the fantastic Omni Group applications (*www.omnigroup.com/*) or my personal favorite, Zengobi's Curio (*www.zengobi.com/products/curio/*). This software makes it easy to create brainstorms like the one in Figure 2.10. Images, text, and so on can be dragged around, manipulated, and edited without having to redraw everything from scratch. You can even drag in image links from the web, retaining their URL information. It's a great tool for creating a live, adaptable brainstorm.

Figure 2.10 **A screenshot from Zengobi's Curio.**

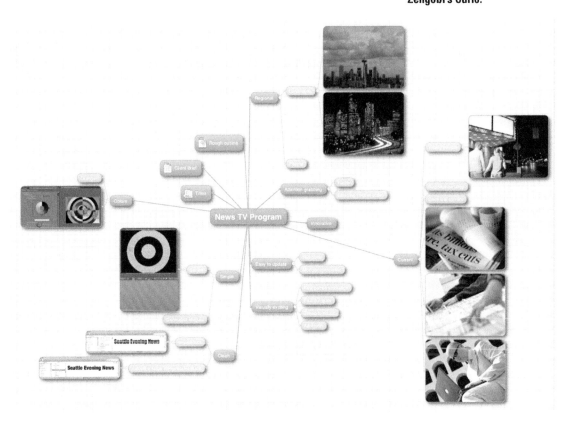

If you don't have access to brainstorming software, then the next best method is to get a huge sheet of paper (or other preferred surface) and jot down whatever comes into your head, usually starting with keywords and concepts taken from the creative brief.

If you find it difficult to come up with any ideas, don't worry. Everybody has that problem, and you are no different. When this happens I usually go off and do something completely different: take my dog for a walk, go to a gallery or the library, watch some television, listen to music, surf the internet, go down to the pub (my personal favorite!). You won't achieve anything except lower back pain and eye strain by staring at a blank screen or an empty page (I'm speaking from experience here), so go and inspire yourself by taking your mind off it, even if only for an hour or so. When you come back to your brainstorm you'll find that your break will have sparked off some new developments.

My brainstorm may start looking something like Figure 2.11, taking keywords directly from the brief. I then focus on these words and add words that come to mind as a direct result of looking at these words. I recommend that you work instinctively with this and try not to "overthink" the process. In Figure 2.12, you can see the words that came from these central concepts. I've also attached the client proposal, rough outlines, and inspirational images, fonts, and movies. From these I was able to develop a design that was suitable for the piece.

Figure 2.11 **My initial brainstorm.**

Figure 2.12 **My expanded brainstorm.**

The Development Stage

Once you have your brainstorm, the next stage is to filter it down, discard any ideas that don't work, and focus on the ones that do. This is where I do find it useful to collaborate with others. It doesn't necessarily have to be with someone who's involved in the project; sometimes it's better to ask opinions of somebody who would fit the criteria of your proposed target audience. For example, if you're designing a kids' television program, get the opinions of your own kids or other children you know.

Moodboards

In most projects I like to create a mood board to refer to. This can be a physical board, such as a corkboard where I can pin the images and ideas that I've chosen to develop into the design. More often these days, I use Curio's idea spaces to deposit digital files I've created into a central space where I can shift them around and experiment further. Ideally you should pick the concepts from your brainstorm session that really jump off the page and generate the strongest responses from you and anyone else

involved. Your moodboard is a common point of reference that you can use throughout the project to remind yourself of what you're trying to achieve. It can also help you to communicate ideas to your clients and coworkers.

After you've "edited" your ideas down and have created a moodboard for reference, the next stage is to put them in order and fine-tune them into a more cohesive form. This can be done in several ways, but since we are concentrating on the moving image, we will focus on the essential stage of storyboard creation.

Storyboards: A History

Storyboards have been essential tools to the production of some of the greatest films and animations of all time. All of the great directors have used them, including Alfred Hitchcock, Orson Welles, Ridley Scott, Tim Burton, Saul Bass, and Walt Disney.

Storyboarding was first developed in the animation industry as a way of "sketching out" ideas before money was spent on expensive film production of the animation. Animation is very expensive to produce, taking teams of people days, weeks, or even months to produce mere seconds of footage. This makes it a completely different creative process from the one used to create video and film, where several "takes" can be shot, and the best one is then selected during the editing process. In animation the shot must be decided and perfected before any production takes place.

Storyboards are very similar to comic strips, usually consisting of frames of the key moments (containing sketches of scenes and camera moves) and text explaining what cannot be illustrated. They allow the director and the designers to work together, finalizing the designs, camera angles, and action before moving into production. A storyboard can be changed easily to accommodate new ideas without costing the team vast amounts of time and money, leaving the production time devoted to perfecting the techniques needed to tell the story.

Why We Use Storyboards

As a creative person, you may come across producers and directors who are not as creative as you are or are creative in different ways. They may not be able to visualize your designs in the way that you can. Storyboards ensures that everyone is "thinking along the same lines," and they help to avoid any misinterpretations. It gives everyone on the production a common point of reference to work from.

Figure 2.13 **Stills from Anatomy of a Murder.** This is one of my favorite opening title sequences by Saul Bass. Even the simplest-looking title sequences will have been planned, experimented with, and storyboarded before production begins. © 1959, renewed 1987, Otto Preminger Films, Ltd. All rights reserved. Courtesy of Columbia Pictures.

Some people mistakenly think that storyboarding a project is a complete waste of time and money. Often storyboarding is the first thing to be cut from a production when there are issues with the budget, since it is commonly viewed as a non-essential stage in the production process. Sure, you can produce a piece without the aid of a storyboard, just as you can bake a cake without following a recipe. But only a very good, experienced cook can bake a perfect cake without following a recipe. It takes an utter genius to create a really compelling piece of film or animation without using a storyboard. It is probably the most important cost-saving stage of the production process.

Anyone in film, TV, games, and even internet production who deals with multidisciplinary production teams needs a storyboard to work with. Besides being an important part of your own animation production process, storyboarding is a service that you can offer to others on a freelance basis. It can often be used as a way of funding your own creative work, while at the same time extending your existing skills.

Working alongside other producers, directors, camera operators, animators, and filmmakers can open your eyes to new ideas and possibilities. It's the kind of job where you continually learn new skills and techniques and are always pushing things forward. You need a good knowledge and understanding of all the jobs involved in the production in order to be a really good storyboard artist.

Often, good storyboard artists in the animation industry are in short supply, meaning there's usually plenty of work out there for the right person. The skills of a good storyboard artist are many. Ideally, you need to be a competent draughtsman and have a good understanding of camera angles and direction. You must be able to tell a good story and be able to work both independently or as part of a team.

A good storyboard artist should be able to take direction from others and also be prepared to make changes to his or her work, no matter how precious that work is to them. Being a good listener with lots of patience is also invaluable! Storyboard artists also require the ability to adapt to a wide range of styles, as well as to be able to follow established designs and produce consistent work.

Good software skills are often required, since mocking things up and changing things using software are usually easier and quicker than doing them with pencil and paper. You will also need to be prepared to put a lot of research into your work and to sketch most things from memory, particularly human poses. This is really important, since you'll be expected to make changes based upon direction from others. For example, it will

be embarrassing and unprofessional if you can't draw the pose a client requests when they ask for the main character to be reaching upward toward the camera while bending to tie his shoelace.

This is a wide range of skills to have, and many storyboard artists start off with only one or two of these skills, building the others as they develop their career. Storyboard artists come from all backgrounds: animators, artists, filmmakers, directors, and even comic book artists. This chapter introduces you to some of the aspects of storyboard production, including drawing, understanding camera angles, video editing, animation rules, and software skills.

It is good practice to look at comic books for ideas of how to put storyboards together. They illustrate a sequence of events in the same way that we want our storyboards to. Comics can give you some excellent ideas for camera angles and unusual compositions (Figure 2.14). The Marvel comics in particular use some fantastic perspective in their frames and should be studied.

Figure 2.14 Storyboard page from *The Small Arms Survey, Geneva*. Storyboard artist Robert Butler has great comic-book skills. © Robert Butler, 2008.

Storyboarding Techniques

Once you've completed your brainstorm, developed it into a mood board, and have developed some solid ideas, it's time to start playing with them and pushing them in some different directions. This is the point where I would go off and sketch my storyboard. My method is to simply divide an A3 sheet of paper into twelve 4 × 3 rectangles with space above, underneath, and between each one for comments. Figure 2.15 shows an A4 storyboard template, which you can find at this book's website: *www.motiondesignessentials.com*. The file, Storyboard01.ai, is an illustrator file that can be resized to your chosen dimensions without losing resolution. Print out a copy so you can develop your own storyboard for your project.

Figure 2.15 **Adobe Illustrator storyboard template.**

Real-World Examples

A storyboard does not need to be a work of art. The one illustrated in Figure 2.16 is pretty basic, using only four frames to tell the whole story; sometimes this is all that's needed. Stick figures are used here to represent the characters. As I said before, don't spend too long deliberating over your storyboard. It is supposed to be only a rough series of ideas that can be easily adjusted to suit your client's needs. Don't fuss with it too much.

Figure 2.16 A rough storyboard example.

A Quick and Rough Storyboard Example

Figure 2.17 Main characters further realized.

Figure 2.16 is an example of a very simple storyboard. Notice that the timing of the animation is written along the top of each drawing, direction notes are underneath, and transitions are marked between the frames. In frame number two, see how a zoom into the screen is represented by direction lines running between the frame edges and a smaller frame. This is, in turn, targeting the zoomed area.

In this instance I would accompany the storyboard with my hand-drawn sketches of the main characters (Figure 2.17). These can be set up to approximate the final colors, textures, and overall quality of the finished piece. This can be done very easily by mocking up a few layers in After Effects, Photoshop, or Illustrator, ensuring that the producers get a clear idea of what the characters look like. In this case, the storyboard is really only for working out timing and camera moves, so don't spend too much time perfecting the details.

A Simple Storyboard Example

In the second example, we can see a slightly more detailed storyboard that shows the movement of the characters. Figure 2.18 shows some frames from a storyboard that I worked on for TV titles for *Pop Art*, which was a series of documentaries about design and music from the swinging '60s. So how did I develop this idea and then get it to the storyboard stage?

Figure 2.18 **A simple storyboard example.**

During the brainstorm process, I let my mind wander a little. When I think of the sixties, I think of Mary Quant's stark black-and-white designs, beatniks dancing in seedy nightclubs, and classic film titles like the brilliant James Bond 007 movie titles. I also think of Saul Bass and Pablo Ferros's fantastic film titles, Blue Note cover art, Andy Warhol, the Pink Panther animations, Austin Powers, and, of course, the hippy culture (Figure 2.19). Now that's quite a lot of inspiration to fit into a minute of graphics, but I included it all into my brainstorm. From there, I singled out the most important elements and developed them into the next phase, using my moodboard. The next task was to figure out how to recombine them to build something new and exciting. It wasn't an easy job, but that's why we love our work: It's a challenge!

From the Bond titles I decided to use the idea of the circles moving onto the screen one after the other; this became the starting point of the titles. It is such a classically familiar film title that the viewer will immediately feel like they have been transported back to the sixties. I continued the circle theme

Figure 2.19 Stills from the finished sequence, influenced by the James Bond film titles and Saul Bass.

throughout the animation, which created a unifying theme and helped pull the design together. I incorporated dancing silhouettes inside the circles, transforming them into psyche-delic spirals. I attempted to play Saul Bass–like tricks by moving from 2D space to 3D space and eventually ended the titles with one of the circles falling to form the letter "o" in the word *Pop*. This is the sort of project I relish: loads of inspiration with very few restraints. You can see the movie itself on the examples page of the book's accompanying website at *www. motiondesignessentials.com*.

The storyboard shown in Figure 2.18 was a little more detailed than the one in the first example. It needed to illustrate

Figure 2.20 A more detailed storyboard for a music video.

clearly how one shot leads to another. Notice how in frame 3 and frame 8, I drew direction arrows to demonstrate the movement happening at this point in the animation of the characters and the camera.

More Detailed Storyboards

Figure 2.20 shows some frames from a music video storyboard. Notice that the drawings have a little more detail but are still fairly rough. These were drawn with 2B and 6B pencils. A music video usually has very quick edits, so I needed to make sure that my storyboard was detailed enough, incorporating all the important scenes.

The other storyboards have focused on camera moves and edits, so this sequence will be much more narrative than the others, telling a definite story from beginning to end. We must make sure that the sequence of events can be understood from the storyboard before we go ahead with the project. The figures will have to be more detailed in this example, and the faces need to have expressions. The whole video will be much more focused on people than the last two, which were more abstract.

You may be asking yourself how you'll know what level of detail is required from the storyboard. This will certainly come with experience, but several other factors must be considered, including budget, client expectations, deadlines, and so forth. Sometimes a client will not even ask for a storyboard because they don't want to pay for it. But you know it's an essential part of the production, so the choice is yours. Should you ask the client for more money to pay for a storyboard, or should you just swallow the cost and create one for your own benefit? I usually create a storyboard whether it's requested or not because I think it's part of my job to educate the clients to the best ways of achieving their objectives. They usually understand the benefit as soon as you sit down with them in front of it. So basically, you can decide on how much time, effort, and detail are required based upon your own assessment of the situation. The ideal scenario is a client who specifically asks for a storyboard and provides plenty of budget so you can really go to town with it.

The images in Figure 2.21 are from an eight-page comic strip *Adventures of a Would-Be Arms Dealer* that were produced for the book *"Small Arms Survey 2008—Risk and Resilience."* Robert Butler, an artist, drew them, and the client was The Small Arms Survey, which was a project of the Graduate Institute of International and Development Studies, Geneva, which monitors the spread and proliferation of small arms around the world. The comic strip was based on a true story involving the results of a journalistic investigation to find out how easy it is to buy and ship

Figure 2.21 **A beautifully drawn storyboard for The Small Arms Survey.** This was a project of the Graduate Institute of International and Development Studies, Geneva. These images were drawn by Robert Butler, an illustrator and storyboard artist.

arms illegally. Each year they publish the results as an academic book. They include an artistic section in the book to graphically convey some of the issues and problems.

Robert says of his work, "As it was based on true events, I tried to give it a filmic look, rather than a comic-book approach, using storyboard techniques to simulate camera shots. The strip had to fit into eight pages, with regular-sized frames, so it was important to make sure that all the text and simulated 'paperwork' would fit in, while still allowing the story to be told in a dynamic way. Some of the frames spill over or use trompe l'oeil to give depth. It was printed with two plates, as used throughout the whole book, allowing shades of gray and tints of red."

Animatics

In many situations, a static storyboard may be enough for the production team to work with, but they will often require at least an idea of how the timing, action, and camera moves will look. This is when an animatic is required.

An animatic is an animated storyboard that is used to set the pacing of your project. There are several approaches to animatic production, usually dependent on what kind of production you are working on. 3D animated film animatics are often created using 3D software packages. Some very good 3D previsualization tools are available that allow you to create real 3D scenes fairly easily, complete with lights, cameras, props, and characters. These applications are being used increasingly in the production of animatics for feature films, music videos, and motion graphic designs. But in many cases, animatics are created in a more traditional way: by animating scenes from the storyboard. Sometimes your client will dictate the techniques to be used for

creating the animatic. If you're working for a big animation stu-
dio, they may have a preference to use previsualixation (previz)
software, or they may even have a proprietary system in place.
When you are the only designer working on the project, you can
decide which software to use. In my experience, most small to
medium-sized design agencies and production companies use
compositing applications like Adobe® After Effects to create ani-
matics from storyboards.

The most common technique I've seen is digitizing the sto-
ryboard artwork either by scanning or drawing directly into
the computer. The images are then split into layers (if neces-
sary) using Adobe Photoshop. Video editing applications such
as Apple® Final Cut Pro or Adobe® Premiere Pro can be used to
roughly edit the images in time with music, narration, or dialog
to ensure that the timing works. Once this has been approved,
finished graphics can be created and dropped into the animatic.
The final stage is usually to add visual effects or graphics to the
animatic, using applications such as Adobe® After Effects or
Apple® Motion.

Once the timing and positioning of elements is agreed upon,
you know exactly what's required to complete the job, and the
preparation of the necessary assets can begin. The great thing
about having an animatic stage in the production is that you
can figure out what works and what doesn't with rough, place-
holder artwork. If something doesn't work, it's not too worrying,
since you haven't wasted time creating the finished graphics and
footage.

Although the costs of production have dropped drastically
with the introduction of cheaper digital mediums, animatics still
remain essential tools in the production of all types of film, ani-
mation, and television programs. Many people involved in the
production process are not creative—for example, they may be
business specialists or lawyers. Sometimes they have difficulty
visualizing what a production is going to look like. Storyboards
and animatics help them see where their money is going and
can even be helpful in increasing the amount of funding for a
project. Even if you don't intend to produce animatics, it is still
useful for you to use computer software to quickly piece together
multiple versions of the same scene for comparison purposes or
for showing the client or director. Storyboards and animatics are
both very important stages in the production process. Ideally, it's
great to include both, but if budgets or deadlines only allow you
to choose one or the other, then make sure the storyboard stage
is kept. It's not that the animatic is dispensable; it's just that
you can get more done in a shorter amount of time on a static
storyboard.

Software

Several software packages aimed at storyboard and animatic artists are available today. Some offer simple drawing and lay-out tools, and others offer compositing and animation as well as 3D cameras and lights. In this book we focus on two applications that are industry standards and are readily available: Adobe Photoshop and Adobe After Effects.

Figure 2.22 A layered image in Adobe Photoshop. Adobe product screenshot reprinted with permission from Adobe Systems Incorporated.

Adobe Photoshop

Photoshop is the ubiquitous software application that is useful for anyone, regardless of the creative industry they are in. You can use Photoshop to cut up your images, composite them into scenes, add color and effects, and prepare them for the animation stage.

Adobe After Effects

After Effects is the application that I use to add movement to the images taken from my storyboards and added to my animatics and finished motion graphic designs. It can be used to group layers together into compositions and animate them using

Figure 2.23 **The same layered image in Adobe After Effects.** Adobe product screenshot reprinted with permission from Adobe Systems Incorporated.

keyframes and presets. You can also add cameras and lights to your scenes so you can show how your designs look from different angles.

Digitizing Artwork

I used to always prefer to draw on paper, probably since that was the way I learned and was most comfortable. However, the process of scanning added yet another job to my long list of tasks, so I needed to find a way to make my whole production process quicker. I now use a Wacom tablet to draw directly into the software application I am using, usually Adobe Photoshop, Adobe Illustrator, or Corel® Painter, depending on the look and feel I'm after.

However, there are several ways to digitize your images if they are not already in a digital format. Here, I'll outline the recommended workflow for getting your images from paper to digital files. Then I'll share a few tips and tricks for optimizing your images in Photoshop, and finally there will be a few tips on animating your images in Adobe After Effects. The first technique we'll look at is scanning.

Scanning

When scanning artwork, use this section as a guide. DPI is a unit of measurement used for print to measure the resolution of an image. When scanning images to be viewed on a screen, it doesn't apply, so you can leave the scanner at a setting of 72 DPI.

Concentrate on the actual pixel dimensions of the image rather than measurements in inches or millimeters.

The two main systems for delivering television signals are PAL and NTSC. The region in which the program will be broadcast determines the system you are designing for. You can check which system is used in your area by referring to Chapter 9, but here is a quick guide for scanning.

PAL Dimensions

- A standard definition 4:3 picture has a square pixel resolution of 768 × 576 pixels (4:3).
- A widescreen picture has a square pixel resolution of 1024 × 576 pixels (16:9).
- HDTV has a resolution of 1920 × 1080.
- Multiply by the "zoom factor" if you need to zoom in or out from the image on screen to avoid losing resolution. For example, if you want to zoom in by 200 percent to your artwork, then scan at double these dimensions (200 percent of a widescreen image would be 2048 × 1152 pixels).

NTSC Dimensions

- A standard definition 4:3 picture has a square pixel resolution of 720 × 534 (4:3).
- A widescreen picture has a square pixel resolution of 872 × 486 (16:9).
- HDTV has a resolution of 1920 × 1080.
- Multiply by the "zoom factor." For example, if you want to zoom in by 200 percent to your artwork, then scan at double these dimensions.

Scanner Settings

Always check the scanner settings before you start scanning. It's much more efficient to get the settings right before scanning because you will have less work to do in Photoshop. Here are some important things to check:

- *Color*—white balance is a setting found in cameras, scanners, and other devices. It allows you to adjust the devices perception of white to make sure the picture has no color cast and is properly color balanced. For example, you may take a photograph under tungsten light, making the colors in your image look yellowish. The white balance control lets you adjust all of the colors correctly, using white as a guide. Once the whites are truly white, the other colors should be fine, too.
- *Levels*—levels provide you with control for adjusting the blacks, whites, and gamma (midpoint gray) of your image.

Using levels ensures that the levels are set correctly to balance the blacks, whites, and midtones.
- *Size*—make sure that you scan to the correct sizes outlined in the preceding section.
- *Crop settings*—crop away any areas you don't need before scanning to keep file sizes down and make scanning faster.

Photographing Artwork

- Always check that the white balance is set on your camera correctly.
- Shoot RAW if possible because it will be easier to use Adobe Lightroom or Apple's Aperture to adjust the camera settings and edit the image nondestructively (*www.adobe.com/products/photoshoplightroom/; www.apple.com/aperture/*).
- Frame tightly around your artwork to avoid the need for cropping.
- Use a standard lens to avoid distortion of the image.
- Avoid using a flash because it can burn out detail.
- Don't use digital zoom because it can degrade the image.

Creating Your Own Composite Images

Some people can't draw but are creative nonetheless, and some people simply prefer to compose images using photo-montage techniques. If you fall into either category, it can be a lot quicker to create things like backgrounds for your animatics using your own photographs. Figures 2.24 and 2.25 show

Figure 2.24 **Source image A.**

Figure 2.25 Source image B.

two photographs I took while out walking my dogs to make up a scene in an imaginary alleyway at night. The two photos were composited together in Photoshop to create Figure 2.26. This frame is from an animatic I created for a well-known computer games company.

Figure 2.26 Composite image made from A and B.

Photoshop Tips

Adobe Photoshop is an essential tool for all designers, and it is very useful for creating storyboards and animatics. This book does not attempt to teach you how to use Photoshop. I assume that you have a good working knowledge of Photoshop, but if you don't, I particularly recommend Steve Caplin's wonderful book *How to Cheat in Photoshop*. This book concentrates on the art of photo-montage and provides you with the most useful techniques for the production of storyboards and animatics. If you need additional help finding some of the features mentioned in this book, you can access Photoshop's online help by going to Help > Photoshop Help from within the Photoshop application. Here are some of the more common uses of Photoshop for motion graphics artists:

1. If you scan multiple images in one pass, or if you are scanning frames from a storyboard, you can use File > Automate > Crop & Straighten to automatically separate the scanned frames into individual image files.

2. For cleaning up smudges and pencil marks on scanned images, you can use the Paintbrush tool with Overlay mode. With Overlay mode selected, you can paint on white areas (with white color selected) to remove gray marks. Any solid black areas will not be affected by the white paint. This means you don't have to be so careful with the edges.

3. Use the Clone tool and the Healing Brush tool to further clean up images or to make clean plates. Start by recreating large areas with the Clone tool. Switch to the Healing Brush to fix any obvious joins or imperfections.

4. Use the Vanishing Point tool to make new composite scenes like the one shown in (Figure 2.27).The Vanishing Point tool allows you to draw, copy, paste, or clone areas, while keeping them in perspective. You can use it to extend walls, ground planes, or to put new elements into a scene without having to work out the perspective for yourself. Some great tutorials about the Vanishing Point tool and other Photoshop features are available on Deke McClelland's fantastically informative, yet strangely and compellingly entertaining website at *www. deke.com*. I highly recommend signing up to Deke.com for fabulous freebies, podcasts, and tutorials.

5. Use the Pattern Maker to create tiled patterns that can be reused in multiple composites.

6. Use Quick Mask mode to make soft and semitransparent selections. You can also use tools like the Smudge tool and the Blur tool to vary the edge softness of a selection while in Quick Mask mode.

7. Instead of deleting pixels from a layer, use layer masks for non-destructive editing.

Figure 2.27 The Vanishing Point filter in Adobe Photoshop. Adobe product screenshot reprinted with permission from Adobe Systems Incorporated.

Figure 2.27 The Vanishing Point filter in Adobe Photoshop. Adobe product screenshot reprinted with permission from Adobe Systems Incorporated.

Nonphoto Blue Removal

Many storyboard artists use nonphoto blue pencils for roughing out their artwork. These pencils use a specific blue that is not reproducible with traditional photocopiers. The artist draws the rough scene with the nonphoto blue pencil (Figure 2.28), which is then shown to the client. Changes can be made on top of the original drawing during this process with a pen or a darker pencil.

After changes have been finalized, the image is photocopied, and the nonphoto blue will disappear, leaving only the finished black lines. Most artists use Photoshop instead of a photocopier, so there are several techniques for removing nonphoto blue in Photoshop. My favorite method is to use Hue Saturation to remove these pencil marks:

1. Go to Image > Adjustments > Hue/Saturation. If you want to do this nondestructively and on multiple layers, you can go to Layer > New Adjustment Layer > Hue/Saturation instead.
2. Select "Cyans" from the drop-down menu at the top.
3. Pull the "Lightness" slider all the way to the right so it reads "+100."

Figure 2.28 **Drawing with nonphoto blue.** © Angie Taylor, 2008.

4. Then switch the drop down menu to "blues" (Figure 2.29), and again move the lightness slider all the way to the right. Now your drawing should be pretty much blue-free.

Figure 2.29 **Nonphoto blue removed in Photoshop using Hue/Saturation.** © Angie Taylor, 2008. Adobe product screenshot reprinted with permission from AdobeSystems Incorporated.

Adobe Bridge Tips

Adobe Bridge comes free with all Adobe applications. It is very useful for managing your files and performing batch processes to help you avoid having to edit files individually in Photoshop (Figure 2.30).

1. In Bridge, go to the Tools menu and choose Photoshop > Batch to apply your Photoshop actions to multiple files in a batch process.

2. In Bridge, go to the Tools menu and choose Photoshop > Image Processor if you want to change the file types of multiple images (Figure 2.31).

3. In Bridge, go to the Tools menu and choose Batch Rename to rename multiple images and move or copy them to another folder.

Figure 2.30 Adobe Bridge. Adobe product screenshot reprinted with permission from Adobe Systems Incorporated.

Figure 2.31 **Adobe Photoshop Image Processor, accessed from Adobe Bridge.** Adobe product screenshot reprinted with permission from Adobe Systems Incorporated.

After Effects Tips

After Effects is my favorite application, bar none. In fact I love it so much that I wrote two books about it (details of which can be found in the bibliography). It is the king of compositing applications, and some people call it "Photoshop on wheels" because it allows you to do everything to moving images that Photoshop does to still images. Just imagine being able to animate everything that Photoshop does, and more, and you will have an idea of the power of After Effects (Figure 2.32). Again, I can't teach you After Effects techniques in this book because it's a behemoth of an application and takes time and dedication to learn. But here are a few helpful hints and tips to help you along the way. Please refer to the bibliography for additional learning resources.

1. Double-click in the empty gray space inside the Project panel as a shortcut to import assets.
2. Import multilayered PSD files as Composition > Layer Size to keep the files at their original size and have the anchor point

Figure 2.32 Adobe After Effects, which is perfect for creating animatics. Adobe product screenshot reprinted with permission from Adobe Systems Incorporated.

in the center of each layer. Do this in most cases, since layers will take less time to render and you will be less likely to have to adjust the anchor point.

3. Import multilayered PSD files as Composition > Document Size to make the files the same size as the composition and have the anchor point in the center of the comp for each layer. This is important if you want to use the layers in other comps but need to keep the position of the layer relative to the comp. It can also be useful if you need extra "room" around the layer for effects to extend into—for example, you can do this to prevent blurs from being cut off by the edge of the layer.

4. Drag a selection of images onto the New Comp button to automatically create a comp. You can also choose to sequence the layers in the order of selection and add a cross-dissolve if necessary. In existing comps you can use the Sequence Layers keyframe assistant to do the same thing.

5. If you are working with music or an audio track like dialog, you can add markers as you preview the audio to help mark pertinent points. For example, with dialog, you could add markers where the conversation jumps from one character to

the other. Or with a music track you could add markers at the beats of the drums. To do this, first select the layer in the comp where you wish the markers to appear. Preview the audio and hit the asterisk key on the number pad every time you want a marker to appear. Then you can jump between markers by hitting J (forward) and K (backward) on the keyboard, adjusting edits and creating actions at the markers.

6. Precompose (group) elements into smaller, more manageable nested compositions. One of the benefits of this is that you don't have to wait for all the layers in the project to update when previewing, just the ones you are currently working on. In the main comp, click on the Collapse Transformations button for each of the nested comps to speed up rendering. Use timecode or descriptive names to name your nested comps.

7. Animate Anchor Point (not Position) and Scale to create 2D camera moves (this can then be easily translated into 3D camera moves if necessary).

8. Use the Easy Ease keyframe assistants to gradually speed up or slow down timing into or out of a keyframe. If necessary, use the Graph Editor for more control.

9. Create fades if required by keyframing the opacity value.

10. Use the built-in animation presets as a starting point for effects, shapes, transformations, and so on.

11. Once you have animated a property or added effects, you can save the resulting keyframes or expressions as Animation Presets so they can be dragged and dropped onto other layers. You can save any fades or other commonly used effects, masks, expressions, or transformations as animation presets so they can be reused easily. Build your own library of animation presets this way to save time.

12. If you are animating in 3D space, I recommend that you start with Auto Orient > Towards Point of Interest switched off. You can then animate the camera's position and then change the Auto-Orient setting to follow the point of interest if required to animate the direction the camera is facing. The same applies to lights with point of interest—spotlights, for example (Figure 2.33).

13. Keep camera moves subtle, and imagine what would be possible in the real world with real camera operators, cranes, tracks, and dollies.

14. Switch on Depth of Field and Shadows to add depth to the composite when working in 3D.

15. Remember that you can also create shift focus effects by animating the camera's Depth of Field settings. This can be a good way to focus the viewer's attention without actually moving the camera. It helps to add "apparent motion" to an otherwise static shot.

Figure 2.33 The After Effects 3D environment. Adobe product screenshot reprinted with permission from Adobe Systems Incorporated.

16. Remember to switch on Open GL previewing in the After Effects preferences. And check that you have updated to the latest Open GL software. Doing this will speed up AE significantly and allow you to move more quickly around the 3D environment. You can find out more about Open GL and supported Open GL cards in the Online Help or on the Adobe website at *www.adobe.com/products/aftereffects*.

Postproduction

Several postproduction processes must be done once you have the signoff from a client. First in the list of postproduction tasks is the final color grading. You need to make sure that the colors and luminance values are safe in your final product if it's intended for broadcast. You may want to add a color treatment to the whole piece to give it a particular "look" or style. Several products can be used, and one is Apple's Color, which is part of the Final Cut Studio package. Adobe After Effects includes a free copy of Color Finesse, another very powerful color correction software tool. If you want an easy-to-use but very powerful color correction and treatment tool, Magic Bullet Looks or Colorista from Red Giant Software are the best in town.

You're likely to need some postproduction done on the audio as well as the picture. Avid's Pro tools and Apple's Logic Studio are the big players in terms of audio postproduction for the desktop. These applications are designed for professional sound engineers and can be quite intimidating if you are not experienced with audio terminology. If you're an editor or motion graphic designer who just wants to do some quick tweaking or correction of audio, then Apple's Soundtrack Pro and Adobe's Soundbooth are both good options because they offer powerful tools with a shallow learning curve.

The Testing Stage

You only know if your product works if you and others test it. Testing can be divided into audience and technical testing. For audience testing, try out your product on people from your target market in a focus group or with other carefully selected individuals. Do they like it? Do they get it? Is the message communicated effectively? Is the interactivity usable? It's important not to use people who were part of the production team, even if they fall within the target audience, because they will bring preconceptions, assumptions, and a prior understanding of the project to the process.

Testing can be a substantial and formal part of the production process, and there's a whole industry devoted to it. But often designers run their work past people in a much more informal manner. However big or small the production, testing should always be carried out.

Technical testing is the process of checking that your product works and runs as it should. It's always tempting to skip if you're running hard up to the deadline, but do this at your own peril. Imagine how embarrassing it would be if you gave a client a blank DVD or a film that doesn't run or an interactive project that has missing assets. Believe me, it happens. I've been given blank discs, corrupt files, and projects with missing or unlinked media by other designers I've worked with. There's no excuse for this, so always double-check your files before you hand them off to your client or colleagues. It's also important to check your files on multiple platforms. If you created your design on a Mac, always check that it also works on a PC. If it's for web delivery, check it on the full range of platforms and browsers.

The Delivery Stage

As we discussed earlier, this is why it is so important to make sure there are clear expectations and good communication throughout the project. On delivery, clients will often ask for tweaks and minor changes to be made to the final version. This is to be expected, and you should always try your best to keep

your clients happy. Just make sure you are not pressured into doing anything above and beyond the original brief. Otherwise, you'll set a precedent that may be difficult to maintain. It's also important to build some contingency time for changes like these. Your schedule should always include time for any necessary tweaking after you've shown the finished work to the client.

When everything is agreed and you are ready to deliver the final product to the client, you have several options. Both Adobe and Apple make it easy for you to compress your footage correctly for final delivery by providing purpose-built tools for the job that provide you with simple presets and batch-processing features. Apple's Compressor and Adobe's Media Encoder both offer easy access to a multitude of formats and compressions. The choice of formats available to you can be bewildering. There are literally hundreds of different formats for delivery across web, broadcast, film, and mobile devices. These applications ease the process by providing easy-to-use presets and batch processing features. To find out more about codecs and video formats, please refer to Chapter 9.

So now you know the processes involved in planning your project, from developing ideas to briefs and creating storyboards. I'd like you to go off with a sketchbook, pencil, pen, eraser, and whatever else you feel you might need to put together a collage-style composition. You can even use Photoshop to create a photomontage storyboard.

If you panic at the beginning of a project, don't worry; nobody else but you will see this. There are techniques to help you visualize your project. If you have to use stick figures in your storyboards and geometric shapes in your animatics, that's fine. The more practice you get, the better you'll become.

Time Management

Up until now this chapter has focused on creative design development, but there's also a lot of logistical planning involved in the management of digital media projects. The realities of time and budgetary constraints can often put the project under pressure, and this may be exacerbated when tasks are distributed across a team.

Your job as a digital media professional will be to create a project that meets the needs of the brief and comes in on time and on budget. Learning how to plan your time and manage your resources are important skills to develop. There are methods that can be employed in every project to manage this process, but each project needs to be closely scrutinized for its individual characteristics. This section looks at how to identify a project's lifecycle and how to best schedule your time.

Scheduling

Planning your time is crucial to the success of a project. A tight budget usually means tight deadlines. It's very important when in a real working environment to stick to schedules. It's all very well thinking to yourself, "Well, I'll just do a couple of extra hours on it here and there," but if you do that with all your jobs, you'll run yourself ragged and be too tired to produce any quality work. Making and following a schedule and monitoring where you've allocated too much or too little time to tasks will enable you to be realistic about the time frame needed to do jobs. Scheduling and time management may not be your most favorite part of the job, but they are essential to creating a quality product on time without losing your sanity!

When the time finally comes to make your schedule, figure out what must be done first and which tasks are dependent on others having been completed. You can't begin editing without first shooting the footage; you cannot complete animations without the finalized assets. For interactive projects, there's a tendency for coding to be completed last, so any schedule drift will squeeze the programmers. An awareness of interdependence of tasks and experience of how long it takes you to do certain things will help you to schedule your project efficiently.

A deadline can be frightening, but it's not always a bad thing because it helps you to be decisive. A good way to cope with a tight deadline is to set a timetable. It'll only take you two minutes, and it's a good feeling to have it to refer to when you're feeling under pressure. I use a combination of Apple's iCal (Figure 2.34) for a basic calendar timetable and Things from Culture Code to devise schedules and alarms. I also like to have a calendar displayed on a wall somewhere so I can check it when the computer is switched off. I particularly like wipe-able calendars as dates often change throughout the creative process!

Apple's iCal (Figure 2.34) is a simple, easy-to-use solution for scheduling your work. You can use it to create multiple, color-coded calendars for each job you're working on. These can be switched on or off to make it easy to understand. You can also publish and share your calendar online with your clients and colleagues so that they can keep an eye on the project's progress (*www.apple.com/macosx/what-is-macosx/mail-ical-address-book.html*).

Windows users can use Microsoft Windows Calendar, which is built into the Windows Vista operating system (*www.microsoft.com/windows/windows-vista/features/calendar.aspx*). A cross-platform alternative is to use Google Calendar, which also allows you to sync up with others involved on the job (*www.google.com/googlecalendar/about.html*).

Figure 2.34 Apple's iCal.

I find that this is enough for me. I simply mark in target dates when I will have expected to achieve a certain task. But some people prefer to use a more formal timetable system to manage their projects. You can do this with any application that supports tables, like Microsoft Excel or Apple Numbers. To create your schedule, list all the tasks you have to complete then place them into a grid representing a timetable, dated between now and the deadline. Work backwards from the deadline to see how much time you can afford to allocate to each part of the project. You may be planning your time by the week, day, half-day, or hour depending on how long you have to turn this project around; this process will show you what you need to get done within each block of time in the grid.

Let's say you've been commissioned to create a DVD with animated intros, transitions and menu backdrops, and you've got two weeks to do it. Working back from the deadline, decide on your internal deadlines for the important points in the project. When should the prototype be finished? What about testing and finalizing? How long should you give to the development of the

prototype? How much time can you afford to give to research and developing ideas? Do you need to devote time to brainstorming and storyboarding?

For a two-week job, I'd aim to give myself a day for research and development, two days for sketching out ideas and meetings with the client. That leaves six working days to complete the job and one day for last-minute changes. Remember that you must include design time as well as permitting time for trial and error if you are developing a new technique. You'll also look much more impressive to the client if you get your work in early rather than late. They'll definitely come back for more if you come in slightly under budget.

Here is a potential schedule for completing the DVD project. This may look like a strict, linear development, and of course, the order in which you complete your work is very important. But don't feel constrained by it. This is intended as a guide and you'll find you can move backwards and forwards through some of these stages.

Week 1	Tasks
Monday	Briefing discussions with client
	Visual research
Tuesday	Brainstorm ideas and create mood boards
	Initial sketches
	Email a range of initial ideas to client for short-listing
Wednesday	Once you have client feedback, continue to refine ideas and draw up storyboards
	and flow diagrams based on their comments
Thursday	Build animatic to work out timings
	Get approval on this before proceeding
	Once you have client approval, source or generate artwork and assets
Friday	Build animations
Saturday/Sunday	Have the weekend off unless you've let the schedule slip and you need to catch up, or the
	client has told you you're barking up the wrong tree and you need to do a lot of reworking
Week 2	
Monday	Continue with animations, if necessary
	Meet with client for approval
Tuesday	Complete animations and render
	Export finished animated sequences
Wednesday	Import assets into DVD authoring software
	Build DVD interactivity
Thursday	Author and test DVD
	Show to the client for feedback
Friday	Implement any changes, tweaks and improvements asked for by client
	Reauthor
	Deadline for delivery of finished DVD

For example, research helps you generate design ideas, which could lead to a need for more research. Testing may uncover problems that drag you back to the implementation stage. Don't feel you have to be too rigid, every project follows these basic steps, but the relative weighting of each of these will vary from project to project.

Work back from the deadline, making sure enough time is allocated for the actual work which is fairly easy to predict. Once this is done you can see how much time is available for preparation and idea development, which is a harder set of tasks to measure. I recommend dividing the remaining time between these less predictable tasks. There's a certain amount of "hope for the best" when doing this but provided you have a rough idea of the time available, it's surprising how closely you can stick to it.

You may wonder why we work backwards from the deadline; it's simple really, starting from the front you run the risk of being too generous in the allocation of preparation time, forcing you to shave some off important production time to make up for it.

Meeting Deadlines

You may feel, when you've set the brief, that two weeks is ample; perhaps you work most efficiently under a sense of rising urgency. What the scheduling process can demonstrate is that it can be difficult to meet the deadline and work to your usual high standards unless you structure your time effectively. You need to take your own internal deadlines seriously and operate with a sense of urgency to make sure your storyboards are completed by their individual deadline. Don't just focus on when the final deadline is. It's really important to be decisive and not to procrastinate. If you don't start an individual task on schedule, you won't finish the whole job on time.

Flexible Deadlines

Not meeting your own deadlines is unprofessional and you will lose work and money if you continually miss them. However, it is worth understanding the difference between a deadline that is nonnegotiable and one that has been imposed arbitrarily to give the project an end point and therefore some momentum. Examples of unmovable deadlines include deadlines for university modules, commissioned work that is associated with a product launch or a scheduled event, or a piece for broadcast. Outside of these examples there may be projects where it's suitable to negotiate more time to ensure quality levels are maintained or money is saved. But just because a deadline isn't fixed, I'm not encouraging you to miss it. You should always do your best to hit

the given deadline. But in some instances production values and budgets may be the fixed point rather than the time and date. So in these situations it may be acceptable to slightly stretch things in your favor.

Some Final Thoughts

In addition to what we've already discussed in this chapter, here are a few tips to help you form your ideas and learn how to visualize and materialize them onto paper and, eventually, the big screen!

- If you can't think of any idea, try looking around your environment for shapes, color combinations, and movements that appeal to you. Nature and the world around you are full of inspiration.
- Look at the structure of buildings or machinery. They are full of shapes, which interlock to create even more interesting forms.
- Look at the way a bird swoops through the air. Perhaps you want to mimic that movement in your animations. Look at the color of the grass contrasted with the sky or the colors of neon lights against the night sky.
- Cut out some images you like from magazines and papers, and then play with them on a table or board, shifting them around to make different patterns, textures, and collages.
- Just look around you for things that please you or make you feel good. If you have any objects you love looking at or touching, try to define what it is about that object that makes it so pleasing to you. If you like it so much, then it's likely that other people will also be able to relate to it.
- Design is nothing complicated; it's just a matter of recognizing what appeals to you and then figuring out a way to realize why and communicate that feeling to others through your own work.
- If at first your ideas are not turning out the way you want them to, don't give up! It's much easier to think that you are no good at something than it is to feel that you are a success. It takes hard work and courage to persevere with your dreams, but if you really want it, you'll succeed.
- If you do panic and feel that you are getting nowhere fast, try deep breathing, I know it sounds ridiculous, I, too, was a scornful skeptic before I was persuaded to try this, but it really works.
- Push all negative thoughts out of your mind each time you breathe out and think positive thoughts each time you inhale.

- If all else fails and you are still staring at a blank piece of paper, try doodling while you are watching television, eating, or out having a drink with friends. Ideas normally buried deep in your subconscious thoughts can sometimes come out in doodles when you are half concentrating on something else.

Recap

In this chapter we've covered the whole design process from beginning to end. We looked at ways of preparing yourself for projects and keeping yourself inspired through the use of sketchbooks and brainstorms. I told you about how moodboards can help you to establish the brief with the client, making sure you're both on the same page. And we also discussed interpretation of briefs and how to deal with them, as well as looking at ways of researching and developing your ideas.

Of course, the next crucial stage is designing the project itself through the use of storyboards, animatics, and the generation of assets. I shared a few of my software tips and tricks to help make this process easier. We also looked at techniques and software for creating realistic schedules. Finally we thought about the importance of technical checking and audience testing before final delivery.

I hope this chapter has given you more confidence and understanding about how to properly plan your projects. I hope you'll be pleasantly surprised to see how your workflow improves when you begin your next project with all this in mind.

Inspiration: Temple Clark, Storyboard Artist

Storyboard Artist Temple Clark, "Electricity" Storyboards

The storyboards in Figures 2.35 to 2.38 were to illustrate the idea for the Elton John song "Electricity," taken from the musical *Billy Elliot*. Stephen Daldry directed the stage version and was also going to direct the video. He wanted to reflect the action of the stage play, in which Billy "breaks free" and flies while dancing in a rehearsal room. In the theater, it's a fantastic moment when Billy actually takes off and soars high above the stage. The theater audience accepts the steel cable that holds him up, but this wouldn't work on film, when viewers like to see the real thing.

"The video also features Elton John singing the song, so the idea was to start it off low key in the rehearsal room. The Billy character would be practicing his dance moves, while Elton

① THE STAGEHAND
EXITS FRAME TO
REVEAL BILLY APPROACH
THE CHAIR.

SWEEPER

BILLY'S P.O.V., PAST
THE SPOTLIGHT BEAM
TOWARDS THE BACK
OF THE HALL.
WE SEE ELTON ON
OLD UPRIGHT PIANO.
HANGING ROPES/CHAINS,
FLOATING DUST etc.

TRACK ROUND ELTON
WHO IS ROTATING IN
OPPOSITE DIRECTION.
BILLY GLOWS IN B/G

POSSIBLY PLAY WITH
SCALE i.e BILLY IS ON
PIANO?

PIANO

TRACK

Figure 2.35 Electricity Storyboards by Temple Clark. Artist: Elton John; director, Stephen Daldry.

② BILLY C/U WITH
ISAAC DANCING IN
SYNCH BEHIND.
WE SEE ELTON IN
B/G.

TRACK

WE TRACK PAST
BILLY AS HE
SWOOPS OVER OUR
HEADS.

MAYBE BRING IN
THE RISING ORANGE
LIGHTS.

BILLY

TRACK

HIGH SHOT —
WE SWOOP DOWN
ON DANCERS.

BILLY

CAM

CONTINUES.

Figure 2.36 Electricity Storyboards by Temple Clark. Artist: Elton John; director, Stephen Daldry.

We see full theatre in B/G.

Transition into fantasy sequence.

We close in on Billy & see what he feels.

B/G light start to streak.

B/G lights go soft focus.

Lighting changes on Billy's face.

We are experiencing what he feels.

Figure 2.37 Electricity Storyboards by Temple Clark. Artist: Elton John; director, Stephen Daldry.

Billy soars up, free of his cable & the theatre walls

We swoop up with Billy into the streaking fairy lights/stars.

Billy lowers down in the spotlight for his final bow.

Elton is just behind, with his immaculate shiney black grand piano.

Figure 2.38 Electricity Storyboards by Temple Clark. Artist: Elton John; director, Stephen Daldry.

accompanied him on the theater's old upright piano. As the song continued, it would transform into fantasy, reflecting Billy's feelings. When Billy starts to fly, he would fly for real, up through the theater lights into a star field. The camera would swoop around with him so the viewer would feel as if he or she was flying with him, sharing Billy's sense of joy.

"These drawings were to tie down some of these ideas. After they had been approved, the next stage was to issue them to the key crew in the making of the video—for example, the director of photography and his or her lighting guys, the art department, the wire staff and stunt coordinator, and the visual effects people. We all met at the theater and went through the boards, checking that everyone understood exactly what was required and ironing out any potential problems beforehand. We discussed the location—whether we could shoot it in the actual theater or whether it would be better to go to a film studio. The camera department and stunt coordinator got together to work out a way to fly the camera (and operator) around without colliding into Billy's wires. We looked at how to set up the lights to make the transition from the theater set to the open sky.

"At this stage, the boards were not there to solve problems but to give an indication of the director's vision. The potential problems were then addressed by the various people involved, and a solution was worked out. Often, on a long or complicated sequence, the boards will then be adapted and redrawn to fit with these solutions to lock down the scene. I believe the purpose of storyboards was to work out and tie down the director's ideas, get client approval, and show the rest of the crew what's involved to sort out the budget and the technical sides.

"In the end, it was decided not to have a 'free-flying' fantasy sequence but to keep it within the theater set. You can view the final video on YouTube to compare the original ideas with the finished product."

3

COMPOSITION

Synopsis

Figure 3.1 **A rule of thirds grid used as a composition guide for a motion graphics project in Adobe After Effects.**

Composition refers to the arrangement of the individual components in your design; it's the sum of all of the parts that form a finished piece of work. The positioning of individual components on a page, screen, or space is vitally important not only aesthetically but in so many other ways. The location of an object, its proximity to other elements in the design, and its properties can convey messages, meanings, and feelings to the viewer. It's important that you consider these when experimenting with the layout for your designs.

Each component of your design consists of properties, which I call "elements"; these include color, shape, contrast, depth, size, position, and orientation. These elements need to be considered and balanced in order for your designs to be truly successful.

There aren't really any hard and fast rules for doing this, no magic formula as such, but I can teach you about grids and

Design Essentials for the Motion Media Artist. DOI: 10.1016/B978-0-240-81181-9.00010-8

guides devised by other artists to help you position elements in a pleasing way. Of course, you may be able to create a good composition purely by experimentation and the use of instinct and intuition. But using grids in conjunction with the knowledge of some of the principles of composition in this chapter will make the job easier and will ensure that your designs are both effective and aesthetically pleasing.

The Elements of Composition

To compose any picture, design, or scene, you first must understand the individual elements that make up the components you're working with. The following sections discuss the fundamental elements of composition.

Shape

In Chapter 1, we discussed shape. It goes without saying that there are the standard geometric shapes that we're all familiar with, such as circles, squares, rectangles, and triangles, as well as nonstandard, freeform shapes. The shape of individual objects should obviously be considered when putting together your designs—not just the individual shape of a single object but also the shapes created by groups of objects or even shapes that form parts of bigger objects. Shape can also result from text blocks, areas of color, shade, or characters within the design. Movement can also form shapes. You must also consider how shapes relate to one another and what messages they project together.

Space

The space where nothing exists also forms shape. In motion graphic design and film, this is referred to as negative space. In print design, it's known as white space. It's important that you consider the shape of the space around the objects in your compositions as much as the shape of the objects themselves. Creating more space around an element in your design gives it more importance, makes it appear grander, and implies quality. There are theories as to why this is the case. Some say it originated in print design when designers started to give importance to subjects by surrounding them in an unusual amount of white space.

In the early days of printing, people filled the paper with as much information as possible. Paper was expensive, so no area of white space should be wasted. Designers saw this and realized they could use this to their advantage. By leaving an unusual amount of space around a picture or block of text, they could imply that their subject was so important that paper could be

wasted. Surrounding their subject in valuable white space raised its importance and perceived value.

This is an example of where a break in conventions can create a new convention. It's now accepted, without most of us really knowing why, that an inordinate amount of space around an object implies quality and importance. Apple adverts are good examples of this extravagant use of negative space, which they use to exaggerate the importance of their products.

Figure 3.2 **Rubin's Vase.** Do you see a vase or two faces?

Negative space can also lead the viewer's eye to where you want it to go or trick it into seeing a hidden message. Rubin's Vase is the name given to a phenomenon discovered by psychologist Edgar Rubin, shown in Figure 3.2. On the left is what appears to be a picture of a vase, and on the right is the same image converted into a black-and-white image. If you concentrate on the white object in the middle of the picture on the right, you still see a vase. But if you concentrate on the black negative space for a little while, you'll begin to see two faces looking at each other. The human mind will try to make sense of what it sees. It assesses a shape, decides which is the dominant object, and disregards the remainder as subordinate background space.

The Rubin Vase effect is also in evidence in Figure 3.3. You can see my favorite use of negative space for a company named Egg and Spoon Couriers. The letter "e" forms the logo, but look closely at the negative space to see extra messaging revealed in the form of an egg on a spoon. The egg and spoon motif implies that the couriers take extra care with fragile items. I can't help being slightly envious of the designer who came up with this concept. They must have been so excited when the idea struck them. The first time you look at the logo, you see an "e," but once you see the egg and spoon, it's hard to see anything else.

Figure 3.3 **Egg and Spoon Couriers' brilliant logo.**
© Thoughtful, 2010.

Line

Line exists only in art and design; it doesn't really exist in real life. We use lines in drawings to create edges, but the edges of objects in the natural world are not really defined by lines. Even something that you may think of as a line—a wire, for example— is not actually a line but a solid object with two edges. We may represent it in a drawing with a line because we can't always represent its depth in scale. So line is really an imaginary element that we use to define an edge where two surfaces meet. Line is

also used in design to create borders or extra definition where it's needed. Text is often outlined to make it stand out or to make it more ornamental. Line can also be used to define the motion path of an object. The human eye is naturally inclined to see lines and define shapes with them. We automatically create imaginary lines in our minds when we are shown a series of dots on a page. We'll naturally fill in the dots to create a line (Figure 3.4).

Figure 3.4 **We naturally connect the dots to create lines.**

Scale

The term *scale*, or *proportion*, is used to describe the relative size of objects in your design. If an object is in scale (that is, it is in proportion with other elements within the composition), it will create a sense of unity. The viewer will tend to believe what he or she is seeing. Push things out of scale if you want to draw attention by creating a weird sense of surrealism. Later in this chapter, you'll see ways to organize the spatial and proportional relationships of design elements by using grid systems in conjunction with composition principles like balance, symmetry, and repetition.

Orientation

Orientation refers to the rotation of objects in your composition. When working within a rectangular frame, you'll instinctively

feel inclined to position things level or perpendicular to the edges of the screen. This is logical, and in the case of text, it makes sense, since it makes it more legible. However, if everything in your design is perfectly horizontal or vertical, your design may look a little boring. Introducing angles to your design can make it more dynamic and can help to break up the monotony.

Depth

Depth (or form) refers to the apparent solidity of individual objects. To give something more depth is to exaggerate its three-dimensional qualities. You can do this in one of two ways. If you're working in two dimensions, it can be achieved by increasing the amount of shading on the object. In 3D applications, depth can be added by adjusting the lighting. Depth can also refer to the perceived distance portrayed in your design. A design can be given more depth if objects are placed at different planar distances. Movement can also add depth to your designs. An object moving toward the camera and breaking out of the frame of the screen will create a feeling of limitless space and depth. The most famous example of this is the opening title sequence from the first *Star Wars* film, where the text crawled onscreen from an imagined vast space beyond the confines of the camera framing before continuing its journey to infinity (and beyond) (Figure 3.5).

Figure 3.5 **A pastiche of the *Star Wars* opening title sequence.** Created in Adobe After Effects CS4.

Motion

This is what sets motion graphic design apart from other forms of design. In its simplest form, it refers to the movement of objects within your design. The three main elements used to create motion are speed, direction, and the motion path that the object travels along. Thought must be given to managing the movement of multiple objects simultaneously. The motion of one object can balance or exaggerate another. Motion has to be considered and balanced in the same way as all of the other composition elements, and it can convey just as much meaning and definition as all the other elements. In Chapter 4, when we discuss the rules of animation, you will get a good understanding of the principles of motion and how to apply them to your work.

Color

Color is extremely important in your designs. In motion graphic design, color can be animated over time (something that obviously can't be done in print design or other static forms of design). So not only do you have the task of balancing colors within a single frame, but you also need to consider its development over time. This may seem overwhelming, but Chapter 6 on color will help you to work out pleasing color combinations and show you how to use color effectively.

Texture

Our last element is texture, which can be used to attract attention, create contrast, or convey feelings. Placing opposite textures next to each other can strengthen a message, while placing objects of similar texture within a space can help to create harmony and calm. See Chapter 1 for more discussion of texture.

Thinking about all of these individual elements as you design your motion graphic projects may seem overwhelming. At first it may feel like a real effort, but with a bit of practice, it will become second nature. Many of the elements listed here will be constrained by the requirements of your clients. They will usually supply you with materials and specifications for the job. For example, they may specify a specific set of colors. This can actually make your job easier because you don't have to "think" so much about what elements to choose. It's just a matter of working around them. So once you have gathered the basic components together and have considered the elements, what next? How do you figure out where everything should go and exactly how much space you'll need?

Arrangements of Composition

When you agree to a job, you're usually provided with some of the components to use in the design: fonts, colors, logos, images, characters, or specifications for other components that must be included. Your job is to provide what the client wants while doing your best to make sure it meets other requirements, such as aesthetics, communicating the correct message, and so on. Solving these problems is not easy; it's a challenge—but, again, that's what we love about our job!

You could just rely on instinct when positioning the elements within your design, but to make it easier on yourself, why not start by learning about some of the conventional layout guidelines that have already been established by other artists. This section shows you how to break up the available space you have, making the organization of elements much easier to figure out.

Framing

The first thing to consider when deciding on a composition structure is the framing of the available space. In Chapter 9, you'll find detailed information about the most common aspect ratios used in motion graphic design and animation. For the purposes of this chapter, we'll stick to the conventional broadcast aspect ratios. In broadcast graphics, you will work with either a traditional 4:3 screen ratio (4 units wide and 3 units tall) or a widescreen ratio of 16:9 (Figures 3.7 and 3.8). Both of these are landscape orientation, meaning that they are wider than they are tall.

Figure 3.7 **A 4:3 PAL composition in Adobe After Effects CS4.**

Figure 3.8 **A 16:9 PAL composition in Adobe After Effects CS4.**

Keep in mind that in web design the aspect ratio can be anything you like. It can be a landscape aspect ratio (wider than it is tall), it could be portrait (taller than it is wide), or it can even be nonrectangular in shape.

When designing for cell phones or other mobile devices, the aspect ratio is often portrait and of course much smaller than broadcast screens or even web graphics. You have to be able to adapt and understand the specific requirements of each device.

Figure 3.9 **An Adobe After Effects CS4 composition, automatically built-in Adobe Device Central for output to multiple devices.**

Something that can be seen and read easily on a computer screen may not be as clear on the small screen of your iPhone. Adobe® has an application called Device Central (Figure 3.9) that allows you to create template compositions in Flash and After Effects that can be tested on software emulators for multiple mobile devices. Check it out if you need to design for devices; it makes the process a whole lot easier.

There will be times when you are forced to reduce the amount of available space because certain information needs to be included. You may be required to leave room for graphics. You also have to take into consideration that the program may be broadcast for people with special needs. In this case you should consider leaving room for a signer (for people with hearing difficulties).

In print design or other types of static design, your available workspace is fixed. All you need to think about is this single,

fixed area. In motion graphic design, you work within a frame, but the viewers' comprehension of the space inside the frame can be altered over time. One minute they may feel that the space inside the frame is a small area, containing flat, graphic elements, and the next they can feel as though they're in a spaceship hurtling through the stars. It can be difficult to resist the urge to create what's known as a closed space within the screen. Most designers tend to do this when starting out.

Closed space is created when elements are placed completely within the boundaries of the screen or if too many horizontal and vertical elements are in the design. Try to get away from the idea of the frame being a constraint used to contain your design elements, and see it as a window for the viewer to look through to see all sorts of wider environments. You can create a more open space by animating objects in such a way that they break out of the confines of the screen, but for it to truly work, the movement of the objects has to be powerful enough to take the viewers' attention on a journey, making them unaware of the screen edges.

Staging

Staging in film and theater is where the art director, director, and sometimes the camera crew design the layout of the space where the action will take place. This includes the structure of sets, positioning of props, and, of course, the actors themselves. Staging is also sometimes rather grandly referred to as *mise-en-scène,* which implies deliberate placement of objects by the director. Everything that appears in the frame is considered carefully, from the scenery to the lighting. Meaning and messaging can be conveyed to the audience by control over things like colors, shapes, and placement of items.

When you are designing motion graphics, remember that you are setting a stage, not a flat piece of artwork. Even when you work in two dimensions, you can usually fake depth with the use of perspective. So when creating motion graphics, you should think of the screen as if it's a three-dimensional space and apply some of the techniques used by film and theater directors to help build killer compositions. The bibliography lists some books that I highly recommend if you want to really get a handle on the language of film. It's too vast a subject to cover here. My favorite book is *The Visual Story* by Bruce Block.

With staging you want to consider the depth of the space as well as the two-dimensional space that exists between the edges of the frame. In some situations the frame can wander around an environment in the same way that a camera would move around a set, focusing on different views at different times. In these

situations it may be necessary to create a map of the journey for planning purposes. This ensures that the positioning of elements is correct and that the time needed to get from one subject to another works.

Grids

Figure 3.10 **Grids used in After Effects for DVD menu design for punk band The Slits.** © Angie Taylor, 2008; artwork © Tessa Pollitt, 1980.

Josef Müller Brockman was one of the first designers to extol the virtues of using grids in graphic design as a flexible system that would encourage consistency and order. He was one of the proponents of the Swiss Style that was established and taught to students in Switzerland in the 1950s. This movement spread rapidly, and the grid system was adopted as *de rigueur* within the print publishing industry.

Many of the conventions relating to this typographic grid system were carried over into web design (See Figures 3.10 and 3.11). When web design first took off, there were no established design rules. Further complicating matters was the fact that the layout of elements within the constraints of HTML is notoriously difficult to control. So graphic designers who were trained in traditional print media brought their own print rules along with them but had to adapt them to suit the new medium. As a result, a slightly looser grid system has developed and is now well-established

To find a really good course on motion graphic design, you really need to choose a specialized university such as Savannah College of Art and Design, which offers a wonderful course in Motion Media Design, or Ravensbourne University in the United Kingdom, which has an excellent BA degree in Motion Graphic Design. Of course, there are lots of other great courses available, these are just two examples.

and documented in various books on web design (see the bibliography). However, it's hard to find an authoritative guide on grid systems specifically developed for moving media. I guess part of the problem is that it's only very recently that specific courses in motion graphic design have appeared, and even now it is hard to find a course aimed squarely and solely at teaching the principles of motion graphic design. Most available courses teach a broader subject of either graphic design (incorporating a module or two on motion graphics) or digital media, which tend to focus more on web design. But more often than not, people come to motion graphic design from other avenues such as traditional graphic design, film studies, or animation courses.

Each of these disciplines offers conventions that can be adopted to help improve a motion graphic design workflow. Over the years, motion graphic designers have built their own unique systems based upon the conventions established by the individual specialist areas. They have taken the fundamental design rules from the Swiss School's typographic grids and mixed them up a bit with established practices from film, web, and animation. In this book, I've attempted to bring some of these conventions together to provide you with a single reference to use while learning your craft.

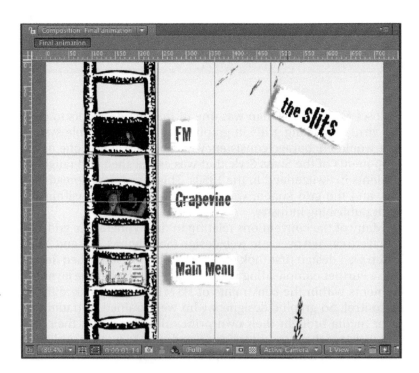

Figure 3.11 Grids used in After Effects for DVD menu design for punk band The Slits.
© Angie Taylor, 2008; artwork © Tessa Pollitt, 1980.

Why Use Grids?

I'm sure we've all experienced hanging pictures on walls or placing a piece of furniture in a room. Without a grid or guide in place, we use a system of trial and error and a process of elimination to find the right position for the item. We may be lucky enough to have somebody to guide us as we try to find the right place—"up a bit, no, down a bit, Okay, left a bit, okay, that's it!" Then once it's in the right place, we then have to get the angle right. Without the use of a guide (like a spirit level), we use our eyes, brains, and our best judgment to determine when the picture is truly level.

Professional picture hangers who work in art galleries would never do it this way. They carefully measure the required distance between paintings and use this as a guide to make sure they are in exactly the right place. They also use tools like spirit levels and angle guides to make sure the pictures are level. If you create graphic designs without the use of grids and guides, you are putting yourself in the place of the amateur picture hanger, wasting valuable time with the process of trial and error until "it looks right."

Grids and guides give you the confidence to place objects, knowing that they are in the right position and are balanced correctly. I'm not completely dismissing the trial-and-error approach; it's fine to take time for experimentation. Sometimes, this allows you to stumble upon new compositions and ideas. This can work well for brainstorming sessions and idea development, but it's not an ideal approach to use once the deadline is set and you need to get the job done quickly and efficiently.

You may think that grids create boring or rigid results, but this really doesn't have to be the case. Grids can provide fluidity and allow for movement. A good designer can adhere to the structure the grid provided without showing any obvious signs in the final design of the underlying grid structure.

Obviously, it's harder to implement a fixed grid on a screen containing moving elements than on a static page or screen, but it's possible. You may start the action on one grid and end on another, or you may want to control the action completely within the confines of a single grid. In the following section, we'll look at some standard grids used for motion graphic design.

Screen Division

The methods you can use for dividing the screen are endless, but in this chapter I'll focus on the basic screen divisions that you can use as a foundation. Once you're comfortable working with these and you want to extend your repertoire a bit further, some of the books listed in the bibliography can provide more information about screen design and grids.

Figure 3.12 Splitting the screen in half horizontally or vertically using guides in Adobe Illustrator.

The first natural division of the screen is to divide it into halves. This can be done horizontally, vertically, or diagonally, as shown in Figures 3.12 and 3.13. You can continue to divide the divisions of the screen into halves horizontally, vertically, or diagonally, as in Figure 3.13. Dividing the screen in half is easy, but it creates a predictable, boring layout. The only time

Figure 3.13 Splitting the screen in half diagonally.

I'd be inclined to use it would be if I wanted to do a classic split-screen effect like you used to see in the old 1950s movies where it was used as a device to show two people having a telephone conversation.

Figure 3.14 **Splitting the screen into quarters.**

Of course, you can continue in this way, splitting into quarters (Figure 3.14), or eighths (Figure 3.15). You can also start to subdivide sections to create asymmetrical layout guides.

Figure 3.15 **Splitting the screen into quarters and eighths.**

Irregular Grids

Grids don't have to be regular, and they don't even have to be based upon straight lines. In the following examples, you can see grids that include diagonals, circles, and curves. The idea is to find a composition that works in basic geometric terms. Then you can try applying it to your compositions. Look to nature, mechanics, or art for inspiration. And there's no reason to assume that grids have to be divided in even increments. You can create all sorts of interesting grids based on uneven subdivisions. Adobe Illustrator has a great feature that allows you to make guides from any vector line. Simply draw the shapes for your grid, select them, and then go to View menu > Guides > Make Guides (Figures 3.16 and 3.17).

Figure 3.16 Adobe Illustrator's Make Guides feature.

The Rule of Thirds

As the song says, "Three is a magic number! Yes, it is. It's a magic number!" (Bob Dorough sang the original version, which was later covered by Jeff Buckley and then De La Soul.) It's the number most people pick as their lucky number (including me—I was born on the third day of the month). The rule of threes is an applied rule taught in English literature courses, and even gardeners plant in groups of three to create a more natural look. It's based upon the belief that collecting words, items, or phrases into groups of threes makes them more memorable, pertinent, or funny. There's also a rule of three in mathematics that I'm not even going to attempt to explain here, but the point is that the number 3 seems to indeed be a "magic number"—or at least an important number.

Applying a screen division based upon thirds seems to be used by everyone in the know—in fact, some say it is overused. The rule of thirds is a very well-established rule used in photography, film, and graphic design. It's an easy formula to use: You simply divide the screen three ways horizontally and three ways vertically to create nine rectangles (Figure 3.18). This is used as a guide for composition when aiming the camera or positioning elements within the frame. The idea is that elements should be approximately lined up with the dividing lines to create a pleasing composition. It seems to miraculously work in every situation. The only downside to using this rule is that it's too much of a no-brainer, so it has become overused. You could take most photographs from a photo-sharing site like Flickr, place a 3 × 3 grid over them, and easily be able to determine which photographers are aware of the rule and are using it. In other words, it's become a bit predictable.

Having said all that, the rule of thirds is a good, safe bet if you want to ensure a layout that works. So why not use it while you're learning? The rule of thirds is just as easy to set up as a two-way split, but it is even better because it offers the option of creating a more interesting nonsymmetrical split. In Figure 3.19, you can see

Figure 3.17 **Irregular guides.** Guides do not have to be made from straight lines. They can also be made from irregular shapes like curves and circles.

Figure 3.18 The proportional grid
in Adobe After Effects, which
divides the screen into thirds.

Figure 3.19 The rule of thirds
grid used for rotating and
cropping images in Adobe
Lightroom.

an example of a rule of third grid superimposed over a photograph in Adobe Lightroom. Photographers and filmmakers sometimes use screen overlays to divide the viewfinder into thirds to help with composition. Most do it naturally without the use of a guide because they've become accustomed to doing it without having to think about it. Many software applications provide thirds grids to help with the cropping of images or positioning of elements on the screen.

The Divine Proportion

The Divine Proportion is a formula for creating perfectly aesthetically pleasing compositions. Does this sound too good to be true? Well, in a way it is, although it seems to always work well when executed within a design. It's not the easiest guide to work with due to the convoluted method required for working it out. It's not as simple as dividing by two—or even three.

The Divine Proportion (also sometimes referred to as the golden mean, golden section, golden ratio, or mean of phi) is calculated based upon a sequence of numbers known as the Fibonacci sequence. Fibonacci (also known a Leonardo da Pisa) was an Italian mathematician who was born in the twelfth century and had an amazing ability to work out equations and sequences that would help explain patterns that occurred in nature. During a competition with other mathematicians, where he had to work out the procreation rate of rabbits (bizarre but apparently true!), he stumbled upon a formula that appeared to accurately predict the proliferation of offspring from one breeding pair. In Fibonacci's sequence, each number is the sum of the previous two numbers, as follows:

1, 1, 2, 3, 5, 8, 13, 21, 34, 55, 89, 144, 288, and so on.

This series of numbers can be used to create geometric shapes. Let's start by looking at how it can be applied to a grid structure. In Figure 3.20, you can see a rectangle divided into 104 equal squares (13 × 8). We can use these as units of measurement to divide the rectangle based upon Fibonacci's sequence. Starting with the number 1, the measurement of each section corresponds to consecutive numbers from the sequence. This results in a rectangle with an aspect ratio of approximately 13:8. (If you break this down to a more specific ratio, you get 1:1.618.) This is the golden ratio, and from this we can work out the so-called divine proportions that occur both in nature and in art.

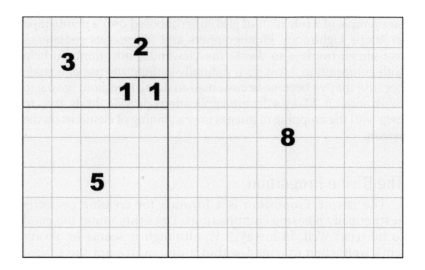

Figure 3.20 A rectangle based upon the Fibonacci sequence.

Artists, mathematicians, and philosophers discovered that this magic measurement occurred everywhere in nature and seemed to produce a pleasing sense of beauty wherever it occurred. The same sequence of numbers can be used to work out other shapes, such as triangles, pentagrams, and multisided shapes such as stars. It's also used to create curves that are seen in nature. In Figure 3.21, you can see a spiral known as the golden spiral (or the Fibonacci spiral) that is derived from this numerical sequence. Notice how the curve dissects each diagonal as it makes its way through the squares.

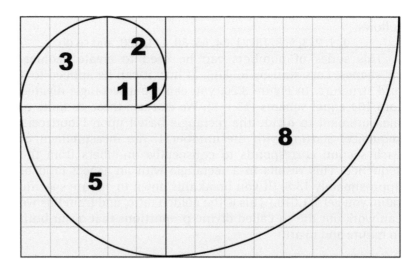

Figure 3.21 The golden spiral.

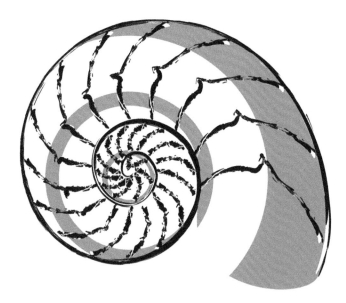

Figure 3.22 **A nautilus shell.**

As I said before, evidence of this golden ratio can be seen in nature—for example, the nautilus shell echoes a perfect golden spiral, as shown in Figure 3.22. The Egyptians recognized its significance and used it to work out dimensions for the great pyramids. The Ancient Greeks also used it when building monuments like the Acropolis. It can be seen and measured in the Roman Parthenon and is everywhere in Renaissance art.

Leonardo da Vinci was a blatant addict of the golden ratio and used it everywhere in his art, including in the *Vitruvian Man* and the *Mona Lisa.* Dieter Rams, the famous German product designer, used the golden ratio in many of his product designs, which in turn influenced Jonathan Ive at Apple to use it in the designs he creates for products such as the iPod (Figure 3.23). The human face even appears to fit this divine proportion. In fact the people considered to be the most classically beautiful often have faces which fit this structure perfectly.

So now you can clearly see why this mathematical equation truly deserves its moniker the Divine Proportion. As I said earlier, this amazing ratio seems too good to be true. Well, the bad news is, it is. It's not *that* easy to implement into screen

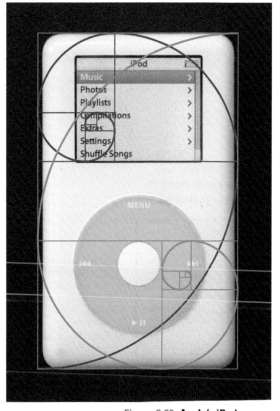

Figure 3.23 **Apple's iPod, which was designed by Jonathan Ive.**

design, since the ratio of 13:8 (or 1:1.618) does not fit with any of the predefined aspect ratios used for broadcast. However, you can use it in web design, or you could create a frame within a frame based upon the golden ratio. I have used it several times for planning the end frame of a title sequence. In other words, it's used to fix the final placement of elements on the screen as they'll appear at the conclusion of the sequence.

Figure 3.24 **Still taken from** **_Hellwoman_ animation.** This composition was based on the golden ratio. © Angie Taylor, 2008.

Figure 3.25 **An easy way to draw a golden rectangle without using calculations.**

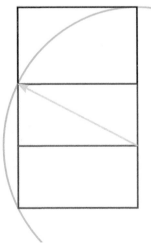

1. Create a perfect square.
2. Draw a diagonal line from the centre of one side to its opposite corner.
3. Using a compass draw an arc using this distance as a radius.
4. Extend the edge you selected to meet the arc, this will now become the long edge of the rectangle.
5. Use a set square and ruler to complete the rectangle.

Let's use an example to show how you can use this ratio in your design. There are two easy ways to work out a rectangle based upon the divine proportion. The first is to create a rough rectangle. First choose a height—say 1024 pixels. Then to work out the width, simply multiply the width by 1.618 = 1657 pixels. This will create a rectangle measuring 1657 × 1024. The second technique involves a few more steps, but the benefit is that it doesn't rely on measurements or calculations. This technique is illustrated in Figure 3.25.

Other Screen Divisions

Many other types of division can be used. Some are dictated by the graphic you have been asked to create, like lower third graphics.

Lower Thirds

As the name implies, this is a graphic element that sits in the lower third of the screen. In Figure 3.26, you can see lower third graphics for the Discovery Channel, created by Rachel Max. It's a common and conventional practice to position the name of the subject or information about an interviewee or upcoming show in this portion of the screen. I asked Rachel to say a few words about these designs:

"I generally dislike having graphics pop up while I'm watching another show, but if you make them cute enough...does it make it OK, I wonder? These lower thirds (sometimes called violators) were a lot of fun to do for RelaTV. Sometimes when you see the provided artwork, it becomes clear how something should be animated, and these jobs were like that. The *Creepy Halloween* promo was especially great to do because it involved character animation. There are certain rules when animating lower thirds— like making sure the type size is big enough and that the font is appropriate. The total duration should be 10–15 seconds; this helps you be decisive about motion and timing. Also, with lower thirds, you have to think of clever ways to bring the information on and off the screen. Sometimes constraints inspire new ways to solve problems."

Figure 3.26 **The Discovery Channel Lower Thirds, by Rachel Max for** *www.relaTV. com.* You can see the fully animated examples at *www. rachelmax.com.*

Square with Side Panel

In situations where a menu system is required (like a DVD menu or a website), divide the screen by positioning a square to one side and then create a side panel from the remaining space.

Breaking the Grid

We spoke briefly about the fact that you can break out of the grid structure. It is true that breaking a grid structure can create a dramatic and attention-grabbing effect, but I only advise doing this once you have learned how to work with elements within the grid. Once you have completed this book and feel confident about continuing your learning, other books are available (see the bibliography) that can show you techniques for doing this creatively.

Perspective Grids

When you design for motion, there is more to consider than just the composition of a flat page or screen. You need to also think about the depth of the composition. We touched on perspective lessons in Chapter 1, so you should have a good idea about what perspective is (if not, you should go back and review that section now before proceeding). In this chapter we'll take things a little further by looking at perspective grids and how to work out views with multiple vanishing points.

Figure 3.27 **A cube from two points.**

In Chapter 1, we drew a cube using a single point of perspective. But if you look at the same cube from a different angle (imagine moving the camera around a little to the right), you'll see that suddenly we are faced with two vanishing points. Why is this? Well, lines or edges in your scene that are not level with the horizon will disappear toward a vanishing point. So in a scene where the angles face in two directions, like the one in Figure 3.27, you start to see multiple vanishing points (in this case, two).

You can precisely measure perspective grid systems by using real-world measurements. With these techniques, you can create drawings that are in perfect proportion. If you want to learn these techniques, there's a really good book dedicated to the subject of perspective drawing titled *The Complete Guide to Perspective,* by John Raynes. The explanation here will provide you with a basis from which you can practice.

Figure 3.28 **Scene from one point.**

Once you've mastered these fundamentals, I encourage you to learn more and really experiment with the perspective in your designs. Figures 3.28 and 3.29 show two examples based on what we've learned so far. Artist Murray Taylor has created street scenes in both one-point and two-point perspectives. Notice how all of the buildings in this scene vanish to a single point on the horizon in Figure 3.28 but to two points in Figure 3.29.

Figure 3.29 **Scene from two points.**

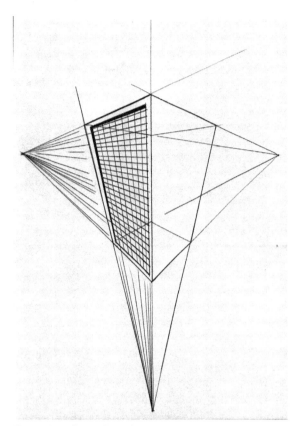

Figure 3.30 Scene from three points. Notice if you turn this image upside down, it looks as though you are viewing it from the opposite angle.

If you could see into the infinite distance, you would see that the vertical edges of objects also eventually hit a vanishing point. If you are level with the horizon (which we usually are), you usually can't see this because the effect is so subtle. But you can clearly see this third-perspective point in extreme views, such as a very high view from a skyscraper or plane, or a very low view from a tiny creature's perspective. In Figure 3.30, you can see an example of a three-point perspective. Notice that the vertical edges are no longer perfectly perpendicular to the horizon and that they now converge toward a point. This point is the third vanishing point in our three-point perspective. The third vanishing point is not on the horizon; its position could be anywhere in the scene and is determined by the height of the viewpoint.

Principles of Composition

So once you've decided which grid you'll use, how do you compose the individual elements within it? How do you work out what size the elements should be and where to position them? What color should they be? How much space should you leave around them? What speed should you use when animating them? There are so many considerations that it can be overwhelming. Luckily, there are a few principles of application that will help you decide the best course. You need to consider all of these principles when choosing your layout. As I've said before, this may seem labored at first, but soon, with a bit of practice, it will become instinctive.

Unity

Most of the time, you should be aiming for unity in your designs. It is usually achieved by consistent use of color, fonts, logos, or other composition elements. There are always exceptions to this rule—for example, you may want to deliberately unsettle the viewer to draw attention to something. In this case, a chaotic design may be more appropriate. You can achieve this by using clashing elements that make the viewer uncomfortable.

Choosing elements that "go together," that fit, and "seem right" creates unity. But how do you know what's right and what's

wrong? Well, let's first think about color. You'll learn more about color in Chapter 6, where I discuss methods for working out color schemes that are pleasing to the eye and convey exactly the right message. You can also look around you to see which colors work together and which don't. If you're new to color, I recommend that you start by limiting yourself to one or two colors to work with or by choosing a warm or cool color scheme. Limitation is a good way to create unity in your designs.

When considering fonts, you create unity by using one typeface in a design. You can work with different font sizes, weights, and styles, but you should try to stick to one typeface. Once you become more experienced in design and know more about the different typefaces and what make them tick, you can push the boundaries a little more. Chapter 5 discusses the idiosyncrasies of working with type. The same applies to the other elements of design, such as texture, motion, line, and shape. While you're learning about design, stick to simplicity until you gain the confidence to be more experimental.

Limitations

Limitations may sound like a bad thing, but as I said before, in the world of design it's a blessing. In the Introduction, I spoke about how restrictions can make your life as a designer easier by reducing the choices you have to make. Limitless choices can be debilitating! Limiting yourself to a small number of colors, fonts, and other elements will make your job a whole lot easier. You can also limit the number of grid sections you use or the number of objects you animate. Resist the urge to be too adventurous; simplicity is your best friend! I once read in a grid design book that you should limit your designs to between five and seven items per screen. I'm not sure if this has been scientifically proven to be true, but it seems like a good number to stick to when learning about composition.

Harmony

If you have applied the methods of unity and limitation, you should automatically achieve harmony in your designs. *Harmony* is a term that is more often applied to music, but it is not surprising that it's used here, too, since there are many similarities between music and the visual arts. In the same way that musicians use rules to determine which notes work well together (known as chords), designers use rules to determine which design elements work well together. Use these rules when you want the viewer to enjoy the experience of watching your designs, push the boundaries, and experiment when you want to jar the senses

or shock the viewer. It's important to be aware that somebody who understands the rules can push the boundaries much more successfully than someone who knows nothing about them in the first place (just as with musicians). In Chapter 6, we look at ways to create harmony by using tried-and-tested color schemes of complementary and analogous colors. In Chapter 5, I tell you how to create harmony by sticking with one typeface rather than mixing too many together. Harmony is often achieved by keeping things simple, choosing elements that complement one another. Avoid placing contrasting elements too close together, since that can create disharmony that can jar the senses.

Repetition

Repetition is used to create a visual rhythm in design in the same way that beats are repeated in music to provide you with a sense of rhythm. People naturally look and listen for rhythm; it can be comforting, invigorating, sensual, or exciting. Different rhythms create different moods in graphic design, just as they do in music. Repeating elements can include colors, motion, size, depth, spacing, orientation—in fact, any element you wish.

The two basic types of repetition in motion graphic design are static and sequential. Static repetition involves the repetition of elements within a single image. For example, in a web or DVD menu design, you may create a design that spans across multiple pages or screens. Each DVD menu can contain titles, subtitles, and other graphics; each web page can include headings, subheadings, and hyperlinks. Within each page or screen, you can repeat the colors on a regular basis to create a sense of rhythm across the page.

Sequential repetition happens across frames or pages. Repetition of elements like the same background color can offer uniformity across multiple pages in a website or DVD menu system. In moving footage or animation, you may have an object that changes color over time—perhaps even once every second. This is an example of sequential rhythm.

It's human nature to attempt to group items together. If we see items repeated, we tend to see the group as a pattern rather than lots of individual items. This pattern effect can serve to hide an object or make it recede into the background. Use this to your advantage. You may want to make an object appear to be part of a larger pattern and then gradually give it more importance by focusing on it, making it bigger or changing its qualities in some other way. But be careful that you don't inadvertently weaken the impact of an element by grouping it together with too many similar objects. As with everything else in design, there is a balance that needs to be achieved. Overusing any technique can produce a tired design.

Variety

Variety is used in conjunction with repetition. As we discussed, repetitive elements can become boring, even ignored, so adding a little variety can spice things up a little. Variety can come in the form of color, size, orientation, or any other element. If we go back to the analogy of music, imagine that the repetition is provided by the rhythm section, the regular bass and drumbeats that get us tapping our feet. Variety is the melody that dances on top of the basic rhythm, stands out, and makes a piece of music memorable. It's exactly the same with visual design. For example, you can create a familiar rhythm to connect them by repeating elements across frames. Then implement a beautiful melody to give it uniqueness so they'll never forget it. This can be done by adding a little variety to the repetitive pattern.

Direction

You may think that an object needs to be moving to have a direction. In motion design, direction *can* apply to the path of a moving object, but it can also be used in reference to an implied visual path that's used to dictate where the viewer's eye will travel. This path can be created by the use of a color trail—highlighted objects or shapes such as arrows or pointed objects. You can also use negative space to direct the eye.

Grouping

Grouping elements together can be a way of creating a sense of unity between elements in your designs. Several different methods of grouping occur in design.

Similarity

Similarity is an easy one to understand. It occurs when objects share common features like size, weight, color, or texture. Clever use of similarity can be used to group items together, even when they are dissimilar in most other ways. For example, you may have a screen containing 50 colored circles, each with a unique, random color. If you color 10 of them in exactly the same color, they will stand out as a group despite their position in the frame.

Proximity

Proximity describes the closeness of objects to one another and is something you may not naturally think of when positioning elements within your designs. It is close to similarity, but it doesn't make sense to say an object has a similar position to another. Instead, if it is near another object, we say it is in close

Figure 3.31 Color proximity. The neutral gray letters appear to take on different hues, depending on their background colors. They will usually suggest the complementary (opposite on the color wheel) color of the background color.

proximity to the object. Earlier we discussed negative space and its importance in making objects feel more important or expensive. Placing an object in close proximity to another will make the viewer think there is a relationship between the two objects.

Color can behave very strangely based upon its proximity to other colors. Color on its own is pure, but surrounded by others it becomes affected by them. In Chapter 6, we look at color in more detail, but for now, let's take a quick look at some of the things that can occur when colors are placed in close proximity to one another. In Figure 3.31, notice how the gray letters each take on different qualities, depending upon which color they are super-imposed. The gray letter "V" on the yellow square has picked up yellow's complementary color and appears to be a cool, purplish gray. The opposite occurs when a gray letter "Y" is placed on a purple background; it seems to be a warmer, yellowish gray. In fact, both letters are completely neutral 50 percent gray.

Gestalt

Gestalt theory is studied in many graphic design courses. It derives from Gestalt psychology, which is a German school of psychology concerned with how the human brain organizes thoughts and processes to solve problems. This theory proposes that the human brain is naturally inclined to group items and to see and describe them as single objects. For example, when I look in the mirror and describe what I see, I don't say to myself, "I see two eyes, a nose, a mouth, some hair, ears, and skin." I say, "I see my face." Similarly, if I see a crowd of people, I don't see lots of individual people; I see a crowd. The brain will also look for things that connect objects or shapes to each based upon related elements. We attempt to group them together to form new shapes that are a sum of these individual parts. Four basic principles explain how we do this:

- *Emergence*—This is when the human brain forms an object from a pattern. We do this as children when we look for faces or animals in cloud formations.
- *Reification*—This happens when our brain creates shape from negative space. In the Egg and Spoon Courier example, we saw an "egg on a spoon" motif jump out from the negative space from the letter "e."
- *Multistability*—This occurs when the interpretation of an ambiguous image jumps back and forth, as it does with the Rubin's Vase image.
- *Invariance*—This is the ability of the human brain to recognize an object, even when viewed in different conditions—for example, from a different angle or painted with a different color.

Figure 3.32 **Emergence.** When you see the image from a distance it looks like foliage, but look more closely and you can see the zebra emerging from the undergrowth.

Emphasis

Emphasis can be applied to an element of your design in a variety of ways: by emboldening the line around an object, creating more space around it, or brightening its color or intensity. However, emphasis is really a matter of balance, and you can just as easily place emphasis on a certain object by reducing the qualities of the other objects around it. For example, you may create a composite image from several photographs but want one to be the main focus (Figure 3.33). By reducing the opacity or saturation of the others, you can make the photo of your choice stand out from the crowd.

Figure 3.33 **Emphasis.** In this example from a title sequence, I have reduced the opacity and blurred and masked all of the images except for the central one of the leopard. This gives the picture more impact. Graphic design and photographs © Angie Taylor, 2008.

Continuity

Continuity can refer to the repetition of colors, fonts, and other design elements used to create a unified, consistent theme across multiple screens or pages (as discussed in the unity and repetition sections). In terms of television broadcast, continuity is important in each individual design (for example, in a opening title sequence), but it's also important to achieve continuity across the whole channel.

TV channels broadcast programs created by different production teams that each have a different style. The job of the in-house channel designer is to bring it all together and make it flow seamlessly. A break in programming causes a break in concentration. It's at these moments that viewers tend to switch channels. Broadcasters try to keep the viewers on their own channel by keeping gaps to a minimum and making sure that viewers are aware of the channel branding. They do this when one program is about to end and the next is about to begin by overlaying logos and teaser graphics such as "Here's what's coming up next," along with branded music and voiceovers. These animated graphics that assist the transition from one program to the next are known as bumpers.

Balance

Getting the right balance between all of your design elements, as well as negative space, is crucial. When you mention "balance," most people think of it as it relates to weight. In design terms, it also refers to weight, but not physical weight. It refers to the perceived weight of objects or elements in your design in relation to one another. Going back to our music analogy, a sound engineer would have the job of finding the right balance of levels for all the instruments used in a song. Each instrument should have just enough volume so it doesn't compete with the other instruments. However, one musical genre may be generally more "bassy" than another. Reggae, for example, has much more pronounced bass and quieter guitar than rock music, where the electric guitar would be the foremost instrument. A similar thing happens in design: You can make one element "louder" than the others by making it bigger, adding more space around it, brightening the color in comparison to the other elements, and so forth. However, when you do this, it's important to compensate by perhaps reducing the color, size, or space around the other elements.

Symmetry

When starting out in design, the temptation is to make everything symmetrical. It's the easiest way for us to balance a composition. Human beings naturally look for symmetry. In fact, in Gestalt theory the need to find order and symmetry in what we see is known as *Prägnanz*. But beware: Too much symmetry can make your designs appear rigid, uninspiring, and downright boring. Asymmetrical designs tend to be more interesting to the viewer, since they naturally try to work out the balance of the piece. When creating asymmetrical layouts, it's still important to achieve balance. Balance does not have to be the result of symmetry; a small, heavy object can balance a large, light object. Of course, symmetry and balance don't only relate to size but to all of the other elements like color, shape, and texture.

Hierarchy

Hierarchy refers to the order of importance an element possesses. This can be portrayed by font size and font weight in regard to titles and subtitles. In a newspaper headline, the strong use of boldface, capital letters shouts, "Look at me! I'm the most important!" Subheadings support the headline in lighter font weights and lowercase characters. Hierarchy doesn't only apply to text, though. Objects in your composition can be given a status of importance based upon your use of color, vibrancy, size, or shape. You can create your own codes to represent primary, secondary, and tertiary importance for them.

Contrast

As with all the other principles, contrast is vitally important and can be used as a way to balance your design. Contrast relates to the lightness and darkness (or brightness) rather than the actual color of a component. If you have a bright background and you want your text to stand out against it, regardless of the color, give the text a low brightness value. When you mention "contrast," people often confuse it with color. They think that a contrasting color is one that is opposite on the color wheel. They may try to achieve contrast by placing opposite color values next to each other at high-intensity values. This can create what's known as a vibrating edge (one that's uncomfortable for the viewer to look at). Notice in Figure 3.34 that the orange text has been placed on a green background. The colors have been placed next to each

ORANGE

Figure 3.34 **Contrast.** Orange text on a green background creates an edge that's difficult to focus on. Notice how the edge appears to vibrate.

other at 100 percent saturation with no dividing border. Notice how the edges seem to vibrate and that it's hard to know which color to focus on; this can be avoided by darkening the green background and desaturating the colors a little. Contrast can also apply to other elements of an object. It can occur between any pairs of properties: light/dark, big/small, rough/smooth, fast/slow, detailed/simple, bright/subdued, or chaotic/ordered.

Movement

Motion design differs from page design. In print design (and to a certain extent web design), the viewer looks at the material on a page-by-page basis, flipping pages in books or on a screen to move from one to the next. Each of these pages or screens is typically presented in a fixed frame. In motion graphic design, the viewer doesn't have to physically move from one image to the other; this is done for them by the designer/animator. This allows the viewers to lose themselves in the design, so they really become submerged in the experience.

I love interactivity for surfing the web, finding information, and actively working. For entertainment, I personally don't want to use any form of interactivity. Even the change of a scene can be enough to break my attention and divert me from my enjoyable fantasy world while watching a movie. I just want to sit back and be entertained passively. It's hard enough to develop a successful layout for a single still image, but your job as a motion graphic designer is even harder because you have the extra work of considering how things should change over time and what people like me want to see.

The flow of movement creates shapes and patterns. You can see this in action when watching fireworks. I remember playing with sparklers as a kid, where the bright light from the sparkler would leave a trail, allowing us to draw shapes by waving them in the air against the dark night sky (Figure 3.35). When planning your animations, think about the path that the objects travel on. Try drawing the motion paths on a piece of paper, and make sure that the shapes they produce work well together. The viewer will enjoy having their eyes led on a smooth, pleasant curve much more than a jagged, awkward path. By drawing the shapes on a path, you can also make sure motion paths are not obstructed.

As I said in the grid section, remember that a grid doesn't have to be a fixed structure. A flowing grid can have a fluid structure; the grid can shift over time, but the elements are pulled through from one frame to the next by clever use of color, repeating elements, typography, and so on. Remember that in many software applications, like Adobe After Effects or Apple's Motion, you can create camera motion. Rather than always animating

Figure 3.35 **A child drawing pictures with a sparkler.**

the components on screen, why not animate the camera around them? You can find more tips on how to control motion and apply the rules of animation and editing, respectively, in Chapters 4 and 7. Please check these out and experiment with them.

Copying Other Designs

One of the best ways to learn about design is to copy other people's work. I'm not suggesting you do this professionally, but as practice, it's a great way to learn. Start by analyzing the work: What do you like? What do you dislike? How does it make you feel? What are the dominant aspects of the design? You can also freeze frames from motion graphics projects you like and try drawing grids over them to see if they adhere to a particular structure. This is a great way to learn about the elements and principles of design.

Recap

So now you can see why I devoted a whole chapter to composition: It's a vast subject and requires a bit of thought. Having said that, as with the other "rules," I don't expect you to be actively thinking about each aspect continuously as you create your designs. Reading about them here and understanding why they are important is enough for them to be buried deep in your mind so when you need them, you can act on them instinctively. The human brain is amazing. It stores a phenomenal amount of information and manages to retrieve it based on context. If only computers could do the same!

Let's recap what we've learned here. We started by looking at the fundamental elements of composition that include shape, color, line, space, scale, depth, and motion. Each of these elements deserves your attention. When creating a design, it is easy to focus on a single element and ignore the others. Imagine that you have been asked to create an animation about color. Naturally, you will focus on the aspect of color for the animation, thinking hard about which colors to use and how to arrange them in proximity to one another. But think about how you can use the other elements to influence the message the viewer gets about the colors. You could use the size of the areas of color to adjust the balance of color, making one more dominant than the others. You could use texture to differentiate among different objects of similar color or to break up the monotony of a color. Get used to thinking about how the elements can impact one another in this way.

Once you have considered the individual elements, you can then put it all together. The first things we tackled were grids and screen layouts. When you're learning your "trade," it makes sense to use the grids and guides that have developed as tried-and-tested formulas for good design. Once you become more confident and understand the principles of composition, you can break out of these grid systems and perhaps even develop new ones to pass on to the next generation of designers.

We finished the chapter by looking at the principles of composition that can influence the decisions about how to compose the elements in these grids. I omitted one important element: instinct. You'll often hear people say that they design "by instinct," just somehow knowing what works. Just remember that these people have probably developed that instinct over years by studying the things that you can learn in this book. The difference can be that they are not always aware that this is something they have learned over the years. They may truly believe that they were born with some instinctive genius for design. I don't subscribe to this theory, but I do believe that practically anyone can learn these skills. You just need to be willing to dedicate enough time to doing so. If you do, you too will become an instinctive designer, and the things you've learned here will become second nature to you in the same way they did for them.

Inspiration: Malcolm Garrett, Graphic Designer

Malcolm Garrett studied typography and graphic communications at Reading University. He was one of the most influential designers during my formative years. The designs he created

for bands, including Magazine and Buzzcocks, were completely revolutionary and introduced a whole new visual language to the tired establishment in the same way that the music of the bands did. I asked him to share some experiences he had while starting out as a designer.

Malcolm was a good friend of Linder, who was studying illustration a year ahead of him at Manchester Polytechnic. In January 1977, Linder introduced Malcolm to her friend, Buzzcocks' singer Howard Devoto; fellow band member Pete Shelley; and their manager Richard Boon, who was to become a close collaborator on many of Buzzcocks' artworks. It was from that point onward that Malcolm began working with the band and also with Magazine, Howard Devoto's next band after leaving Buzzcocks.

"The first requirement was to create a poster for them that could be used to advertise local gigs, with a blank space that could have venue details, etc., added to it by hand. Concerned with the typography initially, my poster featured the first version of the Buzzcocks' logo (Figure 3.36). This was created from some modified Letraset rubdown lettering. I hand-printed a small number of posters, in college, in a variety of different colorways. I discovered recently that, remarkably, some of these still survive.

Figure 3.36 Buzzcocks posters featuring Malcolm's logo designs. References for the *Entertaining Friends* poster were taken from books on architecture and photography, depicting "grids" of schematic rooms. This tour poster was created by the promoter and was a modified version of Malcolm's original design. The architecture reference was later developed more fully by Malcolm into a repeat pattern for the sleeve of *Entertaining Friends,* the live CD recorded on that tour and released much later (Figure 3.43). The poster with the torso is the very first hand-screenprinted poster referred to in the text. The image for this was taken from a small ad in a newspaper.

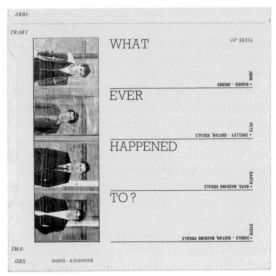

Figure 3.37 **"Orgasm Addict,"
by Buzzcocks.**

Later in the year, after the band had signed to the United Artists record label, they asked Malcolm to work on a design for the cover for the single "Orgasm Addict" (Figure 3.37). A striking montage—one of a number produced by illustrator Linder Sterling—was selected as the image for the cover. Malcolm's job was to make this work in the context of a graphic design.

"With the image chosen, I then handled the design and layout and the production of the actual artwork to make it ready for print. The credits on the rear of the sleeve were typeset letter by letter, by hand, in cold metal, while the main title on the front was stenciled using architects' lettering stencils. The sleeve was restricted to two colors for financial reasons, so I chose a dark color that would render the image well and a bright color to complement it. I found that by photocopying the montage it enhanced the contrast of the image, giving it a more suitable texture for this type of two-color printing. Photocopiers were quite rare at the time, but I had access to one in the drawing office where I was working part-time. I used it to scale the image to fit the seven-inch sleeve but preferred the look of the photocopy slightly over the original.

"I was always very interested in how the meaning of words, and the subsequent distortion of their meaning, could be controlled through the use of typography. I was also interested in the actual shape of letterforms themselves and the structure of the texts they formed, almost to the point of abstraction. This led to an exploration of typography that broke words up in unusual places, and rotated the text midword.

"You can see this in the title lettering on both *Another Music in a Different Kitchen* (the first Buzzcocks' album; see Figure 3.38) and 'Orgasm Addict,' where you'll see that I was very interested in breaking up the text into different planes. To my mind, a strong typographic approach suited both Buzzcocks and Magazine. Peter and Howard were both very lyrically driven, but in quite different ways. Peter's lyrics are often deceptively simple. I always think of him like P.G. Wodehouse, writing volumes in one concise sentence, whereas Howard uses words playfully and abstrusely, appearing to enjoy their structure and physicality, creating lyrics that are somewhere between abstract and obscure, but always potent. Consequently, Buzzcocks' sleeves were often bold, concise, and upfront, while Magazine's harbored a darker sense of latent emotion.

Figure 3.36 **Album sleeve for** *Another Music in a Different Kitchen* **(left), by Buzzcocks. The "Product" plastic bag that the album came in (top right).** *The Different Kitchen* **exhibition leaflet (bottom right).** Each of these illustrates the "Pop Constructivist" epithet that Malcolm was famous for.

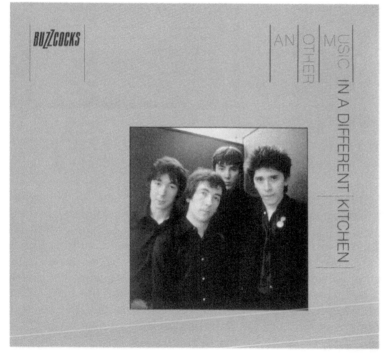

"I remember when first working with Magazine developing a sketchbook full of ideas for a potential logo. Several sketches had all the letters in the word separated in odd groupings, with irregular midword letter spacing. I liked the way it broke up the syntax with a superimposed visual rhythm. A recent Radiohead logo reminds me a little of that approach; mine just never made it

out of the sketchbook. As it came to pass, there was never a desire to use just one font for all of Magazine's record sleeves. Instead, I hoped to introduce a sense of fluidity but with a freedom to go off at tangents, employing subtle maneuvers within the overall visual framework. The typography changed from sleeve to sleeve, yet I feel there is a consistency in visual tone that ties them all together.

Figure 3.39 Sleeve design for *Shot by Both Sides*, by Magazine.

"Linder and Howard chose the cover image for Magazine's first single, 'Shot by Both Sides' (Figure 3.39). Linder was much more of an illustrator, while I was purely a graphic designer. Linder was extremely good at creating powerful imagery, and I was more adept at compiling the various parts, utilizing any visual links to help make everything work cohesively. Consequently, I prepared the typography for the back of the single cover, possibly again using some cold metal typesetting combined with Letraset, and then prepared it as a piece of artwork ready for print."

Malcolm also worked on the cover design for the single "Rhythm of Cruelty" (Figure 3.40). He says, "With the design for the album cover (*Secondhand Daylight*) yet to be finalized, there are few direct links between the artwork for the two records. I used a short filmstrip of images sideways across the sleeve. I can't really remember the origin of the imagery. It is probably a sequence from some obscure porn film found in a book. Before the internet, most of my research was from books, and I gathered

a large collection of picturebooks of all kinds to use as a reference. It was the sense of rhythm from image to image, with an abstract reference to sexual activity that was clearly on my mind."

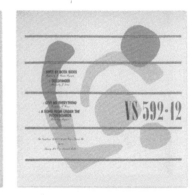

Figure 3.40 **Sleeve design for** ***Rhythm of Cruelty.*** Magazine's four-track EP that illustrates Malcolm's use of four different but visually linked typefaces for the band. The EP uses each font from four different singles on one sleeve.

"*Magic, Murder, and the Weather* was Magazine's last album (Figure 3.41). I devised a grid of vertical bars, which sliced the photo, became a defining space for the typography, and then wrapped the image all the way around the sleeve at both edges. I was always slightly averse to using something just as it was— that's a bit like using paint straight from the tin. And I was always interested in the way the front and the back of a sleeve would work as complementary parts of a larger visual scheme that you could not take in all at once.

Figure 3.41 **Sleeve design for** *Magic, Murder, and the* ***Weather,*** **by Magazine.**

"The tactile experience of turning the sleeve over to link the two parts together was always an important aspect of my work. I also like to make things my own—the photo, chosen because it had been used on a very early flyer for Magazine was a component that I then worked with. The use of color was one way of keeping the visual identity of Buzzcocks and Magazine separate. I always had the intention to produce something that wasn't just a pastiche of something else. For example, I didn't want 'The Correct Use of Soap' to look like a 78, although the origins of the design sprang from looking at the old cardboard sleeves that 78s came in. I only wanted to use that as a starting point and see how I could develop a contemporary solution. I figured if you really liked 'a' and you then took 'b' and mixed them together, you'd get a new letter that isn't even in the alphabet, so many of my designs have hints of several disparate ideas influencing one another. My work for Buzzcocks was once described as 'Pop Constructivism' as it appeared to reference visual styles from the '30s and the '60s in equal measure. In purely commercial terms, this isn't necessarily the best thing to do, as people actually like to know their reference points, and like them to be quite clear.

Figure 3.42 Pages taken from a U.K. government education book, *Space in the Home* from the 1960s that Malcolm took his inspiration from when developing ideas for the Buzzcocks sleeve designs.
© Reproduced under the terms of the Click-Use Licence.

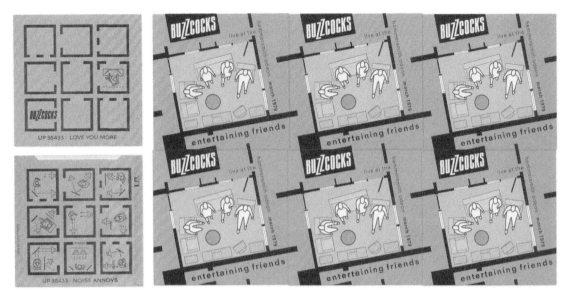

Figure 3.43 **Sleeve designs for Buzzcocks' "Love You More" single and for the *Entertaining Friends* live album.** These show two basic uses of grids and tiling developed from the book. Malcolm developed the 3 × 3 grid used on the cover of "Love You More." He also maintained the grid theme by creating a sleeve for *Entertaining Friends* that when placed side by side with one another, would tile, forming a repeat pattern.

"I lost touch with Magazine in the late '80s, and I was a bit upset that when all of the albums I worked on were issued for the first time on CD I wasn't invited to do the repackaging. When you design a CD version of an album you can't just scale it down from the 12-inch version, as the graphic components begin to work together on a completely different level, and various adjustments need to be made for it to work at the smaller scale. As the designer of the originals I was of course in the best position to make these amended versions, and it saddened me that they were revised without my input. I was always very, very proud of the work I did for Magazine. I really did think it was some of my best and to have the control over reworking them in an appropriate way taken away from me was quite hurtful."

Malcolm has continued to be a strong influence in the design community, and in 1994 he founded multimedia agency AMX with Alasdair Scott, pioneering interactive design and media. He is now creative director at Applied Information Group and is a Royal Designer (RDI). After parting company when the band broke up, Malcolm was happily reunited with Magazine and produced graphic material for the tour early in 2009.

Figure 3.44 Examples of current work at the Applied Information Group. Future of Sound: Identity and information design for forum on sound design for Martyn Ware (Heaven 17) (left). Design included website landing and events pages. Dublin Bus: The bus network is the premier public transport mode in and around the Irish capital (bottom right). The River Liffey, with a single crossing point carrying 70 percent of the north-south connections, presents barriers to understanding how journeys can easily connect across the network. Operator Dublin Bus commissioned Applied Information Group and Dublin consultancy Image Now to develop clearer route information to improve access and encourage the tourist economy. AIG developed a network diagram showing a city center "terminus" area divided into six zones. Stops in the zones are centrally mapped, with route diagrams and timetables at each stop. AIG's network diagram, with associated internet, print and telephone information, pulls it all together.

4

ANIMATION

Figure 4.1 **Still frames from *The Inventors* animations for Children's BBC in Scotland.** © Angie Taylor, 2000.

Synopsis

The term *motion media* covers several disciplines. During my time as a freelancer, I concentrated on animation but also diversified into doing motion graphic design and visual effects work. These three distinct disciplines each require specialist skills, but they also overlap.

The term *animation* is used to describe the process of sequencing drawings, computer-generated artwork, or photographs of models to create the illusion of a moving image. Animation encompasses several categories, including hand-drawn animation, computer-generated animation, and model animation. Each of these can also be broken down into further categories—for example, hand-drawn animation can be divided into cartoon animation and abstract animation. Computer-generated animation can be split into 2D and 3D animation.

Visual effects is the process of applying effects to film, video, or animated footage. Most people think of visual effects in terms of creating amazing 3D creatures, environments, and other CGI elements (computer-generated imagery), but the visual effects umbrella covers several other areas, too. Compositing is the process of combining images and footage together in layers. Keying is the process of removing backgrounds from shots so they can be composited with new ones. Color correction is the process of fixing the color of footage to achieve consistency; it can also be used to apply color treatments to style shots. Within each of these subsets of visual effects it's often necessary to animate values, so animation rules apply here as much as they do in pure animation.

Design Essentials for the Motion Media Artist. DOI: 10.1016/B978-0-240-81181-9.00011-X
© 2011 Angie Taylor. Published by Taylor & Francis. All rights reserved.

143

Motion graphic design is a specialized area of TV, video, film, web, and device content production. Motion graphic designers create moving graphic designs—things like opening title sequences for movies, advertisements, interstitial graphics to run between TV shows, animated logos, and web banners—in fact, anything that incorporates text and moving imagery. A motion graphic designer designs layouts, creates animated sequences, incorporates video, and photography to the mix, and adds visual effects. Therefore, they must have an expansive knowledge that encompasses traditional graphic design skills, animation techniques, and visual effects tricks.

It's important that you learn the rules of animation and how to apply them to your work as a motion graphic designer, animator, or visual effects artist. Time and motion are the two things that set motion graphic design apart from any other type of design. Just as color, composition, and typography combine to convey messages in graphic design, the nature of the movement you create when animating elements can also convey a message to the viewer. Animate something bouncing around on the screen quickly, and you'll create a sense of dynamism and energy (Figure 4.1), or make an object slide or glide to create a more calming or elegant mood.

In this chapter, you'll learn how to understand and control the timing of your animations in order to communicate ideas and feelings to the viewers. You'll also learn how to apply the tried-and-tested rules of animation to your motion graphics projects. This will prepare you for recreating all of the time-based trickery you have seen on the big screen and on music videos, including speed ramps, slow motion, video scrubbing, and time warping.

This book doesn't aim to be a comprehensive manual that covers all of the practical techniques used in animation. The books listed in the bibliography can assist you with this. The focus of this book is to teach you the core principals of animation, making sure you understand their importance before applying them to the work you do.

The History of Animation

It's hard to determine exactly when animation began, but the idea of making still drawings come to life has been developed over centuries. This gradual development really gained momentum during the nineteenth and twentieth centuries. Early moving image technology included the magic lantern, which projected sequences of slides upon which an artist would paint or draw. This magical device relied on a phenomenon known as "persistence of vision," where the human eye looks at an image and remembers it for slightly longer than it's actually visible.

The magic lantern would project these images in quick succession so the human eye was fooled into interpreting it as a single moving image.

In Victorian times, animation-type games like the flip book and the zoetrope were popular. The flip book allowed the player to draw sequential images on the pages of a small book. The pages were then flicked through quickly to trick the eye into seeing the images move. The zoetrope was a more sophisticated version of the flip book. It was a cylindrical drum with regularly spaced slits that one could look through, revealing a moving image (Figure 4.2). This "movie" was, of course, just a sequence of images cycled quickly one after the other. When the drum was spun, it would create the same persistence of vision effect.

Figure 4.2 **A child's zoetrope toy.** The drum is spun as the viewer looks at the images though the slits, creating the illusion of moving images.

Traditional Animation

Traditional stop-frame animation started in the early 1900s. It was created by photographing a series of drawn images that were then transferred to film and played back to give the optical illusion of a moving image. Originally, it was considered

only a novelty for entertaining children and adults until Walt Disney, in the 1930s, developed it into the magical art form it is today. Since then, traditional stop-frame animators have (collectively) developed their skills and techniques over one hundred years. As with most forms of art and design, this has resulted in a well-respected set of rules that should be understood in order to produce successful and compelling animation. We'll be going through these rules in the pages of this chapter to give you a good idea of how to create your own effective animations.

Computer Animation

Computer animation is a much younger art form and has not yet developed as far as traditional animation. The tendency of untrained computer animators is to rely on the computer's immense capabilities to exactly replicate real-world physics. While this is a good practice if you are a visual effects artist, it's not so good for creating convincing animation, since real life isn't quite dynamic enough to really compel the viewer. When Disney created *Snow White* (1937), the animators had a hard time developing the human characters. Like many computer animators of today, they thought that copying real life would be the solution, so they started by tracing film frames. They soon found that the movements were too "real" to be convincing for an animated film. They learned from this that pushing the possibilities of science and nature to extremes would result in more dynamic and appealing animation.

Don't get me wrong. I love what computers are capable of and have an immense amount of admiration for the creators of visual effects, but animation is a different skill with different rules. My philosophy is not to mimic the real world too much and to try to adapt the rules developed over the years by traditional animators. Here are some of the rules and tips for implementing them in your motion graphic designs and animations.

Animation Terms

You can reference this list of commonly used animation terms as you go through the chapter.
- *Stop-frame animation*—Stop-frame animation is also referred to as traditional animation. It involves creating a series of drawings that are played back quickly to give the illusion of a moving image.
- *Cell animation*—Cell animation was so called because it is made up of images drawn or painted onto sheets of clear

celluloid, which can be layered on top of one another and moved independently, making the drawings more flexible so they can be reused in different scenes.

• *Rotoscoping*—Rotoscoping is the process of drawing over individual film or video frames to create a lifelike animation (Figures 4.3 and 4.4). This was originally done by tracing over film frames manually but has been made easier with computer software that can automate a certain amount of the process. However, it's a painstaking and time-consuming process.

Figure 4.3 **Original footage from Dover Book's *Muybridge' Humans in Motion.***

Figure 4.4 **Rotoscoped footage.** You can see this rotoscoped animation on the Animation page of the website *www.motiondesignessentials. com.*

Keyframes

The term keyframe comes from traditional animation. To understand the term, let's look at an example. Imagine Walt Disney wants to create a simple animation of a ball bouncing on the floor. He would make three drawings: the ball at its starting point, the ball as it hits the floor, and the ball at its end point (Figure 4.5). These are all points where major changes occur in the animation—the most important, or "key," moments of the animation—thus the term keyframes. The term is also used in computer animation, where it refers to a point on the timeline where a change occurs in the selected property.

Figure 4.5 Bouncing ball frames. You can see an example of a bouncing ball animation on the Animation page of the website *www. motiondesignessentials.com*.

Tweening

Continuing our story, Walt Disney would then hand these keyframes to his assistant animator, who would then create new drawings to fill in all the frames "in-between" the keyframes. The term *tweening* is used to describe this process, and the name *tweener* to describe the person who carries out the process. In Figure 4.5, the white balls represent the keyframes, and the blue balls would be the tweened frames. Computer software assists in this process by automatically generating frames between the keyframes for you.

Interpolation

Interpolation is the term often used in computer software to describe how change occurs between keyframes—that is, how an object travels from one position to the next. If you observe how things move in the real world, you'll notice that they rarely move at a constant speed but will usually vary their speed as they move. They constantly accelerate, decelerate, and vary in speed. Think of a car pulling out of a driveway: It doesn't just take off at 60 miles per hour but starts off at a slow speed and gradually increases in speed over time.

When you animate objects using software, it's very easy to make something move at a constant speed, but your animations will usually look unnatural if you leave them like this. In traditional animation, changes in speed are achieved by creating

Figure 4.6 **The rough, hand-drawn, tweened drawings of a dog's walk cycle (top) and the final animation where the character was drawn in Illustrator and tweened in Adobe After Effects (bottom).** You can see both walk cycles on the Animation page of the website *www. motiondesignessentials.com*. © Angie Taylor, 2008.

more drawings when the action is slow and less when the action is fast (Figure 4.6). With computer software, you can change the interpolation between keyframes by adjusting speed and velocity settings for keyframes in a graph.

Linear, even speeds are represented by straight lines. In Figure 4.7, you can see the speed represented by curves meaning the object starts moving slowly and then gradually accelerates into action. Changing the keyframe interpolation will determine how quickly or slowly an object builds speed between keyframes. Using preset timings like "eases" or "smooths," you can also soften the transition from one speed to the next to avoid sudden

Figure 4.7 **Example of a speed graph in Adobe After Effects.**

jumps in speed. Your software manual is the best place to look for instructions on how to control speed in your application of choice. Also, see the bibliography.

Velocity

Velocity describes the rate of change of an object's position as it moves. In computer software the velocity setting usually controls how quickly or slowly an object accelerates or decelerates.

Motion Path

A motion path is the path that an object travels along in an animation (Figure 4.8). In computer software these paths are often controlled by the use of Bezier curves. You can learn more about Bezier curves in Chapter 9.

Figure 4.8 A motion path. Here you can see the motion path of a bouncing ball animation in Adobe After Effects.

Animation Types

There are three basic animation types listed below.

Straight-Ahead Animation

Straight-ahead animation is where the animator draws a series of frames in sequence, one after the other, until he or she reaches the end of the animation. This is quite a challenging way to animate because there's no firm plan or schedule in place. But it's the most experimental and creative approach, allowing the animator to make decisions and change ideas as he or she goes. It's nice to allow your animation to evolve as you create it, but can be a risky business, particularly when tight budgets and deadlines are in place. An alternative way that is easier to manage is pose-to-pose animation.

Pose-to-Pose Animation

This is when the lead animator starts by sketching out ideas and then storyboarding the complete animation before any production takes place. Only after everyone on the production team has approved the storyboard are the main poses in the animation drawn. These are the key moments in the animation and are therefore known as the keyframes. The whole story, plus any music, sound effects, or visual effects, is planned well before the animation stage takes place. Once the key drawings are complete, the assistant animator (or tweener) is then given the job to add the in-between drawings afterward. Pose-to-pose animation is probably the most commonly used approach and the one that most of the big animation studios use today. Everything is planned carefully before proceeding with the animation; formulas are followed to reduce risks.

Computer-Generated Animation

Much of the animation you see today is created using computers. Many software applications are available that allow you to animate your designs. These can be separated into three basic categories: compositing and motion graphics applications such as Adobe After Effects or Apple's Motion; 3D applications such as Cinema 4D, 3D Studio Max, or Maya; and web animation packages such as Adobe® Flash or Microsoft® Silverlight applications.

All of these applications use keyframes to mark the key poses in an animation. You just tell the software, "I want this object to start at point A and end at point B," and the software automatically works out all of the steps in-between for you. Unlike a human tweener, the software can't reason, so it doesn't know which path it should take from A to B. Therefore, you must guide the software to determine the steps in-between.

Figure 4.9 A simple task of animating cars driving around a rotary.

In Figure 4.9, I want both cars to drive around the rotary and leave, using opposite exits. If I only set the keyframes at the beginning and end of each car's journey and allow the software to tween this path, the layers would overlap as they cross the center of the screen (Figure 4.10).

In traditional animation, I would draw the car's starting point as my first keyframe and then draw the end point. I would then hand these drawings to my tweener, who would draw the steps in-between. They would of course know how the car should move along the road to get to the exit. When working with computer software, you are the key animator, and the software is your tweener. But the software has no logic; it will animate "as the crow flies"—in a straight line from point A to point B. In Figure 4.10, the cars drive over the roundabout to get from exit to exit instead of staying on the road.

So that's our pose-to-pose animation. Now we have to go in and make adjustments so our car moves along the correct path. This is where I use a combination of the two techniques we looked at earlier, which I call "straight-to-pose animation." Now for the "straight-ahead" part. We've set the extremes, so it's time to go halfway between the extremes to make the adjustments. This is done using Bezier curves to control the path that the cars are moving along. Bezier curves allow you to adjust the path without having to add lots of extra keyframes. When animating with computer software, the fewer keyframes the better if you want to minimize your workload. In Figure 4.11, the cars have been moved out onto the road in-between the beginning and end frames.

Figure 4.10 Notice how the computer crosses the paths as it animates "as the crow flies."

Figure 4.11 The shape of the paths can be changed and adjusted using Bezier curves.

153

The Laws of Physics

Before you can create a convincing animation, you need to understand some basic laws of physics. These laws determine how objects look and move in real life; by mimicking these, you can make your animations more believable. This isn't meant to be a comprehensive physics lesson, but I will try to explain why these concepts are important to a motion graphic artist.

Mass

Mass is the amount of physical matter contained in the object and is determined by a combination of weight, size (or volume), and composition. A cannonball is smaller than a beach ball, but it has more mass because it's made of solid, dense metal. Compare this to a beach ball, which is made from a thin membrane of plastic but largely consists of air. You need to think about the mass of objects when you animate them because it will affect the speed and movement of animated objects.

Gravity

I'm not going to even attempt to explain why gravity works the way it does (if you're really curious, you can Google Newton and find out all about it), but suffice it to say, gravity is a strong force that draws objects toward each other. In terms of animation, gravity is important to consider because it is the force that draws objects toward Earth and so determines how things rise, fall, and move when projected. Gravity also affects the weight of an object (Figure 4.12).

Figure 4.12 **Gravity and directional force.**

Weight

Weight is determined by the mass of the object combined with gravitational force. The moon has about 15 percent of Earth's gravitational force, so objects lifted there will appear to be lighter than if lifted on Earth. If you're animating a character picking up an object, then you need to think about how she would feel with that weight in her hands. When animating text, think about the different ways you can suggest weight. You could make the text appear to be very heavy by making it plummet quickly to the ground and making the screen shudder. Or you could make it seem weightless as if in outer space by making it sway slowly and gracefully around the screen. The opening titles for *Barbarella* (by Arcady and Maurice Binder) feature text animation that dances weightlessly around Barbarella in her spaceship. (You can see this online at the wonderful "The Art of the Title Sequence" website at *www.artofthetitle.com/2009/01/23/ barbarella/*)

Directional Force

Some things in life follow a straight path—for example, a ball dropped from above with no force applied will drop in a straight line. It does this because gravity is the only force being applied to it, and gravity will always pull in one direction: downward, toward the center of Earth. Additional directional forces (or "throw forces") can also be applied to objects that can work with or against gravity, depending on their direction (see Figure 4.12). When you're animating objects that are being projected, think about how hard they are being thrown, since that will affect the way they travel and the shape of the path they follow (also known as the arc).

Arc

If the ball is being thrown from the left, it will be affected by gravity. The result will be the further the ball travels, the nearer it will get to the ground. It is also given an additional force from the person who is throwing. This is known as a left-to-right directional force. When these two forces are combined, this will produce a curved path because the two forces are acting against each other (Figure 4.13).

The shape of the path that the ball follows is also known as an arc. The shape of the arc will depend on how strong the throw force is compared to the gravity force, which, under normal circumstances, remains constant. This is another important consideration to make when animating. Imagine animating a bouncing

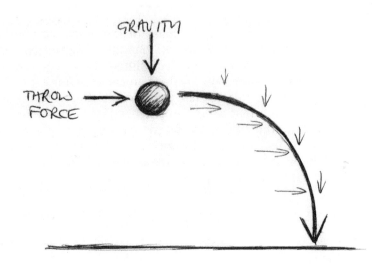

GRAVITY

THROW FORCE

Figure 4.13 The arc is produced by the two forces of gravity and direction working against each other.

ball. You must first consider how hard it's thrown, in what direction it's thrown, and the height it is thrown from. Only after you have considered these factors will you be able to create a believable arc for it to travel along. Then you need to decide how it will bounce. This is not only affected by the weight or mass of the object but also by the damping force of the object it hits when it bounces.

Damping Force

When a ball bounces, the object that it bounces against (e.g., the ground) will absorb some of the energy from the ball, and the result is that its bounce will be dampened (lessened, if you like) each time it comes into contact with the ground. In other words, the arc will get gradually smaller each time the ball bounces. The softer the object that it bounces against, the higher the damping force. This means that it will come to a halt quicker after landing on a soft surface than on a hard surface. As an animator you have to try to imagine how the subject of your animation is going to react, depending on how it's affected by its surroundings. A basketball being bounced onto a wooden basketball court (which is fairly hard) will bounce a great deal because the floor will have a fairly low damping force. However, a football bounced on soft grass will bounce less because a higher damping force kind of "soaks up" the bounce.

Acceleration and Deceleration

In the real world, objects accelerate as they fall and decelerate as they rise. This is due to the force of gravity acting on the mass of the object. The amount of acceleration or deceleration depends on the weight of the object and the direction it is moving in. If it's working along with gravitational force, it will accelerate more quickly. If it's working against gravitational force, it will accelerate more slowly. Gravity will have more of an effect when working against a beach ball bouncing upward than a heavier basketball because the lighter ball offers less resistance. If the balls are moving along with the direction of gravitational force, the heavier ball will move more quickly. When animating, you can suggest a heavier weight by making an object take longer to come to a halt after moving or by making it take longer to accelerate. Light creatures like birds take off very quickly, whereas heavier creatures, like elephants, take time to accelerate into action.

Resistance

Resistance is a general term for any force that acts against the movement of an object or force. Resistance can be provided by gravity, directional force, wind, water, or the surface of another object. Imagine you're animating a character walking in a rainstorm. The wind resistance would perhaps make him walk at an angle, leaning into the storm. Or perhaps you want to animate some text to look as though it's traveling through sludge. Then you would make the text or character look as though it's having to work harder to create the feeling of resistance. If you want to learn more about the physics of animation, you can refer to the resource list on this book's website at *www.motiondesignessentials.com*, or you can reference the bibliography.

The Rules of Animation

Once you understand these basic physics principles, you can apply them to the rules of animation that have been developed over the years by animators. Some of these rules are based on real-life physics, and others on observations and reactions. They provide a set of invaluable "tricks" for animators that have been proven to work in almost every situation. In this section, I use examples of character animation to explain the rules and how they can be applied, but remember that these same principles can be applied to motion graphic design just as effectively.

Timing

Timing is not exactly a rule, but it is the most important aspect of animation. It sets animation apart from other drawn art forms. So much of animation is about timing. Messages or feelings that cannot be portrayed by a still picture can be more easily communicated with the addition of timing. One classic example of timing that you see not only in film but also in real life is a dramatic pause. Think of when somebody whispers a secret to a friend. There's a moment, just before they spill the beans, when they hesitate, looking around to make sure no one's listening. This moment makes the anticipation of the secret greater. Exaggerating a dramatic pause can make an event in your animation funnier, more poignant, or more intense. This is only one example of how timing can make a difference. Several others are discussed in the following paragraphs. Think about timing as you implement these rules in your animations.

Squash and Stretch

One of the most important rules of animation is the squash and stretch rule. For an object to look convincing, it must "give" when external forces are applied to it. These forces include gravity, directional force, and the mass of the object, as well as other surfaces it comes into contact with. Let's go back to the example of the bouncing ball. As the ball hits the ground, two forces collide. Gravitational force and the mass of the object come to blows with the surface of the ground, and this will cause the ball to squash. Obviously a softer ball (for example, a beach ball) will squash and stretch a lot, whereas a cannonball will hardly squash and stretch at all. But perhaps what you didn't know is that the ball will also stretch slightly as it falls and rises. Stretching is kind of like the reflex action that comes before and after squashing. To see this in real life, just think of a rabbit jumping along the ground: As it hits the ground, it squashes down, and as it jumps again, it stretches along the arc (Figure 4.14).

Going back to our bouncing ball example, the only time the ball should look perfectly round is at the top of each arc, where resistance is at its lowest. You can use squash and stretch techniques to convey an object's density and mass. Often, exaggerating squash and stretch can add to the comedy value of your animations. As I mentioned before, Walt Disney discovered that exaggerating these real-life physical reactions made for much more effective animations. That takes me nicely to the next important rule of animation: exaggeration.

Figure 4.14 Notice that the rabbit squashes as it lands on the ground and stretches as it jumps through the air.

Exaggeration

Another important animation rule is the rule of exaggeration. Exaggeration is literally a method of emphasizing something to increase its significance or draw attention to it. Exaggeration in animation terms is used to emphasize whatever key idea or feeling you wish to portray. For example, imagine you create a character who is smoking a cigarette while dancing. You should exaggerate the action that is most relevant to the scene. If the animation's purpose is to illustrate the joys of dancing (perhaps the cigarette is simply there as a tool to suggest the character is in a bar somewhere), the dancing should be exaggerated. If, however, you want to focus on the fact that the character is smoking (perhaps it's an antismoking ad), you would make him smoke in a very ostentatious way, with his feet making tiny little dancing movements (Figure 4.15). By exaggerating certain elements, you can guide the viewers' eyes and give them the exact message that you wish to give.

Using our bouncing ball example again, if we squashed the ball by the correct amount, the animation would probably look a little weak. You would hardly be able to see the squash at all because it would be too slight and would happen too quickly. By exaggerating the amount of squash and stretch and exaggerating the pause when it touches the ground, it will make the animation more dynamic. Good use of exaggeration can make an animation come to life, as long as it is done in a balanced way. To make it really work, choose the most important element of the scene, and apply exaggeration only to that. Think carefully about

Figure 4.15 What features should be exaggerated in your animations? The man on the left is drawn from a low angle, making his feet more dominant. His smoking hand recedes into the distance, making it appear less important. The man on the right is drawn from above. The smoking is much more noticeable because it is closer to the viewer. His feet are further from the viewer, so they are less prominent.

the different elements that can have exaggeration applied to them: movement, facial expressions, squash and stretch, bounce, timing, and facial expressions. By exaggerating one of these elements, you can draw the viewer's attention and make sure that nothing is missed.

Staging

Setting the scene (or staging the animation) involves attracting the viewer's attention and focusing it on a particular subject or area of the screen before the action takes place. You must remember that the viewers do not have the luxury of knowing what is about to happen in your animation, so if something moves very quickly, they may not have time enough to realize what is going on (if they blink, they'll miss it!). This is why it is necessary to set the scene for them. It can also set up a mood or feeling that you want the viewer to understand before the main action takes place. Examples of this would be having the subject move suddenly to attract attention, coloring or lighting your subject in such a way that it stands out from the rest of the scene, or using music or sound effects to capture attention.

Anticipation

Anticipation can also be used to direct the viewer's attention to part of the screen, and it is often intermingled with staging. However, there are differences that make it a rule unto itself. Some anticipation occurs naturally. For example, imagine a mouse is about to hit a cat over the head with a mallet. The mouse has to physically pull the mallet back before plunging it down; the pulling back of the mallet is the anticipation moment. By exaggerating this moment, you can let the viewer know what is about to happen in the scene before it happens. There are other anticipation tricks that do not always happen in nature but are useful in animation. For example, in the old Road Runner cartoons, when the coyote falls off the cliff, he hangs in the air for a second or two before plummeting to the ground. Without the dramatic pause, the viewer would not have time to register the coyote's very fast fall to earth. These pauses are rare moments of stillness in animation, and they can be used to make an action really stand out (Figure 4.16).

Figure 4.16 The character's face tells us that something terrifying is about to happen © Angie Taylor 1999.

Motivation

Motivation is also somewhat linked to staging and anticipation. It occurs when one action clearly shows that another action is about to take place. Imagine that you are animating a car speeding off from a crime scene. When the car motor starts, the engine makes the car shudder. You can exaggerate this movement to let the viewer know that the car is ready to explode into action and zoom off the screen.

Secondary Action

A secondary action is any type of action that results from the main action (Figure 4.17). Examples of this could include your character's tummy wobbling after he has jumped from a great height or an exaggerated facial expression of agony after Tom has been hit on the toe by Jerry. Like anticipation, secondary

Figure 4.17 The character's face reacts after the telephone gives him an electric shock. Secondary actions reinforce the main action © Angie Taylor 1999.

actions can also be used to help to strengthen the idea or feeling you are trying to portray. One thing to avoid is making the secondary action more prominent than the main action, since it can then distract the viewer and detract from your intended message.

Overlap

Overlap is when one action overlaps another. It's very important to apply this rule to make your animations flow nicely and have a natural rhythm. If we look at nature again, very seldom does one action finish completely before another starts. Imagine you are sitting at the breakfast table; you take a bite of your toast and then have a sip of your tea. You may still be putting the toast back down on your plate with one hand while putting the cup of tea to your lips with the other. These are overlapping actions. If you are new to animation, it may seem natural for you to animate actions in sequence, one after the other. You should avoid doing this because it can make your animations look rigid and unnatural if you don't overlap the actions. This will take some practice, but a good tip is to animate the actions individually first and then try overlapping them by adjusting groups of keyframes along the timeline. With this technique, you don't have to get the timing right the first time.

Follow-Through

Follow-through is, again, something that occurs in nature but is often exaggerated in animation. Think of a golfer taking a

swing at a ball. The golf club doesn't stop suddenly when it comes into contact with the ball; it follows through the same path and then gradually settles back down to a halt. You'll also see follow-through when you observe a cat flicking its tail. After the cat has flicked the base of its tail, a wave of action will follow through to the tip of its tail once the base of its tail has stopped moving. This wave action can be observed everywhere you look in nature. Think of the way fish flip their tails and bodies to swim. People show this kind of wave action in their movement, as well, although not always as elegantly as a cat or fish! The human body also sways as it steps from foot to foot when walking. When you are using natural elements like water, plants, people, and animals in your animations, you should try your best to create fluid waves of movement.

Balance

Balance is crucial for an animation to be truly convincing. You must draw your characters in poses that look real and sustainable (Figure 4.18). You can do this by drawing a center line through your character and making sure that you have equal mass on either side of the line. Balance will change according to the weight or mass of an object; heavy objects will generally take longer to pick up speed. They will also take longer to stop moving than light objects because more resistance is needed to balance their heavier weight.

Figure 4.18 The man on the left is standing upright, making him easy to draw. But if your character leans to one side, you need to make sure that his body adjusts to create balance. Notice that he has moved the barbells more to his right to compensate for his leaning to the left. He is also sticking his leg out to compensate. Think about balance not only with human characters but also with text or other objects in your animations © Angie Taylor 2008.

Rhythm

A good understanding of rhythm will help you to work out the timing of your animations. If music is provided as part of the project, you can use this to define the rhythm of the piece. If the project doesn't require music, I often use a soundtrack to help time my animations and then delete it once the animation is completed. Choose a piece of music that conveys the mood you want to convey. You'll be amazed at how the rhythm of the music improves the feel of the whole animation.

Camera Movement

Camera movement can lend filmic conventions to your animation. (These are explored in more depth in Chapters 3 and 7.) Interesting camera angles and animated camera movement can help to represent the point of view of a character. It can add dynamism to an otherwise static scene and can give the viewer a sense of being more involved in the piece.

Applying the Rules

To apply these rules to your own work, you need to be conscious and aware of them at all times. If it helps, use the recap section at the end of this chapter as a checklist to remind yourself of the golden rules as you're animating. Before I explain how to apply these rules of animation to your own work, let me share some of my own techniques with you.

My Animation Process

Although I am a big fan of using software to do as much of the hard work as possible, I still find that I like to get a break from it whenever possible. So I tend to start my projects the good old-fashioned way—with a pencil and paper. I draw all of the main poses of the animation on paper using a nonphoto blue pencil (see Chapter 2 for more details about this). I know a lot of the character poses and movements like the back of my hand by now from life drawing, studying nature, and learning from trial and error, so I have a good back-catalog of inspiration and knowledge that I can call on. However, when I started out, I used references like Muybridge or other examples of animation to get the movements right.

Eadweard Muybridge was a British photographer based in San Francisco, California, where he photographed landscapes. He was hired to settle a bet made by a wealthy businessman on whether all four of a horse's hooves were ever off the ground

simultaneously during a gallop. In order to determine this, Muybridge developed a system of cameras that would allow him to take pictures at fractions of seconds apart. This was before the days of video cameras, so the only way to do it was to use still cameras, spaced apart so they could take pictures at regular intervals while the horse was galloping. He proved that in fact the horse's feet do all leave the ground at the same time (Figure 4.19), and, more important, in the process he stumbled upon the first examples of moving pictures that would eventually develop into film.

Figure 4.19 Muybridge's early images of a horse galloping.

Muybridge continued his studies to include other animals, including human beings, and in doing so, he created a vast and valuable resource of movement reference that is freely available for others to use in their work. These can be found online on the Creative Commons website at *www.creativecommons.org* and searching for Muybridge. Creative Commons is a fantastic resource for artists, animators, and designers. It's a nonprofit corporation dedicated to making it easier for people to share images, consistent with the rules of copyright. It provides free licenses and legal tools required to mark creative work with the freedom the creator wants it to carry, so others can share, remix, or even use commercially. I created the animation in Figure 4.4, using Muybridge as a guide.

I don't see a problem with using these references to help guide you in the beginning, but once you learn how they work, you'll begin to add your own style to the movements, just in the same way you progress with the more aesthetic areas of your work. You start by recreating other things you've seen and then through this process you develop and discover your own techniques, adding style to the content of your designs.

Here's my own personal process for creating animation from my rough sketches.

Once I have roughed out the initial keyframe drawings. I finish off the lines with a pen or dark pencil before scanning them into Photoshop, where I use hue, lightness, and saturation adjustment layers to remove any nonphoto blue from my drawings.

I use a combination of levels, curves, and the paintbrush tool in overlay mode to clean up the drawings. I use layer masks to create transparency where needed because I like to work as nondestructively as possible in case later changes are required.

I also use the Clone tool and Healing Brush tool a lot to fill in areas missed by my drawings. I then separate the drawing into layers and import them into After Effects, where I animate them using various techniques, including the fabulous Puppet tool and Expressions.

As I'm animating in After Effects, I'm constantly reminding myself of the rules of animation, making sure to apply them in my work. You will get to a stage where they become instinctive, just as all of the other rules and principles will once you've practiced them enough (Figure 4.20).

Figure 4.20 One of the characters I designed for the children's BBC series *See You, See Me—The Inventors— John Logie Baird, the Scottish inventor of the television.* This was drawn in Illustrator, with each body part on a separate layer, ready to be animated in Adobe After Effects. You can see this animation on the Animation page of this book's website at *www.motion designessentials.com*.

There are lots of other ways to improve your animation skills that simply can't be learned by reading pages from a book (not even this one!). They involve getting out there and observing the life around you. My advice, above everything else, is to get out there and notice how things move and react with their surroundings. Watch people and how they interact with one another. Study animals and their individual traits. Life drawing classes are also a very good way of studying form and structure (Figure 4.21), which will help you work out things like balance. Your local art college will have evening classes you can enroll in. I thoroughly recommend attending an art class.

Text Animation

Most of the examples we've used so far involve the animation of characters and objects, but all of these rules can also be applied to motion graphic design. Think about applying some of these rules to the next text-based project you work on, and see if they can improve the results.

Figure 4.21 **Life drawing with pen and wash—sketchbook.** © Angie Taylor, 1984.

A good practice exercise is to use an application like Adobe After Effects to animate some ordinary text. If you can use animation to convincingly bring life to an inanimate object, then you know you're doing a good job. Keep the font quite plain and the rendering of the text simple and flat so the only way you can add character or messaging is through the animation. Choose a word that describes an action or person, and animate it to match the characteristics. Remember to think about weight, balance, rhythm, overlapping actions, and secondary actions before animating, and make sure to add plenty of dramatic pause and exaggeration to the actions. You can see an example where I've taken the word "Zoom" and animated it as if it is a car being driven off the screen at *www.motiondesignessentials.com*. Follow the link to Resources.

Two movies appear. Play the first one to see the text simply animating from the start position, offscreen to the right. Notice that you don't really have time to notice what's happening before the text disappears offscreen. Then play the second example. Here, I've added a few rules of animation to bring the animation to life. First, I added motivation in the form of a little positional "shudder" to suggest the engine starting. This is designed to make sure I have the viewer's attention where

I want it before the animation takes place. I then use anticipation (which is, of course, exaggerated). The text pulls back in the opposite direction from where it is aiming and holds for a little while, allowing the viewer to anticipate the motion about to take place. Finally, the text zooms off screen to the right. I exaggerated a skew on the letters to suggest speed and resistance and finished off by adding a puff of smoke as a follow-through action. Last, I added the all-important sound effects to the mix to really bring it to life.

Sound Effects

In order to make your animations truly convincing, you'll need to add sound effects to them. If you're lucky enough to be working on a relatively big production, then there is likely to be a sound designer working alongside you who will collaborate with you, helping to find the right noises, music, and other effects. However, with the convergence of media and the rising expectations being placed upon designers to be able to "do a bit of everything," it's likely that you'll encounter a situation where you are expected to do this job yourself. If this is the case, I'd thoroughly recommend that you take an evening class in sound design or sound engineering so you can learn how to work with audio alongside the experts.

I attended a course in music technology when I was working as a deejay that taught me all about sound mixing and prepared me for being able to provide acceptable soundtracks for my animations. Software companies will tell you, "Buy this software, and you can mix audio like a real sound designer!" That's true—you can, but you need to know what you're aiming for first. You can't just buy sound mixing software and expect to be able to mix sound properly, just in the same way that you wouldn't expect somebody to buy Adobe Illustrator and immediately have the ability to draw wonderful illustrations. Even though I have attended courses and can get by, it's still not my specialist area, and I would always prefer to work with a professional sound designer. That way, I know he or she will add expertise to the production that will step it up from being a good animation to a great animation.

If you are working with music that has been supplied to you or that you've chosen yourself, try to listen for the most distinctive features of the music. It will create good impact if you can time the visuals to coincide with the appropriate parts of the music. As a designer you must learn to suggest things to the viewers without them actually seeing them. One of the most inspiring projects I worked on was Aphex Twin's infamous *Rubber Johnny* video. I worked alongside director Chris Cunningham (*www.director-file.*

com/cunningham) for a year on that project (it was a six-minute music video). I learned a lot by watching Chris at work.

What amazes me about Chris's music videos is that you always feel that the music has been made to go along with the video rather than the other way around. I think this is because he finds a way of matching every single beat or accent of the music to a visual event, and the results are mind-blowing. He is a very demanding director to work with because he expects perfection and will often rework scenes hundreds of times before they are accepted. I'd recommend studying his work to get an idea of how important the links between audio and visuals are in your animations. I'll warn you, though: The content of his videos is considered in bad taste to some (I prefer to call it groundbreaking), so please don't watch them if you are squeamish or are easily offended. Another music video artist whose work is worth watching is Michell Gondry (*www.michelgondry.com*), who also has a knack for matching music to imaginative and innovative visuals.

Panning and Zooming

A fairly common job that you may be asked to do as a motion graphic designer is to create moving footage by animating around a still image. This is "bread-and-butter" work for designers for many reasons. First of all, some subjects can't be filmed or no footage exists, like historical events and characters that existed before the invention of film. Footage can be expensive to obtain, so it can be much cheaper to buy a still image instead. Panning around the image makes for more interesting moving footage than a static image. Traditionally, this kind of work would have been done using a rostrum camera (Figure 4.22). The image would be placed under the camera, mounted on a frame, and then the camera would either be moved closer to or further from the image to pan in and out (or the zoom lens would be used to zoom in and out). The camera could also be moved left, right, up, or down to pan around the image.

These days, computers are used to do the same job, and After Effects is ideal for this type of work. There are a few tips and tricks you should

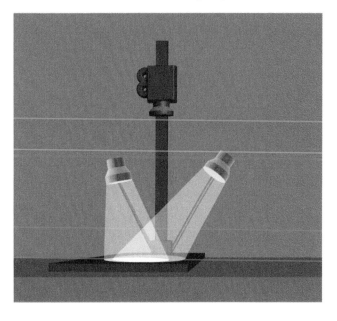

Figure 4.22 **A rostrum camera.** Notice that the camera is on a track so it can be moved up and down or set at an angle. The lights illuminate the artwork. © Angie Taylor, 2010.

be aware of before attempting this yourself. It's not as straight-forward as it first seems. You would naturally assume that the best way to do it would be to animate the scale property to zoom in and out and then the position property to pan around the image. Anyone who has tried this technique will most probably have found it quite awkward. My tip is to animate the Anchor Point property to move around the image. This way you can animate in the Layer panel, where you can have a view of the whole layer, not just the portion that appears within the confines of the composition (Figure 4.23). You also get access to the full motion path within the Layer panel, which makes it easy to tweak and reshape the motion path. Once you have created the movement you like, you can then add 3D lights and cameras to the composition so you can zoom in and out and add finishing touches like depth of field, shadows, and motion blur.

Figure 4.23 Zooming and panning can be controlled in the Layer panel in Adobe After Effects. You can see this animation on the Animation page of this book's website at *www.motiondesignessentials. com.*

Time Remapping

Some of my favorite effects are time-based effects on video footage. These include speed ramps, slow-motion effects, and video scrubbing (like a deejay scratching vinyl but with the video moving back and forth instead of just the audio). Adobe After Effects and Apple Final Cut Pro both have a feature known as Time Remapping that has to be one of my favorite features. You can use it in so many great ways. In After Effects, enabling Time Remapping on a layer reveals Time Remapping as an extra, animatable property in the Timeline (Figure 4.24). Time Remapping allows you to vary the speed of your footage and animate the speed changes over time. You can stretch the timing of your layer backward or forward at any speed you desire (real-time, slow-motion, or ultra-fast). You can also use it as a quick and easy way to create freeze-frames.

Figure 4.24 **Time Remapping in After Effects.**

Recap

So you can see that the rules of animation are important, not just for traditional character animation but also when applied to motion graphic design. You can apply the rules when creating time-based effects in very effective ways: retiming edits or simply by adjusting the timing at which events appear to happen.

In this chapter we started by looking at a short history of animation to give us an idea of the origins of traditional animation and how that developed into the world of computer-generated animation that exists today. We examined some common animation terms that you're likely to hear used in the motion graphics industry, and then we discussed the two main animation types: straight-ahead animation and pose-to-pose animation.

We bravely ventured into the world of physics to get an understanding of how things behave in the natural world. We then looked at how the rules of animation bend these laws of physics ever so slightly in the name of entertainment. These included squash and stretch, exaggeration, staging, anticipation, motivation, secondary action, overlap, follow-through, balance, and rhythm. Finally, we looked at how we can apply these rules to our work, and I provided you with some ideas for exercises that you can use to practice everything you've learned.

Take a break from the book for at least half an hour to clear your mind and to give your eyes a rest. Have a little contemplation about whether you can incorporate any of these ideas into any of your current projects. Write down any ideas you may have, and sketch any visual ideas. When you return from your break, start to experiment with your ideas to see if they'll work.

Now it's time for a few words from an animator whose work I admire hugely: Madeleine Duba. She was kind enough to contribute some examples of her work and an insight into her own creative processes.

Figure 4.25 Madeleine Duba.

Inspiration: Madeleine Duba, Animator

Madeleine Duba is an animation film director and writer who works in illustration, animation, and live action (Figure 4.25). She was born in Switzerland and earned a BA in visual communication (animation, graphics, illustration, and video) at the University of Applied Art in Lucerne, Switzerland, and an MA in communication art and design (animation, illustration, and film) at the Royal College of Art in London. Her creative pool is called DubAnimation, and it provides a complete visualizing svervice: storyboards, animation mixed with live action, documentary-style filming, compositing, editing, and post—in other words, from idea to output! Commercially Madeleine collaborates with international production companies for advertising, film, and children's content and music videos, as well as with international book publishers and distributors. You can see examples of Madeleine's work at *www. dubanimation.com.*

"My father has been an experienced director for many years, and he has influenced me since childhood. When I was six years old, we sometimes used to visit a sound studio together. When I was 10 years old, he was animating for industrial films. I used to help him to click the stop frame button on a 16 mm camera, and I remember that I felt very proud to do that.

"I vaguely remember that I tended to observe the environment with a certain curiosity while my father was working on a film synchronization. I found the atmosphere very interesting and cozy, partly because the light was slightly dimmed and the acoustics were somehow different.

"My favorite subject at school was always visual art and music. There I could reflect my feelings. In my free time, I used to draw and play on the piano. This lead me naturally to make the art college, first a BA in Switzerland and then a masters at the Royal College of Art in London. There I had space to explore. At the art college in Lucerne, Switzerland, I rediscovered animation. First focusing on illustration, it was a great joy when I discovered how to make images move, feeling a certain magic in the process. Until this day, I feel moving image is an endless field to explore, and I hope to continue.

"My hobby is music and dance. It is a nice balance to my work. It is great to use different senses than my eyes. I enjoy playing piano, and if I have time, I love to go to live concerts, listen to music, etc. It inspires me and lets my thoughts flow. Dancing is a good exercise and much more fun than the gym. There, I can study and feel the body movements, which I can then put later into my animation work!

"I still draw regularly. I have my sketchbook always around. However, it is filled with lots of written ideas as well as drawings. I always develop content/ideas for my films as much as visuals. I believe that visuals are pointless without a subtle storyline (this can be as much experimental as literal).

"Sometimes being creative can be a struggle. The journey from the first idea to an inventive story structure needs a lot of patience and research. The way through those thoughts can take sometimes as long as the actual visual production time.

"Studying Illustration beforehand, I've been influenced by surreal and experimental work with lots of humor. Later I started to use this style in films. Eadweard Muybridge's experiments of the movement helped me a lot to understand the animation. Jirí Trnka, head of the Trick Brothers Puppet Animation in Prague (Czech Republic), amazed me throughout his work.

"I do like to look at paintings of a hugh variety of artists. They inspire me for my moodboards, and they influence me to develop different illustration styles, colors, and decor for my story content (Figure 4.26).

Figure 4.26 Water. © Madeleine Duba, 2001.

"Jan Svankmajer's surrealistic view of storytelling also slipped into my work (Figure 4.27) from 'direct-cinema' and 'cinéma vérité.' By watching the films of Jean-Luc Godard, François Truffaut, and even Milos Forman's early work, where he shot episodic stories on locations with nonprofessional performers and improvised scripts, I developed the idea of a cinéma-vérité documentary (Man United/Ladies Choice, Documentary 2001).

Figure 4.27 *Living in a Box,* puppet animation. © Madeleine Duba, 1998.

"Later, a short fiction called *Mirror* (2003) (Figure 4.28) developed with a very raw script. It is a surreal suspense story with a philosophical content of the *Psychoanalysis of the Real.* Buñuel, Hitchcock, and even David Lynch have certainly left an impression, which can be seen in my work.

"I was always amazed by slapstick humor, which I learned definitely in the Czech Republic with Jirí Slíva's and Slitr's stage comedies, in Switzerland Emil Steinberger in *Schweizermacher,*

Figure 4.28 Mirror. © Madeleine Duba, 2003.

Figure 4.29 *Love
Notes.* Winner of the Maple
Leaf Award 2008 at the Canada
International Film Festival.
© Madeleine Duba, 2009.

in England with *Fawlty Towers, Monty Python*, and *Only Fools
and Horses*, not to forget the French Jacques Tati films and many,
many more. I like those stories because they are all brilliant
observations of our society. This humorously ironic film called
Love Notes (Figure 4.29) is about the difference between men and
women and how come they can actually function together, since
their thoughts about daily life can be so reverse.

"I would always like to learn more about technical issues to
be able to combine it with my creative ideas. Seeing new films
containing more and more super professional animation special
effects, I find this very impressive. However, this to combine with
my creative vision is my ambition. *Skiving* is a reflective look at
the '80s through Robbie Williams's eyes (Figures 4.30 and 4.31).
Based on his track from the album *Rudebox*, we journey through
his formative years in a decade where consumerism and the

Figure 4.30 **Robbie Williams,
Skiving—the 80s, 2008.**
© Madeleine Duba, 2008.

Figure 4.31 Robbie Williams,
Skiving—the '80s, **2008.**
© Madeleine Duba, 2008.

rave generation were born. It is a lighthearted look at the dragons that have to be slain, young love that is fumbled and lost, and the demons that remain to be fought for the rest of our lives. Tom Eden takes on the role with aplomb, and when the bombs are dropped on the Falklands in the final act, we are left to count the casualties."

5

TYPE

Synopsis

In this chapter we discuss the importance of text in your designs. We'll explore the nature of typography and the anatomy of type, thinking about the impact of typography on the visual language of your designs. This will extend your ability to express ideas through the visual presentation of words. You'll learn how to modify existing typefaces to personalize them and achieve a more handcrafted look (Figure 5.1). Finally, we'll cover some important considerations that you need to keep in mind when designing text for the screen.

Figure 5.1 *Shock.* Reproduced by permission of Stefano Buffoni. © Stefano Buffoni, 2009.

Inspiration

When I was a teenager growing up in Scotland, I was very influenced by the Punk Rock movement that happened in the late seventies in the United Kingdom. I loved the cut-and-paste, do-it-yourself attitude that was adopted by the designers associated with the period. Some of the top designers of today started during that time, including Malcolm Garrett, Neville Brody, and Jamie Reid (Figure 5.2). It was a time when every young person had the chance to make it as a designer, musician, or artist. Before the punk revolution, it was very hard to get into these industries. They had become tired, elitist establishments.

Sadly, I think we have come full circle, and the industries that were once groundbreaking have sunk back into predictability and conformity. I had hoped the internet would revolutionize

Figure 5.2 *God Save the Queen 1977.* Newsprint collage on paper, 420 mm × 297 mm. Image courtesy of the artist, © Jamie Reid, and the Isis Gallery, London.

Figure 5.3 **Mohawk screenprint.** © Angie Taylor, 1980.

design in a similar way to the punk movement. It did look that way for a while, but things are becoming pretty stale again now. We are constantly bombarded with media via the internet, radio, and television. It even follows us around on our cell phones and iPods. But as media has exploded to such a vast scale, it has become more and more difficult to stand out and make a difference. One way you can make your designs stand out from the rest is by designing your own lettering. This will make your designs stand out head and shoulders above the ones that rely on standard computer fonts.

Computer fonts are very easy to use and abuse, but easy does not always mean good in terms of design. William Morris once said, "The thing that I understand about real art is the expression by man of his pleasure in labor." I can totally relate to this sentiment. I believe we get the most from our chosen art form, and we produce the best work when we lose ourselves in the craft of what we are doing. Believe it or not, manually designing typefaces and letterforms could be just what you need to inspire you with a love for typography.

Going back to my years as a teenager in Aberdeen, I could not afford to buy posters or records of my favorite musicians, so I used to create my own. In my bedroom I would faithfully copy the letterforms and logos used by the bands to create my own posters (Figure 5.3). I lost myself in this process, and as a result, I found a real love for hand-drawing text. This is one of the things I hope to pass onto you here.

What Is Typography?

Typography is the term used to describe a specialist area of design concerned with type. Working with type is an essential part of being a motion graphic designer, and it can be demanding, creatively rewarding, and immensely enjoyable. Typography is the art of selecting typefaces, sizes, colors and textures, type elements on pages or screens, spacing, and alignment of words and letters. As with every other aspect of design, there are rules associated with typography, and it's your choice whether to apply these rules or break them. Either way, you'll become a better designer by gaining an understanding of them.

The type in your designs should be considered as important as any other visual content and should complement every other ingredient. The presentation of the type elements should be in keeping with the visual language you create and, in most cases, should work with the messages contained in the words and images. It's also important that you understand the culture

and history you are creating for and find out if there are any special requirements before making aesthetic choices.

The Origins of Type

The development of movable metal type by Johannes Gutenberg in Germany in the middle of the fifteenth century shifted the reproduction of text from handwritten manuscripts to a mechanized printing process. This revolutionized access to written materials. Books were now printed, bound, and distributed, spreading information, knowledge, and ideas as never before. The impact of this development on culture was probably greater than the digital revolution that occurred in the late twentieth century. It also marked the beginning of the discipline known as typography. Type was now designed and created specifically for duplication. This meant that letters could be assembled in any order to form any word in a wide range of faces, sizes, and weights.

Much of the way we think about typography, and a good deal of the terminology we still use today, comes from traditional printing terminology created during this period. Letters were created on separate blocks and stacked together for printing; this dictated the characteristics of type design for about five hundred years. Long-standing conventions developed as a result of these constraints, and habits are still in evidence today. Even now, when we measure type sizes in points (10, 12, 14, etc.), we are not actually measuring the letters themselves but rather the "body," which is a combination of the letter and any space around it. In printing press terms, *body* meant the size of the brick that the metal letter would need to be carried on (Figure 5.4). The typographic processes involve many terms that you should understand as you go through this chapter. You can use the list of key terms in the "Terminology" sidebar as your one-stop typography reference.

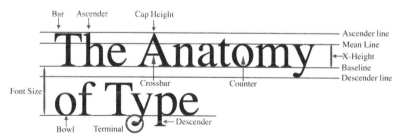

Figure 5.4 **Some of the most commonly used typographic terminology.**

Terminology

Typographic terms are often confused. Before we proceed, it's important that we understand the subtle differences between the terms used to describe the different components of type. The terms *font* and *typeface* can be confused and are often used interchangeably, when in fact they describe subtly different things.

- *Font:* A font is a styled collection consisting of the full alphabet, all numbers, and various other characters such as punctuation marks and symbols. Helvetica Regular and Helvetica Bold are both fonts.
- *Typeface:* A typeface is a collection of fonts. For example, the Helvetica typeface includes the fonts Helvetica Regular, Helvetica Bold, Helvetica Condensed, and Helvetica Italic. A typeface is sometimes referred to as a font family or font face. Basically, each of these terms describes a set of designed fonts that share common characteristics.

The terms *letter, glyph,* and *character* are often used interchangeably to describe the individual characters that make up a font. Again, there are subtle but important differences among these terms:

- *Character:* A character is a single unit that can represent a letter, but could also represent a number, or other symbol in a font—for example, the letter "i", the ampersand symbol, or the number "2."
- *Glyph:* A character consists of one or more glyphs. The term *glyph* refers to a graphical shape that can be part of a character (such as the dot on a lowercase letter "i"); a glyph can also refer to a shape made from a combination of characters (such as the fi ligature; see the section in this chapter on ligatures) (Figure 5.5).

Figure 5.5 A glyph can be a letter, a shape that forms part of a letter, or a combination of letters formed as one single shape.

- *Ascender:* An ascender is the "up" stroke of the lowercase character that rises above the x-height, as in the letters d, h, and k.
- *Descender:* A descender is the "down" stroke of the lowercase character that drops below the baseline, as in the letters g, y, and p.
- *X-height:* This is the height of the main body of the letter (without the ascenders or descenders).
- *Cap-height:* The cap-height is the height of an uppercase character (see Figure 5.4).
- *Baseline:* The line on which characters sit is known as the baseline. Most software applications provide you with a Baseline Shift property, which allows you to move the selected letter or the letters above or below the baseline.
- *Mean line:* The Mean line is the top line in the Figure 5.4. It marks the x-height of the characters.

- *Font size:* Font size or body size refers to the size of the font. This does not refer to the measurement between the top edge of the character and the bottom edge. It refers to the measurement of distance between the baseline of the letters from one line to the next (with no extra line spacing applied).
- *Point size:* Points are the units of measurement used to measure type.
- *Crossbar:* A crossbar is a horizontal stroke across a letter that joins two sides (as in A and H, or across the central stroke, as in f).
- *Bowl:* This is the rounded form that makes up the body shape of letters like e and o, and the main body of the d (without its ascender).
- *Counter:* A counter is a term used to describe the space created by a bowl. This can be fully enclosed as in the letters o or d. Or it can be partially enclosed as in the letters c and e.
- *Terminal:* A terminal is a curve in a character, usually at the end of an ascender or descender.
- *Stress:* Stress is the change in thickness of a stroke as it develops from a thin stroke into a thicker one, or vice versa. The stress of a character can be angled, horizontal, or vertical (Figure 5.6).

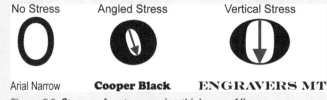

Figure 5.6 Stress refers to a varying thickness of line.

Fonts

The more established and well-designed fonts also include special characters such as ornamental characters, fractions, and ligatures. Be aware that some of the freely downloadable fonts are not complete, which is often why they are freely available. I've seen designers choose a font for a client only to discover that when they need to create new designs, the necessary symbols are not included. If you are using a particular font for a project, make sure that all of the letters and symbols you may ever need are available. To ensure that you are purchasing quality fonts containing all of the characters and special characters, use a reputable font shop like Linotype (*www.linotype.com*) or Adobe® (*www. adobe.com/type/*) (Figure 5.7). These companies allow you to preview the fonts and view all of the characters before you part with your cash.

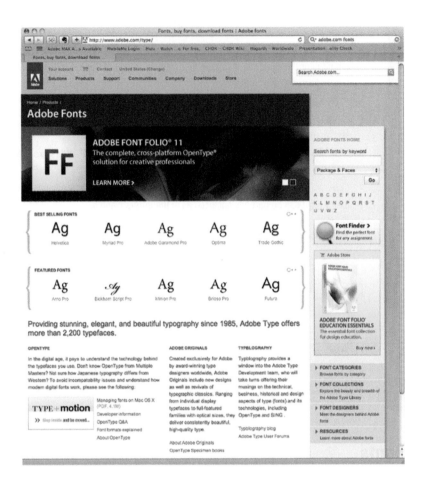

Figure 5.7 You can buy fonts from the Adobe website.

Italics

Italics (sometimes called obliques) are most often used for supporting text like captions and quotes when you want to differentiate a block of text from the main body. Italics are sloping and more smoothly curved than standard type, so they look more like natural handwriting than standard fonts (Figure 5.8). They are generally harder to read than standard fonts, and it's important to understand that there is a difference between faux italics and true italics. You can highlight and italicize any typeface in your word processing package using a faux, computer-generated italicizing. Applying italic styling like this to a standard face slopes the uprights of the letters of a regular font. A true italic is a specific font included in a typeface that is designed to be cursive and flowing as well as sloping.

Figure 5.8 Regular fonts and their italicized versions.

Helvetica Regular *Helvetica Oblique*
Helvetica Bold ***Helvetica Bold Oblique***

Special Characters

A *special character* is the term used to describe an alternative form of a letter, number, or symbol. A common example of this is a slightly more ornamental version of a letter that can be used as the first letter in a body of text as a drop cap. These are usually found in the Glyphs palette of most applications that support special characters (Figure 5.9).

Sed ut perspiciatis unde omnis iste natus error sit voluptatem accusantium doloremque laudantium, totam rem aperiam, eaque ipsa quae ab illo inventore veritatis et quasi architecto beatae vitae dicta sunt explicabo. Nemo enim ipsam voluptatem quia voluptas sit aspernatur aut odit aut fugit, sed quia consequuntur magni dolores eos qui ratione voluptatem sequi nesciunt.

Figure 5.9 A special character is used here to differentiate the first character from the others in the paragraph.

Ligatures

Some combinations of characters can create an unpleasant shape when placed next to each other. Ligatures are combination characters that can be used in place of these clashing characters. In Figure 5.10, the f and i bump into each other, creating difficulty where the dot in the i hits the tip of the f. You could increase spacing between the letters to remedy this, but then the balance would be wrong. The font designer provides you with a more elegant ligature that's automatically used when the fi combination is typed. Of course, this only occurs in applications that support ligatures like Adobe Illustrator, Adobe Photoshop, and Microsoft Word 2010 onward. If your application supports Open Type, it should support ligatures.

When typing combinations like fi, the f and i can clash into each other, creating ugly shapes. The designer provides a custom-made fi ligature for these situations.

Figure 5.10 **A ligature.**

Understanding Typefaces

Designers can spend forever agonizing over subtle differences of typeface choices. Take a look at the two examples in Figure 5.11. Helvetica and Times are clearly different, but can you identify and describe the difference between them? Close examination of the characteristics of these fonts will help you know how to make the best and most suitable choices. Typefaces with similar design characteristics can be defined into two main categories: serif and sans serif. We'll look at serif typefaces first.

Figure 5.11 Helvetica and Times typefaces.

Helvetica Regular Times New Roman Regular
Helvetica Oblique *Times New Roman Italic*

Serif Typefaces

Characters written in serif typefaces have little tails at the end of strokes, called serifs, to maximize readability. These typefaces are generally easier to read in print and are used in magazines and books for body text. The font used in the body text of this book is from a serif typeface named Utopia. Times is the most commonly used serif typeface. Figure 5.12 shows an example from the Times typeface with the serifs circled in red.

Within the serif category, typefaces can be grouped into families, which explains the ancestry of a font or how it relates to other fonts. The largest group is the Roman fonts. They are used to type languages that use the Roman (Latin) alphabet (A, B, C, and so on). Learning how type design fits into a historical context will help you understand how fonts are categorized. The next few paragraphs give you a basic understanding of the lineage of a Roman font.

Figure 5.12 A serif typeface. Two of the serifs on this Times font are circled in red.

Old Style Roman

It's interesting to observe how history has impacted typeface design. The uppercase letters of the earliest Roman fonts, known as Old Style, are based on Roman stone inscriptions, giving them a solid, upright, and formal structure. The capitals carved into stone by the Romans had serifs at the ends of their strokes. The tidiest way to finish off a carved line is with a scooping action of the chisel, gradually thinning the line. This action creates this "tailing-off" detail.

Subsequent printing, and then computer technologies, copied this detail, not because it was still necessary but because it had become conventional. It has since been discovered that the serifs also aid readability at small sizes. Times is probably the most commonly used Roman typeface. Figure 5.13 shows some fonts from the Times typeface.

Times Regular *Times Italic*
Times Bold ***Times Bold Italic***

Figure 5.13 **Some fonts from the Times typeface.**

Lowercase, old-style Roman letters are influenced by Italian script. The style of the characters reflects the shapes of letters written with a broad-nibbed pen, which is typical of the period. Many of the Old Style Roman letters are based on handwriting like this. Garamond is an early example of this kind of typeface. It was developed by Claude Garamond in the 1540s, and interpretations of this font are still very popular today. Figure 5.14 shows the fonts of the Times New Roman typeface, an Old Style font that was developed in the 1930s for use in *The Times* newspaper. So you can see that Old Style Roman fonts are not determined by their date of origin but the characteristics of the typeface. The Old Style typefaces have a fairly universal line weight; the thinner lines that form the crossbars and strokes are only marginally thinner than the fatter uprights. The serifs tend to be curved very gradually and often protrude above the letters.

Times NR Regular *Times NR Italic*
Times NR Bold ***Times NR Bold Italic***

Figure 5.14 **Some fonts from the Times New Roman typeface.**

Roman

Roman fonts are a transitional style between the Old Style faces and the Modern ones. The first example of this category is Baskerville (Figure 5.15). The characters tend to be a little wider, and there is a more defined contrast between thick and thin lines than you would see in an Old Style Roman font. Serifs are less gradually curved and are in line with the letters. John Baskerville devised Baskerville in the 1750s. His intention was to improve readability and modernize the old styles. Baskerville's work was a precursor to what became known as the Modern faces.

Baskerville Regular *Baskerville Italic*
Baskerville Semibold **Baskerville Bold**

Figure 5.15 **Some fonts from the Baskerville typeface.**

Modern

In the 1790s, Giambattista Bodoni abandoned all reference to calligraphy when he decided to more fully develop Baskerville's ideas. Notice in Figure 5.16 how the stroke contrast is exaggerated even further and the gradual curves of the traditional serifs are replaced by continuous fine lines at right angles to the main letters.

Figure 5.16 Some fonts from the Bodoni typeface.

Bodoni Regular

Bodoni Poster

Bodoni Italic

Bodoni Bold

Slab Serifs

You can see how the weight of the line can change the characteristics of a typeface. The fattening of the serifs led to the design of a family of fonts known as slab serifs (also known as Egyptians). These have big, fat, boxy serifs like the example from the Rockwell typeface in Figure 5.17. The first of these, originally known as Antique but now named Egiziano Black, was created by Vincent Figgins in 1815. His intention when designing this typeface was to answer the requirements of advertisements for an unfussy, heavy, and attention-grabbing typeface. In 1816, just a year after Slab Serifs first appeared, William Caslon chose to remove the serifs altogether. By doing so, he created a completely new typeface category that came to be known as the sans serifs.

SLAB SERIF

Figure 5.17 Rockwell, a slab serif typeface.

Sans Serif Typefaces

Sans (French for "without") serif typefaces (also referred to as simply "sans") don't have the tails that serif typefaces have and are generally simpler in shape. Sans serif faces are clear, unfussy, and highly legible. Figure 5.18 shows the typeface Futura. Notice the lack of decoration at the ends of the horizontal and vertical strokes (circled in red).

Although you may associate sans serif fonts with more modern times, they have actually been around for a very long time. The Greeks used them as far back as the fifth century. However, they really gained popularity in the twentieth century. Sans serif typefaces tend to be more suitable for web pages, headings, headlines, and posters, and they are ideal for screen design. They are generally cleaner to use than serif typefaces for motion graphic design, particularly when designing for television, since the "tails" on serif fonts can often

Futura

Figure 5.18 Futura, a sans serif typeface.

create problems when viewed on an interlaced screen. These problems typically occur if the letterforms (particularly the serifs) are too small on the screen (you can learn more about this when you read the interlacing section in Chapter 9). So once you've decided that sans serifs are generally better to use than serifs, your next choice will be which typeface to use. If you are new to typography and are designing text for the screen, I recommend starting with the classic sans fonts.

The Classics

I'm a great fan of the old school typefaces; Helvetica and Gill Sans are two of my favorites. Gill Sans is a sans serif typeface designed specifically for television. Both these typefaces contain the complete set of characters you will need, and they will work flexibly in lots of different situations. It pays to become acquainted with the classic typefaces before you start using some of the more unusual, modern-day typefaces.

Gill Sans Regular **Gill Sans Bold**
Gill Sans Italic ***Gill Sans Bold Italic***

Figure 5.19 **Some fonts from the Gill Sans typeface.**

If you can accumulate a good understanding of these old faithfuls and fully appreciate why they work so well, then you can't go wrong. Many of the better modern-day typefaces are based on the same basic shapes as these old classics. You can see font examples from these typefaces in Figures 5.19 and 5.20. Notice the clean, simple lines and unfussy designs, which are ideal for screen design. Notice that Gill Sans has slightly more stress than Helvetica in the letters, particularly the a, u, and g. Helvetica has very evenly weighted lines, so it appears slightly more modern than Gill Sans, which is beginning to show its age.

Helvetica Neue UltraLight Helvetica Neue Light
Helvetica Neue Regular **Helvetica Neue Bold**

Figure 5.20 **Some fonts from the Helvetica typeface.**

Your next choice is to decide which font you want to use. You'll often find a huge variety of fonts within one typeface. Univers, another sans serif typeface, has numerous font variations of width, weight, and axis. Figure 5.21 shows a few of them. Notice the different weights, including Regular (or Roman), Light, Ultra Light, Bold, Black, and Ultra Black (or Extra Black).

Univers Roman **Univers Bold**
Univers Black Univers Light Ultra Condensed
Univers Extended Oblique Univers Ultra Condensed
Univers Extra Black Extended Oblique

Figure 5.21 **Some fonts from the Univers typeface.**

A font can be vertical, like Univers Roman, with perfectly vertical upstrokes. Or it can be at an oblique angle (usually referred to as either oblique or italic) like the Univers Oblique fonts in Figure 5.21. The width of the letters within a typeface can vary, too. Notice that condensed and extended fonts are also available. So keep in mind that you should look through an entire typeface to find the right font for your needs. It could be that the one you are most familiar with is not exactly right, but if you dig down through the other lesser-known fonts within the typeface, you could find exactly what you're looking for. Univers Light may not be suitable for a nice, chunky title sequence, but Univers Extra Black Extended may be perfect.

More recently, typefaces have begun to cross the boundaries between sans and sans serif. These can work as a compromise because they can contain serifed, semiserifed, and sans serifed fonts within one family. In Figure 5.22, you can see examples from the Rotis typeface. Notice the whole range of weights for serif fonts, as well as sans serif and italic versions of the typeface. Notice the differences between the sans serif and serif versions of the uppercase R. The serif versions have those inimitable tails, making it easy to identify it as a serif font.

Figure 5.22 The Rotis font.

Rotis Sans Serif

Rotis Semi Serif

Rotis Semi Sans italic

Rotis Semi Serif Bold

Script Typefaces

Figure 5.23 Script fonts.

Apple chancery

Edwardian Script

Brush Script

Marker Felt

Bradley Hand

Script typefaces are based on handwriting and usually consist of soft, curved strokes and detailed flourishes, which tend to make them look very feminine. Formal scripts are based upon seventeenth- and eighteenth-century handwriting that was done with fountain pens, so it has variations in stroke width that mimic this. I don't typically use formal script fonts due to the fact that they often have fine lines, which are not really suitable for TV graphics. However, there are times when you need a feminine or elegant look and feel, and these are perfect in those situations. If you need a slightly chunkier and less formal handwriting font, then you may find the casual scripts more suitable. Casual scripts are based upon a less formal style of handwriting that became popular throughout the twentieth century. In Figure 5.23, the first two fonts are more traditional formal fonts, and the other three are considered casual scripts.

Now you know how to identify a category of typeface, but that's just the beginning of the analysis. There are thousands of different typefaces to choose from in each category, so where do you start?

Choosing Typefaces

There are two main considerations to take into account when practicing typography. The literal meaning of the actual word is important, but so is the meaning that can be implied by the presentation of the letters and words. The shape and pattern of the letters can communicate something complementary, or entirely different, to the true definition of the actual words.

Cultural Associations

Typefaces carry inherent associations and cultural references. The message a font conveys can be dramatically changed by its association. It's important to keep this in mind when choosing the font most suitable to your particular needs.

The first printed books were printed in a typeface designed to look similar to the calligraphy of their contemporary handwritten counterparts. This typestyle came to be known as Blackletter, and versions of it remain popular to this day (Figure 5.24).

Medieval or just plain Evil?

Figure 5.24 **The Blackletter typeface.**

The Blackletter typeface is often used in situations where the designer wants to evoke a sense of medieval history, since it refers to the lettering used during that period. Blackletter has also adopted a different set of associations due to its use by the Nazis in the 1930s and 1940s to emphasize their links to traditional German heritage. As a result of this connection, the typeface has gained some darker connotations, which have now become part and parcel of the character of the font. You can see how understanding the origin of a typeface can really help to discern its cultural impact. It may be fine to use Blackletter in North America, since it is more likely to be associated with its medieval origins, but you may have to be more careful about how you use it in Europe.

Blackletter implies a complex and potentially contradictory set of ideas. Would you have thought a typeface could say so much? Not all typefaces have such a rich history packed into them, but all convey certain moods because of their weight, shape, angles, and proportions.

Characteristics

Not only do fonts have a family and an ancestry, but they also have a personality. A font's personality will help you choose which one is most appropriate to use. It's usually very clear when something is in the wrong typeface; it's almost like making a social faux pas. In Figure 5.25, a flowery, feminine, script font, Edwardian Script ITC, has been chosen to illustrate the words "The Big Butch Gym" in bright pink. It's really the wrong font for portraying a masculine quality. However, sometimes, choosing the "wrong" font can be powerful and used to advantage for creating a sense of irony. When it comes to matching the personality of a font to the message you want to convey, you need to rely on your instincts and judgment. You can learn a lot about the characteristics of fonts just by noticing which fonts other designers use in various situations.

Figure 5.25 The wrong choice of font can be used to create a sense of irony.

Comparing Typefaces

Unless you have an encyclopedic knowledge of typefaces and fonts, you will need to look through font books and libraries to seek out your perfect match. Computer technologies have democratized the design process, freeing us to experiment with typography in a way that was impossible when all text had to be printed from movable type. This freedom and choice can sometimes be overwhelming, but never fear! I'm here to help you by providing you with tips, tricks, and guidelines that will help you to maneuver through the myriad typefaces available.

How many fonts have you got on your computer system, and how familiar are you with their characteristics? You're bound to have an extensive resource already, even if you haven't added to what came with your computer. It's worth starting to make your font choices within this preexisting collection (which should already include the standard classic fonts) before expanding it. You can use purpose-built software applications to manage fonts and quickly compare the available fonts on your system.

If you use a Mac, Font Book is a good way to explore and manage the fonts on your system (Figure 5.26). You can use it to compare fonts, install, uninstall, view, and organize your fonts into your own custom collections based upon style, project, or other preferences. And the good news is, it is included with OS

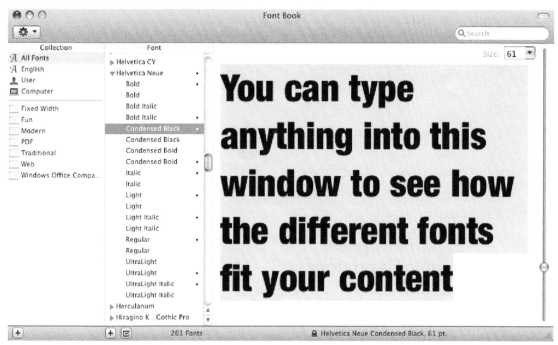

Figure 5.26 Applications like Apple's Font Book (*www.apple.com/pro/tips/fontbook.html*) can help you arrange your fonts into collections and preview them to make sure they are right for your designs before installing them.

X. On Windows you can use the Fonts control panel for basic functionality. It will allow you to preview, install, add, or remove fonts, but it won't allow you to create collections. Linotype makes a free font manager called Font Explorer (known as Font Explorer X on Mac). It is cross-platform and allows you to manage your fonts easily.

Buying Typefaces

However many typefaces you already have, the likelihood is you probably will never have enough. There will be times when you won't have the specific one you need for a particular piece of design. At times like these, there's an almost endless number of typefaces and fonts to buy online from specialist services like Linotype (*www.linotype.com*) (Figure 5.27), Font Shop (*www.fontshop.com*), and, of course, Adobe (*www.adobe.com/type*). Remember that the people who make a living developing and distributing typefaces are just like you; they are designers who are trying to make a living from their art. If you wouldn't be happy if a designer stole your designs, then you shouldn't use another designer's fonts without paying for them. Font piracy is very common, but it doesn't make it right, and you can be sued for using fonts without a license. You must pay for commercial fonts.

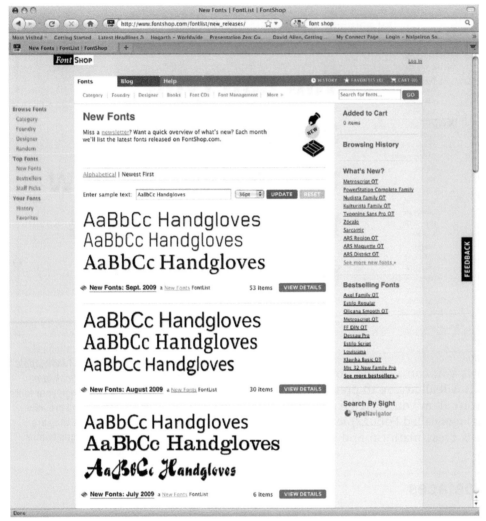

Figure 5.27 The Linotype website (*www.linotype.com*).

Free Fonts

If you don't have the resources to buy fonts, there are plenty of free alternatives you can use instead. *www.dafont.com* is a really good example of a free font service and has an extensive archive of font faces that won't cost you a penny (Figure 5.28). You can search by style and customize the display wording to help you visualize the font for your specific design. All of the fonts are free to download, most are free for personal use, and some are free for all uses. Always make sure to check the licensing agreement before you use these typefaces for anything other than personal use.

Figure 5.28 *www.dafont.com.* Many websites offer free downloads of fonts. Just make sure to check usage agreements before using them.

A Practical Exercise

Here is a method for deciding which font to use. Make a list of words, and then find the typeface that best conveys the meaning of each word. Some examples are *formal, friendly, spontaneous, sensual, cheerful, panic, party, shy, inconspicuous, elegant, loud, distinguished, casual, businesslike, technical, homemade, angry, scruffy,* or *playful* (or think of your own). To get you started, here are some possible solutions to some of these words.

In Figure 5.29, the word *Businesslike* is printed in Copperplate, which is the kind of font face that could be engraved on a sign

Figure 5.29 Copperplate is a very conventional, businesslike serif typeface.

BUSINESSLIKE

Figure 5.30 Edwardian Script is a quite fancy, elegant typeface.

outside an accountant's or lawyer's office. In Figure 5.30, the word *Elegant* is printed in Edwardian Script, which is a script style that is feminine, flowing, and curved, with long ascenders and descenders.

In Figure 5.31, *Friendly* is printed in Cooper Black, which is rounded, curvy, and chunky, just like a lovely, cuddly best friend. In Figure 5.32, *Inconspicuous* is printed in Helvetica Regular, which is a widely adaptable sans serif font with a well-balanced shape that can sit comfortably in a wide range of designs. Helvetica has a fairly unique ability to look either traditional or contemporary, depending on the nature of the design it sits within.

In Figure 5.33, *Homemade* is printed in the Bradley Hand typeface, which closely resembles handwriting and has rough edges. The characters look as if they were written on a chalkboard with chalk. It helps to know roughly what to look for in fonts in order to fulfill your needs, so some understanding of the anatomy of the letterforms is useful.

Friendly

Figure 5.31 The friendly face of Cooper Black!

Inconspicuous

Figure 5.32 Use Helvetica Regular if you want the text to look good but to go largely unnoticed.

Homemade

Figure 5.33 Use fonts like Bradley Hand if you want a hand-drawn look.

The Anatomy of Type

You can learn a lot about typography by carefully observing the text you see in your everyday life. Notice which fonts are used for different purposes: billboards, magazines, store signs, graffiti, television, movies, the web. A good exercise in observing typography is to photograph typography and identify whether it's in keeping with its message. If you do this, you will start to notice typography that would have otherwise blended into the background. The best way is to take pictures with your phone or another cheap, portable camera, place them side-by-side, and assess the similarities, differences, and specific purposes of the fonts used. You'll be surprised how much you can learn by doing this.

Size Matters

The body size can vary considerably among different fonts. In Figure 5.34, both Didot and Impact are displayed in the same point size. Their x-heights are very different, even though they have the same body size. In some cases, the x-height may be the same, but the overall proportions may be different. For example,

the ascenders may be longer on one typeface than another. A small x-height gives more room for the ascenders and descenders, giving the impression of a longer, more elegant character (for example, look at the "d" in the Didot sample). In the third example, Copperplate, with its low cap-height and extended width, is compared at the same body size to the tall, slender Extra Extended version of Gloucester MT.

Figure 5.34 **Variations in size and x-height.**

Weight Problems

The term *weight* refers to the "chunkiness" of a font. The Helvetica typeface contains several different weights of font, including Ultralight, Light, Regular, and Bold. Compare the capital Os in Figure 5.35, which are printed in different fonts. Notice how their weights are dramatically different. One way to analyze the differences is to look at the counters. The space in the middle of an enclosed shape in a letter is the counter, and the size of the counter says a lot about the weight of the face. Small counters are the result of heavier faces, which look denser and darker, particularly as blocks of text. Impact has the smallest counter in these examples. Generally, chunky fonts like Impact or bold fonts like Helvetica Bold are more suitable for motion graphic design than lighter, thinner fonts. Impact is a great font to use as a stencil when creating mattes or masks (you can find out more about creating transparencies in Chapter 9).

Figure 5.35 **Variations in weights and counters.**

Coping with Stress

Stress is the difference in thickness in the strokes used in a character. Look at the stresses of the Os in Figure 5.35. Futura has no stress, since it maintains the same width of line all the way around. Impact has a subtle amount of stress; it's slightly thinner at the very top and bottom than at the sides. Didot and Zapfino have a very high contrast stress. Zapfino's axis is at an oblique angle. (This is known as angled stress, actually.) Wide Latin and

Stencil both show an exaggerated stress. Look how fat the lines are at the sides of the letter. Most of the characters are made up of a continuous line, except Stencil, where the line is broken so the counter is not enclosed.

Line

It's also useful to examine the complexity of the line. Figure 5.36 shows two examples of the letters "a" and "g" in two different typefaces. The first example is of each of the letters in the Modern Number 20 typeface. Notice that each of the letters has two distinct components, which are known as double-storey structures. The second examples show single-storey versions of the same letters in the Chalkboard typeface. The double-storey letters are much more complex shapes than their single-storey counterparts. You may want to consider when to use complex shapes versus simpler shapes. Although I much prefer the double-storey structures for their intricate elegance, often with motion graphics it's better to keep things simple. However, there are no set rules on this one, so you have my permission to be reckless and go a bit crazy!

Figure 5.36 **Double-storey and single-storey characters.**

Decoration

The shape of the strokes and serifs impact the mood of the font enormously. Figure 5.37 shows uppercase examples of the letter "i." The weights of the serifs range from hairline to block. When analyzing the characteristics of type, it helps if you can enlarge a text character to fill your computer screen. This allows you to look closely at its anatomy.

Slab serif faces (see Figure 5.37), sometimes referred to as Egyptians, have thick bold serifs, making them useful as highly attention-grabbing titles. They're also great for track mattes (where the footage will be played through the stenciled characters) because they are both chunky and bold. All three of the

Figure 5.37 **Slab serifs.** Didot Verdana **Rockwell Extra Bold**

examples in Figure 5.37 have a squared-off shape, referred to as unbracketed serifs. With bracketed serifs, there's a curved line that joins the serif to the main stroke of the letter (Figure 5.38), making a softer, less severe shape.

Serif shapes vary widely, from serifs so small that they're pretty much vestigial, to soft, curved serifs, to those whose brackets are straight lines or geometric shapes (like the ones in Figure 5.39).

Sans serif faces, which you might think of as having no decoration, also have many variations. The simplest form of uppercase sans serif "I" is straight-sided and square-topped, but the stroke sides can be curved inward or outward, and smooth or uneven, and the ends of the strokes can be rounded or convex, all creating a different visual effect (Figure 5.40).

Letter shapes are not always solid lines but can be broken shapes or outlines. These shapes may then be filled with decoration. The lines themselves may be elaborate and embellished. In particular, the script typefaces are usually based on sophisticated calligraphy or handwriting. Figure 5.41 shows some examples of the letter "J" in various script typefaces. Notice the decorative swashes.

Everything we've looked at so far focuses on the shape of the individual characters, but words, lines, and paragraphs also make shapes. We'll start by looking at how to think in terms of words. We'll then look at how to work with lines and paragraphs of text.

Figure 5.38 **The bracketed serifs of the Baskerville Regular font.**

Figure 5.39 **A selection of assorted serifs.**

Figure 5.40 **A variety of sans serif typefaces.**

swash

Figure 5.41 **Script typefaces with decorative swashes.**

Spacing

To a good typographer, the space between letters is just as important as the characters themselves. There are several controls for adjusting the space between characters, words, lines, and paragraphs. Most software applications provide controls for letter spacing and line spacing. In Adobe applications, the control panel (previously the Options bar) that runs along the top of the application updates to show you character controls when the type tool is

active. You can change some of the typographic controls here, but for more comprehensive options, you can access the Character panel, which can be opened from the Window menu.

Figure 5.42 shows the Character panel in Illustrator. Notice the Font Family menu (used to select typefaces) and below it the Font Style menu for selecting individual styled fonts from within the selected typeface. Below these are other menus for selecting the font size and other character options like tracking and kerning.

The Character Panel in Adobe Illustrator

Figure 5.42 **The Character panel in Illustrator.**

Letter Spacing

First, we'll look at some ways to control the spaces between the characters, which is called letter spacing. Using computer software, the two main options for adjusting the space between individual characters are tracking and kerning.

Tracking

Tracking is used to increase or decrease the spacing around selected characters. Most software applications allow you to increase or decrease tracking by selecting a range of characters and adjusting the settings. The spacing will be increased by an equal amount between all selected characters. Note that it's quite common to add more tracking between characters for screen design than for print designs (both web graphics and broadcast motion graphics) due to the light emitted from the screen, causing a slight "bleed." (There's more information about this later in the chapter.)

Reducing the tracking can create a crowded effect, so you must be careful with this option. Notice how some of the letters can crash into each other (Figure 5.43). Increasing the tracking gives each letter room to breathe, but the letters can become somewhat disassociated from each other, making the words harder to

Reduced Tracking
Normal Tracking
Increased Tracking

Figure 5.43 **Spacing that results from both negative and positive tracking.**

read. Tracking is a great way to quickly add a little space between all the characters, but in most cases you'll also need to work on the space between the individual letter pairs. Different combinations of characters require different amounts of spacing. Because of this, tracking is typically used in conjunction with kerning.

Kerning

Kerning is used to increase or decrease the space between letter pairs. It's essential to use kerning along with tracking, since different combinations of letter pairs create different amounts of space. Look at the first example of two capital As in Figure 5.44, and notice the V-shaped space that is created between them. In the second example, an A next to a V creates a corridor between two oblique parallel lines, which benefits from being kerned more tightly in the third example.

Some letters need more spacing than others. Letters that have uprights on both sides—like H, N and I—look much more tightly bunched than round shapes like O and Q. The curved shapes create more white space between their edges, the baseline, and the mean line.

Kerning can be a little fiddly if you've never used it before. Normally, I would go through all letter pairs, checking that all had the correct amount of spacing between them. This has to be judged by eye, and it can be tricky for a beginner to know exactly how much spacing to use between the letters. But experience and practice will make this second nature.

I've been asked why it's not advisable to use tracking to adjust space between selected letter pairs. The reason is that tracking

A. No Kerning B. No Kerning C. -140 Kerning Figure 5.44 **Kerned letter pairs.**

increases and decreases the spacing on either side of the character, whereas kerning increases or decreases a single space between the letters (Figure 5.45).

a. The space between the **n** and **i** was created using kerning controls

b. The space between the **n** and **i** was created using Tracking controls

Figure 5.45 Kerning is used to increase spacing between letter pairs.

Line Spacing

The spacing between lines also affects the overall readability and aesthetics of your text. There are a couple of controls available in software applications that allow you to adjust the line spacing. The first is Leading.

Leading

Leading describes the spacing between the lines of text in paragraphs. The term comes from the earliest days of printing when type was set using metal printing blocks on a Gutenberg Press. Strips of lead would be placed between the type to increase or decrease spacing. Thankfully, things have got a lot easier these days; you simply drag a slider or type in a value to increase or decrease the space between the lines of text on a page. The spacing is measured between the baselines of each line of text (just as the font size is).

If you have only one line of text, adjusting the leading value will appear to make no difference at all in the spacing of selected text. This is because the spacing between lines of text is what's actually increased or decreased (as opposed to the position of the character). So you need to select at least two lines of text to be able to see the change.

The leading is as important as the size, face, and weight in creating the density of type on the page or screen. In turn, this affects both the visual impact and the readability. If the leading is reduced too much, ascenders and descenders can collide (as in Figure 5.46). However, lines of text can become dissociated if the leading is increased too much (as in Figure 5.47)

Figure 5.46 Too little leading can make ascenders and descenders crash into each other.

Descending characters like g, y, p and q can clash with Ascending ones like t, h, and b if you don't add enough leading

does this point have

Figure 5.47 Too much leading can make lines appear dissociated.

any connection to this one?

You can use leading in designs to create variations in tone, but you can also use leading to provide a greater sense of importance to the words. In Figure 5.48, the leading has been reduced between the words *Don't* and *Look* to bring them together. Extra leading has been added between the words *Look* and *Now* to make them more powerful, and a graphic has been placed into the gap.

Decreasing the leading value to a smaller point size than the font size makes the text denser. This can create an overpowering and dark atmosphere, as in the title sequence in Figure 5.49. A heavyweight font face was used in upper case with negative tracking and leading values. As a consequence, the names on the screen have more power and impact than they would have with a standard amount of leading.

We've seen that tracking and kerning are important. This is particularly true in film titles, where few words appear on the screen at any one time, and they will be displayed at a huge size on the screen. Any errors will be magnified in this situation, so you need to ensure that the letters are clear and properly spaced. Remember that you can't get away with just adding a uniform spacing between all of the letters; kerning letter pairs is essential.

Figure 5.48 Tight leading can be used to good effect to create a sense of drama.

Figure 5.49 Using a small amount of leading can add impact to a title.

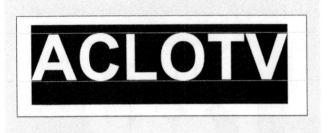

Figure 5.50 Notice how capital letters are naturally spacious.

Some letters need more spacing than others. Capital letters like A, C, L, O, T, and V are naturally spacious letters. This is because they are wide letters and are constructed with round edges or diagonals that create some "natural" space around them. Study the space between the guides and the letter edges in Figure 5.50. In Figure 5.51, the letters F, R, and E are not as spacious because they have flatter edges. Upright letters like M, H, and N, which are closed in on both sides, look big and wide and will really fill their space. Notice in Figure 5.51 how the word COALS seems to be more spacious than the word FREE, yet both have 0 kerning values between letter pairs. To help see the space between the letters more clearly, you can select them individually and look at the block created by the selection (Figure 5.52).

Use kerning to space letters so the "weight" of the space between the letters is even to the eye. Spacious letters need little space when placed next to each other, whereas slimmer or more dense characters, particularly the letter "I," will need extra spacing. In Figure 5.53 the word *FATTER* is shown first with no kerning applied. Notice that the gap between the F and the A seems much bigger than the space between the E and the R. In the second example, you can see that I've reduced the kerning between the F and the A as much as I can. I've also increased kerning between other letter pairs, particularly the E and the R.

The word *THINNER* needs much less work because the letters are naturally more similar in terms of spacing (Figure 5.54). However, the letter "I" was lost in the pack, so I added more spacing around it and slightly adjusted the other letters. To the untrained eye, these changes may seem subtle and unnecessary, but they are important, particularly when the titles are viewed on large screens.

Letters like A, O, V, U, and W can create too much space at the edges (because of nonflat edges), so you may be forced to overlap the edge of a margin to compensate. Think about these things

COALS
FREE
MHN

Figure 5.51 All three words have same spacing applied, yet they appear different.

ACLOTV

ACLOTV

ACLOTV

Figure 5.52 Selecting letters helps you to see the space around them as shapes.

FATTER
FATTER

Figure 5.53 The first example has no kerning applied. The second has been carefully kerned.

THINNER
THINNER

Figure 5.54 The word *THINNER* needs less kerning than the word *FATTER* because the letters are more similar to each other in terms of spacing.

when you kern by eye, and give each letter room to breathe. This same factor of whether a capital letter has a flat edge also impacts its positioning, so you may have to force certain words to overlap margins to compensate for their shape (Figure 5.55). Words with flat and upright edges can be aligned easily. When left-aligned, the title DON'T LOOK NOW is aligned perfectly because all the starting letters have flat, vertical edges.

In Figure 5.56, THE ODD COUPLE is a bit more problematic because the letters O and C do not look well-positioned. When the text is left-aligned, the extra space created by the curves of the O and C make it appear as if those letters have been pushed too far to the right. To improve the alignment, you can kern the space before the letters O and C to move them to the left until the balance is improved. Notice how I have used Illustrator's rulers and guides as a grid to help guide me into getting the spacing right so the characters have a pleasing composition. You can learn more about using grids in Chapter 3.

Look for the same issues when you're using center alignment; words should be aligned visually based on the weight, shape, and kerning of the letters, but consideration must be given to the space around the letters, too.

DON'T LOOK NOW

Figure 5.55 The edges of these letters are all flat, making it easy to align them.

Figure 5.56 In the example on the right, the curves of the O and C are kerned to align them centrally with the letter T on the line above.

Baseline Shift

Baseline shift allows you to individually move selected characters up or down relative to their baseline. This can be used to inject a bit of character (excuse the pun!) by making the text appear to be sitting on a curved line, as I've done in Figure 5.57 to make this Apple Chancery script font a little more organic looking. You can also see this used to good effect in Figure 5.58.

Figure 5.57 Baseline shift can be adjusted to add a bit of character and movement to your text.

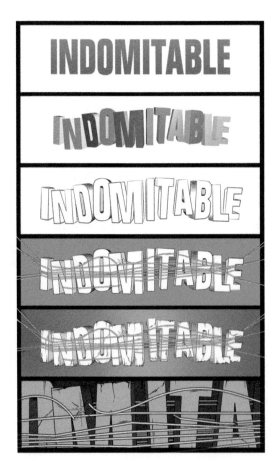

Figure 5.58 This example from typographer Nicolas A. Girard shows how adjusting the spacing, rotation, and baseline shift of the characters can make the text much more interesting. It was then treated with the 3D effect in Adobe Illustrator to give it a three-dimensional quality before adding more detail. © Nicolas A. Girard, 2009.

Figure 5.59 Baseline shift can also be used to adjust the balance of text. The larger letter B is adjusted to create a drop cap type of effect.

I often use baseline shift to adjust the balance of a character after resizing it. In Figure 5.59, I used a negative baseline shift value to move the letter B so it is more in line with the other, smaller letters.

Word Spacing

The spacing between words impacts on the density as well. It is generally thought that the amount of space between words should be roughly the body width of a lowercase "i" (Figure 5.60). When you are creating titles or short lines of text, you can fine-tune the space between words manually using kerning.

The Space Between Words

Figure 5.60 A good measure of space is the letter "i."

Thinking in Shapes

When you look at text, you should train yourself to pay attention to the shapes of the characters and the shapes formed by the space around them (their "negative space"). Think of a block of text as a picture rather than just a lump of text. Each letter is an individual shape, and when these letters are combined into words, the words form new shapes. The words are combined to make sentences, and then sentences become paragraphs. The combination of the type and the space around it will form a

Figure 5.61 Think about the shapes that space creates between characters, and consider both positive and negative space.

Figure 5.62 A great exercise to help you enjoy the craft of typography and understand the importance of negative space is to divide a sheet into squares and in each square trace some letter forms from magazines at different sizes. Concentrate on the shapes you can create by interlocking the shapes of the letters.

pattern within the paragraph. The key to good typography is to make sure that the amount of space compared to the amount of solid text is balanced.

In Figure 5.61, I put the letters "e" and "g" together using the Impact typeface. The first example is just as typed. In the second example, I thought about the shape in-between the letters, and as a result, I decided to adjust the baseline shift setting of the "g" to make its end stroke match up horizontally with the end stroke of the "e." In the third example, I closed the gap between the letters to exaggerate the interlocking shape. Try combining two characters and see if you can create some interesting shapes (Figure 5.62). Remember that you can use kerning to close or open gaps between letters, baseline shift to move them up or down, and, of course, font size to make them bigger or smaller.

Paragraph Spacing

When working with long paragraphs of text, it becomes impractical to adjust the space between characters and words manually. So it's common to allow the software to automate the word spacing across paragraphs. When doing this, you can still consider aesthetics and assert a certain level of control over how the spacing is applied. As a rule of thumb, when you look at a paragraph of text, the characters and spaces should be pretty evenly distributed. As a test, pick up a good magazine, and look at the paragraphs through half-closed eyes. You should see a good balance represented by an even spread of gray throughout the text block (this is referred to as

the "color" of the text). If, however, you do the same with a cheap newspaper, you'll probably see big chunks of white space among the paragraphs, making the text look uneven and fragmented, which makes it more difficult to read

Alignment

You can control the way the text is anchored to the text frame by using the alignment options in Illustrator's Paragraph panel (Figure 5.63). These options are available in most software applications. Alignment is controlled by selecting a paragraph and clicking one of the button choices.

Each of the three columns of text in Figure 5.64 is arranged differently. The first is left-aligned. This is usually the default setting

Figure 5.63 **The Paragraph panel in Adobe Illustrator.**

Alignment and justification buttons
Left Indent
1st Line Left
Space before Paragraph
Hyphenate

Right Indent
Space after Paragraph

Figure 5.64 **Left-aligned, right-aligned, and justified text.**

LEFT ALIGNED

Lorem ipsum dolor sit amet, consectetur adipiscing elit. Nullam eu sapien ligula. Proin quis vestibulum dolor. Etiam et ipsum non lacus mollis lacinia. Fusce tempus leo nec nulla rutrum volutpat. Vestibulum eros arcu, porttitor et cursus eget, fringilla at nulla. Mauris mauris elit, varius non molestie vitae, pellentesque vel est. Suspendisse in mauris tellus. Quisque ac nunc sapien. Lorem ipsum dolor sit amet, consectetur adipiscing elit. Integer eget est tortor, quis hendrerit risus. Vestibulum cursus turpis eget mi luctus quis posuere lacus gravida. Curabitur a felis vitae ante ultricies interdum. Nullam in venenatis massa.
Vestibulum ante ipsum primis in faucibus orci luctus et ultrices posuere cubilia Curae; Vivamus interdum mauris quis nunc viverra venenatis. Donec neque nulla, lacinia vel pharetra at, scelerisque a augue. Cras at tellus orci, at ultrices nisi.

RIGHT ALIGNED

Lorem ipsum dolor sit amet, consectetur adipiscing elit. Nullam eu sapien ligula. Proin quis vestibulum dolor. Etiam et ipsum non lacus mollis lacinia. Fusce tempus leo nec nulla rutrum volutpat. Vestibulum eros arcu, porttitor et cursus eget, fringilla at nulla. Mauris mauris elit, varius non molestie vitae, pellentesque vel est. Suspendisse in mauris tellus. Quisque ac nunc sapien. Lorem ipsum dolor sit amet, consectetur adipiscing elit. Integer eget est tortor, quis hendrerit risus. Vestibulum cursus turpis eget mi luctus quis posuere lacus gravida. Curabitur a felis vitae ante ultricies interdum. Nullam in venenatis massa.
Vestibulum ante ipsum primis in faucibus orci luctus et ultrices posuere cubilia Curae; Vivamus interdum mauris quis nunc viverra venenatis. Donec neque nulla, lacinia vel pharetra at, scelerisque a augue. Cras at tellus orci, at ultrices nisi.

JUSTIFIED

Lorem ipsum dolor sit amet, consectetur adipiscing elit. Nullam eu sapien ligula. Proin quis vestibulum dolor. Etiam et ipsum non lacus mollis lacinia. Fusce tempus leo nec nulla rutrum volutpat. Vestibulum eros arcu, porttitor et cursus eget, fringilla at nulla. Mauris mauris elit, varius non molestie vitae, pellentesque vel est. Suspendisse in mauris tellus. Quisque ac nunc sapien. Lorem ipsum dolor sit amet, consectetur adipiscing elit. Integer eget est tortor, quis hendrerit risus. Vestibulum cursus turpis eget mi luctus quis posuere lacus gravida. Curabitur a felis vitae ante ultricies interdum. Nullam in venenatis massa.
Vestibulum ante ipsum primis in faucibus orci luctus et ultrices posuere cubilia Curae; Vivamus interdum mauris quis nunc viverra venenatis. Donec neque nulla, lacinia vel pharetra at, scelerisque a augue. Cras at tellus orci, at ultrices nisi.

in software applications and is the most commonly used because text is read from left to right in the Western world. The left edge of the lines of text is aligned (or anchored) along a straight edge of the text frame. The words on each line are evenly spaced, which causes an uneven edge down the right side of the text column or text frame. Right-alignment does the opposite. The lines of text are anchored along a straight right edge. The lines are staggered on the left edge. Justified text adjusts the word spacing to create straight edges down both the left and right sides of the text frame. This can result in highly irregular spacing between words and can create ugly blocks of white space in the text, which makes the text more difficult to read.

You can change the method of justification with most good software applications. With the default setting, the computer makes a guess at the best way to space the letters to fit the available space. The Paragraph panel in Adobe applications like Illustrator or Photoshop allows you to choose different justification options, but they also allow you to choose how the spacing is worked out across lines of text. These options are accessed in the Options menu of the Paragraph panel.

The default mode for Adobe programs is to use the standard Single Line Composer for paragraph handling. In this mode, the word spacing and hyphenation is dealt with on a line-by-line basis. Using Adobe's own Every Line Composer, words can be moved onto other lines in order to make the spacing across a paragraph as even as possible. This avoids variation of spacing from line to line, which can look ugly. The software "looks" at the whole block of text before it decides where to put the spacing. In Figure 5.65, a paragraph of text has been justified, but notice that the word spacing in the paragraph on the right (using the Every Line Composer) is much more evenly spaced.

Figure 5.65 Adobe's Every Line composer improves word spacing.

Legibility and Readability

Although you may not often be required to create paragraph text for screen designs, there are times you may need to work with it when creating DVD menus, websites, or rolling titles for movies or television. It's crucial that the audience is able to read the text at all times, even when the text is animated. Capital letters are generally more legible and are better for drawing the viewer's attention, but they're not as easy to read as lowercase letters. In order to be easily readable, the body text should be in a font that's clear and simple. Overall it should be so easy to read that the reader sees only the content of the words, not the layout or typeface. Sans serif faces are thought to have better legibility than readability, but because they are clean and free from intricate detail, they are commonly used for text on the screen.

Drop Caps

One way to indicate to the reader that a new theme is being introduced in paragraph text is to use a drop cap. A drop cap is when the first letter of the paragraph is made bigger, extending downward to a depth of three or four lines of the paragraph (Figure 5.66). Drop caps help to draw people into the text and are a good way to indicate the start of a new subject.

Hierarchies of Information

You can establish a hierarchy of information with your choices of font, size, weight, and style. This makes it easier for your audience to understand what purpose the text is serving. Sticking to the same typographical conventions in a single piece of work and other related projects will allow the audience to easily distinguish between the text for titles, subtitles, and captions. Establishing a good, solid hierarchy of information is important for clarity and will help to avoid confusion. Your work may require text that's organized into topics under main headings and subheadings (for example, a DVD menu). You can indicate the structure by making the DVD title larger than the submenu links. The sizes you choose can be determined by how much impact you want to make with your text component and how quickly you want to catch people's attention.

Lorem ipsum dolor sit amet, consectetur adipiscing elit. Nullam eu sapien ligula. Proin quis vestibulum dolor. Etiam et ipsum non lacus mollis lacinia. Fusce tempus leo nec nulla rutrum volutpat. Vestibulum eros arcu, porttitor et cursus eget, fringilla at nulla. Mauris mauris elit, varius non molestie vitae, pellentesque vel est. Suspendisse in mauris tellus.

Opaque ac nunc sapien. Lorem ipsum dolor sit amet, consectetur adipiscing elit. Integer eget est tortor, quis hendrerit risus. Vestibulum cursus turpis eget mi luctus quis posuere lacus gravida. Curabitur a felis vitae ante ultricies interdum. Nullam in venenatis massa.

Figure 5.66 **A drop cap.**

Software Recommendations

We have seen that we can trace the roots of many typefaces back to handwriting, stone-carving, and traditional printing, but now that fonts are digital, there's so much more we can do with them. What you do with type-based design is limited only by your ideas. There are lots of software applications that can be used for formatting digital text, but my personal favorite is Adobe's Illustrator. Adobe Photoshop offers some of the same typographic control, but Illustrator offers more in terms of flexibility and experimentation. The Character panel (available under Window > Type > Character) (see Figure 5.42) offers familiar font, style, size, tracking, kerning, baseline shift, and leading options. There are also all sorts of effects you can apply to type while it remains editable, like the Warp effect (Figure 5.67).

The Type on a Path tool allows you to create a shape for your text to align itself along (Figure 5.68). In Illustrator, you can work with the fills and strokes of the type while it remains editable, including creating multiple strokes.

Figure 5.67 The Warp effect in Adobe Illustrator.

Figure 5.68 Type on a path in Adobe Illustrator.

Figure 5.69 Create Outlines in Adobe Illustrator allows to you to reshape your letters.

You can save all these characteristics as a Text Style to reapply easily to other text objects in your project. Illustrator allows you to change your type from editable text to vector shapes, providing you with endless creative possibilities. You can also create outlines from text, enabling you to manually adjust anchor points and bezier curves. This gives you ultimate control over your type by permitting you to customize characters. You do this by selecting the text and choosing Create Outlines from the Text menu (Figure 5.69). But remember that once you convert the type to shapes, it is no longer editable as type, so it's a good idea to create a duplicate of your layer before you do this, just in case you need to make changes to the text at a later date. Once you've done this, you can add, remove, or manually adjust the points and curves to create new and interesting shapes from your letters.

By using Illustrator to expand letters and words into vector objects, you can adapt the shape of your letter forms extensively, making design features that are specific to a project (Figure 5.70). You can even add effects like Punk and Bloat or Roughen to make the text less uniform and more organic (Figure 5.71)

Figure 5.70 Then you can adjust the points to customize the shapes.

Figure 5.71 Effects like Punk and Bloat can be used to create more organic effects.

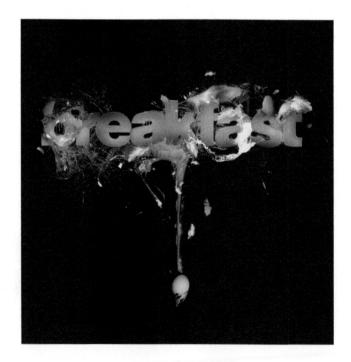

Figure 5.72 **Breakfast: Respect the most important meal of the day.** This example from designer Stefan Chinof shows what you can achieve by customizing a standard font. © Stefan Chinof, 2009.

Handmade and Experimental Type

There's no substitute for creating your own unique typefaces by hand. Although I love how easy it is to use the readily available set of computer fonts, I find they can look a little bit too perfect and impersonal. Creating your own text can be a way of revolutionizing your designs and making them stand out. Text made from physical objects or that's hand-drawn can be full of personality, and, most important, it's unique. Hand-drawn text can be scanned, physical type photographed, or filmed. In Figure 5.73, type has been created from photographs of people "drawing" with fire, using Photoshop to manipulate the fire more clearly into the letter shapes.

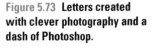

Figure 5.73 **Letters created with clever photography and a dash of Photoshop.**

As I mentioned previously, I loved to draw my own fonts by hand before computer-generated fonts existed. I would copy them from a source and then adapt them. When I began studying at art college, I found that tracing letter forms by hand was a very useful exercise. We used what's known as a Grant projector to enlarge letters from magazines. We then traced the letters and created individual designs around each of the letters of the alphabet. It was a great way of getting to know the shapes. As an alternative to the Grant projector, you can try using a photocopier to enlarge the text, or try printing it out from the computer, messing with it, and then scanning it back in. Hand-drawn text has a lovely, raw, informal quality that's harder to achieve using computer-generated fonts (Figure 5.74). Manipulating the text in this

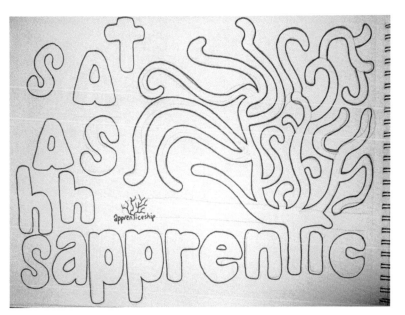

Figure 5.74 Hand-drawn text adds a whole new dimension to designs. This text was drawn by designer Waikit Kan. He scanned the hand-drawn text and then used the Live Trace feature in Adobe Illustrator to create vector art from the scans. © Waikit Kan, 2008.

way gives your creativity a good workout and can also be very therapeutic.

Figure 5.75 shows some examples of hand-drawn text used in posters. Here you can see some of the sketchbook development work that led to one of the poster designs. These sketches were digitized and then finessed in Illustrator before inclusion into the final poster.

Figure 5.75 The hand-drawn text used in a finished poster design. © Waikit Kan, 2008.

Typography for the Screen

Think of all the situations where text features on a screen; watch an evening of TV and you'll see captions, titles, credits, ads, and so on. Film and TV titles should draw the audience in, capture their imaginations, and create a mood for the show. Motion graphic designers have a great opportunity to create some inventive and interesting work, but creating text for the screen presents specific issues particular to the medium that can test your skills as a designer.

Design considerations for motion graphics are similar in some ways to those of print design. Just as in static design, the text content needs to be legible, well laid out, and in keeping with the content. But the job of a motion graphic designer must also include the added dimensions involved with motion. Movements of text, objects, and cameras on screen force you to be aware of the patterns and rhythms created by motion. Other filmic conventions that you must take into consideration include editing, transitions, focus, lighting, camera angles, and sound. There are also technical issues particular to screen design that will affect your design decisions. These include the screen aspect ratio or resolution, which you can find out more about in Chapter 9.

Color and Luminance

Print designers can print proofs, so they know exactly how the colors will look when the reader sees their design. In motion graphics your content could be watched on a variety of mediums, ranging from cell phones to the web, film theater, or television. All of these examples vary widely in terms of screen size, quality, and brightness. In print design it's most common to have black text on a white background. This is the most readable way to present large blocks of text, and it uses the least amount of ink. But in

Figure 5.76 White letters on black appear fatter than black letters on white.

screen design, white text on a black background looks bolder and is often easier for the viewer to read. Notice in Figure 5.76 that the white text is stronger and more clearly defined.

Do I look fat in black?
Do I look fat in white?

You may also notice that light text on a dark background can make the type look chunkier, so the letters may need a little more space between them. Screens display images by emitting light, and light tends to bleed at the edges of shapes and letter forms (Figure 5.77). This bleeding makes the text appear even bolder, less precise, and more difficult to read. Adding a little extra tracking to your text can help solve these problems. The bleeding is most noticeable when foreground and background colors clash or are highly contrasting.

Figure 5.77 Beware of bleeding edges when putting white text on a black background.

Light bleeds

You can reduce contrast between the colors you use by bringing the tones closer together but maintaining just enough differentiation between them. Generally, strong colors work better than soft pastel shades on the screen, so if you reduce the contrast by adjusting the luminance of the colors, you might want to compensate by increasing saturation. See Chapter 6 for more information on how to work with luminance and saturation.

Character Properties

When designing for television, you should always design your strokes to be nice and chunky (Figure 5.78). Fine lines become lost and indistinct on the screen, and you increase the chance of interlace flicker when you use very thin horizontal lines.

Figure 5.78 Chunky fonts work well for screen graphics.

CHUNKY STROKES

These characteristics make script and serif fonts, particularly those with ornate details or fine serifs, less suitable for use on the screen (Figure 5.79). Similarly, compact fonts and those with very small counters are equally problematic.

Substantial and open sans serif fonts, which are clear and unfussy, generally work best for screen design. This explains the popularity of typefaces like Helvetica, Arial, Univers, Futura, and Gill Sans in motion graphics design.

Figure 5.79 Highly detailed fonts can be hard to read on the screen.

It's also much more common to use capital in print design. If you use lower case, however, try to use large sizes and bold fonts. The content of text on screen should be served in small, digestible chunks. Keep it short. Fewer than five lines of text on screen at any one time is a good rule of thumb to stick to if possible. This applies even when text is scrolling. You'll notice that even scrolling credits are often separated into groups so the text is easier to digest.

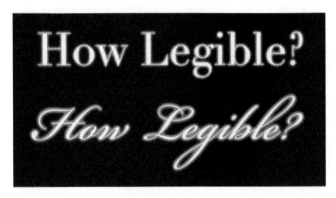

Recap

So there you have it! Of course, there's a lot more you can learn about typography, but this chapter should give you plenty of information to get you started. If you want to expand your knowledge, you can check out the bibliography and our website at *www.motiondesignessentials.com*, where you'll find more information and recommendations for further reading.

Let's recap what we've learned in this chapter. First of all, we covered the basic terminology of typography and its history. You can refer back to this list of terms whenever you need to. Then we looked at how type is constructed—its anatomy, if you will. I hope you felt inspired to think more about text in terms of shapes and patterns after reading this section. You also learned how to use various typographic controls to enhance and customize your designs, making them stand out among the rest. And finally we studied some of the rules of typography specific to motion graphic design. I hope that you now feel confident and able to make informed decisions about typefaces and that you feel inspired to have a go at designing your own typeface. If you do, a website that helps you to easily create a font from your own handwriting is available at *www.fontcapture.com/*.

Figure 5.80 **Robert Hranitzky.**

Inspiration: Robert Hranitzky, Motion Graphics Designer

"I started to draw when I was about six years old, and then started to build everything I could imagine with Legos. While still at school, I started to play around with Photoshop and discovered the endless possibilities when combining creative energy and amazing tools. While studying graphic design, I realized that much more emotions can be created when combining images with motion and sound, so finally I became a motion graphics designer.

"I am very passionate about what I do. No matter where I am, I always strive for something new, either looking for some nice angles when I have my camera with me, or sketching in my sketch book. Sometimes, creativity feels like a demon that just hunts you, and you don't know when the next idea will pop up. In a way, I find it hard to relax sometimes because there is so much inspiration out there.

Figure 5.81 Flashforum Conference. Client: Flashforum. Type: Event trailer.

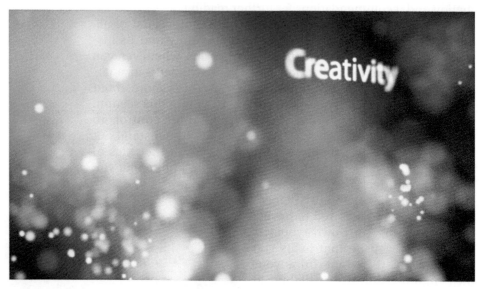

Figure 5.82 Audi R8. Production: ZIGGY mediahouse GmbH. Colorgrading: Scanwerk GmbH. Art Direction: A. Endo, R. Hranitzky. Type: Showroom film.

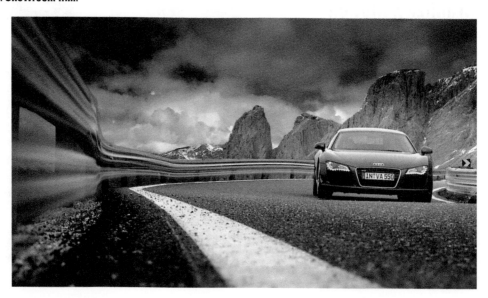

"I have other interests outside my work, I love playing basketball—photography, sketching, and drawing as well. If there is time, I also enjoy playing the latest computer games. Last but not least, I LOVE movies, especially those from Pixar. However, a lot of my hobbies tie into my work, too, so it is difficult to differentiate between work and leisure.

"I don't have time to draw as much as I would like to. Most of the drawing I have been doing recently was project related and not so much in my spare time. I draw more and more digitally, by the way, using my Wacom Cintiq, which allows for a quicker workflow and more flexibility, especially for creating moodframes or storyboards.

Figure 5.83 **Carl Zeiss iLED. Agency: McCann Erickson. Type: Showroom commercial.**

"Everything inspires my work: traveling, nature, friends, and family. If I struggle to come up with something, design books, movies, and the internet offer good inspiration as well. Sometimes if a client or a brief is difficult or tricky, you have to try harder to find something that you and your client will be happy with. Mostly this part of a project is more difficult and time consuming than the actual production.

"I find every single Pixar movie is so inspiring, not just because they continue to improve their animation, look, and overall quality of their work, but especially because they succeed to touch you in a special way that many other (traditional) movies don't do. The latest example would be *Up*. Other than that, any good artist and his/her constant pursuit to create compelling work (no matter if sketches, animations, or designs) is also very inspiring and motivating.

**Figure 5.84 BMW Welt.
Production company: lucie_p
GmbH. Type: Showroom film.**

"I would love to learn more about those little things that I consider my weaknesses—especially those aspects that are not directly linked to visual creativity, like scripting and expressions. Fortunately, I have good colleagues and friends who know these things better than me, so with their help and knowledge, a project setup can be much more effective.

"The work I have been most proud of was my diploma short film *Diona Con Carne*. It was the longest and yet most fulfilling project I have worked on so far. It was my first real 3D animation project, so I had to learn 3D from scratch, but I thought if I don't

**Figure 5.85 BMW Welt.
Production company: lucie_p
GmbH. Type: Showroom film.**

Figure 5.86 **Flashforum Conference: Promo. Client: Flashforum. Type: Event trailer.**

Figure 5.87 *Diona Con Carne.* **Thesis project.**

start learning it now, with my last school project ahead, I might never start doing so. It was such a wonderful experience to see the characters come alive after creating and designing them on the drawing board first. I was almost obsessed by this project—on the one hand the pressure to create a good diploma, and on the other hand my own ambition to create something cool and tell a story. And, of course, always with an uncertain feeling on how it will turn out, since back then I had no experience in creating a complex 3D animation."

6

COLOR

Figure 6.1 © Richard Walker, 2010.

Synopsis

The aim of this chapter is to increase your understanding of how you can make color work in your motion graphic projects. First, you will explore the theories of color by examining the artist's color model. This will allow you to examine characteristics and meanings of individual colors and color schemes, and it will guide you in making informed color choices. I'll introduce you to the RGB color model used in computer software

Design Essentials for the Motion Media Artist. DOI: 10.1016/B978-0-240-81181-9.00013-3

and explain the differences between colors for screen design and those for print design. We'll look at alternative methods for specifying colors based on hue, brightness, and saturation. We'll also talk about color management—how to work with technology to ensure that your colors are displayed correctly across multiple devices. Color is vitally important to every motion graphic designer. It can be used not only to create attractive color schemes to please the eye but also to draw the viewer's attention or add emphasis to your designs. Used intelligently, color can make a good design great.

Introduction

I have an early memory of watching the highly colored graphics in cartoons moving around the screen (Figure 6.2). It was the dynamic and brightly colored graphics that attracted me to them. Color is the first thing to attract your attention, even before the details of the shape of an object. Color can

Figure 6.2 **Cartoons from BBC's** *See You, See Me.* © Angie Taylor, 2004.

convey a mood, and, of course, it makes the artwork more attractive. In order to work with color effectively, you have to understand its power and how to manipulate it. Which colors catch the eye? What kinds of emotional responses do colors invoke? How do colors combine effectively? Color is a central component of design, and it impacts enormously on the audience's reading of an image. Colors have meaning, mood, and cultural associations. A good designer can use color to make his or her designs attractive, but a great one knows how to channel the various layers of color to make the designs stand out and really make an impact.

Inspiration

Color amazes and excites me on a daily basis. Being open and aware of the color you see all around you is one of the things that makes life worth living. Look around and find inspiration from color combinations that occur in both nature and man-made designs. The shifting colors in the long, Scottish summer evening skies, with blues and oranges swirling around each other. The aquamarine color of the sea against the myriad shades of sandy brown pebbles on Brighton Beach (Figure 6.3). The beautiful green forests and deep blue waters of the Canadian wilderness.

Figure 6.3 **Still frame from** *Righton Brighton* **animation** © Angie Taylor, 2008.

These are all combinations that continue to inspire me and make me feel happy inside. In fact, the colors that artists and designers use are taken from nature. Paint was originally mixed from pigments, dug from earth, crushed from stones, or ground from plants and animal matter. Color names are often derived from these origins. For example, burnt umber was originally made from umber clay, and the name "yellow ochre" comes from ochre, another clay that contains mineral oxides that turn it a variety of different reds, yellows, and browns. Cobalt blue comes from cobalt salts.

When I was at art college, I studied painting and learned about the colors and their names. It wasn't easy living on a student grant, and those of us with little money would have to forego yellow ochres and burnt umbers. It was just too expensive to have a complete quota of artist's colors in all the paints we needed: oils, acrylics, and gouache. Instead, I would buy large tubes of the three primary colors (red, yellow, and blue), plus black and white, and mix all of the other colors I needed from these (Figure 6.4). It was much more difficult to get the exact color required, but it really taught me how to "think in color." I can mix virtually any color now from scratch, and it also helps me understand how to mix colors in software applications.

If you weren't lucky enough to have the hands-on experience with color that I have, you may not have developed an instinctive

Figure 6.4 My paint box from my younger days. It's full of paint tubes with exciting, romantic names like raw umber, burnt sienna, ivory black, ultramarine, cyclamen, and crimson. When I opened this box to photograph it, I felt the excited anticipation of painting a picture that I used to feel when I was studying painting. I must get back to it sometime.

Figure 6.5 **One of my artist's paint palettes, used for mixing acrylic paints.**

understanding of color. But no worries—there are other ways of getting to grips with color without having to go buy tubes of paint and start mixing! That's what I hope to pass on to you in this chapter. First, let's get excited about color by looking at the meanings and moods they convey.

Color Perception

Light is the source of all color; where there is no light, there is no color. Ordinary light, such as sunlight, appears to have no color, and we assume that all objects have their own color, not just the light that hits them. This is technically incorrect because it's the light that provides the color; the surfaces of objects only determine how the light is reflected back to us. Let's take a look at how this happens.

White light contains all of the colors. To see them, you can hold a prism up to a light source, and it will split the light into the

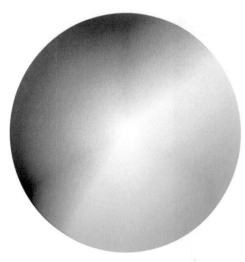

Figure 6.6 The colors of the visible spectrum.

colors of the visible spectrum: red, orange, yellow, green, blue, indigo, and violet (Figure 6.6).

The human eye receives light and interprets color from it based upon the variations in the wavelengths of light rays we see. In general terms, the longest wavelengths make us see reds, and the shortest ones produce violet results. (There are wavelengths longer than red (infrareds) and shorter than violets (ultraviolets) that are out of the visible range, so we can't see them.)

The eye has two types of receptors named rods and cones. These interpret light and, therefore, allow us to see color. Rods are responsible for measuring values of lightness and darkness, whereas cones provide the actual color sensitivity.

Cones are roughly divided into three categories, with each group recognizing a different primary color when light hits them (red, green, and blue). Of course, we can distinguish millions of colors when these receptors combine their results. Our eyes cleverly build each of the perceived colors by mixing differing amounts of red, green, and blue (from the cones), together with the brightness information from the rods. Light, and therefore color, can get to these receptors in one of three ways:

• Direct color is generated from a light source, such as the sun or fire. These emit wavelengths directly into your eyes.

• Transmitted color occurs when a light source passes through a semitransparent colored material, such as a color filter or a stained glass window. The filter will absorb some of the wavelengths, only allowing certain ones to travel through to your eyes.

• Reflected color happens when light bounces off a physical object before being received by the receptors in your eyes. The surface properties of the object determine which wavelengths will be absorbed and which will be reflected. The surface of a green leaf will absorb all the wavelengths of the color spectrum, except green, which it reflects back to you; this is why you see a leaf as green (Figure 6.7). White surfaces reflect back all the wavelengths in the spectrum (Figure 6.8). Black surfaces reflect none of them (Figure 6.9).

The color of an object can be influenced by more than one of these. For example, if you shine a white light onto a green leaf, you will see green, but pass the light through a colored filter, and the perceived color of the leaf will change.

It's interesting to speculate whether all people see color in the same way. How do we know my red is the same as your red? It could be that everybody sees color differently. It's a known fact that people with color blindness see color differently from most

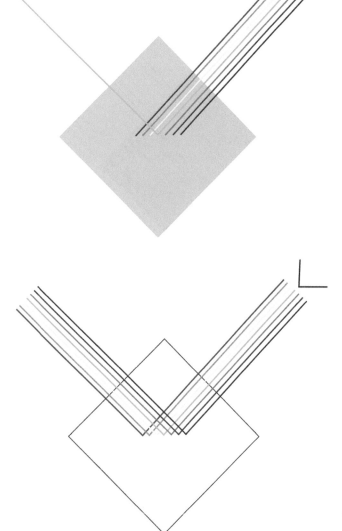

Figure 6.7 A green surface is absorbing all of the wavelengths in the color spectrum except the green ones, which bounce off the surface and are received by our eyes.

Figure 6.8 A white surface is absorbing none of the wavelengths in the color spectrum.

people due to a lack of color receptors in their eyes. It may be the case that subtle differences in color receptors can cause us all to see something slightly different when we look at a color, but I suppose we'll never really know for sure because we can't look through one another's eyes. But what we do know is that the frequencies that red produces make us feel a certain way. We still describe red as red and will associate that color with certain things. Response to color is a highly personal and subjective thing, but we can make some generalizations about colors, what

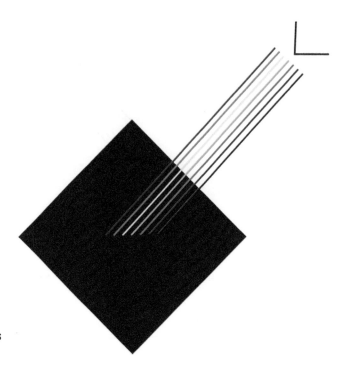

Figure 6.9 A black surface is absorbing all of the wavelengths in the color spectrum.

they mean, and how they work together. This results in proven color theories, which are useful tools to you as a designer when making color choices.

Color and Meaning

Colors have strong associations that we absorb subconsciously. It's easy to make something stand out with clever and considered use of color. But remember that people respond emotionally to color, and the response can be different from person to person or across cultures. Because of this, you need to be careful when choosing colors for anything that will be viewed internationally, like a website. Take wedding dresses as an example. In Europe and North America, they are generally white, which represents simplicity, purity, and virginity. In India, red represents those same virtues, and you will see red wedding dresses because of this. You can see how color can have opposite meanings depending on who is viewing them; this is especially important in today's global economy. Always keep this is mind as you design with color.

Color associations can also change over time. Think of the color green and how it is used to symbolize wealth and money. Today, however, it symbolizes the environment to such an extent that the term *green* is used to describe the ideals and politics that are focused on ecology and creating a caring planet (Figure 6.10).

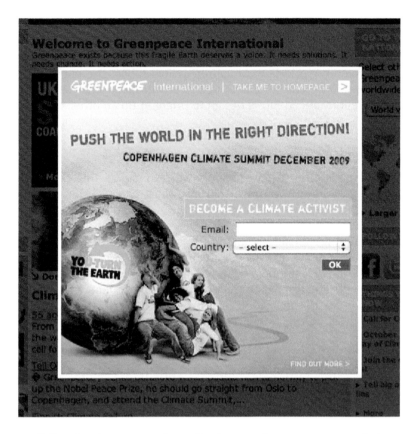

Figure 6.10 Organizations like Greenpeace have successfully changed the implied meaning of the color green to represent environmental issues. Screenshot of the Greenpeace website reproduced with the kind permission of Greenpeace (*www.greenpeace.org/international*).

Following is an overview of colors and common associations for each in a variety of cultures. Refer to this section as you think about how to effectively communicate using color in your designs.

Red

Red is a stimulating color that can dominate a design if not used with caution, but because of this, it's also great for attracting attention. Red can represent heat, fire, love, passion, blood, anger, and revolution. It was the chosen color of the Communist Party. Left-wing socialists are often described as "reds." In the United Kingdom, red is the color of the left-wing Labor Party, whereas in the United States, it's the color of the right-wing Republican Party. Use red to highlight important elements in your designs and to draw the viewer's eye.

Yellow

Yellow is highly visible and bright, particularly when set against black. The combination of yellow and black is common in nature (bees, wasps, snakes) and is used as a warning against stings or bites. Yellow can represent sunshine, brightness, happiness, and

optimism, but it can also represent cowardice, betrayal, or illness. In the United Kingdom, it is used by the Liberal Party, so it has middle-of-the-road connotations. In Buddhism, yellow is the most revered color; Buddhist priests wear saffron yellow robes. The good thing about yellow is that it tends to mix well with most other colors, so it can be introduced into a design to brighten up an otherwise dull image.

Orange

Orange is often used to signify warmth, suggesting the coziness of gathering around a roaring fire. It can also be seen as energetic, cheerful, and brash. Orange is the color used to represent Protestantism because it represents the House of Orange and, more specifically, William Orange. It's the color of several democratic political parties, including some in Canada and Kenya. Orange is the best color to use if you want your designs to come to life and appear energetic and healthy. It blends the rebellious of red with the friendliness of yellow to create an interesting but convivial color.

Blue

Blue can signify cold, winter, clarity, liquid, or ice. It suggests cold temperatures and can also be used to demonstrate emotional coldness and detachment. It is usually considered to be a peaceful and calming color. It is also a metaphor for sadness, hence "singing the blues." As with red and orange, it can mean very different things politically speaking. In the United Kingdom, blue is the color of the right-wing Conservative Party, whereas in the United States, it's the color of the left-wing Democratic Party. Use blue in your designs when you want them to be fairly conventional and widely accepted. Blue is what I consider to be a safe color to use in many situations, but you may want to combine it with a warmer color to give the design some character.

Green

Green represents nature, growth, renewal, or fertility, but it can also evoke feelings of nausea and envy, and it has been used to represent evil, witchcraft, and decay. Green represents safety when used in traffic signals to tell drivers it's safe to proceed. It's also used by doctors and ambulances with their flashing lights. Green also represents Celtic cultures; in Ireland and Scotland, it represents Catholicism and republicanism. It has also been adopted to represent the environmental movement. Green is another universally acceptable color; most people are

happy to look at greens for a long period of time, so it's a good choice as a background for large bodies of type (in a website, for example).

Purple

Purple is a regal color, representing aristocracy, luxury, rank, bravery, wealth, and excess. It can also suggest pomposity and conceit. It's considered to be quite campy and slightly eccentric. Jenny Joseph's humorous poem about old age starts with the line "When I'm an old woman, I shall wear purple." It's often worn by larger-than-life characters like Prince or Jimi Hendrix, and it is a favorite color for goths and emos. Probably because of these associations, it's not often used in politics and tends to be adopted by fringe parties who are late to join the political race, like the United Kingdom Independence Party. Use purple when you want your designs to be a little daring and exciting; it works well combined with reds and blues because it is made up of a mixture of those two colors.

Pink

Pink is the color we all associate with girls, toys, dolls, and makeup. It is essentially feminine and is often avoided like the plague by big, rugged men. As a result, it has been adopted as the campiest of colors and is used widely by the gay community in the form of a pink triangle. This is partly to take ownership back from the Nazi Party, who used a downfacing pink triangle to mark out homosexual men in concentration camps. What was originally designed as a badge of shame has been turned upright to represent gay rights and pride. Pink has been out of fashion for a long time, but recently it has seen a resurgence in popularity. I love pinks, and I think they can be used to very good effect, particularly when combined with blues and grays. The contrast of camp pink with conservative blues can create a real sense of drama and excitement.

Black

Black is formal, powerful, elegant, mysterious, and sophisticated, but it also stands for darkness, space, night, emptiness, depression, death, and mourning. In the Western world, funerals are surrounded with people dressed in black. Goths and punks wear a lot of black because of this association with death and horror. It's often used to represent something unconventional or rebellious. The Anarchists flag is predominantly black, as is the pirates' Jolly Roger flag. The Italian Fascist movement the Black-Shirts used black, as did Hitler's SS officers. The Nazi Party used

a black triangle to mark out "antisocials" in the concentration camps. These people included the mentally ill, alcoholics, prostitutes, and lesbians. The upturned black triangle has now been reclaimed and is used by lesbians as a symbol of pride in the fight against prejudice and discrimination. As a neutral, and used as a background in design, black makes other colors stand out and look brighter.

White

In the Western world, white represents purity, innocence, virtue, truth, empowerment, and sacredness. White has also been used to denote cowardice in the form of a white flag to signal a surrender. White doves are a sign of peace. John Lennon and Yoko Ono dressed their bedroom in white for their famous Amsterdam bed-in, where they campaigned for world peace. It is the color of wedding dresses in many European cultures but is the color of mourning in much of Asia. The pope wears a white robe, and white clothing is worn in Mormon temples. As a background in design, it creates open space for other colors and designs to sit in. It also suggests simplicity and provides a great background when you want to suggest limitless space.

Gray

Gray can represent industry; it is neutral and modest but it can also be interpreted as boring. Gray can suggest old age and conservatism. But gray can be used in combination with color to create a very classy effect. It can be used to good effect to neutralize or give a solid base to brighter, more vibrant colors. Adding a gray background to a design consisting of pastel colors can bring the pastels to life.

Given this complex mix of mood responses and cultural associations, you need to keep your audience in mind when you pick your colors. Cultural associations can shift, so the meanings of colors are not necessarily stable and fixed. Color preferences will vary with the age, background, and gender of your audience. Make sure you keep this in mind when choosing colors for your designs. It's not just about what colors you like or which colors excite you; you need to put yourself in the shoes of your audience and clients. It's quite common for a client to attempt direction regarding color usage. If they have corporate colors, then you'll probably be forced to work with these, but if there are no set restrictions, it is useful to discuss choices and to educate your clients on the best choice of color for their needs.

Try using this chapter as a reference when explaining the meanings and science of color to them.

Gender can also play a part in color preference. It seems to be the case that softer colors are used when women are the target market, and men are assumed to respond to stronger, brighter colors. Obviously, not everyone fits into these stereotypical categories, but sometimes you're forced to work along with conventions and stereotypes in order to ensure that the maximum number of your target audience will respond to your designs. It's hard to determine for sure whether there are true, inherent differences in color perception between the sexes and, if so, whether they are due to nature or nurture.

An understanding of the meanings colors carry will influence your color choices. It will also help you enormously to understand how to put these colors together in combinations that can convey a more complex and considered message to your audience. In order to fully grasp why certain color combinations work and others don't, it's essential for you to understand color theory.

The Artist's Color Model

The colors we see around us every day can be reproduced by several methods. Colors can be recreated using paint, ink, or, as in the case of computer displays, light. Your first experience of mixing colors was probably in your art classes at school. At the beginning of this chapter, I told you about my days at art college, mixing the primary colors to create the full range I needed for my paintings. In painting, the primary colors red, yellow, and blue, along with the neutrals, black, and white are the foundations that all other colors are made from.

Many systems (called color models) have been developed to enable us to define a set of colors that can be created from a small set of primary colors like this. The one used in schools and painting classes is the artist's color model (also known as the RYB color model). I still find this the most useful model for teaching color theories and for studying my own ideas for color combinations. In the artist's color model, the three basic primaries, from which all of the other colors are made, are red, yellow, and blue.

Figure 6.11 is a color wheel based on the artist's color model, showing the full range of colors. This is a tool designers use for working color schemes. I'll be using the color wheel to analyze the characteristics and relationships of colors throughout this exploration of color theory.

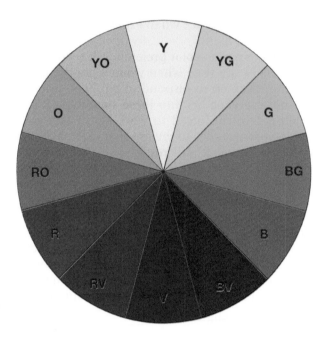

Figure 6.11 **The 12 basic colors that make up the color wheel.**

Primary Colors

Figure 6.12 expands the three artist's primary colors of red, yellow, and blue. These colors are pure, meaning that all the other colors on the wheel are made by combining these three primaries in varying amounts. But the primaries cannot be created by combining just any of the other colors. This is why they are referred to as the primary colors; they are the basis for all other colors.

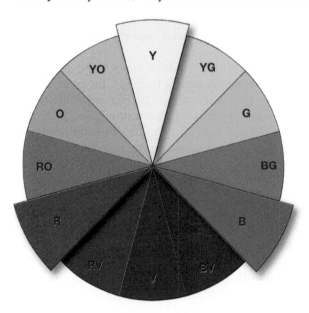

Figure 6.12 **The primary colors: red, yellow, and blue.**

Secondary Colors

The primary colors are likely to have been the colors you used when painting as a child in school. You probably mixed red and yellow to make orange, yellow and blue to make green, and blue and red to make violet (which most of us refer to as purple). Orange, green, and violet are the secondary colors, that are produced by combining two primaries in equal measure (Figure 6.13). These colors are complementary to the primary colors because they are each directly opposite one of the primaries. For example, orange is the complementary color for blue because it is opposite on the wheel. Green is complementary to red, and yellow is complementary to violet. You'll learn more about working with complementary colors later in this chapter.

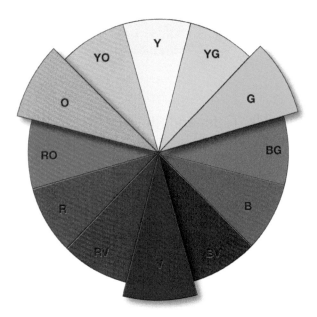

Figure 6.13 **The secondary colors: green, orange, and violet.**

Tertiary Colors

The tertiary colors are created by mixing a primary color and a secondary color in equal measures. These tertiary colors have double-barreled names like yellow-orange, red-orange, red-violet, blue-violet, blue-green, and yellow-green (Figure 6.14).

You can continue to mix secondaries and tertiaries with themselves, with each other, or with the primaries to make other variations in color, but for the purpose of understanding color, it's best to start with the 12 colors you see on the color wheel. You'll be amazed at just how many combinations you can achieve with just these and the neutrals.

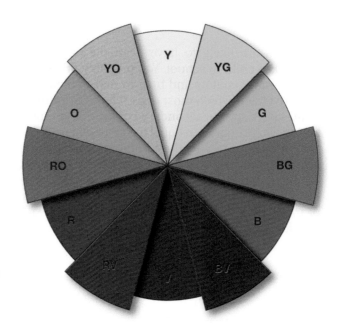

Figure 6.14 The tertiary colors: yellow-orange, red-orange, red-violet, blue-violet, blue-green, and yellow-green.

Neutrals, Tints, and Shades

Black and white are known as the neutrals (Figure 6.15). Mixing these together in varying amounts creates all of the shades of gray in-between. These can be mixed with the colors from the color wheel to lighten or darken them. When you add black to a color, you create what's referred to as a shade. Adding white to a color will create a tint. Using this method, you can create millions of other colors. Now you know how to use the color wheel to identify colors and the relationships between them. Let's look at how we can figure out which color combinations work well and which don't.

Figure 6.15 The neutrals include all of the shades of gray, including black and white.

Color Theory

The aesthetic quality of your chosen color palette is, to a certain extent, subjective, but color theory provides you with rules that can help you make informed choices. You will certainly use your instincts and knowledge of colors and their common

cultural associations when you choose colors, but you can also use color theories to guide these decisions. These theories highlight the effect of certain color combinations. You were just introduced to the 12-step color wheel, and we will use it again here as a planning tool for your choices of color schemes. The following schemes will help you visualize color relationships before you combine them in your designs. We'll start with the simplest color scheme: monochromatic.

Monochromatic

The monochromatic color scheme is made up of a single color that uses the neutrals to add variations in terms of contrast, lightness, and darkness (Figure 6.16). This scheme looks clean and elegant, and it is very easy to work with. There is no risk of creating clashing colors because the tints and shades are guaranteed to go well together. The monochromatic scheme is very easy on the eyes, especially if you choose either a blue or green hue. However, there are disadvantages to using this color scheme. As you can imagine, it can be difficult to highlight the

Figure 6.16 The monochromatic color scheme applied to an illustration.
© Mark Coleran, 2010.

most important elements without any additional colors. It can suffer from a lack of color contrast and is not as vibrant as some of the other schemes.

Analogous

The analogous color scheme typically uses three colors that are adjacent to one another on the color wheel (Figures 6.17 and 6.18). For example, yellow-green and yellow-orange can be used in combination with yellow, which acts as the dominant hue, and

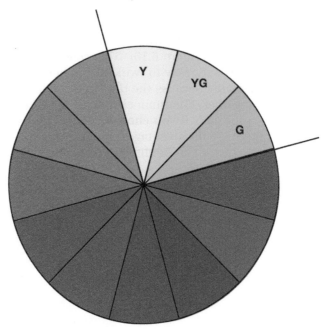

Figure 6.17 **The analogous scheme highlighted on the color wheel.**

the others are used to enrich the scheme. It's common for the purest color to get the emphasis in analogous schemes. In this case, yellow is the purest color, since it has not been diluted by mixing it with another color.

Analogous color schemes tend to work best when one of the colors is a primary color. They are low in color contrast, so they are usually calming, unified, restful, and introspective. The analogous scheme is similar to the monochromatic one, and it is just as easy to create. The benefit over monochromatic is that it offers more opportunity to highlight certain areas with accent colors. You should avoid combining warm and cool colors in this scheme. Endeavor to stick to all warm or all cool colors. Warm colors are those on the left side of the color wheel (including reds, yellows, and oranges), and cool colors are on the right and include green, blues, and purples.

Figure 6.18 **The analogous color scheme applied to an illustration.** © Mark Coleran, 2010.

Complementary

Complementary colors are color pairs that are directly opposite each other on the color wheel. Take orange and blue as an example (Figure 6.19). Combining complementary colors creates vibrant, lively color schemes that are at the same time harmonious. The complementary color scheme is very good for drawing attention. It allows you to put very different colors next to each other but still retain a sense of balance. You can also use a hot color against a cold one—for example, red with green or orange with blue.

When using the complementary scheme, it's important to make one color more dominant than the other, using

Figure 6.19 **The complementary color scheme highlighted on the color wheel.**

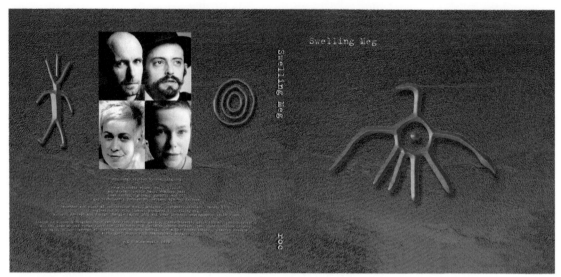

Figure 6.20 A complementary color scheme on a CD cover design. © Angie Taylor, 2000.

Figure 6.21 The split complementary color scheme.

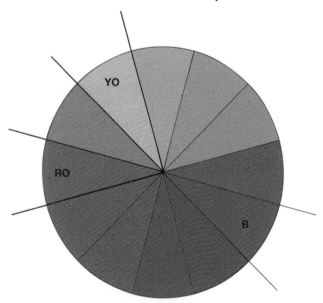

the less dominant complementary color for accents. You can do this by having more of one color than the other or by creating more vivid versions of one color than the other. For example, if you use a warm color as an accent, you can desaturate the opposite cool colors to increase the differences between the colors, creating a sense of contrast. You should avoid desaturating warm colors too much (e.g., dullish browns, reds, oranges, or yellows). In Figure 6.20, I have used my favorite combination—orange and blue—but you can choose any two opposite colors and all the shades of those colors in your scheme.

Figure 6.20 shows a CD cover I designed that uses a complementary color scheme of orange and blue. Notice how I've used orange for the symbols that I wanted to be the main, energetic focus. I've used blue for the more neutral background.

Split Complementary

A split complementary color scheme is based upon three colors. Instead of pairing a color with its complement, you use a dominant color from one side of the color wheel and the two colors on either side of its complement (Figure 6.21). This reduces the tension of complementary pairing and introduces an element of calming. The result can be more sophisticated and subtle than a straight complement.

Figure 6.22 **A split complementary color scheme applied to an illustration.**
© Mark Coleran, 2010.

The split complementary scheme is harder to balance than the other schemes, but it offers more variety than the complementary scheme while retaining a strong visual contrast. There are no rules to say that you need to include a primary color in the combination, but I think it's easier to make it work if you use a primary color as the dominant color (Figure 6.22).

Triadic

The triadic scheme combines three colors that are equally spaced around the color wheel. This combination offers strong richness of color (Figures 6.23 and 6.24). A triadic color scheme can be made out of the three primaries, or you can shift the selection around the color wheel to find other combinations. It can be quite hard to make triadic combinations work. It helps if you can adjust the lightness and saturation to soften the tones of the color. To help make this scheme work, you can try choosing one dominant color to be used in larger amounts than the others. If the colors look too gaudy, you can make the nondominant colors less vivid by adding a little black (to darken) or white (to lighten).

Figure 6.23 The triadic color scheme.

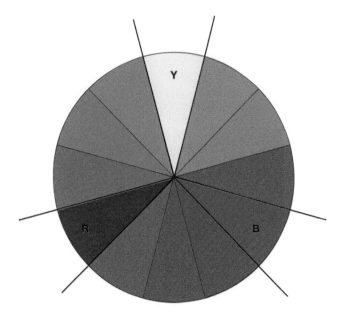

Figure 6.24 Lokesh Karekar's illustration _5star_ uses a triadic color scheme of red, yellow, and blue. © Lokesh Karekar, 2009. Locopopo Design Studio (_www. locopopo.com_).

Clashing Colors

Clashing color schemes are not often advisable to use unless you want to provoke a strong reaction from the viewer. Used intelligently, a clashing color scheme can create a dynamic, energetic effect, but you really need to know what you're doing and understand how to balance the colors correctly. This will come with practice. To create a clashing color scheme, you simply match a selected color with one of the colors on either side of its complementary color. In Figure 6.25, yellow is my chosen color. Violet is yellow's complementary color, so to create a clash, I'll combine it with either blue-violet or red-violet. (You may have noticed that the two colors highlighted are from the split complementary scheme. Good for you if you did!) A clashing color for our key color, yellow, could be either red-violet or blue violet.

There are other color schemes available, but try to get a good understanding of these basic schemes before attempting the more advanced and harder to manage schemes. There are plenty of resources listed in the bibliography that will help you extend your repertoire.

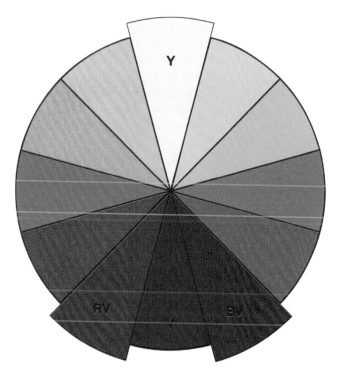

Figure 6.25 **The clashing color scheme.**

Digital Color Models

Colors that are produced digitally can be described based on certain color models just like the artist's color model. You may have heard the terms *CMYK* and *RGB* before; these are the most popular color models used in software applications to describe colors. CMYK is used in print publishing and therefore is not covered in depth in this book. It is used to explain colors reproduced with ink, paint, or other pigment-based mediums (cyan, magenta, yellow, and black). This is known as a *subtractive* color model, which refers to the fact that the combination of colors tends to darken the result and will eventually produce black if enough colors are added together. Notice that the combination of all three colors creates black (Figure 6.26).

RGB is the most common color model used to describe colors for anything that will be viewed on a screen (Figure 6.27). When working with images for your motion graphics projects in applications like Photoshop or Illustrator, you should make sure to work in an RGB color space, not CMYK. This can be selected in the document setup options.

Figure 6.26 **The CMYK subtractive color model.**

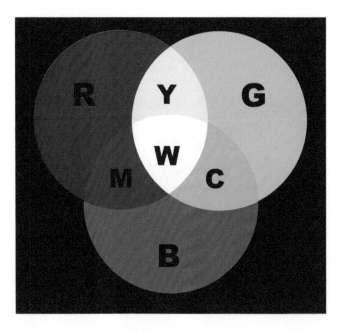

Figure 6.27 **The RGB additive color model.**

The RGB model is used in digital imaging and computer displays that use light to transmit colors. Human sensitivity to light was used as the basis for the creation of this model. As we discussed earlier, red, green, and blue are the primary colors of light, and just as with other primary color systems, differently proportioned mixtures of these three make all of the other visible colors. Notice in Figure 6.27 that mixing together maximum values of red light and green light produces yellow light. Notice also that yellow is a lighter, brighter color than either red or green, which is an indication that the colors lighten as the primaries combine. If you add together maximum amounts of all three RGB primaries (red, green, and blue), you will produce pure white. Black happens when there is an absence of light and therefore color.

Computer displays and TVs use light to display images, so the primaries used for screen design are also red, green, and blue. As with the artist's primary color model that we explored earlier, the mixing of the three primary colors (of light—in this case, red, green, and blue) can be mixed to make all of the possible colors.

The RGB values are contained in three color channels within the image. RGB colors are represented numerically, where the numbers refer to the amount of each color. The number 0 means there's no color present, and 255 represents the maximum value for that channel. An RGB color is represented by three numbers: one for red, another for green, and then finally blue. Pure red is measured as 255, 0, 0 (Figure 6.28); pure green is 0, 255, 0; and pure blue is 0, 0, 255. White has the maximum amount of each color, so it has a value of 255, 255, 255 (Figure 6.29). Black has zero color and is represented by a value of 0, 0, 0 (Figure 6.30).You can find out more in-depth information about channels in Chapter 9.

Figure 6.28 **RGB value 255, 0, 0 makes red.**

Figure 6.29 **RGB value 255, 255, 255 makes white.**

Figure 6.30 **RGB value 0, 0, 0 makes black.**

Hue, Saturation, and Brightness

Although your images are made up from RGB channels, there are alternative methods you can use to measure or choose your colors. My favorite is the HSB color model. This allows you to choose or mix colors by defining values for hue,

Figure 6.31 **The RGB color panel and the HSB color panel.**

saturation, and brightness. Most software applications allow you to choose between RGB and HSB as methods for describing colors. In Adobe® applications, this choice is made in the color panel's wing menu or in the color picker dialog box. In Figure 6.31, you see two color panels. The first one measures the color, using RGB values. The second measures exactly the same color, using HSB values. Both result in the same color; it's just the method used to describe the color that is different.

The three key properties that combine to make a color are hue, saturation, and brightness. The terms *color* and *hue* cause a lot of confusion, and they are often used interchangeably, but there is a subtle yet important difference.

Hue

Hue refers to the essential, pure, core component of a color, with no adjustments in terms of lightness and saturation. In Figure 6.32, all of the nine colors displayed share the same hue but have different amounts of saturation and brightness. It's the changes in saturation and lightness that set them apart as different colors.

Figure 6.32 **All of these colors share the same hue.**

However, a minute shift in hue, with no change in saturation or brightness, can also create a different color. If you were to split the color wheel into increments measured by degrees, then there are 360 possible hues in the full RGB color spectrum (Figure 6.33).

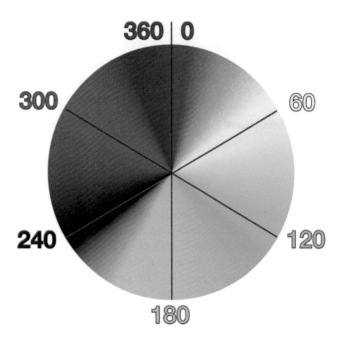

Figure 6.33 360 degrees of hue in a color wheel.

Brightness

Brightness refers to the lightness or darkness of a color (Figure 6.34). Brightness is adjusted by adding the neutral black to the pure hue. An example of this could be adding black to red to create maroon.

Figure 6.34 Pure hues mix with white to lighten (making tints) and with black to darken (making shades). Here you see different shades of red (created by mixing black with the pure red hue).

Saturation

Saturation refers to the intensity of a hue. If we go back to the analogy of the painter mixing colors, they would desaturate the color by adding water, making the color weaker (Figure 6.35). Pure colors are at full saturation, and colors are at their most vivid and active when they're fully saturated. Saturation is usually measured by percentage. Notice how the colors appear to get lighter as they become increasingly desaturated (Figure 6.36).

Adobe Creative Suite software allows you to choose from the whole range of hues, tints, shades, and tones in the color picker. In Figure 6.37, the Photoshop Color Picker demonstrates

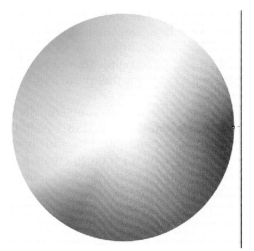

Figure 6.35 **The color wheel with all hues fully saturated at the circumference. They become less saturated toward the center axis, where the colors become completely desaturated to white.**

Figure 6.36 **Tones of green range from fully saturated to fully desaturated.**

Figure 6.37 **The Adobe Color Picker.**

this flexibility. The slider on the right-hand side allows you to choose the hue. The large square area provides you with brightness adjustment (from top to bottom) and saturation adjustment (from left to right). This allows you to select all the tints and shades available for that particular hue, from pure black to pure white.

You may be asking yourself, "So when do I use RGB controls and when do I use HSB?" Well, there are no set rules; you use whichever method suits your particular needs. Let me give you an example. If I want to create a pure red, then I would use RGB because all I need to do is adjust the red value to 255 and reduce the green and blue values to 0—easy! However, if I want to reduce saturation of a color, then I'd choose HSB, since it allows me to do it with one slider instead of adjusting three sliders (which you'd have to do to reduce saturation using RGB). I would also tend to opt for HSB when I want to be more experimental with color and perhaps choose it more instinctively, since, for me, it's closer to the analogy of paint mixing than RGB.

Adobe Illustrator has a great new tool built into it called the Recolor Artwork/Edit Colors tool. It allows you to select a piece of artwork and recolor it using an interface designed specifically for that purpose. It provides you with lots of different options for editing the colors either selectively or in groups. You can choose RGB, HSB, and other color models. You can change colors based upon color theory examples—for example, quickly and easily apply a monochromatic or complementary color scheme to your artwork. In Figures 6.38 and 6.39, you can see the original artwork and then the same artwork with an analogous color scheme applied to it.

Figure 6.38 Illustrator's Recolor Artwork/Edit Colors tool, original.

Figure 6.39 **Illustrator's Recolor Artwork/Edit Colors tool, analogous color added.**

Making It Work

Now that you've learned about color schemes and the individual components of color, you should have a good understanding of how to incorporate the right colors into your designs. You can now use your understanding of the relationship among colors in a very practical way to build your own favorite schemes. Start by choosing one key color for your design. This could be a corporate color, your client's chosen color, or a personal preference.

You can also consider what colors their competitors are using. You don't want to accidentally use a color that will cause your client problems with marketing and communications. What are the perceived tastes and preferences of the target audience? Think about the message you're intending to convey and the audience you're aiming to reach to decide whether your scheme needs to be dynamically contrasting, subtly harmonious, or somewhere in-between.

Having made these decisions, you can build your own custom palette based around this key color. Compositions consisting of a restricted range of hues are generally more coherent than those that use a wide range of hues. To begin, try limiting the number you use in each design to a maximum of three. Remember that you can introduce plenty of variety by adjusting the saturation and brightness to create different tints and shades of color.

Adjacent Colors

Besides thinking about which hues, shades, and tints to choose, you need to think about which ones are adjacent in your design. The relationship a color has with its nearest neighbor impacts on the perception of its characteristics. Colors can

Figure 6.40 Notice how the red is stronger against certain colors.

appear to vary in intensity when the background changes into white, black, and other colors. For example, Figure 6.40 shows that the red color seems more brilliant against black, white, or its clashing color green than it does against midgray or a neighboring color from the wheel. Think about this when you choose your background colors, do you want objects to blend in or stand out?

Color Blindness

Color blindness limits people's color perception. Some with this condition find it difficult to distinguish red from green or blue from yellow. You should try your best to make allowances for color-blind viewers by exaggerating the differences in hue, saturation, and brightness of adjacent colors. Tend more toward complementary color schemes than analogous ones, put dark colors against light backgrounds or light colors against dark backgrounds, and avoid red/green or blue/yellow schemes.

Color Difference

Widening the difference between colors can help to make an object stand out in your composition. When the color values are too close to each other, an object can recede into the background. Outlining can be a useful device for drawing attention to a particular object in a design if it does get lost against a background, but you need to be careful, since this can impact on color relationships. In these cases, the outline creates a boundary by becoming the adjacent color to both the object and the background. In Figure 6.41, notice that the first two examples are lost against their backgrounds, whereas the outlines in the second examples are much bolder.

Figure 6.41 Notice how the outlines define the colors more strongly.

Color Rhythm

You should aim to create rhythm in your designs using color. Areas of color create visual interest and draw the eye in. Areas of space (which might be white, black, or a solid-color background) are restful to the eye. It can be pleasing to arrive at a repeated, and therefore expected, color element. Experiment with the rhythm of colors by leaving space between colors and repeating colors at even intervals. Notice how in Figure 6.42 the same red is repeated at regular intervals to pull all the other colors together successfully.

Figure 6.42 In *Chaitime,* by Lokesh Karekar, the red pulls all the other colors together. © Lokesh Karekar, 2009. Locopopo Design Studio (*www.locopopo.com*).

Color and Temperature

As we discussed earlier, colors on the left of the color wheel are hot and active, while colors on the right are cold and passive. Reds, along with yellows and oranges, are good to use for elements that you want to stand out in your designs. Figure 6.43 shows an image designed using reds, oranges, and yellows, the colors of India.

Blue and green can suggest coolness in terms of both temperature and emotion. Blue is associated with feelings of restraint and reserve, and this emotional distance is echoed in a sense of physical distance, since blue objects in your designs can appear to recede away from you. Figure 6.44 shows another image by Gordeev of an arctic environment that uses blues and greens.

Figure 6.43 Andrey Gordeev's India image uses the warm, holy colors of India: red, yellow, and orange. © Andrey Gordeev, 2009 (*www.behance.net/Gordei*).

Figure 6.44 Andrey Gordeev's Eskimo image uses the cool colors of the Arctic: blues and greens. © Andrey Gordeev 2009.

Color Management

My intention here is to raise your awareness about color management. I'm not, however, going to explain the complex world of color management in its entirety. There are plenty of excellent resources listed in the bibliography that you can refer to if you need more details. This is an overview of what color management does and why. Consider it a practical guide to get you familiar with the concepts of color management for motion graphics.

Color Space

The color space is the environment you work with in your software applications. The first choice you make in applications like Photoshop or After Effects is which color mode to work in. For motion graphics, you should always work in RGB mode. As we've seen, the RGB color model contains all the millions of possible colors that can be achieved by mixing RGB. But not all of these colors can be displayed accurately on a television or on the web. In fact, each output medium may be capable of reproducing a completely different subset of colors than the other.

A color space is a defined subset of the RGB colors that can be reproduced in a particular area of production. For example, the HDTV (rec. 709) color space should be used when outputting footage destined for HD viewing. SDTV NTSC should be chosen if you are outputting for standard definition broadcast in the United States. SDTV PAL should be chosen if you are outputting for standard definition broadcast in Europe. Working in a color space means you avoid choosing colors that won't work when outputting to the final viewing destination. If you want to study this subject further, there's a great article on color space conversion here at *www.cambridgeincolour.com/tutorials/color-space-conversion.htm.*

Gamut

Gamut is the term that describes the range of colors that can be reproduced by a particular device or a particular system. For example, pure red (255, 0, 0) can be displayed on a computer monitor but will not be reproduced accurately on a standard definition video monitor. The reason for this is that broadcast color spaces like the HDTV (re. 709) 16–235 limit colors to luminance values between the broadcast safe limits of 16–235. So any colors outside that range will be considered out of gamut. In Figure 6.45, you can see gamuts for PAL and NTSC, as well as the different flavors of RGB. Any colors outside these contained areas would be considered "out of gamut" for the particular color space.

Figure 6.45 The full color spectrum represented on a graph as a color space. The highlighted triangles represent the colors available within the gamut of each color space.

Color Consistency

Color management allows you to handle footage and assets from a range of different input devices (like scanners, cameras, etc.) and ensure that the colors remain consistent across all of the other devices used in the production process. These can include hardware devices (like computer monitors or printers) but also software. It's important that the deep red you see in Photoshop is the same deep red you see in After Effects and on the television screen it will be broadcast on. Color management means that colors are assigned specific numeric values and hardware is assigned a profile. The software then performs the appropriate conversions to ensure that the color's appearance is maintained across the workflow. The next section discusses how the software intercepts and manages these conversions.

Color Profile

Software like Photoshop and After Effects will build a profile for each device in your workflow from input to output, based upon your chosen working space. This profile is embedded into any images or movies that you produce using the software. Once you have this profile, the software endeavors to show you the same

colors on each device. Adobe uses ICC color profiles (International Color Consortium) to do this. If the color profile of the input device is attached to an asset, then a color management system can use the information embedded in it to maintain the appearance of particular color values when they are sent to another device. The software looks at the embedded profile of the file (to determine color space), and it also looks at the profile of the hardware device (like the monitor) and makes the appropriate conversions.

Image editing, video editing, and motion graphics software will allow you to work with the embedded ICC profiles contained in your assets, or to assign profiles that you have stored, and to identify the profile of the output device. If you import or open assets that have existing color profiles (perhaps created by others), the software can either maintain its original color space or convert it to the project's working color space. One limitation of color management is that you don't always know the specific output device for a particular project. If your work is for web delivery, DVD, or broadcast, you do not know what computer, DVD player,

Figure 6.46 **The color settings dialog box in Adobe Photoshop.** This is where you can set up your working space.

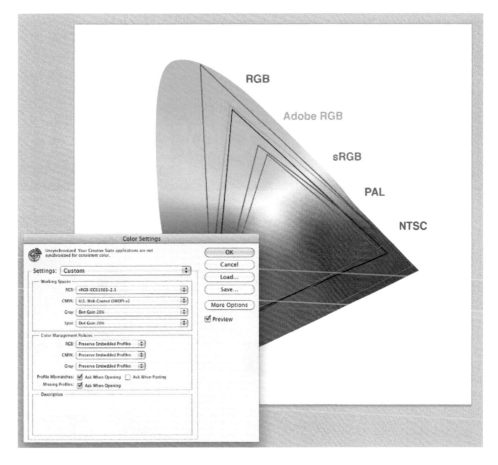

or TV will display it. But have no fear; you can use color management to test your colors in a range of generic conditions by simulating output for different media such as cinema or broadcast. To try and minimize the impact of the wide variety of conditions your work will be displayed in, you can choose one of the generic profiles such as ProPhoto RGB, which is a good general purpose color space for video and animation workflows.

Monitor Calibration

Successful color management relies on a well-calibrated monitor. Calibration is the process of checking a device against a set of standards to create a profile. There are a number of software and hardware solutions for calibrating monitors. A *colorimeter* is a device that measures the color output from your monitor and builds a profile for it. I am a big fan of the Color Munki products (Figure 6.47). It's worth investing in a calibration device like this, but if you can't afford to, then at least use your built-in system software to calibrate your monitor and create a profile.

Figure 6.47 Colormunki calibration tools (*www. colormunki.com/***).**

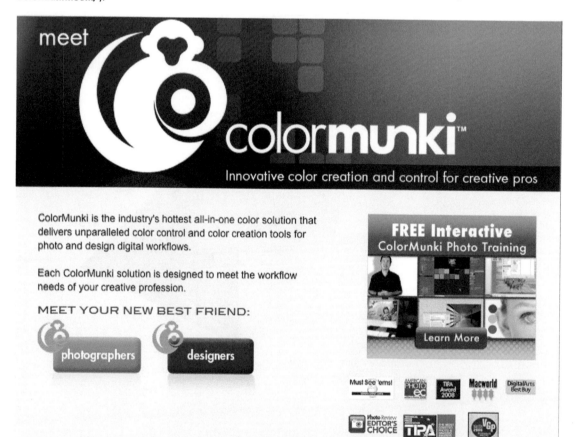

Remember to always test your output as widely as possible, and adjust it where necessary. Test web output on both Macs and PCs, test on a range of monitors, and try varying the brightness and contrast to see whether your color palette is still distinct and readable. For broadcast, you should always preview your work on a professional monitor to check that the colors accurately display on the TV screen. If you don't test, you may be embarrassed to discover that your initial color choices, which looked great on your computer monitor, look muddy and horrible when broadcast. Don't let a fairly straightforward technical process frighten you off from color management. Use the software's own online help system to guide you in setting this up so your whole workflow is managed properly. You can also refer to the bibliography for more reading material regarding color management.

Color Correction

Color correction (also known as grading in the world of motion graphics and film) is the term used to describe the process of adjusting color to match shots or simply improve the "look" of a piece of video or film. The two types of color correction are primary, where the whole image is given a color treatment using various effects and filters like levels, curves, or the HSL effect, and secondary, where you selectively adjust colors in a shot.

For example, you may decide that you wish to change the color of an actor's outfit without adjusting the background color. Most compositing and editing applications have tools for both primary and secondary color correction, as does Adobe Photoshop. There are various ways to make the selections for secondary color corrections, including the use of masks and mattes. (These subjects are covered in more detail in Chapter 9.) Ron Brinkmann's *Art and Science of Digital Compositing* is a fantastic book if you want to find out more about this topic. You can find more details about it in the bibliography.

Recap

In this chapter you examined both the art and a little taster of the science of color. You learned how to use color to communicate your messages more confidently, and you should have a good understanding of some of the technical issues you may experience when working with digital color.

We looked at two main color models—the artist's color model and the RGB model—and we discovered ways of visualizing the relationships among colors. We studied the meanings of color, including cultural associations and the temperature of colors.

Then we looked at some of the color combinations we could come up with based upon the color theories and our own interpretations of color.

Finally, we braved the slightly intimidating subject of color management, which didn't hurt too much (I hope). In Chapter 9, you will see more about broadcast-safe colors and how to work with other color systems. Some of the resources in the bibliography can give you more in-depth information regarding color.

Inspiration: Richard Walker, Artist

The following is an inspirational piece written by my friend and fellow artist Richard Walker. You can find out more about Richard and his work at *www.richardwalkerworks.com*.

Figure 6.48 © Richard Walker, 2010.

My Life in Color—A Close Relationship

Hi Ho Silver Lining

At art school in the '70s I visited the interior design department.

It was all a mystery to me. I had no idea what they did there. I was amazed to find a completely empty studio filled with floating silver pillows. This Warhol moment has remained with me ever since and at that time almost lured me onto the course.

Back then, silver was the color of the future.

Gray Areas

Once when decorating a room, I spent much time searching for a gray without blue in it. The only alternatives seemed to be varying shades of sludge… too warm, too brown. Everything I looked at also completely changed in daylight or artificial light. Finally after becoming rather obsessed I found a gray with a little green in it. Not too warm, not too cool. A perfect neutral background to hang modern art against.

Was that too much to ask for?

Seeing Red

Sometimes I wake up with things on my mind. A whole list of chores and deadlines to tackle. Often without thinking, I find myself wearing something red, which for me is the color of action and positive thinking. My old art teacher used to say a single red element acted as an exclamation mark in architecture. I always remember the little red-hooded figure running through the gray alleys of Venice in *Don't Look Now.*

You don't need much red, a little goes a long way.

Turning Blue

I once stood in front of an Yves Klein blue pigment painting at MOMA New York and was photographed wearing complementary orange. That blue seemed to exist beyond all other colors: eternal, mysterious, and enveloping. As a teenager I had Joni Mitchell's *Blue,* which was introspective, intimate, and sad. I was drawn in by the blue-on-blue cover photograph.

I often wear blue in the same way I wear red, but for the opposite reason. I have blue eyes.

Figure 6.49 © Richard Walker, 2010.

Difficult Green

Green is the color with which I have the most problems: a love/hate relationship. I love lime, bottle, khaki, and leaf green, but have difficulties with emerald, sage, Kelly, and veridian. Maybe it is something institutional from my childhood: gloss green doors in old school corridors.

Peversely, Brian Eno's *Another Green World* is one of my favorite albums.

Yellow Peril

Yellow crosses the color spectrum between warm and cool. This can cause havoc if casually misused. As a painter and print-maker I think in layers: A good way of pulling together disparate elements in an image is introducing a pale yellow wash. This often unifies and harmonizes other colors.

Never forget however fresh and happy the color yellow is perceived, it is also the color of urine, pus, and jaundice.

Figure 6.50 © Richard Walker, 2010.

Curious Orange

Orange is a tricky one: on the one hand it is wild, vibrant and sunny, on the other it can be sad and gloomy, like the street-lights in suburban towns, or the dim glow of a bedside lamp. The huge mirrored sun in Tate Modern's turbine hall was, for many, a relaxing, chilled-out experience. I found it quite depressing.

Browned Off

The British like brown: clothes and furnishings mainly. This is something to do with blending in, earthiness and nature. This may also be a fear of color. Brown can be dull, indecisive, and vague, but can also be rich, bitter, and exciting.

Things may be changing.

Purple Haze

Purple is a shifting color, as it doesn't have its own identity, lying between red and blue. Muted mauves, dusty lilacs, and hot violets are all useful shades that can build bridges between strong primaries. Politicians often wear purple ties.

I saw someone wearing a t-shirt that said "Start Wearing Purple," which told me all I needed to know.

Instinctive Pink

Pink... I would be lost without it! In all its forms pink is per-fect: soft, wild, erotic, shocking, vibrant, clashing, dreamy, pretty, seductive. I have always used some form of pink in my work.

From the early punky prints through the hot cityscapes into the later dreamscapes, pink has been instinctive.

Historically pink was a color reserved for the boys, then it became the color that dare not speak its name, and now it seems once again, real, red-blooded masculine men can wear pink again... but this time with irony.

Figure 6.51 © Richard Walker, 2010.

White Spaces

There is nothing more exciting to me than walking into a big white space. Be it an art gallery or a snowfield, it has a purifying and defining quality. Apparently the sum of all colors is white, which I accept as true but find hard to understand. Perhaps white gives you the space to imagine colors.

As with black, there are different shades of white... some look very dirty.

Paint It Black

Gloss black printed over matt black is very exciting. There are many shades of black; some add drama and others kill something dead. My mother said if you wear black in the winter, it will suck the color from your face, so always wear a scarf in-between the two.

Space may be the final frontier... full of black holes, but space is not really black... it is filled with stars.

EDITING

Synopsis

Okay, let me put my hands up right away and admit that editing is not my forte; I am no expert at it. You see, I think the industry can be split into two distinct camps: those who create individual elements, including illustrations, photographs, video footage, or animation, and those who take these elements and craft them together to tell a story. Of course, there's a third camp of rare individuals who excel at both, but most people are a better fit with one than the other.

My skills are really in the creation of elements, and when working on a long piece, I prefer to leave the job of editing to an expert, a professional video editor who spends every day cutting footage. However, within your work as a motion graphic designer or animator, you will be required to do a fair amount of editing here and there, so it's important that you understand some of the rules.

This chapter isn't designed to be a comprehensive guide to video editing. I only intend to cover a few basic rules to help you create edits for use in your motion graphic designs. If you want to learn about how to be a *bona fide* video editor, then some of the books listed in the bibliography can teach you the skills you need to become a full-time, professional video editor.

A Brief History of Video Editing

Most of the rules and conventions used in video editing were established in film editing. With traditional film editing, a strip of film was physically cut and pasted together to change the order and timing of events. The purpose was to tell a more dynamic and interesting story, or at times, to change the perception of a story.

Video editing was traditionally done on tape using a similar process of cutting the tape and pasting it back together into new configurations. Editing performed directly on tape is known as linear editing. The downside to this type of editing is that it's often destructive. Once sections of tape are cut, it's not easy to reinstate them. Linear editing can also be performed by mixing two sources of video onto a third tape. This can be done with three

Design Essentials for the Motion Media Artist. DOI: 10.1016/B978-0-240-81181-9.00014-5

Figure 7.1 **Editing in Adobe®
Premiere Pro.**

VCRs and a mixing unit or using a dedicated vision mixer. Each of these processes is described as "linear" because they involve placing clips one after the other in sequence. It's not possible to place a clip at the end and work backward or to work in any non-linear way.

Nonlinear editing allows you to work any way you like—backward, forward, or even in a more random fashion. When computers evolved sufficiently to cope with the file sizes that video provided, engineers began to develop nonlinear digital video editing systems. With these you could capture video onto hard disks. Frames of video could be accessed in any order, and actions could be performed on multiple clips simultaneously. This revolutionized the video industry and opened up video editing to anyone with a fairly powerful computer and fast hard drives (capable of playing back video in real time). It's a totally nondestructive process that allows the video editor to get more creative with the process of storytelling.

The first nonlinear video editing software applications appeared in the early '90s and included Avid's Media Composer (which is still a strong product today) and Newtek's

Video Toaster Flyer, which is sadly no longer with us. Both of these ran on proprietary equipment: Media Composer ran on a customized Apple Mac with added powerful graphics/video, in/out cards, and fast hard drives capable of playing back compressed video. Newtek's solution ran on the wonderful Commodore Amiga (which was the first computer I worked on, too!). It also included additional hardware in the form of a video in/out card. It wasn't long before other software companies followed suit, and in the '90s a plethora of desktop video editing tools became available. These included the much-missed Media 100 and Edios editing systems. Later Adobe® and Apple® would join the race with Premiere and Final Cut Pro, respectively. We'll continue to look more closely at these throughout this chapter.

The Principles of Editing

Some of the principles of animation that we have already looked at also apply to editing, but there are a few more that are specific to editing. I hope these will help you think about editing as a creative craft, as opposed to just joining together a few clips in sequence.

Chapters 3 and 8 both discuss developing a visual language to communicate your ideas without the use of written or spoken words. Once you have learned this language you can use it to weave a story. Here are some additional principles to think about that are more specific to editing video.

Storytelling

Video editing is a very specialized craft and can take years to master. It's become much easier to learn about video editing since the introduction of desktop editing systems such as Apple's Final Cut Pro and Adobe's Premiere Pro. But cutting video is not just about putting chunks of footage together in a sequence; it's first and foremost about telling a story.

If you're a freelance animator or motion graphic designer, there may be times when you have to assume the roles of both director and editor. If this is the case, then you probably have a good overview of the whole project. But in productions where everyone adopts specialist roles, it's also important that you understand one another's jobs and the challenges each of you face. In a typical production, the director (and art director, if there is one) will plan out the production, putting together a shot-list of everything required to tell the story. A good director

will work with the editors, consulting them to find out if they have any specific needs.

The best way to learn about storytelling is to read stories and watch films. Notice the patterns they follow, and try to see if you can use what you observe in your own work. Most stories begin by establishing the main characters and the location.

Establishing Shot

The establishing shot is similar to "setting the scene," which we discussed in Chapter 4. It tells the audience who the main characters are, what their location is, and any other important points they need to know. The opening title sequence for *Midnight Cowboy* is a great example of an establishing shot. Both the characters and the location are established during the opening title sequence.

In abstract animation or graphic sequences, the establishing shot may introduce a company logo or some important message that you want the viewer to think about while watching your sequence. Motion graphic sequences are generally quite short, so you don't often have time to be too clever with your establishing shots. In Figure 7.2, you can see the main character waving to attract attention while wearing a loud and attention-grabbing sandwich board.

Figure 7.2 Still taken from
***La Tienda De Luis,* Channel 4**
television. © Angie Taylor, 2001.

Maintaining Flow

Once the story has been established, it needs to flow seamlessly so the viewer is completely unaware of the technical process that's taken place. There are some exceptions to this. MTV, for example, famously broke all the rules of editing in the 1980s and 1990s, creating a whole new style. This style actually developed partly by accident. When it started out, MTV gained a reputation in the industry for employing students and amateurs to produce its shows. Skeptics accused it of being stingy, but the real reason for doing so was to achieve a look to break the mold—something more youthful and dynamic. Many of the people chosen had no formal training in video editing, so they were unaware of the established editing rules and conventions that were used. Many early examples of the work done by MTV were pretty dodgy, full of bad editing decisions and poor technical output (in my opinion). But because these young editors weren't restricted by convention, creativity shone through, and MTV's style eventually established itself as fresh, new, and exciting. Everyone wanted to recreate the MTV look.

So you see, breaking rules often creates innovation. MTV planned to use young people because it believed they would provide fresh ideas. But what it didn't bank on was that some of the technical errors would inadvertently open up people's minds to new, edgy, fast-action editing that, if placed in the right hands, can be really effective. What would have been difficult to accept 20 years ago is now the norm and is considered a valid form of storytelling. But creating a flowing story isn't only about the speed of the cuts; it's more to do with creating a rhythm that people are comfortable following.

Pacing and Rhythm

Pacing refers to the speed of the sequence. As a general rule, fast pacing creates excitement, interest, or tension, and it is used frequently in action movies. Slow pacing is typically used in romantic films or period dramas. Pacing can vary over the duration of the piece. If you think about feature films, they often begin at a fairly slow pace that builds as the story progresses. By altering the pacing throughout the piece, you can create a sense of rhythm and drama. One my favorite books is *The Visual Story* by Bruce Block. One chapter is dedicated to the visual structure of film, which features graphs that depict the story structure of famous films. I thoroughly recommend that you read this book to get a better understanding of how a film's pacing can be determined by all sorts of factors, including editing.

I spoke about rhythm in both Chapters 3 and 4. You might want to go back and reread the sections on rhythm because they have relevance here as well. Human beings understand and respond to rhythms; we feel naturally comforted by them. Rhythm is most often associated with audio, and it occurs when the instruments create a regular pattern of notes or beats. But rhythm also occurs visually. As we saw in Chapter 3, you can create a visual rhythm by repeating color, texture, or other design elements. You can also create rhythm across frames by repeating or accentuating certain actions in an animation.

With editing you can create rhythm by varying the length of individual clips or transitions in a sequence. There are a few guidelines to follow when making decisions about clip length. For example, you need to hold a little longer on clips that contain more detail, such as an establishing wide shot, that inform the viewer of the location and the characters or that you want the viewer to pay particular attention to. Close-up shots don't have to be on the screen as long because they generally contain less detail. It doesn't take long for the brain to register what a single character is doing and make any interpretations from her actions. However, a wider establishing shot typically contains several items that you want the viewer to notice (these could include scenery, multiple characters, vehicles, signs, and animals). In this case, you must give them more time to take it all in, perhaps use a panning shot that travels past the pertinent elements.

Movement within shots also adds detail as the camera moves and the view changes. You must give the viewer enough time to register these changes; it takes longer to comprehend moving shots than those from a fixed camera. If you are trying to create an MTV style edit where the cuts are short and snappy, make sure that you avoid camera moves within the clips for this reason.

You can also create rhythm by using different shots of the same scene or same duration. For example, if you have two characters having a conversation, it is more interesting to make the edit mimic the conversation, jumping back and forth from one character to the other as they exchange sentences rather than having a single wide shot showing both characters chatting simultaneously. It may seem boring to stick to these conventions, but they are followed because they work. As I always say, learn what works first, and then go about finding ways to bend the rules with knowledge supporting you.

Continuity

Continuity is what a good editor always aims for. When good continuity is achieved, the viewer hardly notices that the cuts between clips even exist. There are a few things to be aware of that will help you achieve a sense of continuity in your edit.

Direction

The direction of movement of elements in your shot can determine where the best cuts should be. Movement should almost always remain continuous and follow the same direction. Imagine you're editing a sequence where a car is driving from one town to the next. Obviously you can't show the entire journey from start to finish because it would take too long. So you need to create an edit that suggests that a journey has taken place. To do this, you can edit together clips of different scenes that the driver passes, using cross-dissolves to suggest the passage of time.

It's important for continuity that the direction of the journey is always maintained either from left to right or from right to left. The viewer will feel disorientated and confused if you cut from a character moving in one direction to a clip of him suddenly moving in the opposite direction. In our example, even though the driver may change direction several times throughout the real journey, for the purpose of the story, it's always best in the edit to have the car headed in one direction. The only time it's acceptable to have a change in direction is to show the direction change happening on screen so the viewer has seen it happen. You sometimes see this happen in car chases, where a vehicle makes a U-turn on screen before taking off in a different direction.

Finally, and I'm not sure if this is a standard editing rule, but I was taught that when cutting shots of action—for example, somebody walking or running—cutting on a frame where their leg is moving upward will portray a positive feeling, while cutting when the foot is moving down conveys a negative one. It may seem like a trivial detail, but editing with an eye to the direction of movement in a shot is essential to a polished, professional piece.

Cuts

There are several types of cuts, and each one will be useful in different situations. When starting out, I recommend sticking to simple cuts as much as possible. This will discipline you as you perfect your craft and editing skills. You will know you're on the right track when you can create a seamless join between clips with a simple cut.

Match Cuts

A match cut is when the editor matches the action from one shot with another. Sometimes the shots can be related—for example, they may match a rear shot of somebody placing a cup of coffee on a table, with a front shot of them doing the same action. The shots can also be unrelated—for example, a shot of a merry-go-round could be cut with a shot of a person spinning in the same direction as the merry-go-round. The similarity in composition

and action is what ties the shots together. The viewer's eye accepts the transition between one shot and another because the movement and composition of the shot are continuous, even though the subject matter has changed. When done with skill, it can be used as a clever way to jump between otherwise unrelated subjects.

Jump Cuts

A jump cut is a cut where the editor switches between different views of the same subject, usually to create a deliberately disjointed or jarring edit. Examples of this can be seen in documentary editing when a person is being interviewed. Multiple camera angles will be filmed simultaneously, and the editor will create rhythm and interest by cutting from one camera angle to another during the interview. This technique can be executed at the end of sentences to break up monotony without creating too much distraction from the subject. You can see jump cuts used fairly obviously in films made by music video directors, where they will cut different views of the same subject in time with music.

Cutaways

Cutaways are used as a kind of transition where editing from one shot to the next is problematic. They can also be used to break up a scene that's too long and perhaps a little boring. A cutaway involves cutting to a completely separate but related scene. This sounds similar to a match cut, but with a cutaway, there's no attempt to match the action between the shots; they can be completely separate shots and/or scenes. An example of this would be a dream sequence. You could have a shot of a character sleeping soundly and then cut away to her dream sequence and then cut back to a shot of her waking up. The cutaway shot is often used to provide incidental information that can't be conveyed by the main clip. In westerns, as the cowboy rides into town, you often see cutaways to tumbleweeds or vultures circling overhead, indicating the isolation of the location and the danger he's about to encounter.

Cutaways can also be used to cover up difficult shots or a lack of continuity. Imagine you have a shot of somebody talking. As they are filmed, somebody walks past the camera and ruins an otherwise perfect shot. Cutting away from the interviewee to footage showing the subject of the interview cannot only cover up the error but can also serve to illustrate the subject matter more clearly.

L-cuts

An L-cut happens when the editor cuts the audio at a different point from the video. It's called an L-cut because the trimmed clips create an "L" shape in the timeline of the desktop

Figure 7.3 **An L-cut.**

editing system (Figure 7.3). Light travels much faster than sound, so we see and hear things at different speeds. So it's become common practice to introduce a sound before we see the related action. Imagine a scenario where you are cutting from a forest scene to a shot of a waterfall. Introducing the sound of the waterfall just slightly before the image will ease the transition from one shot to the other. This is usually done by means of an audio cross-fade, fading one clip out as the other fades up in volume.

Transitions

Desktop editing applications like Avid® Media Composer, Apple® Final Cut Pro, and Adobe® Premiere Pro provide you with plenty of transitions to choose from. As I said earlier, this doesn't mean you should feel obliged to use them all, but you should understand the differences between them.

The general rule of thumb with transitions is "less is more!" Desktop editing systems provide you with a plethora of funky transitions to choose from: wipes, fades, dissolves; even 3D transitions like page curls and box wipes are easy to drag and drop between your clips. But use these sparingly if you don't want your edit to end up looking like a 1980s music video.

Figure 7.4 A cross-dissolve.
Photographs © Angie Taylor, 2010.

Transitions can be used to soften cuts and they are mostly used for two reasons. If a cut just won't work or is too jarring, a cross-dissolve can ease one shot into another more smoothly. You can also use cross-dissolves to create a feeling that time has elapsed between one shot and another (Figure 7.4).

Dissolves

The most common, and probably least offensive, video transition is the dissolve or fade. Dissolves tend to be quite soft, since they transition between clips by fading them in or out. A cross-dissolve, which fades out the outgoing clip while fading in the incoming clip, is probably the most commonly used transition. Other dissolves include additive dissolves (Figure 7.5), which combine the color values of the clips to create a blend.

Figure 7.5 An additive dissolve. Photographs © Angie Taylor, 2010.

Wipes

A wipe is a transition that somehow pushes one image off the screen and pulls the next one on. Desktop editing systems provide a variety of wipes, including clock wipes, which wipe the image off the screen in a circular direction like the hands of a clock, and band wipes, which create venetian blind–like strips from the incoming and outgoing clips (Figure 7.6).

Figure 7.6 A wipe. Photographs © Angie Taylor, 2010.

Iris

An iris is similar to a wipe, but instead of moving one clip off screen, one clip opens from a specified center point to reveal another (Figure 7.7). Examples of iris transitions include star, cross, and diamond.

Figure 7.7 An Iris. Photographs © Angie Taylor, 2010.

Map

Map transitions use an image map to determine how one clip blends with the next. You can choose between luminance maps, which use the luminance values to determine the transparency of the outgoing and incoming clips, and other channel maps, which allow you to use color channels, alpha channels, or other image channels to create the blend between clips (Figure 7.8). You can be really creative with map transitions because they allow a great deal of customization. You can use virtually any image to create a unique and interesting effect. These transitions are a bit like working with blending modes in Photoshop. You just need to experiment with them a little to figure out the different effects they are capable of producing. During experimentation you'll often stumble upon a style or effect that you like and can use in your own work.

Figure 7.8 A map. Photographs © Angie Taylor, 2010.

3D

3D transitions tend to be a bit overused by overenthusiastic "newbies." Used in moderation, they can be effective, but they tend to be a bit cheesy if used inappropriately. They use a faux 3D effect to transition from one clip to the next. The most common one is probably the cube spin, which renders the incoming and outgoing images onto the side of a cube. The cube then turns to reveal the following clip (Figure 7.9).

Another 3D transition that has become a bit of a standing joke among designers and editors is the ubiquitous page peel (or page turn). With this transition, a page is turned to reveal the next clip underneath (Figure 7.10). The dear old page peel was overused in the '80s when it first appeared and tends to be

Figure 7.9 **A cube spin.**
Photographs © Angie Taylor, 2010.

Figure 7.10 **A page peel.**
Photographs © Angie Taylor, 2010.

associated with wedding videos, since it was the perfect transition for these, making the video appear like a wedding photograph album.

Color Consistency

As I'm sure you can imagine, jumping between shots with vastly different color values can create a jarring effect, particularly if the shots are of the same subject. To avoid this, you need to white-balance all of the cameras that will be used in a shoot before shooting begins. To white-balance a camera, you focus on something pure white (usually a white card) and click on the white-balance button. This will ensure that they all register the

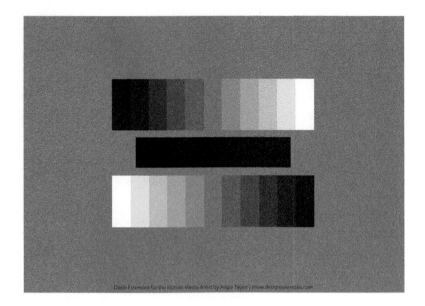

Figure 7.11 A printable chip chart. You can also download one from the website at *www.motiondesignessentials. com.*

same color as white and will therefore balance all other colors to match across cameras as well as possible. Color correction can also be done in postproduction using desktop editing software or more specialized color correction tools (which we discussed in Chapter 6).

I usually shoot a chip chart (Figure 7.11) before proceeding with a shoot, too; this is a test card containing shades of gray. A few frames are shot at the beginning of a shoot after white-balancing. The frames can be used during postproduction to determine gray values and match them across multiple shots. However, it's always preferable to prevent problems at the shooting stage of production, since postproduction can be costly and time-consuming. A little forward planning goes a long way in video and film production and can save oodles of time and money further down the road. You can find out more about color correction in Chapters 6 and 9.

Editing Applications

When it comes to desktop editing applications, you have many choices, but my three top choices are Avid Media Composer, Apple Final Cut Pro, and Adobe Premiere Pro. In my opinion, these three are pretty evenly matched, but they all have strengths and weaknesses. People will naturally try to champion their own favorite application, regardless of the requirements of the individual. I use all three, each in different circumstances.

Avid

When I worked as a freelancer, most of the facilities used Avid editing systems. This is changing gradually as Final Cut Pro and Premiere Pro are gaining ground, but Avid is still the first choice for many professional editors. Avid Media Composer (Figure 7.12) excels at editing and asset management. If you want to simply cut video and perhaps add the odd transition here and there, then Avid is a solid, reliable, and efficient system. It's perfect for editing long-form pieces like films or documentaries and offers all of the tools a professional video editor would expect. However, it doesn't have the flexibility or range of effects that the other desktop editing systems offer.

Figure 7.12 **Avid Media Composer.**

Final Cut Pro

Final Cut Pro (Figure 7.13) has gained ground rapidly since its introduction by Apple in 1999 and is probably the most popular editing system used today by small to medium-sized businesses and freelancers. Several feature films have been edited on Final Cut Pro, so it's now well-respected and is seen as a major player in the industry. Final Cut Pro is the application I use most often for editing videos. It's easy to use and offers me all the features I need to cut sequences together for my motion graphic projects. I can mix footage from different sources, and it runs very smoothly on my Mac and my Macbook Pro. It also comes with some great additional applications as part of Final Cut Studio, including Motion (Apple's motion graphics application) and Color (Apple's color correction application). Most of the motion

Figure 7.13 Apple's Final Cut Pro.

graphics work I do is in Adobe After Effects, and I use Automatic Duck (a third-party plug-in; *www.automaticduck.com*) to translate my Final Cut Pro edit into an After Effects composition. This means I don't need to go through a time-consuming rendering process to get the edited sequence into After Effects.

Premiere Pro

Premiere Pro (Figure 7.14) is a great application but has suffered over the past few years from a bad reputation when it was known simply as Adobe Premiere. This was gained as the result of a particularly weak version that appeared in the '90s, just as Final Cut Pro, the apparent child prodigy of editing applications, was born. Adobe reacted badly and, in my opinion, compounded their problems by deciding to stop development of Premiere on the Mac and only develop it on PCs. This was seen as a sign of defeat and sent a message to users that Premiere was substandard. I'm glad to say that Premiere Pro was reborn and is now completely crossplatform. It finally seems to be shaking off its reputation and is being adopted more and more widely by the film and video industry.

The BBC uses Premiere Pro extensively, and it has also been used to cut feature films. It comes bundled with Adobe Encore (Adobe's DVD and Blu-ray software) and On Location, which

Figure 7.14 **Adobe Premiere Pro.**

allows direct-to-disk recording from cameras as well as excellent video monitoring tools. The thing that I love about Premiere Pro is its excellent Dynamic Link integration with After Effects. With this I can easily move my sequences to After Effects, keeping a live link between the applications. This means I can jump back and forth between the applications as often as I need without having to do any rendering. This makes Premiere Pro the perfect place to start for my animation projects. I can import all my graphics and storyboards into Premiere Pro. I use the real-time editing capabilities to roughly cut the images and get the timing right, adding basic animation, all in real time. I can jump to After Effects to add effects and tweak the animation, using expressions, scripting, and motion tracking where necessary. Throughout the process, I can continue to jump back and forth, taking advantage of each of their individual strengths to get the job done quickly and efficiently.

Tools

Within each of the editing applications, you have access to several tools designed for cutting video clips into coherent sequences. I'm not going to cover all of the tools here, but I want to call your attention to a few of my favorites that I use

on a regular basis. When starting out, most people tend to use the standard selection tool to manually edit clips in the timeline (and also for moving clips around the timeline). You do this by individually trimming the in point of one clip and then the out point of the next clip. Doing this takes time, so these tools are designed to speed up the editing process by allowing you to trim or move multiple elements simultaneously. These are always referred to as advanced editing tools, but I believe everyone should use them because they are really are quite easy.

Ripple

The Ripple edit tool allows you to trim a clip by adjusting its in or out point, just like the selection tool does (Figure 7.15). It automatically prevents gaps in the timeline by dragging the clips adjacent to the edit point in the same direction as the edited in or out point. The benefit of this tool is that you don't have to perform a

Figure 7.15 **Ripple.**

separate action to remove gaps after editing. Keep in mind that trimming clips with the ripple edit tool will affect the overall duration of the sequence as it closes gaps. So you need to be careful that you don't inadvertently move important edit points or move unlinked video clips to the point where they are no longer in sync with the audio.

Roll

The Roll edit tool (Figure 7.16) is similar to the Ripple edit tool, but instead of moving the adjacent clips to close the gap, it simultaneously trims the adjacent clip. If you're trimming the out point of the first clip (to shorten it), this tool will extend the incoming clip by moving its in point to the same location in the timeline. The roll edit tool will not affect the length of the sequence but will affect the duration of clips on either side of the edit point.

Figure 7.16 **Roll.**

Slip

The slip edit tool (Figure 7.17) allows you to change the portion of footage used in a clip while maintaining its duration and position in the timeline. The in point and out point of the clip in the timeline will stay fixed in place, but the in and out points of the actual clip are changed. Imagine you've edited a series of clips in time with music; the edits are perfectly placed on the drumbeats, and you don't want to move them. In one of the clips a character is obscured, so you need to choose a portion of the clip where she is no longer obscured. The slip tool allows you to do this. It's kind of like sliding a piece of film under a fixed frame to determine which portion will be used.

Figure 7.17 **Slip.**

Slide

The slide tool (Figure 7.18) allows you to move a clip along the timeline. It avoid gaps by simultaneously trimming the out point of the preceding clip and the in point of the following clip to accommodate the movement. If you move a clip to the left, the preceding clip will get longer and the following clip will get shorter to accommodate the position change in the timeline.

Figure 7.18 **Slide.**

Automate to Sequence (Premiere Pro only)

One of my favorite features of Premiere Pro is the Automate to Sequence button (Figure 7.19). It's a simple yet effective button that I use often. Basically, it automatically performs edits for you. Just select a few clips from your bin, click this button, and then choose how you'd like the clips placed on the timeline. Choices include the option of placing clips in the timeline, untrimmed, or in sequence. Or you can have it trim the clips and place them at precreated markers, editing the clips so they fit perfectly in-between the markers.

The majority of work I do is either character animation or music videos, and this is perfect for both of these. Character animation often includes dialog, so I lay down markers where each character begins to speak and then automate the process of cutting from one character to the next. If I need to cut video clips in time to the beats of audio when creating a music video, I can play the music and interactively add markers while the music is playing by tapping the * key on the number pad in time with the beats. It's then a simple case of using Automate to Sequence to cut the clips to the beats. If need be, I can then use the slip tool to slip the clip within the edit points till I have the correct content displaying.

Figure 7.19 Automate to Sequence.

Inspiration: Joost van der Hoeven, Motion Graphic Designer and Editor

"My favorite subjects in high school were math and art. I always had this dualistic interest in computer technology and design/photography/music. When I was choosing a university, my mentor pointed out that I could go to art school. I was surprised, because I didn't know that a course existed that would meet all my interests.

"I started creating motion graphics when I was 16, programming in Basic on a PC. This was in the summer of 1988, when I got accepted into art school. I finished art school after four years of study. I wanted to create music videos, and I didn't want to hang around longer than necessary. I got my first job as a junior editor on a Quantel Editbox creating promos for Dutch broadcaster Veronica. I became more interested in motion graphics, so I switched and started working on the Quantel Hal.

"Eventually I wanted out of commercial broadcast (too much 'baked air' for my taste!). I applied for a job with a computer company creating marketing material and training CD-ROMS. When they cut the CD-ROM activity and asked me

Figure 7.20 *Rondje Delta.* Title animation for *Rondje Delta,* a television documentary for a Dutch broadcaster. © NCRV, 2009.

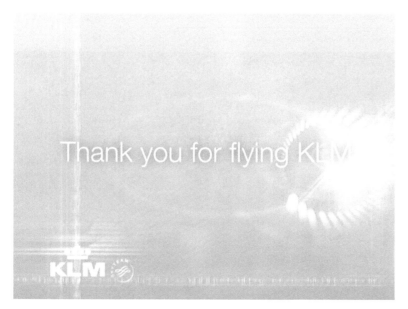

Figure 7.21 **KLM: inflight video design.** © RODIN/KLM, 2009.

to become an account manager, I quit because all I wanted was to create videos. At this point I started my own company. That was in 1998, and I am still am self-employed today.

"Sometimes I'm envious of people who work in a team as they belong to a whole. But after I complete a project, most of the time I'm thrilled to be starting again somewhere else, meeting other people and getting to know how they work. Getting to work in different 'kitchens' is one of the things that I love most about being self-employed.

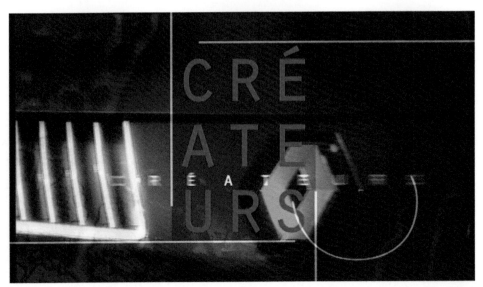

Figure 7.22 Createurs advertisement for Renault.
© Palazzina, 2006.

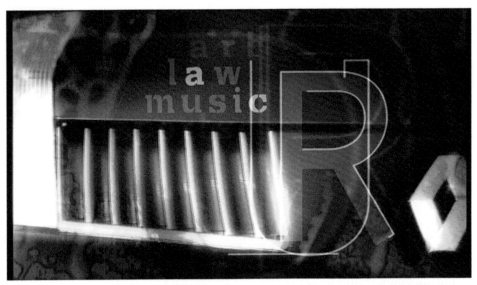

Figure 7.23 Createurs advertisement for Renault.
© Palazzina, 2006.

"I risk sounding arrogant, but my own curiosity is what really drives me to be creative. I always want to know why things work the way they do. 'Why?' is much more interesting than 'How?' Building a collage from all the answers that I find is the essence of my creativity. People also inspire me, because they point in directions that I cannot imagine on my own. Their work (books, films, history, interviews, etc.) is my big source of inspiration.

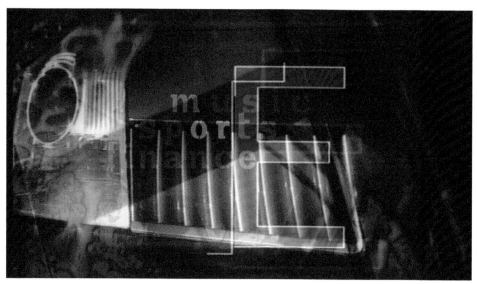

Figure 7.24 **Createurs advertisement for Renault.**
© Palazzina, 2006.

"Unfortunately I stopped drawing and doodling because at art school I saw that other people drew much better then I did, and I had a very bad teacher who told me that my drawing was no good. I still find it sad that for some reason I can't find the joy anymore in doodling the way I did in high school.

"Sometimes when a project is just not what you hoped for, and I cannot find a way to make it work, it can be a struggle. But in general it is almost a way of life to me. I don't mind rotoscoping 2000 frames if I feel comfortable that the end result is just what I want. But if a text or logo just doesn't look right I can really pull my hair to get it the way I think it should be.

"On the creative side, I'm always looking into how effects or styles from commercials or film titles are done. I like to read and do those 'case studies.' And when I go jogging or need to drive for a while I either listen to music (a mix of alternative pop, salsa, and latin-jazz), or to podcasts with interviews with people in the VFX and motion graphics industry. These podcast are very inspiring and motivating. For some reason I enjoy the longer audio podcasts more than the shorter video podcast. I find this curious, as I can't deny that my work is rather visual.

"There is not one 'kind' of work I like most. I like the variation. I love commercials, but they are demanding. I like corporate presentations; you get a lot of freedom, but you are the one-eyed-king in the land of the blind. Consulting and training people is great; people ask a lot and appreciate your advice and this gives me a lot of confidence and is pleasing also seeing the progress that people make after they've done training is very rewarding. But it sucks you dry if you're doing it too long and too often.

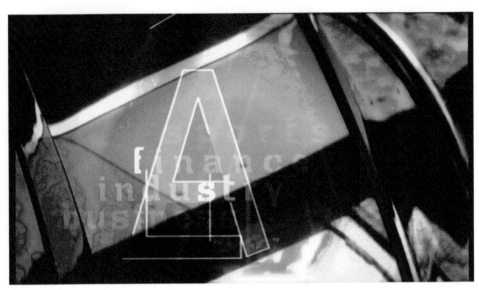

Figure 7.25 Createurs advertisement for Renault.
© Palazzina, 2006.

"In terms of editing, it's all in service of the story. So cuts are king, but sometimes you need a clown or a young princess to get the story going. Follow your instinct. But accept that it must serve the story and make the edit better. If it is nice but it does not comply with these two, kill your darling and go on. To maintain continuity within an edit, make a breakdown of the types of scenes. This could be about places: Location A, B, etc. Or the mood: spring/happy, autumn/sad, dark/sorrow, fear/chase. Or even custom, like in a documentary: narration, interviews, facts, drama, etc. Try to keep the editing pace and form constant in the various types, but the difference between the scenes can alter.

"The MTV style of editing inspired me in the 1990s, but the problem with this style of editing is that the form is more important than the message. This can lead to bad communication but great art. How many great commercials are out there miss the commercial point completely because everybody remembers the spot but nobody remembers the brand? While this often has more to do with scriptwriting, my point is that you should always ask the question: Is this telling the story you or your client wants to tell?

"Finally, here are a few of my top tips. When editing I always try to cut in motion, not on beat, this makes the edits more invisible. Motion in shot is on beat; this makes the beat part of the shot, not of the edit. Always try to make the client part of the creative process. This will help you do a better job, as the client is aware of your progress. It's also a good idea to make more than one version when presenting your work to your client. Always know *why* you made a decision. Collect ideas and bookmark them so you can refer to them at anytime."

8

COMMUNICATION

Synopsis

Figure 8.1 **Stills from Brainstorm, an animation by Madeleine Duba.** © Madeleine Duba, 2009. You can find out more about Madeleine and her work in Chapter 4.

Communication is possibly the most important but over-looked aspect of design. Ask the average man or woman in the street, "What is the designer's job," and most of them will answer something along the lines of "They make things look nice" or "They add the decoration." The majority of people tend to think this way—including a good number of working designers! But they're obviously unaware of the fundamental aspect of design: visual communication.

The literal meaning of *communication* is "the transference of information from one place to another." I say "place" rather than "person" because information can travel between devices as well as between people. Also, when information transfers from one

Design Essentials for the Motion Media Artist. DOI: 10.1016/B978-0-240-81181-9.00015-7

293

person to another, it also travels from one place to another. For example, the spoken word is transmitted by one person's mouth, but it is received by the other person's ears.

As a designer, your job is to transmit these messages visually, through various forms of media. Your first job is to find out what formats are expected; these include QuickTime movies, MP4s, and streaming video clips. The format you choose depends largely on the device the final content will be delivered on. Will it be broadcast, streamed from a website, or pushed to a mobile device? Chapter 9 can help you to determine which formats and codecs are appropriate for each delivery vehicle.

Once you've chosen the format, you need to learn more about the problems the client wants to tackle. To do this, you need to ask yourself a series of questions: How do I sell this product? How do I make this object desirable? How do I communicate my company's message? How do I attract attention to important information? How do I warn people about dangers? How do I inform people about my latest news?

In order to determine the problems you're facing and figure out the appropriate solutions, you need to learn to communicate well with your clients. Understanding different personality traits will help you to encourage your clients to be specific about their needs. This chapter explores different techniques to help you do just that.

Good communication helps in all aspects of a designer's work. For example, networking is essential if you want to be successful in the industry. It's nice to think that you can just be good at what you do and that people will discover you, but in reality, unless you are very lucky, you won't get very far without a bit of networking.

Good communication skills are also vital when attending interviews, making creative pitches, or presenting your portfolio to potential employers. There are rules that will help you conduct yourself well at an interview and help you make successful pitches for creative work. In this chapter we'll look at all these aspects of communication, and I'll share some tips and tricks that have helped me along the way during my career.

Visual Communication

When people ask me why we need rules for design, I like to use the analogy of spoken languages. In order to communicate with people in other countries, you need to learn their language and the rules pertaining to the local customs. We're all familiar with the cliché of the tourist who is unable to speak the language of the country he is visiting, shouting louder in a vain attempt to be understood. Sure, shouting louder slightly increases your chance of being understood, but you also run the risk of looking like a complete idiot and are likely to offend the locals. The same

applies to design: If you try to do it without understanding the basic principles, you run the risk of offending people and looking amateurish. Visual communication isn't just about trying to attract attention. It's about your designs, your passions, your ideas, and finding the best way to communicate them with the world.

The Components of Visual Communication

In this section I summarize the basic components of visual communication. In the preceding chapters of this book, we looked at how the physical, aesthetic components of design convey messages. We'll expand on this here by studying the message itself.

We have learned that the placement of one color beside another or the choice of a particular font can convey a message to the viewer in the same way that words put together in a sentence can to a reader. The combination of multiple messages makes up a more complex story in the same way a collection of sentences can weave together to form a novel. My aim here is for you to understand these complexities and feel confident to communicate the correct message to the viewer.

Story

Stories don't have to be made from words. Silent films tell stories, as do paintings and still images. Motion graphic design is the most amazing art form because it gives you access to all of the others. You can combine imagery, animation, film, video, words (spoken, written, or sung), and music to communicate your story. We are all used to communicating verbally; we are taught to do this from a very early age with reading and writing. But when we are taught to draw as children, the main focus is about whether the image looks realistic or pretty. It's not until much later in our education (if at all) that we begin to question the meaning of images and learn how to use them as a means of communication.

In the preceding chapters, you learned about what I consider to be the essentials of motion graphic design. Once you understand how to control these individual components and are using the techniques you've learned instinctively, without even being aware that you are, you'll naturally begin to combine them, creating rich and increasingly complex stories for the viewer. For example, you can use color to influence the viewer into deciding whether a character in a film is good or evil. Think of Batman, where all the evil characters are dressed in greens and purples, and the "goodies" are dressed in yellows and reds. It's an easy code for the viewer to subconsciously follow. Meanwhile, you can use size to determine the importance of characters within each group and animation to convey their individual characters.

Another example of how a story can be told visually is with the opening titles of a film. You may be required to "set the stage" for the film, using the opening scene. Car journeys are often used in opening title sequences because they clearly establish how a character came to be in an opening scene or situation. A typical example is Pablo Ferro's wonderfully evocative titles for *Midnight Cowboy*, where we find John Voight's character's rebelliousness established as he says good-bye to his ordinary life in his local small-town diner and begins his journey toward what he hopes is a better life in New York City. (You can find a link to this movie on the Communication page of my website at *www. motiondesignessentials.com.*)

Bob Kurtz's wonderful sequence for the *Pink Panther 2* movie is another good example of where the opening titles are used to establish the main characters as well as the rough plot. This follows a long line of great titles for the Pink Panther films, which were first established by Friz Freleng and his partner David H. DePatie for the first Pink Panther film in 1964. In fact, the Pink Panther character that was designed for the opening sequence was so incredibly well-conceived and developed that it spawned an animated cartoon series of its own. This had never been done successfully before. (You can find a link to this movie on the Communication page of my website at *www.motiondesignessentials.com.*)

Theme

While the story may vary over time, moving from day to night or from a positive mood to a negative one, the theme is what unifies it and gives the story its core purpose. In the *Midnight Cowboy* example, the opening titles are superimposed over film footage, nearly all of it exhibiting a left-to-right directional movement (denoting the fact that he's heading east on a journey). In the Pink Panther example, the theme is the hopelessness of Inspector Clouseau as he is constantly outwitted by the Pink Panther character.

Symbolism

You can also use symbolism in your story. In *Midnight Cowboy*, Voight's character dresses in his best, very shiny cowboy boots. He removes his prized Stetson from its box. This tells us how important these clothes are to him and, in turn, telling us this journey is very important to him. The lucky horseshoe on his shirt symbolizes luck and the gamble he is about to take. The Pink Panther character, however, only exists in the title sequence; he doesn't actually appear in the film at all. He's there to symbolize the eccentric, rebellious, jewel thief characters who always win over the silly conformist establishment represented by Clouseau.

Meaning

You can try your best to make sure that you convey the correct meanings through the use of color, animation, typography, and so on. This usually means a compromise of designing for the majority, since we all interpret things in slightly different ways. Some interpretations are based on objective truths—for example, black is black, and white is white. These are facts. However, as we discussed in Chapter 6, the interpretations of color meanings can be vastly different depending on the culture, age group, or other demographics. This is a subjective interpretation because it is based upon the opinions of the respective populations.

There will be other subjective splits: Some people love a certain color, and other people hate it. This personal feeling toward color is also subjective. So when you consider the elements that you will use in your designs, make sure to think about the cold, hard facts relating to the elements, but also consider the subjective opinions of your target audience.

Literal Meaning

It is possible to use the written word creatively; it's arguably the easiest way to communicate a literal message that isn't easily misinterpreted. It's commonly believed that words equate to facts, whereas images are a little more ambiguous. They can be interpreted in many different ways. Images are more commonly open to misinterpretation, but you can minimize the risk of being misunderstood by using literal imagery. An example of using literal imagery to emphasize speed would be to use an image of a Ducati motorcycle zooming around a racetrack, perhaps emphasizing it even more by zooming the camera in to focus on its speedometer.

Ambiguous Meaning

Of course, the meanings of words can be ambiguous. Take the word *wicked*. The primary definitions of this word are "cruel," "heartless," and "evil," but the word has also been adopted into slang dialects as a term meaning "great" or "severe."

This kind of ambiguity also occurs with imagery. In Chapter 3, you saw the image of Rubin's Vase, which can be interpreted as either a vase or two heads facing each other. Rubin's Vase is really considered an optical illusion, deliberately designed to be ambiguous. At times, however, the ambiguity can be less "designed" and more apparent. Lady Sovereign's music video for her track *Hoodie* (directed by Family) sees a gang of rough-looking kids dressed in hoodies chasing a woman through a shopping precinct. The audience (and the woman) assumes that the gang is planning to mug the woman, but at the end of the video, it turns out that they are chasing her in an effort to return her bag, which she dropped

while shopping. The video is intended to turn stereotypes on their heads, and it makes the woman look foolish for thinking the worst of the young people.

You may choose ambiguous imagery for several reasons. Maybe you may want to attract attention by confusing the viewer, making them "think twice." You may want to hedge your bets, making sure that your audience doesn't presume a single point of view. If you want to really make them think, then you may want to work with abstract imagery.

Abstraction

Abstract is the opposite of literal in terms of definition. Abstract art attempts to communicate without using references to anything that exists within our universe (as far as we know!). It can also be the result of taking real-world references and twisting them to make them less obviously recognizable. Abstract imagery has more to do with conveying a feeling and less with communicating a literal message. Man Ray and Marcel Duchamp were two of the first artists to experiment with abstract imagery in film. In 1926 they made a film called *Anémic Cinéma*.

Duchamp and Man Ray were part of the Dadaist art movement, which sought to turn convention on its head in an attempt to shock and to open minds to the pointlessness of war and the modern world. It took everyday objects and put them in odd situations or rendered them useless. One example was the sculpture *Gift* by Man Ray, which was a clothes iron with spikes attached to the plate. Although *Gift* is not abstract, by breaking conventions it forced people to think "out of the box," which, along with other movements like Cubism and Fauvism, paved the way for other more abstract art movements to thrive in the twentieth century. (You can find a link to this sculpture on the Communication page of my website at *www.motiondesignessentials.com*.)

Duchamp and Man Ray also made a film together that had an even more abstract concept. It begins with a spinning abstract spiral (similar to those you see in old films when people are being hypnotized). The spiral continues to spin, but words replace the lines of the spiral, and the images and words alternate throughout the film. Duchamp was obsessed with language, and in this piece he wanted to confound the viewer by abstracting both the words and the imagery so they made no literal sense. The viewers would then make their own subjective opinions about the piece. The words used are inspired by alliteration, puns, and plays on words; they tease the viewer with irony. The title itself—*Anémic Cinéma*—is a palindrome, and the phrases used in the piece play with double meanings. Viewers are never sure if their interpretations are correct. You can see *Anémic Cinéma* and other avante-garde films at a fantastic website named UBUWEB (*www.ubu.com/film/duchamp_anemic.html*).

I like to work with abstract imagery. It can be more interesting if the viewer has to work a little harder to get your meaning. When the viewer ultimately understands the meaning, they tend to connect to the imagery more than they would with literal imagery. Perhaps this is because they see themselves as a bit clever for getting it! It gives them a sense of affinity with the subject, and they'll tend to share it with others because it makes

Figure 8.2 **Pop Art.** ©Angie Taylor, 2001.

them feel good to show how clever they are. The opening titles for *Pop Art* (Figure 8.2) paid homage to *Anémic Cinéma* with the use of abstract spirals forming the background to the dancing silhouettes. It's nice to pay homage to art that's inspired you. It's a way of carrying it forward and keeping it alive.

Conformity

Conformity equals boring, right? Well, perhaps, but conformity can be your best friend if you want to be a good visual communicator. Some of the most groundbreaking designers of our time are natural conformists. Take Jonathan Ive at Apple, whose designs are seen as revolutionary. However, he uses the same tried-and-tested formulas that designers have used for centuries. Remember how we saw the divine proportion overlaid on top of the iPod in Chapter 3? In this trendsetting design, he is applying the rules in new and interesting ways. The key to good design is to use established rules that conform to people's expectations but introduce small changes in one area—just enough to make your design stand out from the rest.

Rebelliousness

Having said all of that, it is important that methods change and adapt to remain fresh. People become desensitized to messaging when it's delivered in the same old way. Fresh ideas lead to the development of the visual language we use. Change can spark new movements and fashions. Experimentation, risk-taking, breaking new boundaries—these are all vital practices if we want our craft to continue evolving. When MTV started in the early '80s, there had been nothing quite like it before. Having a channel that broadcast nothing but music videos was a big risk; there were no precedents. It not only broke new ground in terms of programming, but it also introduced a new style of editing. In an attempt to appeal to a young crowd, MTV employed students to create graphics and interstitials for the channel. Their lack of experience meant that conventions weren't followed, and as

a result, a new "style" was born. Many old-school editors threw up their hands; all they could see were mistakes. But to the new, emerging audience, this was a welcome break from the norm and has now been sucked into convention just as the old rules were.

Communication with People

We all have to communicate with other people through our work as designers. In fact, we probably spend about 40 percent of our time doing so. Think of all the time you spend writing emails, calling clients, chatting with contemporaries, bouncing ideas around, social networking, brainstorming, meeting with colleagues—the list goes on! It's very important that you develop good interpersonal communication skills if you want to succeed in this industry. The first step is recognizing that people process information in different ways; not everyone will understand things the same way you do. Then you need to learn techniques that will help you to persuade clients and colleagues to be specific about their needs. With this achieved, you'll be set up to deliver exactly what they want.

Knowledge

When working within a creative industry like ours, it's important to share your knowledge with other people. You should never be afraid to share knowledge; it's good for the soul, and whatever you give out, you will get back tenfold! The two types of knowledge you can share with others are explicit knowledge and tacit knowledge. Explicit knowledge is communicated easily in written or spoken form—for example, "You should avoid mixing too many fonts within a single design." Tacit knowledge is more difficult to communicate using only the written word and often requires some sort of physical or visual demonstration to get the point across. For example, you may need to show somebody a technique for making certain marks with a drawing tool; it would be difficult to demonstrate this technique using only words. Visuals or an animation would make it much more obvious. When developing your designs, you need to think about how best to communicate the messages you've been asked to deliver. Are words necessary to get all the messages across, or would it be better to use a combination of illustration, color, and other design elements? You also need to consider people's individual strengths and weaknesses in terms of learning.

Learning Styles

One of the things that really pains me is having to convince noncreative clients or colleagues why certain design decisions

are right for them and why some of their ideas may be ill-advised. They can't quite grasp that what may work in one situation may be not be the right choice in another. They can also find it hard to separate themselves from their own sense of "taste." I often clam up if faced with a businesslike project manager who is only interested in how my creative workflow will impact cost and schedules. So what's the answer? How do we maintain good design when faced with the constant need to explain ourselves? How can we remain fresh and resolute in this environment? How you learn things dictates both how you absorb information and deliver it to other people. By being sympathetic to other people's needs, you can improve your own communication skills.

I was chatting with Rob Pickering, a good friend and colleague, about the fact that I couldn't get a point across to one of my clients (and, believe me, I tried!). He introduced me to the concept of learning styles, which was initially developed as a concept that forms part of *neurolinguistic programming*—a type of therapy. The subset that covers the basic learning styles has become increasingly adopted by businesses as a tool to aid communication between staff and to help develop successful marketing campaigns. According to the concept, there are three learning styles: auditory, visual, and kinesthetic. Obviously, there are more than three types of personalities, and each person's learning style can be defined by varying combinations of these three basic propensities.

Now, I am a natural born skeptic, so I instinctively recoil from anything that tries to define us by a simplistic set of rules. But, I thought, why not give it a go and see if it helps? I am naturally wary of categorizing people, but as long as it's not taken too seriously, used as a rough guide (still allowing for deviations from stereotypes), then I think it can be a useful tool to help us think the way our clients and colleagues do and therefore communicate better with them.

Neurolinguistic programming is a much wider subject than I intend to cover here, and I'm not necessarily endorsing the approach. But I do find it useful, to a point. Understanding that people have different learning styles can help you analyze and understand the differences among the people you work with and help you to develop better methods of communication with them. And why not use any tool available to you? After all, you can choose your friends, but you can't always choose your colleagues and clients.

Auditory

People who exhibit high percentages of an auditory learning style tend to learn the most through verbal discussions, listening, hearing, or reading the written word. They are good listeners and have a strong ability for interpreting underlying meanings and reading between the lines. They pick up nuances that other people

may miss by listening to the tone of your voice for clues, as well as listening to the words themselves. Although they can cope well with written information, they often find it easier to digest if it's heard, so audio books, audio podcasts, and radio programs are popular with them. When communicating with people who have a strong auditory learning style, you can communicate quite successfully by conference calls, emails, and other forms of remote communication. Because of their ability to figure out hidden messaging, they tend to be attracted to jobs in research, marketing, or public relations.

Visual

Visual learners get the most from images or other visual stimuli. They tend to rely on body language and facial expressions to communicate their messages and use gesticulation to communicate. If these visual means of communication are removed (for example, communicating by phone call, instant messaging, or email), they can have difficulty in finding the right words to express themselves. They'll often doodle or take notes to absorb information during meetings, often not referring to notes afterward. The simple act of writing the notes helps them to see the words—which in turn helps them to remember them.

When they're communicating, they'll often prefer to use diagrams, graphs, and presentations in order to get their points across. The best way to communicate with strong visual learners is to use highly illustrated presentations with few words. If you can, get in front of them! Face-to-face meetings are usually preferable, since they'll probably find it difficult to communicate remotely. Not surprisingly, many people who are attracted to jobs as designers tend to be a combination of mainly visual, with a little leaning toward kinesthetic style.

Kinesthetic

Kinesthetic learners pick up and communicate information best when they have some sort of physical engagement with the subject. They will get the most from a hands-on approach, like interactive brainstorming on a white board. You could ask them to read a software manual a thousand times, but they most likely would never understand the instructions. You can even show them diagrams, but the chances are that they still won't get it. However, physically showing them how to do something or, even better, getting them personally involved in performing the task will help them remember it for a long time.

Kinesthetic learners desire constant activity and exploration. Tending to have a very low attention span, they are easily distracted, so you need to keep meetings moving at a fast pace. Don't

bog them down with too much detail. On the positive side, because kinesthetic learners' minds move quickly, they are good problem solvers and are great for sparking off lots of ideas. The downside is that they are not great finishers, so you probably don't want them involved at the final stages of production, where attention to detail is paramount. When working with people who have a strong leaning toward kinesthetic learning, engage them in the design process, get them to brainstorm with you, let them try things out for themselves. Creative directors tend to be strong kinesthetic learners with a healthy sprinkling of visual style thrown in for good measure.

Being Aware

The interesting part comes when you match them to each other. Think of two people who communicate easily, and you can be pretty certain that they share similar learning styles. On the other hand, I've often witnessed people screaming at each other, "But I don't understand! Why can't you see *my* point?" and then hear, "But I just don't get it!" Chances are the two people having the conversation have opposing learning styles. The most revealing part for me was looking at myself in the "learning styles mirror" when I thought back to all the times I've sat in meetings, fidgeting and twiddling with my chair adjustments, unable to concentrate on the endless barrage of written or spoken information being thrown at me. I'm a visual learner with a healthy dose of kinesthetic; the written word just doesn't do it for me.

Obviously, explicit information is easy to communicate to either of these groups because it can usually be communicated in ways other than just the written word. If we take our example of "avoid mixing too many fonts in a single design," this message can be backed up with visual examples—for example, placing a design that uses too many fonts next to a good design for comparison. Tacit knowledge can be a bit more problematic to communicate if you are dealing with auditory learners, since the message can't be written easily. In these situations I find the use of analogies really helpful. When trying to communicate the technique for making certain marks with a drawing tool, back it up with written or spoken instructions such as "Place your pencil lightly on the paper, holding it as you would hold a knife when cutting food. Move your hand quickly from side to side, as if you were brushing away crumbs."

Being aware of these personality differences can help you understand how your clients and colleagues think. Although you'll never think in the same way they do, try to see things through their eyes. Being compassionate to their way of thinking may just help you communicate your ideas more easily and improve designer-client relationships.

Communicating with Clients

So what learning type is your client? Is a phone call enough to establish the project requirements? Are you better off meeting them in person, communicating eye-to-eye? Would email be a suitable method to use? Or could you get them physically involved in the project at all—maybe having a brainstorming session over lunch? There may be times when you'll be presenting to a group, and in these cases, you must take all learning styles into consideration. It's easy if you're addressing a group of creatives who all have similar styles, but there may be times when the group includes a mixture of people with a diverse range of learning styles. If this is the case, design a presentation that incorporates an equal mix of elements to appeal to all styles, and make sure to communicate your message equally in all possible ways. For example, you may have a chart behind you on a slide (for the visual learners) as you talk about the subject (for the auditory learners). You can also invite the audience to become involved in the presentation by asking them to respond to questions. This will help the kinesthetic learners connect with you more easily.

Pitching

In the design industry, and increasingly in the production industry, there's an established process of unpaid creative pitching where companies compete for jobs. The process involves the client sending out a brief to several companies; then each creates a rough proposal for the job. The client chooses a winner, who continues to the next stage in the design process. The others go back to pitch for the next job! It sounds great; the best design solution will surely win. What could possibly be wrong with this process? Well, in my opinion there are several problems with this process, and that's why I'm not a great advocate of creative pitching. In most situations, these creative pitches are unpaid, meaning each company that takes part is losing money during the process (unless, of course, they are the lucky winner). The company that is offering the pitch has nothing to lose. They have all the power and have no restrictions in terms of budget, making them more likely to ask for more than they actually need. I'd probably be more in favor of creative pitching if it was a paid process, but it's generally not.

In this section I'll outline what I consider to be the problems associated with unpaid creative pitches. I really believe it's something that our industry would be better off without. I'm not going to lie to you by stating opinions about the benefits of creative pitching when I don't actually believe in them. However, I will offer some advice to you in case you end up being involved in the process. There are also plenty of other resources out there that are more positive about pitching and will tell you various methods for

ensuring successful pitches (she said, dubiously!). I'll cite them in the bibliography so that you can make up your own mind after reading them.

Problems with Unpaid Creative Pitching

Creative pitching is usually unpaid, so it can cost the agency or production company a lot of money to produce, both in materials and human resources. In 2005 the BDI (British Design Innovation) did some research into unpaid creative pitching and discovered that the average cost to an agency is about $60,000 per year—time and money wasted in my opinion. That means that creative pitching is costing our industry hundreds of thousands of dollars per year and wasting about 10 to 15 percent of man-hours per annum. (And this is just in the United Kingdom.)

Pitching is often exclusive, since there are usually "minimum requirements" specified. For example, the pitch is only open to companies of a certain size. There was recently a series of angry emails circulating in the letters pages of *Design Week* about the fact that a lucrative pitch was open only to companies with more than ten employees (excluding many of the smaller production companies and collectives from the opportunity to take part) (*www.designweek.co.uk/*). Even if smaller companies are allowed to join in the process, the larger companies already have an unfair advantage, since they can afford to throw more resources at creative pitches.

The creative pitch process usually involves a presentation of a proposal to the clients. If you are lucky, you may get some face-to-face time with the client, but often it's a case of being given a short amount of time to present one solution to them. The client hasn't witnessed the design process that you went through and in this situation is too focused on the aesthetics of the final piece.

Not enough consideration is given to the problem-solving processes that develop a final piece of work, and there is little emphasis placed on the strengths and weaknesses in communication. Often no consideration is made regarding how you and the clients will work as a team. These are all important considerations that should not be overlooked.

As we discussed earlier, decisions made based upon aesthetics are often subjective views. Often the people making these decisions are nondesigners, so they are not always trained to be objective about what works and what doesn't.

Finally, unpaid creative pitching isn't always good for your team. It puts them under undue stress and often results in substandard work because not enough time is given for proper research and development of ideas. It can really damage morale when a high percentage of jobs fall through after the creative pitch process. It's natural to think it failed because the design wasn't good enough when it could really be due to all sorts of other contributing factors.

If You Have to Pitch...

If you have to create an unpaid pitch for a job, there are a few commonsense rules that will help increase your chances of success.

Avoiding Potential Problems

Get specific requirements pinned down early, and make sure you have evidence of the requirements in writing to avoid disputes over misunderstandings. Focus on your design process rather than just presenting a single, finished design. Seeing a finished design that looks great is important, but clients really need to be convinced that you can work with them and adapt to changes. By outlining your design process, they'll get more of an understanding about where you're coming from, and they will feel more confident about working with you.

Sell the clients your services: Talk about what makes you unique, how you come up with ideas, how you work as a team, and communicate throughout the design process. Save all of your team's sketchbooks, moodboards, storyboards, and animatics from previous jobs and pitches to use in future presentations. Sometimes you can win a pitch by presenting the complete design process from a previous job as a portfolio.

Save time by creating a single presentation template that you can use for all clients and pitches. Keep your presentation simple and concise. There's more information about presentations later in this chapter, and I've included a presentation template that you can use on the website at *www.motiondesignessentials.com*.

Make sure that the client agrees to provide you with plenty of preparation time for research and development of ideas. Don't be bullied into promising more than you can deliver in the specified time. Chapter 2 includes more advice relating to this, and reading it will help you plan your pitch properly.

Be sure of your resources; make sure you've figured out if you will need subcontractors or freelancers. Then you need to make sure they are available before entering into the pitch process. Ask plenty of questions at the early stages. Speak to the clients in person, and if at all possible, insist on face-to-face meetings.

Refining Your Ideas

Research everything carefully: the client, the competition (other companies pitching for the job as well as the client's competitors), and, of course, the target audience. Develop ideas or concepts while in the initial meeting with the client, even if it's a rough sketch on a coaster or napkin. Follow this up with research, and from this create moodboards, brainstorms, treatments, and storyboards. Try to check these with the client at regular intervals, just as you would if the job was a done deal.

When presenting rough ideas, show multiple versions with variable colors, fonts, or even alternative rough layouts. This way you'll make it appear that you are flexible, and you'll increase the chances of connecting with the clients.

Structuring the Pitch

You may be offered 30 minutes to present your pitch, but if you're last in the queue and other people have run over, you may be asked to cut your presentation short—so be prepared. Devise three pitches: a ten-second pitch that you could tell somebody who has to rush out of the meeting; a one-minute pitch that you can deliver over the phone, and your complete, finished pitch.

Make sure the pitch is modular so you can add or remove sections if necessary without interrupting the flow.

- Start with the most important information, since people's attention will be freshest at the start.
- Recap key, important factors again at the end.
- Practice, practice, practice, and test your timings several times until you know the presentation inside out.
- You should never have to use notes in a presentation, since reading from them will prevent you from performing naturally.
- You should know the subject well enough so no unexpected questions or diversions will throw you out of kilter.
- Be snappy and to the point. If you can get your idea across in a shorter time than allotted, then do so; they'll probably thank you for it, especially if they've been sitting through a whole day of slide presentations.

The Communication Process

So you may have won a creative pitch to get the job, or you might have been lucky enough to have it offered to you on a plate— no pitching required. Either way, the time comes when you need to communicate with the client to get the job done. In this section we'll look at the typical progress of a motion graphics project in terms of communication with the client. In Chapter 2, we talked about how to plan your projects. Here we focus on the communication techniques you'll need to use as you go through these processes.

The Brief and the First Client Meeting

The first thing you'll get from your client is a brief, which outlines the requirements of the project. We looked at methods of interpreting briefs in Chapter 2, so make sure you've read that chapter before proceeding. You may be lucky and be the only person the client has in mind for the job, but often the client may

want several companies to pitch for the same job. If this is the case, find out who your competition is. Figure out which of your strengths sets you apart from the other companies, and focus on these. Once you have established the brief, determined the needs of the client, and found out who the target audience is, the next stage is to find the best way to communicate your idea to the audience. If dialog is to be included in the piece, the obvious place to start is with a script.

The Script

There are times when scripts will be provided to you, and other times when you will be expected to collaborate on the script. I'm not going to attempt to cover the art of good scriptwriting here, as that deserves a book in itself. (See the bibliography for some books that can help you with this.) In terms of communicating with others on scripts, I find Google® Docs are a really good option for any collaborative writing because you can share and edit the documents online, removing the need to email small changes back and forth. Google Wave also allows simultaneous editing and playback of changes. I tried Google Wave, but at the time of this writing, it was still in beta, so I was hesitant about using it on an important project. Adobe® Story is another beta software product that, like Google Docs, syncs to the cloud, allowing easy editing and color-coded scripting from multiple characters.

Brainstorms

Brainstorming allows for complete freedom of expression. As soon as I have a script and a brief, this is the first thing I do, either alone or in collaboration with others. When brainstorming, scribble down notes and sketch layouts, using words as well as images; sometimes ideas are more easily and quickly written than drawn. A huge whiteboard or a large sketchbook is good for brainstorming. You can find more brainstorming tips and tricks in Chapter 2.

The Second Client Meeting

After the brainstorm is complete, I like to recommend a second client meeting where you can work with the client adapting the script and going through ideas. Allow the client to lead this meeting, but guide them gently and persuasively. Look for positive or negative reactions to your ideas, and encourage them to be specific about their needs. There's no substitute for personal meetings at this stage, since you can pick up a lot of responses by observing their reactions to the work you present them.

Storyboards

Once everything has been agreed upon (and you have any changes in writing), it's time to move ahead with a storyboard and animatic. As we discussed in Chapter 2, this is a very important stage in any production and should never be skipped. It allows you to plan out the project, work out timings, and spot potential problems before they occur. It also gives everyone on the team a common point of reference to work from, avoiding possible misinterpretations down the road.

The Third Client Meeting

At the third client meeting you will review the storyboard or animatic and record any changes required. Remember to emphasize to the client that changes will be more difficult and costly after this stage, so encourage them to be honest and upfront about any concerns they may have.

Creating Source Files and Shooting the Video

Once the script, storyboard, and animatic have been approved, you can then create a list of the assets required to get the job completed (you can find out more about storyboards and animatics in Chapter 2). You can create a shooting list of any video footage you want to capture, including rough durations, shot angles, and any other specifications. You also need to create a list of any drawings you'll need and make sure you allocate enough time to create them. These lists will help you devise a schedule and make it obvious how much time will be required for each job. At this point, if you don't think you can achieve it on your own, you can start to allocate jobs to colleagues or subcontractors.

Use the lists you've created to communicate with your team and the client about their own specific requirements for the job. Software applications like OmniPlan can help you plan a large project like this and communicate the schedule to your team. The downside to OmniPlan is that not very many people have it, so another option is to use Google Calendars to share schedules online.

Reviewing the Final Piece

The edits can usually be shown to the client remotely using Adobe Clip Notes or Apple's® iChat Theater. Both of these technologies make the reviewing and commenting process easier when working with video or animation files. There may be several stages to this process as you go back and forth with the

client, refining changes as you go. At the end of this process, you can then show the final piece to the client, which is usually done in person.

Making Changes

I know it's hard to believe, but even after all your careful planning and consultation with your client, there's always the chance that they'll chime in with some last-minute changes. Actually, you should assume that this will happen (and then remember that the client is always right). You can learn methods of gentle persuasion to try to dissuade them from incurring the cost of last-minute changes. The best method I've found is to ask them for their reasons and listen carefully to their answers. Don't dismiss their ideas; try them out for size to see if they make sense. If not, formulate some solid reasons why they won't, and explain them to the client. If the client's ideas are good and would benefit the production, then maybe you should go along with them. It's always tempting to take the easiest way out, but if the changes would really make a positive difference, then perhaps it would be better to implement them. There were times when my relentless, bullying, taskmaster of an editor asked me to make changes to the text in this book. That was really frustrating, especially since I thought writing the manuscript was the last stage. But in the long run, I know that her suggestions were usually right and the subsequent changes would make this a better book.

Billing

When creating the final bill, make sure you remember to include time, materials, and equipment costs. Once you have sent the bill off to the client, you can't make any changes. You can create a spreadsheet to keep track of costs throughout the project and share this with your team. Many studios and agencies have studio management software set up to keep track of costs and keep everyone informed of progress. Some options are Sohnar Traffic (*www.sohnar.com*), Streamtime (*http://previewstreamtime.com*), and Farmers WIFE (*www.farmerswife.com*). These systems can be expensive to implement, but they make cost tracking easier. The company I currently work for as Creative Director, GridIron® Software, makes a product called Flow that is a good option for organizations of all sizes. It tracks your files automatically, helping you bill your clients accurately and budget for future jobs, taking the guesswork out of the equation. It also helps you to communicate costs of changes to your clients by presenting a map of the project that can be shared across networks. This can help to reduce the likelihood that your client won't insist on difficult and expensive changes (see *www.gridironsoftware.com*).

Remote Working

I'm interested in the recent trend of decoupling seen in TV and film production companies. It's the world that I used to live in, so it's close to my heart. Decoupling refers to the process of reducing costs to the client by outsourcing some of the work to freelancers or external services rather than providing them in-house. Decoupling offers big opportunities to everyone in our industry from company directors to freelancers and runners—if we can be brave enough to embrace it.

Increasingly, over the past 20 years, production companies have been expected to be flexible, pressured to increase their skills, enabling them to deliver every possible service and format to their clients. This entails increasing staff to cover all areas of production, extending the capabilities of the company so they can also generate content for new and emerging mediums (web, mobile devices, games, etc.). The result is increased costs due to wages and also investment in bigger studio spaces.

The inevitable has happened: The work that was plentiful during times of development has somewhat dried up. Production companies are competing even harder for the same jobs, while clients find it harder to differentiate between companies, as they all offer essentially the same services. Frustrated freelancers who weren't finding the right amount of work (or satisfaction from it) started to create their own collectives. For a while these injected some new life into the industry, but they too have suffered from what I call the "jack of all trades syndrome"—feeling that they must offer all services in-house, often stretching the capabilities of their employees and making the work suffer as a result.

Of course, there are pros and cons with everything in life, and this is no exception. On a positive note, decoupling could provide the opportunity to return to an industry where craft specialization matters. Instead of all production companies offering essentially the same services and competing for every scrap of work, each could become king of a particular area, passing work on to other companies when the work is more suited to their specific skill field. A certain amount of this already goes on within Soho (where I used to freelance), but I really believe this could be extended further. It could potentially improve the quality of work, employee morale, and confidence in individual companies.

By letting some of their in-house designers go and replacing them with freelancers, companies could open up to diversity, calling on different specialist skills appropriate for each job. It could create healthy competition between freelance creatives but also an opportunity to create alliances—not to mention a network for swapping skills. In-house designers can sometimes find it hard to maintain focus and motivation, so those more suited to a freelance lifestyle could benefit greatly here.

I worked as a freelancer in the industry for over 12 years, so I know only too well the challenges that can be faced. Remote working is not easy; you need to be motivated, focused, proactive, and willing to network. Ideas can be harder to develop on your own. It's amazing how much creative development goes on during breaks around the coffee machine or meetings in the pub after work for production companies. Get rid of your in-house team and you risk losing the teamwork that's so valuable for the development of ideas. You could also risk losing any sense of company identity.

It can be hard to find the right people at the right time to work on a production; they may be busy with another company, but on the whole, I see decoupling as an exciting prospect. It increases the unknown in the equation. Risk and uncertainty can be scary, but embrace them and you often find new, exciting challenges that, combined with a bit of initiative, can be the impetus to creativity in its truest sense.

Networking

As you can imagine, the increase in remote working can be a real challenge in terms of communication, both for the company and the remote workers. One company that I visited recently told me they provide open plan spaces for their employees because it increases productivity by about 20 percent. As the trend for remote working grows, we may need to find new ways to create group environments online so we can easily share ideas and prevent ourselves from becoming isolated and stale.

Instant messaging and video conferencing can help to a certain extent, and social networking becomes increasingly important as more people opt to work from home. I used to steer clear of Facebook and other social networking sites, thinking they were a haven for sad, lonely people. Since most of my work has moved to my home studio, I have come to rely on them more and more so I now feel a "virtual" sense of community. They stop me from feeling isolated and allow me to share ideas and inspiration.

However, there are times when I find that remote communication methods like email, instant messaging, and even phone conversations can lead to misinterpretations and difficulties in communication. I sometimes leave a remote conversation unconvinced that I've managed to put my point across or feeling that I'm not being understood properly. Because of this, I like to make sure that I am involved with plenty of face-to-face networking, too. Nothing substitutes for talking to somebody in person, particularly if you're a visual learner. It's also a good idea to join local guilds, clubs, user groups, and associations, since they will give you the opportunity to network in person with people who have shared interests. They can also keep you updated with information about local events, funding, and other useful activities in your area, and they help keep you connected and informed about your contemporaries and their work.

The good news is that all methods of communication have become a lot easier over the past 20 years, and we have more choice than ever. You can still mix with contemporaries over a few drinks at an art opening, seminar, or exhibition, or you can connect using a wide choice of online tools.

Online Networking

Social networking has in many ways become more important than having your own website. The great benefit of social networking to the viewer is that they can easily catch up on news from lots of different people on one site, or even on one page. The benefits for you are that you can reach thousands of people more easily, update content more easily, and take

advantage of the social networking site's vast database. There are also lots of specialist websites that are more specifically targeted toward the motion graphic design industry that offer support and networking capabilities. These provide tutorials and offer help, advice, forums, and inspirational examples of work. I've included links to my favorite specialist sites in the bibliography.

Facebook

Facebook is great for casual networking with friends and coworkers. I believe that it's good to show the people you work with a little bit of your personality, and Facebook allows you to manage this quite easily. You can post pictures, videos, links, and virtually anything else for all your friends, contemporaries, and colleagues to see in one fell swoop. If you want to control who sees what, it's easy to set different privacy options for different groups. For example, you may want your "Friends" group to have access to everything on your Facebook page but your "Work" group not to have access to the private photographs of your weekend activities. I have Facebook open in the background as I work, and it's nice to see when people post news, ideas, inspirational examples of work, or simply updates on their activities. It kind of makes me feel like I have other people in the office with me!

LinkedIn

LinkedIn is a great site for work-related networking. You create your own profile page, which can include a resume (CV) and short synopsis about the skills you offer. Once your page is established, you can set about linking to other people you know in the same way as you do with any other social networking site. Through connecting with people you know directly, you can easily extend your connections to people they know, so the intricate web grows. It's a great place for finding out who's available for work, posting your CV and recommending colleagues. As with Facebook, you can customize the options to make it work for you.

Twitter

I must admit, I'm not a huge fan of Twitter. I find it too limiting, and it takes the creativity out of writing. Twitter allows you to send short, character-limited messages like URL links, comments, and observations to the world. If people see your messages (and they like what you say), they can choose to follow you. You can also choose to follow people you are interested in.

Figure 8.3 **LinkedIn.**

Messages from the "Tweeters" you choose to follow automatically show up when you open Twitter so you can get a flavor of what all your interesting parties are up to. It's a great vehicle if you find a link you want to share quickly with a group who shares mutual interests, but I personally find it a bit too limiting. If you want to quickly share a short snippet of information with the world, it's the ideal platform.

Figure 8.4 Twitter.

Blogging

Blogging is a wonderful art form. It turns obsessives and enthusiasts into writers and philosophers. There are so many authors out there who would never have even considered writing books until they experienced the power of the blog! Blogging is basically a process of posting regular updates of information on an online page that users can subscribe to. If they subscribe, they will be automatically notified when you update your blog, meaning that they don't have to keep checking for new information as they do with a regular website.

The thought of writing a book can be pretty intimidating (believe me!), but a blog is much less intimidating because you only publish small chunks at a time. After blogging for a year or

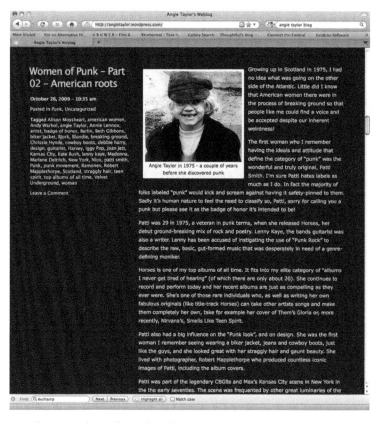

Figure 8.5 **A blog**.

two, authors realize that they have written the equivalent of a book and often set about having their blogs collated and published as traditional printed books. The movie *Julie and Julia* is about a woman named Julie Powell who had this experience. She created a blog about cooking the recipes from American chef Julia Child's cookbook over the space of a year. Her blog was so successful that she became an author in her own right, and a film was made about the whole phenomenon. I also have my own blog called *Creative Pro Therapy* (*www.creativeprotherapy.com*) where I talk about design, music, and anything else that interests me. I find it a very creative and cathartic process to force myself to write regularly, hence the name of the Blog.

Website

Of course, you should have your own website if you want to project a professional image. It used to be quite expensive and time-consuming to keep your own site, but not anymore. You don't even need a dedicated web hosting service, but instead you can create a complete, customized website for yourself on blogging sites like Wordpress. These provide you with easy-to-use templates and make updating the content of your site easy. You don't have to

Figure 8.6 My website is at www.angietaylor.co.uk.

be a web designer to create a good-looking, up-to-date, functional website anymore. However, if you can afford to, I always recommend hiring a professional web designer to create your web presence for you. As I've said before, I believe in supporting specialists, and they often know better, more effective ways of managing your web presence than you do.

Presenting Yourself

We spoke a little about presenting your work in the pitching section, but here are a few additional tips and tricks to keep in mind if you need to present yourself for an interview or other high-pressure situation.

Showreels

Showreels are the best way of showcasing your work as a motion graphic designer. There are various different methods for delivering your showreel, but the easiest for you and the viewer is to have it easily accessible online from your website. When designing your reel, keep it as short as possible—two minutes maximum. Only include work that you are really proud of. If anything makes you cringe when you watch it, remove it immediately! It's much better to be shorter but better than risk boring the viewer with a long, mediocre showreel.

Choice of music is also very important. The music should almost blend into the background while still providing a sense of rhythm to the edits in your showreel. You should also make sure it will not color anyone's opinion, so choose a track that is quite neutral. You can use some of the tips and tricks from Chapter 7 to help you with cutting your clips to a soundtrack. You can see some great showreels for inspiration on the Motionographer website at *http://motionographer.com/cream*.

Resumes

You should always have your resume (or CV) up to date. It's easy to do this using a service like LinkedIn, which makes editing it and sending it to prospective employers easy. If possible, summarize your resume so it fits on a single page. Two pages should be the maximum, but you should be able to get enough information to make yourself sound irresistible on one sheet. When you

want to attract somebody's attention, less is more, so avoid including the part-time job you had working at the local diner when you left school.

Portfolios

Most people put their portfolio online now. Illustrators digitize their work and exhibit it on websites like http://www.illustration-mundo.com/wp/ where you can search through different illustrators work to find a style you need for a particular job. Alternatively, you can easily set up an online gallery with services like Mobile Me from Apple®. There may still be times when you're required to present a nondigital, static portfolio. You may want to present drawings or storyboards that you've created to prospective employers or clients. Here are some tips to follow if this is the case:

- Invest a little money in a proper, smart-looking portfolio. It doesn't have to be top-of-the-line or expensive to look good.
- Use hinged portfolios to avoid losing artwork. They also make it easy to add or remove or reorder items.
- Label the front cover clearly with name, address, phone, email, and URL, just in case it gets lost, but also so that the person looking at it has all the information they may need.
- Spell check everything—*three* times! And don't rely on software spell-checkers; they don't always catch context-related spelling errors. Get at least two other people to check the spelling and grammar for you.
- Include a table of contents to help the viewer navigate your portfolio with job titles, client names, dates, and any other notes that may be useful.
- Mount all your artwork on boards using spray mount. Use gloves when smoothing to avoid getting spray mount on the surfaces of the images.
- Trim edges neatly and at right angles using a guillotine.
- Keep board size, color, and quality uniform (black, white, or gray are best).
- Small images can be mounted in groups on full-size boards.
- Use PVC sleeves for any loose notes and sketches
- Show work in chronological order, showing progress from sketches through to stills taken from completed projects.
- Remember, if the presentation of your work is weak, it will make the work itself appear to be weak, as well.
- Finally, when you're talking about your work or presenting it in a slideshow, always be confident about it. Avoid being defensive, since it implies that you're insecure and need to defend your ideas. Take criticism confidently, and either act on it or explain calmly why you think your ideas are good ones.

Recap

So to recap, there are many forms of communication involved in motion graphic design—not only via the work itself but between all the people involved in the production process. Learning new ways to communicate will ensure that the work you do is as painless as possible, but it will also help you find new ideas that can inform your work. Read as much as you can about communication. There are plenty of books out there that cover the subject from various different angles.

Figure 8.7 **Steve Caplin.**

Inspiration: Steve Caplin, Graphic Designer and Author

Steve Caplin, a very talented graphic designer and author, wrote a very successful book called *How to Cheat in Photoshop*. You can find out more about this book and view his online portfolio at *www.stevecaplin.com*.

"I got into the career I'm now following entirely by accident, as is so often the case. I left university with a degree in philosophy, which is fun to study but isn't a great career path. My first job was playing the piano in a wine bar. The manager of the wine bar left to start a listings magazine, and I started it with him. He dropped out after just four issues, and I kept the thing going for four more years; then turned it into a free newspaper. I spent the next decade editing magazines, including nine months producing publications for the Museums Association.

"In 1987 the advent of Aldus PageMaker meant that it was now possible for me to create an entire magazine more easily than ever before: with a Mac Plus, I started the satirical magazine *The Truth*. As the first desktop published magazine in the United Kingdom, it was something of a trailblazer and won a few awards. But the best prize came in the form of a video camera, a video digitizing card for my Mac, and copies of two early photomontage applications: Image Studio and Digital Darkroom. That's when I started experimenting with creating satirical montages.

"*The Truth's* distributors went bust in 1989, so I had to close the magazine down, but I had all this computer equipment left over and continued to play around with montages. I met the editor of *Punch* and showed him what I'd been toying around with. He commissioned an illustration for the following week, and then a regular weekly photomontage cartoon strip—a political strip set in 10 Downing Street, the home of the British prime minister. Then *The Guardian* phoned up and said they wanted a similar weekly strip to run in the newspaper. With this

Figure 8.8 © Steve Caplin, 2006.

kind of exposure, it wasn't long before more newspapers, magazines, and advertising agencies started phoning for work.

"The magazine and newspaper work has always been a pleasure. Advertising jobs, though, pay ridiculously well, but they buy your soul; they start off employing you as an artist, but you end up a technician as art directors make endless unnecessary, tiny changes to artwork they've simply got bored with staring at. If I wasn't doing this job I'd probably be moaning about how awful my day job is, I suppose, and spending my weekends and evenings doing the stuff I do now. My main hobbies are music and woodwork. Each weekend I build something that didn't exist before. Could be a large project—I've built a 16-foot camera obscura and a full-size bar billiards table—or even something small like a turned bowl or candlestick. I don't really mind what it is, as long as I'm making something.

"Working in wood is an entirely different approach to working on a computer, mainly because there's no Undo key: you make a decision, and then you're stuck with it. In some ways, this is how photomontages used to be before Photoshop brought in layers in version 3. Once an element was placed into the montage, it was stuck there. I used to make complex montages from polystyrene, toy soldiers and bits of household junk, though—before I found

Figure 8.9 © Steve Caplin, 2006.

Figure 8.10 **Camera Obscura.**
© Steve Caplin, 2006.

I could have more fun doing the same thing in Photoshop. Most of my work is commissioned for newspapers and magazines, so what inspires me there is the deadline and trying to interpret a brief in an innovative way. But I also create personal work, and I'm increasingly becoming interested in animation: the timeline in After Effects adds a whole new dimension—literally—to working with photomontage. If I'm on a tight deadline, I find the adrenaline rush usually does the trick on its own. It may be the increased oxygen, but outdoor thinking always proves profitable. I often walk around the garden to think out ideas; if I hang around parks gazing blankly into space I feel I'm likely to be arrested. The trick to coming up with ways of illustrating stories is to think obliquely. Often the most obvious idea isn't the one that will work best in practice, and presenting ideas visually is a different matter to explaining concepts verbally. I often start by exploring common metaphors, just to see where they end up. But it's always the case that it's the simplest idea that sells the story you're trying to tell. It's all about communication, getting the point across as quickly and efficiently as possible."

TECHNICAL

Synopsis

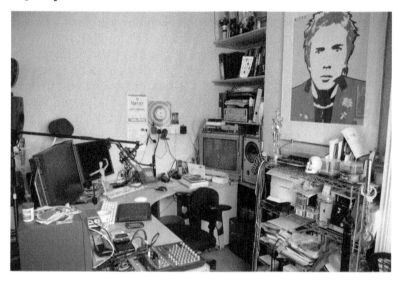

Figure 9.1 **My studio.**

Okay, so I'm asking myself, how can I make sure you can get through a chapter called "Technical" without slashing your wrists? None of us want to face dreaded technical issues, but sadly, if you are working in digital media, there's no avoiding them. This stuff wasn't designed to make life easier for you. In fact, it wasn't designed at all but was cobbled together over years with various different applications in mind. Computers were originally designed to compute, not to add visual effects to film, so as a result, they're not always readily set up for the task in hand. You may need to do a certain amount of jiggery-pokery to get them to work the way you need them to and to get them talking nicely to other equipment (that was often designed to do other things). It's not my intention to explore each of these areas in depth or to get too bogged down in technical jargon. There are plenty of other resources that you can turn to for this—if you're feeling particularly masochistic! By the end of this chapter, you'll have the basics and enough to get started with your motion graphic projects. My hope is to introduce you to some important concepts in as entertaining a way as possible and inspire you to find out more when you're ready.

Design Essentials for the Motion Media Artist. DOI: 10.1016/B978-0-240-81181-9.00016-9

Introduction

When I first ventured into the magical, mystical world of computer graphics, I had no idea what I was doing. Sure, I'd done an art degree, so I knew how to make things "look nice," but I had no idea how computers worked or the differences between the different types of media that could be output from them. Computers weren't even around when I was at college, so I had to dive right into the deep end, and it was a *very* steep learning curve for me.

After leaving college, I did a couple of courses on graphic design to learn about the software I would need to create my designs and animations. I learned a lot of things, but they never taught me about the real technical nitty-gritty that I soon discovered was necessary if I ever wanted my designs to be seen outside of my own studio. My first foray into the delights of "making things work" was on my first paid job doing motion graphics.

I'd sent an ad to all the production companies in my region (about 400 of them), basically saying, I'm a designer with my own equipment, and I can make animations and motion graphics for you. Call me if you're interested. Not surprisingly, my phone hardly rang at all (it was 1996 after all). Very few people were using desktop computers to create animation. Most established television companies didn't regard it as a serious proposition. They still invested in proprietary systems that cost hundreds of thousands of dollars to create graphics and weren't convinced that a cocky young lady with a Mac could produce work equaling their massive financial investments.

But out of the 400 letters I sent, I got two replies. I ignored the one asking for sexual favors and proceeded to call the other one, which was from a lovely man named James Hawkes at a company called Atacama. I will forever remain indebted to James. He took a chance, believed in me, and offered me one of the best jobs I've ever had. Now, he didn't just do it out of the kindness of his heart; he needed to get a job done cheaply, and, believe me, I was *cheap*!

The job was to do all the graphics for a movie he was making about Captain James Cook and his voyages around the world (Figure 9.3). We had the most amazing footage to work with. I often wish I could get a second chance to work with the same material with the knowledge I have now, but alas, that's not to be. Anyway, I digress. He hired me, plus an editor straight out of college. We were handed the rushes and shown a few examples of "stuff he liked" and then set to work in his very lovely studio in the Scottish Borders. The editor was working on an AVID system, and I was working on After Effects. All went well—until it came time to render! There were all these weird lines across my

Figure 9.2 **Atacama's website.**

Figure 9.3 **Stills from** *The Voyages*, **made for the Cook Museum in Middlesborough, U.K.**

footage, and it wouldn't play back properly on the Avid system. None of us really had the answer, and Avid was less than helpful at that time about opening up their editing system to nasty, foreign QuickTime movies. So we had to dive in and teach ourselves to get the movie finished. It was a baptism of fire!

Thankfully, things are a lot easier these days. To start, working with Avid systems is a lot simpler. And there is more awareness of

technical issues in general, so it's easier to find solutions online for most of the problems you may encounter when designing content for the screen. However, it is good to get at least a basic understanding about the kinds of issues you are likely to come across in the real world. I wish somebody had done it for me all those years ago!

The technical details that follow are here to draw your attention to important issues that you need to be aware of when designing motion graphics and animation. Some subjects will be covered comprehensively in this chapter, and others are explained in more detail elsewhere. When this is the case, I will direct you to the appropriate information in the bibliography or on this book's website at *www.motiondesignessentials.com*.

When designing for moving media, the first thing you need to think about is what format you will be outputting to. This could be anything from videotape to the web, DVD, as a QuickTime movie, or a Flash file distributed on a variety of handheld devices, all the way up to high-resolution film or 4K digital film files. The "rules" used for delivery differ according to your chosen output format. Since I am from a broadcast background, I'll focus on the medium that I know best, but I'll cover other mediums as well and will refer you other places where you can find out more.

When you're working as a motion graphic designer, you're likely to be supplied with footage that your client wants you to include in the production. It's important that you understand the different formats available.

Video Formats

Unfortunately for us, there is not one, universal video format (the life of a motion graphic designer is seldom easy). The format you need to design for, in the case of video, is determined by the geographic location where the finished movie will be viewed.

- *PAL*—In Europe, the video format used is named PAL (which stands for Phase Alternating Line).
- *NTSC*—In the United States, Canada, Mexico, and Japan, the video format used is NTSC (National Television Standards Committee).
- *SECAM*—This format (stands for *sequence a memoir*) is used in France but is generally being phased out in favor of pan-European adoption of the PAL standard.

Each of these formats has different rules regarding frame rate, aspect ratios, color gamuts, and field order that you must adhere to if you want your designs to look as expected on each particular device. In the following paragraphs, I will explain these differences to you and give you what you will need to ensure that you are using the correct settings for your chosen format. We'll start by looking at frame rates.

Frame Rates

The frame rate is the number of frames (or pictures) that are transmitted for every second of footage. Generally, the higher the frame rate, the smoother the playback. The frame rate of your digital files should be based upon whatever your final output will be.

If you are outputting your final movie for the European PAL video format, you must use a frame rate of 25 fps. NTSC has a frame rate of 29.97 fps. The frame rate of film is 24 fps. Movies intended for distribution on a digital medium such as the internet, hard disks, or from digital disks such as CD-ROM or flash disks do not have a fixed frame rate. They are usually played at between 8 and 15 fps.

The choice of frame rate is often decided based on the data transfer rate of the delivery medium. A movie designed to be downloaded and watched on a computer may have a frame rate of 15 fps, whereas if it was to be streamed over a modem connection, which has a much lower bandwidth, it would play back smoother at a lower frame rate of perhaps 8 fps. It's very hard to set defined rules here, so each case needs to be assessed individually. When altering the frame rate of any original video that you want to include in your work, try to keep the frame rate as a multiple of the original (e.g., change from 30 to 15, half the frame rate). This will ensure that the motion remains even and that frames do not have to be duplicated to fill in awkward timing gaps.

Timecode

When working with time-based mediums (e.g., video or animation), you need a method for measuring and displaying the time (Figure 9.4). In animation software applications, time is often measured in frames. With this method, the footage is measured by the number of frames it is made up from; no reference to time is used (e.g., hours, minutes, seconds). To work out the length of a project, you simply divide the number of frames by the working frame rate. So an animation of 200 frames in length played back at 25 fps will be exactly 8 seconds long.

Most editing and motion graphic applications enable you to measure time in SMPTE timecode (developed by the American Society of Motion Picture and Television Engineers). This allows you to more easily measure time because it is divided into hours, minutes, seconds, and frames (Figure 9.4).

Figure 9.4 **Final Cut Pro's timecode viewer.**

Fields and Interlacing

Remember that I told you how the footage in my first project was full of weird lines? Well, I later discovered that these were the result of interlaced footage. What is *that*, you ask? Well, each

frame of footage shot using a video camera (with the exception of footage shot in progressive mode) actually consists of two separate fields. Think of these as two images split like venetian blinds and then slotted together to form one picture (Figure 9.5).

Figure 9.5 If you separated the two fields of video, this is an exaggerated idea of how they'd look placed side by side. Footage courtesy of www. artbeats.com.

These two fields are captured in sequence onto videotape and then combined when you capture the footage into your computer to make up one complete, interlaced frame. When you view an interlaced frame on your computer, you will see both fields displayed together. Where objects or the camera are moving, you will see a ghosting effect caused by the combining of the two fields (Figure 9.6).

Figure 9.6 An interlaced frame in Adobe After Effects. Notice that you can see double of each of the audience in the background. This is due to the camera moving. Footage courtesy of www.artbeats.com.

The reason for interlacing video goes back to the days when television was in its early stages. When televisions were first invented, they used progressive scan screens (like your computer monitor). A progressive scan scans the screen once from top to bottom for each frame. The problem with this is that the

phosphors, used for displaying pictures on TV screens, would heat up to create the picture, but by the time the picture had scanned down to the bottom of the screen, the phosphors at the top were already beginning to cool and were therefore losing their luminance. This phenomenon resulted in a downward, dark banding as the phosphors cooled down. The solution to this problem was to interlace the video—that is, to split it into two separate fields. This way, the picture information was split into two, so the phosphors needed less time to be active. These fields of video are then played in such quick succession that the human eye reads them as one complete frame. If you look at your interlaced TV screen closely, you see a very slight flickering that you don't see on computer monitors and progressive displays.

The first problem is that the order in which these fields occur is dependent on the video format you are using. Some formats capture the upper field first, and some capture the lower field first. The general rules are that PAL uses the upper field first, and PAL DV, NTSC, and NTSC DV all use the lower field first. There are a few exceptions to this rule. There are very few constants in the world of digital video, so it doesn't hurt to check the field order with the manufacturer of the equipment you are using and also to check the format on which the final movie will be shown.

How Software Deals with Fields

When shooting PAL 25 fps footage, the fields are captured at double the frame rate: 50 fields per second. Each field is captured sequentially at a different moment in time. The time interval is so small that we don't really see it (again, due to persistence of vision that we discussed in Chapter 4), so we read the image as one complete frame. When you capture the footage into a computer (or digitize it), the two fields will usually be mixed together to make up each frame shown on the screen.

Because of this, you may see a feathering effect where the two fields are different from each other. This is especially noticeable where the subject (or the camera) is moving; the faster the movement, the more feathering that occurs (Figure 9.7). This is what happens when two separate fields are combined (or interlaced) together. You can imagine that applying effects or transformations to this image would result in a pretty poor-quality output.

Figure 9.7 A single interlaced frame viewed on a computer monitor. Notice the feathering.

Deinterlacing

To overcome this problem, applications like Adobe® After Effects can deinterlace (or separate) the fields for you. It will also interpolate the gaps to create a full picture so you can apply effects and transitions to individual fields rather than to the mixed frames, ensuring the highest quality possible on output. Figure 9.8 shows the two individual frames originating from the interlaced frame in Figure 9.7.

Figure 9.8 Two separated fields taken from an interlaced frame of video.

Footage that is going to be broadcast or printed back to videotape should generally be reinterlaced on the way back out of compositing or effects software like Adobe After Effects. It's vitally important to get the field order right both on import and render stages. The fields are captured and/or rendered at different moments in time, so if interpreted or rendered incorrectly, the footage will play a later moment in time before an earlier one. This will cause a stuttering or jerky movement, which is a telltale sign that your field order is wrong, so look out for it.

Any footage rendered from After Effects or from some of the most popular nonlinear editing applications (such as Apple® Final Cut Pro, Adobe® Premiere Pro, or Avid® Media Composer) will include a label that tells the software the correct field order on import. You can usually let the software decide how it wants to deal with fields, but it's still important that you are aware of interlacing issues, even if you do not fully understand them. At least you should know enough by now to spot the incorrect interpretation of field order. This is particularly important if you are, like me, a freelancer. Every company will have a different setup and a unique way of approaching the same job. It is vital that you are aware of the pitfalls you may encounter and what to do about them. Interlacing errors are among the most common mistakes I've encountered. To find out how the software you use deals with these issues, refer to the online help or user manual.

Other Causes of Jittery Motion

There are a couple of other things that can cause a jittery motion in your movies and animations. If you have checked the field order, and everything in that regard seems to be okay, something else may be causing the problem. If you are moving text or any other similar graphics up or down the screen, you may get a jittery effect that can be exacerbated by interlacing. To overcome this, you should make sure that the speed at which the text is moving is at an even multiple of your field rate. For example, if you are working in PAL, the speed of the scroll should be a multiple of 50. It can be hard to work this out, so Apple's Motion contains a behavior that will automatically do this for you. Adobe After Effects also has an Autoscroll Animation Preset that you can use.

You should generally avoid using very thin horizontal lines in your designs, since they tend to flicker between the fields if they are too thin. Always make sure that your horizontal lines are at least two pixels deep, if not more. Many software applications have built-in "Reduce Interlace Flicker" effects. All these really do is add a slight vertical blur of about one or two pixels to help alleviate the problem. If the software you're using doesn't have a filter for this purpose, you can create your own by adding a slight vertical blur to the text or graphics before rendering.

If you do recognize a problem, you can reference this book and the online help system of the software application you are using to help you fix it. There's also a great chapter in Trish and Chris Meyer's wonderful book *Creating Motion Graphics with After Effects* on interlacing issues, which goes into greater detail than I've done here.

Aspect Ratios

There are two things to consider in terms of aspect ratios; the frame aspect ratio and the pixel aspect ratio. We'll look at frame aspect ratios in a short while but first let's take a look at pixels.

Pixel Aspect Ratios

The term *pixel* is an abbreviation of picture cell. Pixels are what the images on the screen are made up of. If you were to put a magnifying glass up to the computer screen, you would see that your images are made up of thousands of tiny little squares or cells that form a grid. If you zoom into your images in Photoshop, you can see the pixels for yourself. The pixel aspect ratio determines the dimensions of each individual pixel used to make up the complete picture on screen. It's important that you understand the differences between the different pixel aspect ratios; otherwise, your images can appear distorted when viewed on a television screen.

Square Pixels

Computers display pictures using square pixels. Any original footage created in a 3D application (like Maxon Cinema 4D), illustration application (like Adobe Illustrator), or an image editing application (like Adobe Photoshop) will usually consist of square pixels (Figure 9.9).

Nonsquare Pixels

The pixels used to make up an image on a video monitor or a television are not square but are rectangular in shape. Just to complicate matters even more, the shape of the rectangle differs depending on whether you are using a PAL or NTSC system. Because there are several subcategories, the entire group has been generalized and is represented by the term *nonsquare* pixels. You may hear the term *D1* commonly used to describe the shape of nonsquare pixels. Technically, this is the wrong term to use, but they are usually referring to nonsquare pixels. D1 is actually a videotape format that complies with the universal ITU-R 601 standard for converting analog signals for digital television broadcast.

PAL

Your computer's square pixels measure 1 unit by 1 unit, and it takes 788 of these square pixels to make up the width of a 4:3 PAL screen and 576 to make up the height. PAL nonsquare pixels (also referred to as D1 or DV PAL) are the same height as square pixels but are approximately 9 percent wider. Because these pixels are wider, fewer of them are needed to fill the same frame width: only 720. The same 576 pixels are required to fill the height. In the case of PAL nonsquare pixels, the height remains the same, while the width changes (Figure 9.9).

Figure 9.9 Shapes of PAL, NTSC, and square pixels.

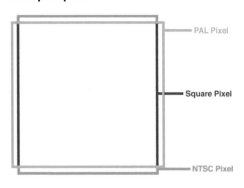

NTSC

Your computer's square pixels measure 1 unit by 1 unit, and it takes 720 of these square pixels to make up the width of a 4:3 NTSC screen and 534 to make up the height. NTSC pixels are the same width as your computer's square pixels but are taller. This means 720 of them are used to fill the same 4:3 screen width, and 486 to make up the height of the 4:3 NTSC screen. Nonsquare NTSC pixels are tall and thin as opposed to PAL's short and wide pixels. NTSC pixels are the same width as a square pixel but are approximately 10 percent taller. In the case of NTSC nonsquare pixels, the width remains the same, while the height changes (see Figure 9.9).

At this point your head is probably spinning, so take a break, have a walk, grab a coffee, phone a friend, or do something else for a while to absorb what you've learned so far. When you come back, we'll continue our intrepid journey into the wonderful world of TV graphics!

Frame Aspect Ratios

The frame aspect ratio describes the dimensions of the screen that the footage will be displayed on. All content designed for broadcast must comply with the correct aspect ratio determined by local broadcast standards. In this section I'll outline the most commonly used aspect ratios.

Figure 9.10 **A 4:3 frame aspect ratio.**

Standard Definition TV

Most televisions have either a 4:3 frame aspect ratio (four units width; three units height) (Figure 9.10) or, in the case of widescreen televisions, a 16:9 frame aspect ratio (16 units width; 9 units height). The resolution of the screen depends on whether you're outputting PAL or NTSC.

High-Definition TV

High-definition televisions are now widely available, and programs are broadcast via cable and satellite in HD. HD uses square pixels and has a fixed 16:9 resolution of 1920 × 1080 (Figure 9.11).

Computer Displays

Computer equipment can be set up to use different display resolutions, depending on the graphics display capabilities of each particular system. They can be 4:3 (e.g., 1024 × 768; 1280 × 1024), but they are more commonly 5:4 (1600 × 1280). Movies destined for playback on a computer screen do not have to fill the screen, so they can be created at virtually any size. Players like QuickTime and Windows Media Player will resize to fit the content.

Figure 9.11 **A 16:9 frame aspect ratio.**

Film

Digital film sizes range from 2K (2048 × 1556) to 4K (4096 × 3112).

Practicalities

So why is all this important? Well, you need to be aware of these aspect ratios when you are creating source materials for your movies, or otherwise the footage may become distorted when it's broadcast. Most software applications used for creating broadcast graphics provide an option for working in a nonsquare environment. They allow you to work within the software using nonsquare dimensions, since the software does the conversion process for you in the background. Not all applications allow you to do this, however. For example, Adobe Illustrator only allows you to work in a square pixel environment. So it's important that you are aware of this and design your graphics accordingly to avoid them appearing distorted when viewed on the screen.

Adobe Photoshop, Adobe Illustrator, and Adobe After Effects all offer presets that allow you to pick exactly the correct frame and pixel aspect ratio for a particular delivery format (Figure 9.12). I recommend using these presets to avoid making mistakes. You should also refer to your application user manual or online help for specific instructions regarding aspect ratios.

Figure 9.12 Software applications offer useful presets that ensure you choose the correct aspect ratios for your work.

When creating 4:3 footage for broadcast in a square pixel environment, you should create your files at

PAL: 788 × 576

NTSC: 720 × 534

When creating 4:3 footage for broadcast in a nonsquare pixel environment, you should create your files at

PAL: 720 × 576

NTSC: 720 × 486

Note: You must also make sure to choose the correct nonsquare pixel aspect ratio, specific to the format, and your region when working in these dimensions. This can be done in the New File dialog box in Photoshop (Figure 9.13).

Figure 9.13 The preset for creating HDV source footage in Photoshop.

Widescreen

Okay, we've covered the rules for 4:3 televisions, but what about outputting for widescreen? Over the last few years, it has been generally accepted in the broadcast industry that widescreen is the standard format. Widescreen's format has a 16:9 frame aspect ratio as opposed to the regular 4:3 aspect ratio. This gives the viewer a wider picture, similar to the panoramic vision of the human eye (Figure 9.14).

Across the world, broadcasters are adopting this new standard, and many of the newer digital channels are broadcast in true widescreen. However, in the United Kingdom and many other regions, terrestrial television networks still broadcast some of their programs using the 4:3 aspect ratio. In these cases, widescreen images need to go through a conversion process on their journey to your TV screen.

The correct 16:9 frame aspect ratio for broadcast in the United Kingdom is the same as for 4:3—720 × 576. The difference between 4:3 broadcast and widescreen lies in the pixel aspect ratio. Widescreen pixels are much wider than their 4:3 counterparts.

A widescreen picture, although having the same frame aspect ratio of 4:3, will contain a squashed 16:9 image. When the images are broadcast on a 16:9 screen, the anamorphic widescreen pixels will adjust to fill the screen.

Figure 9.14 **A still image from Hennings Haus, Lomond Productions for Channel 4 television.**

Designing for Widescreen

If you are creating footage in a square pixel environment and the footage is destined for a widescreen broadcast, you should use the following frame aspect ratios.

- When creating 16:9 footage for broadcast in a square pixel environment, you should create your files at PAL—1050 × 576—or NTSC widescreen—872 × 486.
- When creating 16:9 footage for broadcast in a nonsquare pixel environment, you should create your files at PAL—720 × 576—or NTSC—720 × 486.

Note: You must also make sure to choose the correct nonsquare pixel aspect ratio, specific to the format, and your region when working in these dimensions.

When creating HD footage for broadcast, it will always be square pixels. (However, the frame rate will be different, depending on the region.) You should create your files at 1920 × 1080.

Making Widescreen Safe for 4:3

Although widescreen is becoming the standard, there are still a lot of people watching television on old 4:3 sets. Depending on how the images are broadcast and how the individual has set up the options on his or her TV, the image can be viewed in different ways. The picture in Figure 9.14 is a still from an animation that was designed for broadcast in the widescreen format. If this is viewed on a standard 4:3 TV screen from an analog broadcast, the image will be squashed horizontally (as in Figure 9.15). However, there are ways of treating the footage to keep this from happening. There are several options for formatting widescreen footage safe for 4:3 broadcasts, let's take a look.

Figure 9.15 The same still image squashed into a 4:3 screen.

Letterboxing

One way to send widescreen images through a 4:3 analog network is to use the letterbox format (Figure 9.16). The image is broadcast with a black strip at the top and bottom of the screen. When viewed on a 4:3 screen, the black bars remain, but when viewed on a widescreen TV, the image can be adjusted to fill the whole screen, trimming off the black bars. I'm not a great fan of letterboxing because resolution is lost when the image is adjusted to fill the 16:9 aspect ratio. But if there is no other option—say, your client has insisted on this option—then letterboxing can be a solution. Letterboxing is often used to adjust films for television broadcast, since a traditional film frame is too wide for your TV. Note in Figure 9.16 that my image is now undistorted even though it is being viewed on a 4:3 screen.

Figure 9.16 **The same still image letterboxed.**

Simulcasting

Simulcasting is when the same program is broadcast on the 4:3 terrestrial service at the same time as on the widescreen digital service. Most broadcasters, including the BBC, provide simulcasts of most of their HD programs. There are a few, very special programs that are delivered as two separate versions (a 4:3 version and a 16:9 version), but this is rare due to the costs involved. Most producers will provide one version of the program that can be viewed on both 16:9 and 4:3. When dealing with simulcast broadcast, you will be asked to provide two versions of the file, one for standard definition and another for HD.

Center Cutout

Another option for displaying widescreen images on a 4:3 screen is for the broadcaster to remove parts of the picture before airing. This is known as a center cutout and basically works by selecting a 4:3 area of the 16:9 picture and discarding the rest. In my opinion, this process is the most unsatisfactory because it often results in a poor composition for both formats. It also makes life particularly difficult for any camera operators attempting to shoot live action with widescreen cameras, since the

footage at either side of the screen may be removed. In this case, the designer doesn't do anything differently, and the broadcaster takes care of the problem.

Compromise

The most widely adopted solution to the problem is to use a 14:9 frame aspect ratio, which is a compromise between the two formats. When viewing a 14:9 image on a 4:3 screen, the viewer will see black panels at the top and bottom of the screen, but these are smaller than with the letterbox format, as you can see in Figure 9.17.

Figure 9.17 **The same still image with a 14:9 trim.**

Digital viewers with widescreen televisions will receive the full wide-screen picture. The yellow parts represent the areas of the widescreen picture, which are trimmed off during the conversion. The downside to this compromise is that when viewing the 14:9 terrestrial broadcast on a widescreen television, the picture will include small black panels at either side of the screen. However, most analog widescreen televisions are able to adjust the picture to fit the available screen space, and this will get rid of the problem.

In this situation, the only thing you need to be careful of is to ensure that nothing essential is included in these cutoff areas. If you are shooting footage or designing footage from scratch for inclusion in a widescreen broadcast, it is very important to stick within the 14:9 safe areas to ensure that your footage will be safe on all systems. Adobe After Effects includes a 14:9 safe zone overlay that helps you avoid these problems. You can download templates and the latest information regarding widescreen and HDTV formats from the BBC website at *www.bbc.co.uk/delivery/*.

Figure 9.18 **After Effects safe zones.**

Safe Zones

When graphics are broadcast on television, the edges of the image may be cut off as a result of transmission or 16:9 compensation. Most motion graphic or editing applications provide you with safe zone guides, which help you to avoid placing anything crucial within these risky areas. In Figure 9.18, we can see the safe zones from Adobe After Effects. The inner,

yellow region is the title safe zone, and all text should be contained within this area. The outer, red region is the action safe zone. All essential action should be limited to this area. Anything outside the action safe area is not guaranteed to be seen when the final piece is broadcast. When working on 16:9 content, After Effects provides a third, blue center cut zone. Anything outside this area may be removed when a viewer watches your 16:9 content on a 4:3 television.

Captions

Captions will usually sit at the bottom of the title safe zone. These are often referred to as lower third graphics because they usually exist within the lower third portion of the screen. Rolling credits should also be contained within the title safe area (and within the center cut area when working on 16:9 projects). In the old days, before computers were used for TV graphics, roller machines were used to roll a sheet of paper containing the credits at an even speed past the camera. Nowadays the same can be done with motion graphic software like Adobe After Effects or Apple's Motion. When the credits are rolled vertically, the line spacing should also be increased to compensate for the vertical movement of the text.

Digital Video Platforms

There are several different platforms (or architectures) that allow you to play back and edit video on your computer. Probably the most popular are Apple's QuickTime and Microsoft Windows Media, although there are many more including Direct X, Adobe Flash FLV, and Microsoft Silverlight. Most cross-platform editing applications support QuickTime or Windows Media, so these have become the standard for most of the work done with video on computers. Each platform supports a selection of different codecs for outputting video for a multitude of different delivery media. First, we need to go through some basic terminology, and then we will learn how all of this affects the work you do.

Compression and Codecs

The term *codec* is an abbreviation of compressor/decompressor. Codecs compress the video footage when it's written to disk. The same codec is responsible for decompressing the video when the viewer presses the Play button to watch it. This is why the viewer of your videos must have the same codec on their system as the one used to compress the footage. (Don't worry; this will all make sense soon.)

So why do we need to compress and then decompress video in the first place? Well, uncompressed video consists of multiple frames played back in sequence to give the impression of continuous movement. Each frame is a self-contained image, which can be large in terms of file size. Imagine that each frame of our video was to be approximately 1–2 MB in size. If we then multiply the file size of one frame by the number of frames per second (25 for PAL, 29.97 for NTSC), we can work out that uncompressed video needs to play back from disk at a speed of at least 27–30 MB per second.

Data Rates

The speed at which video frames can be played from a disk is also known as the data rate—that is, the rate at which data are written to, or played back from disk. Most desktop systems cannot cope with such high data rates. You can see evidence of this if you try to play back uncompressed, full-screen video on your desktop computer. The video will stutter or even grind to a halt. This is, in basic terms, because the hard drive cannot run fast enough to play back that amount of material from the hard disk every second.

Compression is also required when capturing video or printing your video back to tape. Most people who work with desktop video will have accelerated hard drives on their systems that allow them to achieve faster data rates and therefore use less compression on their footage. These systems will process the video fast enough to write sufficient frames per second to disk.

Compression

Codecs work by compressing the footage when it is written to the hard disk or to videotape and then decompressing it again when it is played back. There are different methods of reducing the amount of data that the computer has to deal with, depending on what the preferred tradeoff is.

The human brain is very skilled at perceiving either high levels of motion and detail simultaneously or high levels of motion and color simultaneously. But if the brain is concentrating on details, it takes less notice of color, and vice versa. It's these limitations that make compression possible. We can reduce the visual information provided without losing the apparent quality of the footage. The two basic types of compression are temporal and spatial.

Spatial Compression

Spatial compression (also known as intraframe compression) affects one single frame at a time. It works by looking at each

frame and reducing the information on a frame-by-frame basis. For example, some spatial compression codecs, including the animation codec, work by reducing the amount of colors used in each frame. This type of compression is best used on animations containing large areas of flat color—for example, 2D animation. These codecs work by creating averages for colors that are very similar to each other. If used on more photographic images, the results from this type of spatial compression can sometimes appear blocky.

Other spatial compression codecs include the Photo JPEG codec, which is a version of the JPEG codec specifically designed for moving images. It uses an algorithm designed by the Joint Photographic Experts Group specifically for compressing photographic images. This is very similar to how compression works for web graphics. In that case, you would use gifs for flat, vector-type graphics and jpegs for photographic images. The only difference here is that video codecs work across multiple frames.

Temporal Compression

Temporal compression (also known as interframe compression) works by comparing the data across multiple frames. For example, some temporal compression codecs look for identical areas in sequential frames and will repeat these areas rather than redraw the same area on every subsequent frame. Doing this will reduce the file size and improve playback speed and performance. This sort of compression works well with footage shot from a fixed camera, where areas such as static backgrounds do not alter much from frame to frame. Temporal compression has been divided into two subcategories: lossy and lossless.

Lossy compression usually reduces the file size significantly, but you may also lose quality. This happens because it changes the actual image data in the image. An example of this would be the Photo JPEG codec, which can result in blockiness known as JPEG artifacting. Anyone who has compressed images for the web using the JPEG compression will have seen this phenomenon. The pro of lossy compression is that it's easier to achieve smaller file sizes. You will need to make a tradeoff between quality and file size, and each situation is different; there are no set rules.

Lossless compression will reduce the file size of your video files without affecting the image quality. An example of this would be the animation codec. This codec reduces the file size by describing large, consistent areas of color as opposed to individual pixels, which requires more data. These codecs are the best ones for archiving footage that you may want to reuse later. You may not save a lot of disk space with these, but you will maintain the quality.

Codecs by Medium

New codecs are developed all the time, so it's hard to print a definitive list that will remain up to date. For this reason, I have not attempted to list all available codecs here but instead give you examples of the codecs used for different media. Each codec excels at compressing a particular type of footage. These are the ones that you will be likely to come across as a motion graphics designer.

Videotape

Some codecs are specifically designed for working with footage that comes from or is destined for videotape. An example is the DV PAL or DV NTSC codec. These should be used when working with generic DV footage and the footage is going back to tape. There are also several hardware-specific codecs that will be installed on your system when you install a new video capture card. The codec for use with the card will usually be added to your system when you install the card's driver software. Once installed, this codec will be available in any software application that supports the same digital video platform as the card manufacturer.

Broadcast

When outputting footage for broadcast, you should check with the production company or broadcaster about what format and codec they require. A safe bet is to output QuickTime movies with the animation codec because it is lossless. However, they may prefer a codec that matches their editing system. For example, AVID has its own Media Composer codec that is designed for use with its own editing systems.

Disc-Based Media

Other codecs are designed to compress footage to be played on CD-ROM, DVD, or Blu-ray. Cinepak, Indeo, and MPEG 1 are often used for CD-ROM movies, and MPEG 2 is the standard for DVD. Again, always check with your client to see if they have a preference before compressing the final footage.

Web

Some codecs are specifically designed for web footage. Examples of these include Adobe's Flash FLV, Sorenson, Real Video, and the ubiquitous H264 codec (which is also used for handheld devices such as iPods). Most clients will have a preference for either QuickTime or Flash Video. Once you have determined this, it's a case of trying out different options to see what

gives you the best results. I find that QuickTime movies with the H264 codec are good, and FLVs can also yield some amazing results at small file sizes. It's important to remember, though, that what works well for one piece of footage may not work well for the next. The content of the footage will determine which is the best codec to use in each situation.

Audio

Audio codecs are specifically designed to reduce data rates of audio files—for example, IMA, Qualcomm, Q Design, and Real Audio.

The technology used for video is ever changing, so it's important that you keep on top of new developments. Don't rely only on the list in this book; make sure to stay informed of new codes and technologies. Adobe also has some excellent documentation on compression that can be accessed via its website customer support section. You can also stop here for technical documents, tips, and advice. Search for "Compression Primer," which is an in-depth document on compression and is regularly updated with current information (*www.adobe.com/support/ main.html*).

Bitmap versus Vector

The two basic types of 2D images that you will work with when using software to create artwork are bitmap images and vector images. Understanding the difference between the two file types will help you as you create your designs.

Bitmap Images

Adobe Photoshop, Corel Painter, and other image editing software applications create bitmap images, sometimes referred to as raster images. Bitmap images are described using a grid of square pixels. The amount of detail in a bitmap image is determined by its physical dimensions, measured in pixels.

Figure 9.19 Bitmap images are made up of pixels.

Image Size

In the world of video, the size of an image is measured by its pixel dimensions. Think of a digital image like a mosaic: The more tiles you use to make up an image, the more detail you'll get from the image. In Figure 9.19, you can see a close-up of a section of an image of tulips in Bitmap mode. Notice the individual pixels making up the picture.

Resolution

This measurement in pixels is known as the resolution of the image. In Figure 9.20, you can see another bitmap image that has a resolution of 860 × 846 pixels. I have magnified the image so you can see how it looks at pixel level. Notice that the original image is a good size and the edges are smooth.

In Figure 9.21, you can see the same image at a lower resolution (86 × 85 pixels). Notice that the image is smaller on screen than the higher-resolution image. The zoomed area reveals a much lower quality of image with much blockier edges. An image distributed over an area of 86 × 85 pixels will have less detail than the same image distributed over an area measuring 860 × 846, since fewer blocks are available with which to describe the image.

Figure 9.20 This image has a resolution of 860 × 846 pixels.

Figure 9.21 This image has a resolution of 86 × 85 pixels.

Figure 9.22 The 86 × 85 image has been enlarged 200 percent.

Bitmaps are resolution-dependent, which means that the amount of pixels with which you describe your image remains constant—in other words, the image will always be made up from the same number of building blocks, no matter what size.

Pixelation

The downside to this is that if you try to stretch the image or magnify it, you will lose detail and will see pixelation. In Figure 9.22, I've taken the 86 × 85 image and blown it up 200 percent. Notice that the blocks have just been made bigger, and no more detail has been added; in fact, the resizing has also softened the image.

Pixelation is when you can clearly see the square edges of the pixels making up the picture. This happens when you enlarge the image and therefore magnify the "building blocks" that the image is made from. When working with bitmap images, you should always create the image at the largest size you envisage it being on screen. Avoid the need to enlarge the image above 100 percent when animating it.

Bitmaps are the ideal format for photographic images or any images that use subtle blends of color because each pixel in a bitmap image contains its own individual color information. We'll discuss this further later in this chapter.

Vector Images

If you want flexibility in terms of resolution, you should use vector images, since they can be resized up or down at a whim. Adobe Illustrator, Corel Draw, and other drawing programs create vector images (Figure 9.23). These images are described using geometric shapes and curves called vectors, which can contain color, gradients, patterns, and transparency. These geometric shapes are described mathematically and are incredibly precise. This is one reason why they are the choice of technical illustrators, graph makers, and typographers. The colors in a vector image are not described on a pixel-by-pixel basis, like bitmaps.

Figure 9.23 **A vector illustration in Adobe Illustrator.**
© Angie Taylor, 2000.

Instead, they are defined by geometrically described areas. Because of this, the file sizes tend to be smaller. Vector graphics are resolution-independent, which means they can be scaled up or down with no loss of quality or detail. They are not really suitable for photographic images and are generally better suited to cartoons or illustrations.

Bezier Curves

Bezier curves are used in most drawing and image manipulation applications to create vector images and to control shapes and effects. They are also used in compositing applications like Adobe After Effects for masking and for controlling motion paths, so it's vital that you learn how to create and control them. They are not easy or intuitive to use at first, but they are definitely worth learning because they offer a level of control and precision that can't be matched. I'm not going to attempt to teach you how to use Bezier curves here, since the controls can differ from application to application, but many online training materials are available. I recommend using the online help for the application you are using as a starting point, and then it's just a matter of practice makes perfect! In Figure 9.24, you can see a drum kit being traced around using Bezier curves in Adobe's After Effects. It's useful to practice your Bezier techniques on images like this because they contain a mixture of straight edges and curves.

Figure 9.24 Adjusting Bezier curves in Adobe After Effects.

Channels

When designing for television or any other screen-based medium, you will usually be working with RGB images. RGB images are made up from three, eight-bit, grayscale images, called channels.

Traditional Color Photography

I find that it helps to think about traditional photography to understand more about channels. In 1861, a Scottish scientist named James Clerk Maxwell discovered that if he shot three black-and-white images of the same subject from a fixed camera, one through a red filter, one through a green filter, and one through a blue filter, the three shots could be combined to create a full-color image.

Maxwell developed these images into transparencies and then projected red light through the image shot with the red filter, green light through the one shot through green, and blue through the blue. When these three images were projected separately onto a screen, a red image, a blue image, and a green image would appear. But when the projectors were angled so these images overlapped exactly, as if by magic a full-color image appeared.

This is the basic way that all color photography and television work. If you look closely at video projectors, you can see the three colored lights pointing at the screen (red, green, and blue). Interestingly, if you shine a pure red light, a pure blue light, and a pure green light onto the same surface, they will mix together to create white light. This is known as an additive color system because adding together the results of each of the colors creates white.

The Science of Color

To fully understand channels, it's advisable to get your head around a small amount of math and science. I do apologize, but I'll try to be gentle. The software you use to work with your RGB images works in the same way as the traditional photography technique, where red, green, and blue combine to make white light. In software, these three color components are called channels. As we've already discussed, adding together different combinations of red, green, and blue allows you to create all the colors of the spectrum. We also know that combining these colors, each at their maximum value, creates pure white.

The same thing happens in reverse with a rainbow. A rainbow is just tiny water droplets in the air acting as prisms, splitting up light into its component colors. So we know from this that light is made up of all the colors in the rainbow added together (Figure 9.25).

Figure 9.25 **The full-color spectrum.**

The Math of Channels

In Photoshop and After Effects, each image contains a red channel, a green channel, and a blue channel. Each of these channels consists of a grayscale image that determines the amount of color used in every single pixel in your image. When these three grayscale channels are blended together, they make up a full-color image, just as they did in traditional photography. Each pixel's color is represented by a numeric value.

Every pixel has 256 possible levels of gray (including pure black and pure white). These levels are measured using numeric values ranging from 0 (black) to 255 (white). RGB colors are known as

additive colors, and as the number increases, so does the amount of color per pixel. These numbers are listed for red, green, and blue, respectively, so a number of (255, 0, 0) would be pure red; (0, 255, 0) would be green; and (0, 0, 255) would be blue.

But why 256 levels? Well, here comes the math! An RGB image is a 24-bit image. If we divide a 24-bit image by 3 (the number of channels), we can determine that each of the three RGB channels has 8 bits. A bit is binary, meaning that it has two possible values—black or white—and 2 to the power of 8 (the number of bits) is 256. This means that every pixel in each channel has 256 possible levels of gray (numbered between 0 and 255). Remember that although the channels are called red, green, and blue, they actually appear as a grayscale image.

Because this is an additive color system, when all three channels have maximum values of 255(255, 255, 255), pure white is produced. When all three channels have a value of 0(0, 0, 0), you get pure black (an absence of light and color). The higher the values, the brighter (and stronger) the colors—hence the name additive colors. These three channels are combined together to make one 24-bit image, which has about 16.7 million possible colors (2 [either black or white] to the power of 24). The bibliography contains further resources that explain these concepts in different ways. You may find it useful to study these.

Figure 9.26 Notice the red, green, and blue channels in this image.

Photoshop Channels

Photoshop and After Effects are extra special because they allow you to see and work on individual channels. It is important to understand the significance of channels because they are integral to the manipulation of images and movies in both Photoshop and After Effects. Besides being able to adjust an image by altering the channels, you can use the grayscale information provided by your channels in a variety of creative ways. Let's take a look at what these individual channels look like in Photoshop.

Figure 9.26 shows a photograph I took of some flowers in Arundel Castle's gorgeous gardens. I've taken it into Photoshop as an RGB image. There are very definite areas of red and green in this picture, and a little blue. Notice

Photoshop's channels panel on the right showing the three-color channels plus the composite RGB image (Figure 9.27). In each of the channels, if white is present, the specified color will show at 100 percent. If black is present, none of the specified color will show. If the image is 50 percent gray, 50 percent of the color will show, and so on.

In Figure 9.28, you can see the individual color channels that make up the image. Notice that the white areas contain most of the specified color. In the red channel, the flowers are almost white; this is because there is a lot of red in the flowers. Compare this to the flowers in the blue channel. They are much darker because there is hardly any blue contained in the flowers. In Figure 9.29 you can see the channels, in their own colors to help you understand the distribution of color from each of the three channels.

Figure 9.27 **The Photoshop channels panel.**

Figure 9.28 The red, green, and blue grayscale channels as they really look in the Photoshop channels panel.

Figure 9.29 The red, green, and blue channels adjusted to demonstrate how much of each color is in the final image.

Interestingly, in an RGB image, the red channel tends to contain most of the contrast information; the green contains most of the detail information; and the blue channel contains most of the noise. This is very useful information when correcting images. For example, if your image is noisy, blur only the blue channel,

Figure 9.30 The Photoshop Channel Mixer. After Effects has an animatable version of this.

or substitute the blue channel with a copy of the green to reduce the noise and keep the contrast and clarity of your image.

The Channel Mixer in Photoshop is an excellent but sadly underused tool that allows you to do some very clever things with channels. In Figure 9.30, I've used the Channel Mixer to change the color of the tulips to pink. This is done by swapping the percentage of color distribution through the channels. As you can see in the Channel Mixer palette on the bottom right of the screen, I've changed the settings so instead of having 100 percent red color being transmitted by the red channel, we have 60 percent red and 40 percent blue. You can find out more about channels and how to use them in creative and interesting ways by referring to the bibliography. In particular, Ron Brinkmann's excellent book *The Art and Science of Digital Compositing* is a must-read for anyone interested in using channels for digital compositing. It's full of excellent information and will give you a lot more ideas about how you can use channels creatively in your work.

Transparency

There are several methods for creating transparent areas in footage. Here are the main options.

Mattes

Grayscale images are extremely important for digital compositing. They are used in all sorts of creative ways, including in mattes. A matte is an image or movie that tells the compositing software which areas in your image or movie should be transparent and which areas should remain opaque.

Mattes work similarly to the color channels and determine the amount of color in your images or movies. In this case, the grayscale values determine the transparency of pixels in your images. Black represents areas you want to be transparent (so none of the color shows through), and white represents areas you want to be opaque (so all the color shows through). It follows that 50 percent gray represents 50 percent opacity, and all the other 256 shades of gray represent all the other percentages of opacity between 0

and 100 percent. The matte provides you with a nondestructive method for selecting areas to be transparent without losing the original information in the RGB channels. People who use proprietary broadcast systems refer to these mattes as stencils.

Transparency provided by mattes allows you to mix the images together into a composite image. Many applications, including Adobe After Effects, allow you to import these mattes as separate layers and use the grayscale information to affect another layer in the same composition. Royalty-free footage often comes with a separate matte file, which can be used in this way. You can also create mattes for footage yourself in Photoshop, Illustrator, or After Effects. Any image can be used as a matte, but it is more effective and easier to predict results with grayscale images.

Alpha Channels

Another way to save saving mattes is by embedding them into the associated image file. You can save certain file types (such as picts or tiffs, for example) as 32-bit images. These images contain a fourth 8-bit grayscale channel called an alpha channel. An alpha channel is a matte that is embedded into a separate channel in your image. Like a separate matte, it can contain information about which areas of an image you want to be transparent and which you want to be opaque.

Figure 9.31 An alpha channel creates transparent pixels.

Alpha channels are convenient to use because they are embedded in your image and therefore don't need to be imported as a separate image. In Figure 9.31, you can see I've created a fourth alpha channel in the channels panel to create some transparency based on the text. In Figure 9.32, you can see the alpha channel used to create this effect. Notice that black areas become transparent in the image, and white areas become opaque in the image. Gray areas will be semitransparent based upon their grayscale value.

Some of the proprietary film and broadcast systems do not support embedded alpha channels, so if you are supplying footage to be conformed in one of these systems, you must save

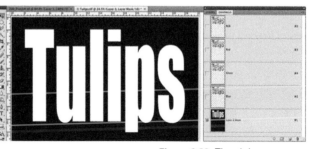

Figure 9.32 The alpha channel displayed in the main Photoshop window.

the alpha channels as separate mattes. You should always check with the individual companies about the limitations of the editing system you are outputting for. And just when you thought you knew everything there was to know about alpha channels… sorry, but there are two types of alpha channels: straight and premultiplied.

Straight Alpha Channels

A straight alpha channel has the transparency information only in the alpha channel of the image. The other three channels of the image remain unchanged and are therefore unmatted when saved from their original application. After Effects reads the alpha information and makes transparent any areas determined by the alpha channel.

The edges of a straight matte are antialiased against transparent pixels and can therefore be placed against any color of background without problems. Straight alpha channels are usually the most versatile to use, since the alpha channel has not been used to alter the RGB information. This leaves the image information untouched and open to change. Notice the channels panel in Figure 9.33; the three color channels remain unaffected by the alpha channel.

Figure 9.33 A straight alpha channel. The three color channels remain unaffected by the alpha channel.

Premultiplied Alpha Channels

In a premultiplied image, one or all of the RGB channels in the image will have used the alpha information to change the appearance of the image. This is accomplished by multiplying the alpha information with a color. The selected area may have been filled with another color, for example. This image has been matted before leaving the original application. Premultiplied alphas are generally less flexible, since the RGB information has been changed before the file is saved for export. This makes it very difficult to adapt the original without degrading the image. Notice in Figure 9.35 that the three color channels have been affected by the selection.

Figure 9.34 The result of applying the alpha channel in After Effects. It behaves like a stencil.

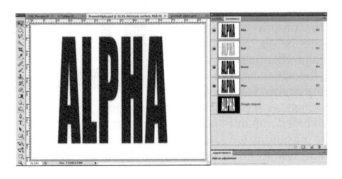

Figure 9.35 Notice that the three color channels have been affected by the selection.

When this happens, the edges separating the subject from the background are antialiased, or smoothed, creating a soft, blended edge between the foreground and the background colors. This can create a halo effect if the alpha is not correctly interpreted (Figure 9.36). Applications like Adobe After Effects can remove this halo effect by removing all traces of the specified color from the RGB image (Figure 9.37).

Figure 9.36 Notice the edges of the alpha have been antialiased against white, resulting in this halo effect.

Many 3D animation applications can only use premultiplied alpha channels. In these cases you must try to keep the background as evenly colored as possible to make it easy for After Effects, or whatever compositing application you use, to remove the color. The general rule that I use is to use straight alphas wherever possible. Photoshop, After Effects, and Illustrator are some of the few applications that support straight alpha channels. After Effects will be able to tell what type of alpha channel has been saved if the image was created in Photoshop or Illustrator, since the images are tagged accordingly.

Figure 9.37 Adobe After Effects can remove the halo caused by premultiplied alpha channels.

If your image was created somewhere else, you may have to tell After Effects what type of alpha channel it is. This is done in the Interpret Footage dialog box (Figure 9.37). This is also where you can select the premultiplied color.

Masks

Besides importing ready-made mattes and alpha channels, you can create your own mattes inside applications like After Effects or Apple Motion by using masks. Masks are user-defined shapes that select areas of your image for transparency or opacity. The term

comes from traditional photography, where a solution would be painted on the negative to stop exposure of certain areas.

Masks can be drawn in After Effects using Bezier drawing tools, which are very similar to those used in Photoshop and Illustrator to draw paths. You can also feather, or soften, the edges of your masks. Masks can be used to isolate part of your layer when no matte or alpha channels exist.

Layer Modes

Layer modes—or blending modes, as they are called in Photoshop—can be used creatively to combine images together without altering the opacity of the layers. You can create very pleasing effects by using layer modes to composite your images; they can give a movie depth and texture while being reasonably fast to render. The best way to learn about these modes is to experiment with lots of different combinations of footage; this way you'll learn how to use them instinctively rather than in a formulaic way. I think that it does help, however, to have an explanation of how they work so you can avoid too much head scratching.

Remember when we discussed channels, we spoke about how an image is made up of 3×8-bit, grayscale channels. Each is made up of 256 shades of gray, and these are numbered between 0 and 255. Well, understanding this concept will help you understand how these modes work. Layer modes work by performing mathematics with the numeric color values of the channels. By adding, subtracting, multiplying, and dividing these values, the compositing software comes up with a composite image, which is kind of a blend between the two originals. Let's take a look at the Add mode as an example.

Add

As the name implies, the Add mode adds the values from the selected layer to the underlying layers. This usually results in an image that is lighter than the original because the values are added together. Pure black is valued at 0, so adding areas of black will have no effect on underlying colors. Adding white to an underlying color will make that area pure white. White is represented by 255. Add this value to any other number, and the result will always add up to a number of at least 255, and you can't get much whiter than that! This mode tends to produce an image that is clipped toward the positive (lightest) values. In Figure 9.38, a movie has had a gradient placed on top of it in After Effects. The first image shows the original movie in an After Effects composition, and the second shows the gradient placed on top of the movie.

Figure 9.38 The first image shows the original movie in an After Effects composition, and the second shows the gradient placed on top of the movie.

The other modes use similar methods to calculate new results for blending the layers together. Don't worry if you don't understand these concepts immediately. The best way to learn is by experimenting with the different modes and comparing your results. You will eventually find that you can use the modes quite intuitively.

Safe Colors and Working Spaces

In Chapter 6, we spoke about gamuts—the fact that some devices are incapable of displaying the full range of RGB colors. Television screens cannot display all the colors and luminance values that a computer can. Colors that are too highly saturated or too high in luminance (brightness) can cause problems when broadcast. In extreme cases, highly saturated colors can even interfere with the audio and cause noise interference. So you should always endeavor to choose safe colors for your text and graphics if you're outputting content for broadcast. The safe colors for TV systems vary according to what part of the world you are located in, but a general rule of thumb is that a television's safe luminance values range between 16 and 235. To ensure your graphics and animations are safe for broadcast, any blacks you use should not have lower values than 16, 16, 16, and any whites should not exceed 235, 235, 235.

Remember also that certain actions that take place during the compositing process (like using additive blending modes or lighting effects) can force the luminance values outside the safe limits. Most video editing or compositing applications offer you tools that can check whether your footage is broadcast safe. Final Cut Pro, for example, has a Range Check function under the View menu that highlights the areas that are unsafe for broadcast by reducing either the luminance value or the chrominance value. Adobe After Effects has a Broadcast Colors

Figure 9.39 The result of applying the Add blending mode to the gradient layer to blend it with the layer below.

Animation preset that you can use. These will fix the colors for you in an automated way, but if you really want to have control, use a professional studio monitor to keep an eye on your colors at all times. There was a time when all motion graphic designers would use a hardware vectorscope and waveform monitor to monitor the colors, making sure they kept within safe limits. Big production companies still use these, but they are often too pricey for individual freelancers to afford. Some software applications, like Final Cut Pro, come with a software vectorscope for checking colors and a waveform monitor for checking luminance values (Figure 9.40).

Figure 9.40 Final Cut Pro's Waveform monitors and vectorscope.

Recap

Wow, I'm impressed! You have not only made it to the end of the dreaded technical chapter, but you've also made it to the end of the book! Well... almost. You should still make sure to consult the bibliography, which lists lots of useful resources you can use to learn more about the topics we've covered in this book. Before you do that, however, let's recap what we've learned in this chapter.

First of all, we looked at the most common video formats: PAL, NTSC, SECAM, and HD. We discussed how each of these work in terms of frame rates and timecodes. I showed you how interlacing could cause problems when working with digital video and

talked about how software deals with fields and other causes of jittery motion.

We talked about aspect ratios with regard to pixel aspect ratio and frame aspect ratio and how to work with them in all situations. You learned some of the practicalities of designing for widescreen and working in safe zones for things like captions and rolling credits.

Then we moved on to the tricky stuff, understanding digital video platforms, video compression, and data rates. We also looked at how to output for all types of media, including video, broadcast, and the web.

I explained the differences between bitmap images and vector graphics created with Bezier curves and how a good understanding of color channels can help take your work to the next level. We discussed transparency and how to composite your images successfully.

Finally, we focused on safety—how to ensure that your designs use safe colors and working spaces.

There's always more to learn in the wonderful world of motion graphics. That's why I love it. I'll never get bored! But before you take on any more information, I suggest that you use what you've learned in the pages of this book and start applying it to some of your own work, either at a paying job or in an experimental project.

I hope this book has helped to inspire you and has given you a better understanding about how to make your designs work. After all, that's all we set out to do in the first place! Once you feel confident, perhaps you'll get opportunities to take this cumulative knowledge and pass it on to the next generation of artists, animators, illustrators, and designers.

You'll be surprised how much of the information you've read has subconsciously worked its way into your brain. A good friend of mine, the esteemed artist, Bunty Cairo, told me that the best way to learn is to study something hard and then immediately and deliberately forget about it and move on. That way, you'll use what you've learned in an instinctive way.

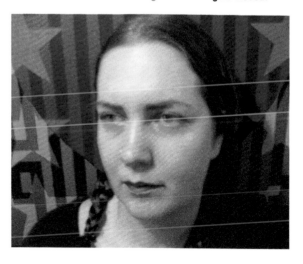

Figure 9.41 **Birgitta Hosea.**

Inspiration: Birgitta Hosea, Artist

Birgitta Hosea is a London-based artist who works in the field of expanded animation. Her practice ranges from video installation and performance art to commercial motion graphics. Her work has

Figure 9.42 Still from *Mr. and Mrs. Smith*. © Birgitta Hosea, 2010.

Figure 9.43 Still image from *London Angel*. © Birgitta Hosea, 2007.

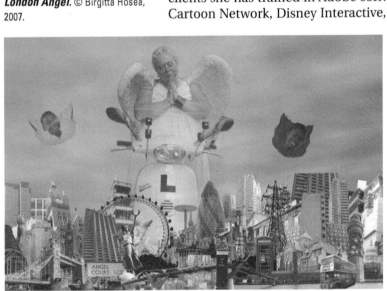

been exhibited in galleries and festivals all over the world, including 1era Bienal Internacional de Performance, Santiago de Chile; Act Art 7, London; British Film Institute, London; Centre for Drawing, London; Chicago Underground Film Festival; Cosmic Zoom Festival, Denmark; Kinetica Art Fair, London; San Diego Museum of Photographic Arts; Technarte, Spain; Upstage 999 Festival, New Zealand; Turkey; Canada; Serbia; and Norway. She has also directed, art directed, and/or animated promotional films and corporate videos for clients such as Adobe, SAP, Trois Palmes Film Festival, Nickelodeon, Chiat Day, Focal Press, and Musion Holographic Projection Systems. She was recently awarded a MAMA Award for Holographic Arts and in 2004 was awarded an honorary fellowship by the Royal Society of the Arts (FRSA).

Birgitta is employed part-time by Central Saint Martins College of Art and Design, University of the Arts London, as Course Director of the MA in character animation. She is also an Adobe Certified Expert and Adobe Education Leader and works for Adobe as a freelancer, senior presentation artist, and organizer of Adobe Inspired Media, a monthly networking event in motion graphics, animation, and postproduction. Corporate clients she has trained in Adobe software include BBC, Sky, MTV, Cartoon Network, Disney Interactive, SVT, and Saatchi & Saatchi, and she has also written two books on Flash for Focal Press.

"I used to work in design for performance and initially started learning software so that I could find new techniques for making design presentation drawings to show to clients. I quickly fell in love with computers and haven't looked back since then.

"It can be hard to keep up with the latest techniques, since technology

Figure 9.44 *Out There in the Dark,* live performance with projections, 2008–2010. © Birgitta Hosea, 2010.

changes so fast, so I make sure that I put time aside to keep up-to-date by looking at online tutorials, magazines, books, trade shows, and technology events. However, you must be careful when using software programs. It is easy to become overwhelmed with the tools that you use and produce work that looks as if it is made by the software and not you. It's important to develop your own creativity as well as to learn technical skills. Don't just rely on the internet for inspiration—everyone else is looking there, too. Drawing is a very important part of my creative process and the starting point of every project that I do. I have grown to love the touch screen drawing software on my phone, which is always with me if I want to make a quick sketch. I draw to help myself think. Be curious about everything. I regularly travel and visit museums, libraries, film festivals, street markets, and art galleries to keep myself inspired with new ideas. I keep notebooks that are filled with thoughts, reflections, and the beginnings of ideas, quick sketches, notes from conversations I've had, pictures cut out from magazines, brochures, and packaging. They are interesting to look back on after a few years have passed and can show you how much you have progressed. Above all, my biggest inspiration comes from exchanging ideas with other people—friends, colleagues, students, people met in passing. Both giving and receiving supportive feedback on your work from other people is the best way to develop your practice and stimulate new ideas."

Bibliography

Here is a selection of books that I have read and dipped into many a time during my career as a motion graphic designer. I hope you, too, will get knowledge and inspiration from them. I'd like to thank all of the authors for sharing their knowledge and for all the hard work involved in putting these great books together.

You can also find a growing selection of books in the resources section of this book's website, where you can also tell me about your own favorite books and resources: *www.motiondesignessentials.com*.

General Motion Graphic Design

1. *Motion Graphics: Graphic Design for Broadcast and Film,* by Steve Curran. Rockport Publishers, ISBN-10: 1564968383.
2. *Pause: 59 Minutes of Motion Graphics,* by Peter Hall. Universe Publishers, ISBN: 0789304775.
3. *Motion Graphic Design: Applied History and Aesthetics,* by Jon Krasner. Focal Press, ISBN-10: 0240809890.
4. *The Thames and Hudson Manual of Television Graphics,* by Ron Hurrell. Thames and Hudson, ISBN: 0500670048.
5. *The Art and Science of Digital Compositing: Techniques for Visual Effects, Animation and* Motion Graphics, by Ron Brinkmann. Morgan Kaufmann, ISBN-10: 0123706386.
6. *Television Graphics,* by Ron Hurrel. Thames and Hudson, ISBN: 0500680043.

Software

1. *How to Cheat in Photoshop CS4: The Art of Creating Photorealistic Montages,* by Steve Caplin. Focal Press, ISBN-10: 0240521153.
2. *Adobe Photoshop CS4 for Photographers: A Professional Image Editor's Guide to the Creative Use of Photoshop for the Macintosh and PC,* by Martin Evening. Focal Press, ISBN: 0240521250.
3. *Adobe After Effects CS5 Visual Effects and Compositing Studio Techniques,* by Mark Christiansen. Adobe, ISBN-10: 032171962X.
4. *Creating Motion Graphics with After Effects: Essential and Advanced Techniques (DV Expert Series),* by Trish and Chris Meyer. Focal Press, ISBN-10: 0240810104.

Drawing

1. *How to Draw Comics the Marvel Way* by Stan Lee and John Buscema. Titan Books, ISBN: 0907610668.
2. *Scrawl: Dirty Graphics and Strange Characters,* by Rick Blackshaw, Mike Dorrian, and Liz Farrelly. Booth-Clibborn Editions, ISBN: 1861541422.

Design Essentials for the Motion Media Artist. DOI: 10.1016/B978-0-240-81181-9.00017-0
© 2011 Angie Taylor. Published by Taylor & Francis. All rights reserved.

3. *The Art of the Storyboard, A Filmmaker's Introduction,* 2nd ed., by John Hart. Focal Press, ISBN-10: 0240809602.
4. *The Complete Guide to Perspective,* by John Raynes. North Light Books, ISBN-10: 1581805160.
5. *What Shall We Draw?,* by Adrian Hill. Blandford Press, ASIN: B001O41R76.

Composition

1. *Geometry of Design,* by Kimberly Elam. Princeton Architectural Press, ISBN: 1568982496.
2. *Motion Design: Moving Graphics for Television, Music Video, Cinema and Digital Interfaces,* by Matt Woolman. RotoVision, ISBN: 2880467896.
3. *Motion by Design* by Spencer Drate, David Robbins, and Judith Salavetz. Laurence King Publishing, ISBN-10: 1856694712.
4. *Avant-Garde Graphics 1918–1935,* by Lutz Becker and Richard Hollis. Hayward Gallery Publishing, ISBN: 1853322385.
5. *Swiss Graphic Design: The Origins and Growth of an International Style 1920–1965,* by Richard Hollis. Laurence King Publishing, ISBN: 1856694879.
6. *Graphic Design for the Electronic Age,* by Jan V. White. Watson-Guptill, ISBN: 082302122X.
7. *Graphic Idea Notebook: Inventive Techniques for Designing Printed Pages,* by Jan V. White. Watson-Guptill, ISBN: 0823021491.
8. *Grids for the Internet & Other Digital Media,* by Veruschka Götz. AVA Publishing, ISBN-10: 2884790039.

Animation

1. *The Illusion of Life: Disney Animation,* by Thomas Johnson. Hyperion, ISBN: 0786860707.
2. *The Animation Book: A Complete Guide to Animated Filmmaking—From Flip-Books to Sound Cartoons to 3D Animation,* by Kit Laybourne. Crown Publications, ISBN: 0517886022.
3. *Timing for Animation,* by Harold Whitaker and John Halas. Focal Press, ISBN: 0240521609.
4. *The Animator's Survival Kit,* by Richard E. Williams. Faber and Faber, ISBN-10: 0571238343.
5. *The Art of the Animated Image—An Anthology,* edited by Charles Solomon. American Film Institute, ISBN-10: 9991475338.
6. *Cartoon Animation,* by Preston J. Blair. Walter Foster, ISBN: 0929261518.
7. *How to Animate Film Cartoons,* by Preston J. Blair. Walter Foster, ISBN: 1560100699.
8. *Art in Motion: Animation Aesthetics* (revised edition), by Maureen Furniss. John Libby Publishing, ISBN: 9780861966639.
9. *Animation: The Whole Story,* by Howard Beckerman. Allworth Press, ISBN: 1581153015.
10. *Understanding Animation,* by Paul Wells. Routledge, ISBN-10: 0415397294.

Type

1. *Type in Motion 2,* by Matt Woolman and Jeffrey Bellantoni. Thames & Hudson, ISBN-10: 0500512434.
2. *Stop Stealing Sheep & Find Out How Type Works,* 2nd ed., by Erik Spiekermann and E. M. Ginger. Adobe Press, ISBN-10: 0201703394.
3. *The Designer's Guide to Web Type: Your Connection to the Best Fonts Online,* by Kathleen Ziegler and Nick Greco (Editor). HarperCollins Design International, ISBN-10: 0060933739.

4. *Moving Type*, by Jeff Bellantoni and Matthew Woolman. Rotovision, ISBN-10: 2880463696.
5. *Type Graphics: The Power of Type in Graphic Design*, by Margaret E. Richardson. Rockport, ISBN: 156496714X.
6. *Thinking with Type: A Critical Guide for Designers, Writers, Editors and Students*, by Ellen Lupton. Princeton Architectural Press, ISBN: 1568984480.
7. *Type and Typography*, by Phil Baines and Andrew Haslam. Laurence King Publishing, ISBN: 1856692442.
8. *About Face: Reviving the Rules of Typography*, by David Jury. RotoVision, ISBN: 2880466776.
9. *The Graphic Language of Neville Brody*, by Jon Wozencroft. Thames and Hudson, ISBN: 0500274967.

Color

1. *Colour*, by Edith Anderson Feisner. Laurence King Publishing, ISBN: 1856694410.
2. *Digital Colour for the Internet and Other Media*, by Studio 7.5. AVA Publishing, ISBN: 2884790268.
3. *Big Color: Maximise the Potential of Your Design through Use of Color*, edited by Roger Walton. HB1/HarperCollins Publishers, ISBN: 3931884848.
4. *Colour Index*, by Jim Krause. A David and Charles Book, ISBN-13: 9780715313978.
5. *Color Design Workbook: A Real-World Guide to Using Color in Graphic Design*, by Adams Morioka and Terry Stone. Rockport, ISBN-13: 9781592534333.
6. *Digital Color for the Internet and Other Media*, by Carola Zwick. AVA Publishing, ISBN-10: 2884790268.
7. *Chroma*, by Derek Jarman. Vintage, ISBN: 9780099474913.

Websites

You can find an up-to-date selection of websites on this book's website at *www.motiondesignessentials.com.*

Adobe provides a series of excellent white papers on color spaces and color management, as well as other subjects. These are updated often, so URL links change on a regular basis, but they can be searched for on the Adobe website at *www.adobe.com.*

The following websites are also referenced by Adobe as good sources of information regarding color:

www.poynton.com
www.graymachine.com/2009/04/rgb-to-hsl-expressions/
www.adobe.com/go/learn_ae_colormanagementpaper
www.adobe.com/go/vid0260

Editing and Filmmaking

1. *The Visual Story: Creating the Visual Structure of Film, TV and Digital Media*, by Bruce Block. Focal Press, ISBN-10: 0240807790.
2. *Film Directing Shot by Shot: Visualizing from Concept to Screen*, by Steven Katz. Michael Wiese Productions, ISBN: 0941188108.
3. *The Guerilla Film Makers Handbook*, by Genevieve Jolliffe and Chris Jones. Continuum International Publishing Group—Academic and Professional, ISBN: 0826447139.
4. *Grammar of the Shot*, by Roy Thompson. Focal Press, ISBN-10: 0240521218 .

Communication

1. *Creativity,* by P. E. Vernon. Penguin Books, ASIN: B00128KJOG.
2. *Camera Lucida,* by Roland Barthes. Vintage, ISBN: 0099225417.
3. *A Barthes Reader,* by Roland Barthes. Vintage, ISBN: 0374521441.
4. *The Poetics of Space,* by Gaston Bachelard, Etienne Gilson, and John Stilgoe. Beacon Press, ISBN: 0807064734.
5. *The Artist's Way,* by Julia Cameron. Pan, ISBN: 0330343580.
6. *The Tipping Point,* by Malcolm Gladwell. Back Bay Books, ISBN-10: 0316346624.
7. *MTIV: Process, Inspiration and Practice for the New Media Designer,* by Hillman Curtis. New Riders, ISBN-10: 0735711658.

Technical

1. *The Digital Factbook,* edited by Bob Pank. Quantel: *www.quantel.com/repository/files/library_DigitalFactBook_20th.pdf.*
2. *Design Notes Log,* by Robert W. Compton. Phi Rho Press: ISBN: 0-960737636.
3. *The Widescreen Book,* by Martin L. Bell. BBC Resources: *www.informotion.co.uk/delivery_widescreen_book.pdf.*
4. *Digital Video and HDTV Algorithms and Interfaces,* by Charles Poynton. Morgan Kaufmann Publishers, ISBN-10: 1558607927.

INDEX

Note: Page numbers followed by *b* indicates boxes, *f* indicates figures.

Printed and bound by CPI Group (UK) Ltd, Croydon, CR0 4YY

22/10/2024

01777530-0010